TRACING GESTURES

UCL World Archaeology Series

General Editor: Ruth Whitehouse

Published in association with the UCL Institute of Archaeology, this series provides a home for exemplary scholarship which showcases high-quality research across the full spectrum of world archaeology, archaeological science, heritage studies and cognate disciplines. A full list of volumes published in the series prior to its move to Bloomsbury is available online at https://www.ucl.ac.uk/archaeology/about-us/institute-archaeology-publications.

TRACING GESTURES

THE ART AND ARCHAEOLOGY OF BODILY COMMUNICATION

Edited by Amy J. Maitland Gardner and Carl Walsh

BLOOMSBURY ACADEMIC
LONDON • NEW YORK • OXFORD • NEW DELHI • SYDNEY

BLOOMSBURY ACADEMIC
Bloomsbury Publishing Plc
50 Bedford Square, London, WC1B 3DP, UK
1385 Broadway, New York, NY 10018, USA
29 Earlsfort Terrace, Dublin 2, Ireland

BLOOMSBURY, BLOOMSBURY ACADEMIC and the Diana logo
are trademarks of Bloomsbury Publishing Plc

First published in Great Britain 2022
Paperback edition published 2024

Cover design: Terry Woodley
Cover image © Alice Clough and Fo Hamblin

A catalogue record for this book is available from the British Library.

Library of Congress Cataloging-in-Publication Data
Names: Gardner, Amy J. Maitland, editor. | Walsh, Carl, editor.
Title: Tracing gestures : the art and archaeology of bodily communication /
edited by Amy J. Maitland Gardner and Carl Walsh.
Description: London ; New York : Bloomsbury Academic, 2022. |
Series: UCL world archaeology series | Includes bibliographical references.
Identifiers: LCCN 2022008780 | ISBN 9781350276987 (hardback) |
ISBN 9781350276994 (paperback) | ISBN 9781350277007 (ebook) |
ISBN 9781350277014 (epub) | ISBN 9781350277021
Subjects: LCSH: Speech and gesture. | Body language. | Social archaeology. | Civilization, Ancient.
Classification: LCC BF637.N66 T73 2022 | DDC 153.6—dc23/eng/20220405
LC record available at https://lccn.loc.gov/2022008780

ISBN: HB: 978-1-3502-7698-7
 PB: 978-1-3502-7699-4
 ePDF: 978-1-3502-7700-7
 eBook: 978-1-3502-7701-4

Series: UCL World Archaeology Series

Typeset by RefineCatch Limited, Bungay, Suffolk

To find out more about our authors and books visit www.bloomsbury.com
and sign up for our newsletters.

In memory of the life and work of Adam Kendon (1934–2022)

CONTENTS

Part I The Materiality of Gesture

Part II The Visuality of Gesture

FIGURES

TABLES

CONTRIBUTORS

David Calabro is a visiting assistant professor of Ancient Scripture at Brigham Young University, Provo, Utah, USA. His research focuses on the cultural history of language, ritual, narrative and sacred space in the Near East. His book, *Hands Lifted to Heaven: Ritual Gestures in Northwest Semitic Literature and Art*, is currently under contract with Penn State University Press/Eisenbrauns.

Alice Clough is an artist and researcher working across the fields of anthropology, contemporary art and archaeology in the UK. Her PhD research focuses on storytelling, critical posthumanism, and wonder in British development-led archaeological settings. Alice's artistic practice spans diverse media to encounter vibrant materials, ancient objects, and pervasive cultural narratives. She has published on practice-led research and ways of learning, street art and materiality.

Josef Fulka is Associate Professor at the Faculty of Humanities, Charles University, Prague, and Senior Researcher at the Institute of Philosophy, Academy of Sciences of the Czech Republic. His research interests focus on eighteenth- and twentieth-century philosophy, psychoanalysis and gesture studies. His most recent book is *Gesture and Sign Language in the 18th Century French Philosophy* (2020).

Lucy Goodison is an independent scholar whose career traces two trajectories: as an academic specializing in Aegean archaeology and as a professional practitioner of therapeutic bodywork. Her research interests focus on the religion of Minoan Crete and on re-theorizing the mind/body split. Lucy's books include: *Death, Women and the Sun: Symbolism of Regeneration in Early Aegean Religion* (1989), *Moving Heaven and Earth: Sexuality, Spirituality and Social Change* (1990), *Holy Trees and Other Ecological Surprises* (2010) and, co-editing with Christine Morris, *Ancient Goddesses: The Myths and the Evidence* (1998).

Audrey Gouy is Lecturer in History of Ancient Art & Archaeology at the University of Pau and Pays de l'Adour. She is a specialist in pre-Roman iconography, rituals and performances and wrote her PhD thesis on Etruscan dances from the eighth to fifth centuries BCE using an anthropo-iconographical approach.

Fo Hamblin is Senior Lecturer in Textile Design at Nottingham Trent University, UK. Trained in textiles and jewellery, her practice-research explores the interplay between the performing body and 'vibrant' materials through a process-driven approach. Fo's research explores theories of material engagement, including the integration of digital practices and performative pedagogy in art and design education. Resonances of material/body are encapsulated in film collaborations, *Choreography of Making* (2015)

and *Gloop* (2018). Fo is a member of the Digital Craft and Embodied Knowledge Research Group, part of the Fashion and Textile Research Group, School of Art & Design, Nottingham Trent University.

John S. Henderson is Professor of Anthropology at Cornell University, New York, USA. He holds an AB degree from Cornell and MPhil and PhD degrees from Yale University. He has taught anthropology and archaeology at Cornell since 1971 and has served as Director of Cornell's Archaeology and Latin American Studies Programs. Henderson's interests centre on early complex societies. He has written or edited seven books, including *The World of the Ancient Maya* (1981). His current research focuses on the lower Ulúa River Valley, where he has directed many seasons of field research.

Kathryn M. Hudson is Research Assistant Professor in Anthropology and a member of the Department of Anthropology and the Department of Linguistics at the University at Buffalo, NY, USA. Her research focuses primarily on mechanisms of identity construction, processes of visual and non-verbal communication, ceramic analysis and the documentation of cultural and linguistic traditions; her main geographic foci are Mexico and Central America, the Pacific and South-Eastern Europe. She has published and presented widely on these topics.

Christine Kuehn is an independent scholar in Germany and was previously Professor in the Department of Linguistics at Hokkaido University, Japan. While working in Japan, Germany and the USA, her research interests focus on multimodal perception, the impact of gesture and other non-verbal dimensions on human cognition and communication as well as the implications for intercultural understanding. Expanding the subject of her book, *Body – Language: Elements of a Linguistic Explication of Nonverbal Communication* (2002), she has published on gesture and intercultural competence, foreign language acquisition, multi-sensory teaching and the role of gestures in history, religion and art.

Mireia López-Bertran is Associate Professor in the Department of Art History at the Universitat de València, Spain. Her main interest is art and iconography of the Iron Age Mediterranean from an embodied and gender perspective. More specifically, she specializes in Phoenician-Punic archaeology and focuses on coroplastic artworks.

Amy J. Maitland Gardner is an alumna of the Institute of Archaeology at University College London, UK. Her research focuses on ancient Maya art and culture, with comparative interests in the art and archaeology of Precolumbian cultures of Central America and gesture. Her primary research and publication topics include gestures and their histories, bodily communication and visual languages, processes of interaction and identity, graphics of ancient writing systems and archaeological theory.

Timothy J. McNiven is Associate Professor, Emeritus, in the Departments of History of Art and Classics at Ohio State University, USA. His research focuses on the use and meaning of gestures in Greek art, especially vase painting. He has also published on artistic conventions, gender studies and the representation of children. Recent

publications include: 'The View from Beyond the Kline: Symposial Space and Beyond', in J. Oakley (ed.) *Athenian Potters and Painters III* (2014) and 'Sex, Gender, and Sexuality in Ancient Greek Art', in T. J. Smith and D. Plantzos (eds), *A Companion to Greek Art* (2012).

Christine Morris is Andrew A. David Professor of Greek Archaeology & History in the Department of Classics, Trinity College Dublin, Ireland. Her research interests focus on the Aegean Bronze Age, especially ceramic studies (pictorial pottery, figurines); ancient art; Mycenaean intercultural relations in the Aegean and Eastern Mediterranean; ancient religion (goddesses, experiential/embodied aspects). Her publications include: *Ancient Goddesses* (with Lucy Goodison, 1998); *The Archaeology of Spiritualities* (with K. Rountree and Alan Peatfield, eds, 2012); *Unlocking Sacred Landscapes: Spatial Analysis of Ritual and Cult, Studies in Mediterranean Archaeology* (with Giorgos Papantoniou and Athanasios Vionis, eds, 2019).

Isabelle Vella Gregory is affiliate scholar at the McDonald Institute for Archaeological Research, University of Cambridge, UK, and Deputy Director of the Jebel Moya excavations in the Sahel, Sudan. Her research interests include the west, central and southern Mediterranean, the Sahel, ceramics and figurines.

Carl Walsh is a curatorial assistant at the Institute for the Study of the Ancient World at New York University (USA) and former postdoctoral fellow at the Barnes Foundation in Philadelphia (USA). He is an archaeologist specializing in ancient Nubia and cross-cultural interactions in the Mediterranean, western Asia, and north Africa during the Bronze Age.

EDITORS' PREFACE

This volume is based on the conference, *Tracing Gestures: The Art and Archaeology of Bodily Communication*, which was held over two days in November 2014 at University College London (UCL). We would like to thank the Institute of Archaeology at UCL for financial and technical support, to the volunteers who helped run the event and to the presenters and participants who made the conference such a stimulating and enjoyable event for everyone. We would particularly like to thank Sue Hamilton for her welcome address and the keynote speaker, Adam Kendon. In constructing this volume, we express our gratitude to the authors for their contributions, to the peer reviewers who provided feedback for the chapters, and to Ruth Whitehouse and Marion Cutting, Lily Mac Mahon and Georgina Leighton for their support and work on the volume.

SERIES PREFACE

INSTITUTE OF
ARCHAEOLOGY

The Institute of Archaeology of University College London is one of the oldest, largest and most prestigious archaeology research facilities in the world. Its extensive publications programme includes theory, research, pedagogy and reference materials of the highest quality across archaeology, cultural heritage and cognate disciplines. Through its publications, the Institute brings together key areas of theoretical and substantive knowledge, improves archaeological and heritage practice and makes archaeological findings accessible to the general public, researchers and practitioners. It also publishes staff research projects, site and survey reports, ethnographic work and conference proceedings. The publications programme is now produced in partnership with Bloomsbury and is open to submissions from scholars across the globe.

This volume is part of the Institute's World Archaeology Series. This is a successor to the previous General Series, produced initially in-house, then in conjunction with successively UCL Press, Left Coast Press and Routledge, a part of the Taylor & Francis group.

Details of the Institute's 80-plus publications both within and outside the General Series can be found at: https://www.ucl.ac.uk/archaeology/about-us/institute-archaeology-publications.

Ruth Whitehouse, General Editor
Emeritus Professor, UCL Institute of Archaeology

Sue Hamilton
Director, UCL Institute of Archaeology

INTRODUCTION
TRACING GESTURES IN THE ANCIENT WORLD
Amy J. Maitland Gardner and Carl Walsh

Gestures – bodily actions ranging from arm and hand movements to ways of walking – are embedded in all aspects of human society and are central to the lived human experience. People express emotions, ideas, attitudes, feelings and narratives through a vast array of bodily movements and positions. Their essential role in human communication has led to gesture, as a subject, being heavily researched in many fields of study – such as psychology, linguistics, sociology and anthropology amongst others – resulting in the establishment of gesture studies as an interdisciplinary field in its own right (Kendon 2004: 2).[1] Within archaeology, however, gesture remains under-researched. This is primarily due to the nature of archaeological evidence, which consists of human and material remains rather than the living and moving body. It is also due to a slower awareness about the significance of gesture in archaeological enquiry compared to other disciplines, and, historically, a limited connectivity amongst scholars investigating ancient gestures in dispersed fields and contexts.

This volume, *Tracing Gestures: The Art and Archaeology of Bodily Communication*, illustrates how the deep history of gesture can be examined through archaeological sources – materials, objects, architecture, figural art, burials and texts – with contributions spanning several time periods and cultural contexts. The origins of this volume arose from dialogues explored at a two-day conference that the editors organized in 2014 at University College London (UCL). The conference was pivotal in bringing together scholars to explore the multifaceted nature of bodily communication in relation to archaeological data. This volume has developed through strong engagement with the contributors, all of whom presented papers at the conference, and whose diverse fields of study span an ever-increasing geographic focus for the study of gesture, from the Mediterranean, to Mesoamerica, to the Near East, and to Asia. The contributions feature a range of theoretical and methodological approaches to gesture, providing an interdisciplinary discussion of the role of gestures in the ancient world.

The notion of 'tracing' is an important focal point in this volume. Tracing refers to identifying the material residues of gesture in the archaeological record and the processes of reconstructing bodily actions of ancient societies. Tracing also refers to the temporal scope of our interest in gesture, ranging from some of the earliest points in human prehistory right up to the modern period. It extends beyond physical action to investigate the sociocultural roles of gesture and how they can be used for a variety of intents within larger constructs, such as identity, notions of inclusivity and exclusivity and in performance.

A number of factors place this volume within current archaeological dialogues. Archaeology's focus on the body has gained considerable traction over the past twenty years. Theoretical movements such as embodiment (considering the corporeality and materiality of past bodies through lived experience and perception) and phenomenology (considering the in-being experience of the body through its interactions with surroundings, especially landscape) offer avenues through which the relationship between the living body and the material world can be examined. Framed within these theoretical domains, research has considered how bodily experience is significant in the past lives of human societies and how the body can be examined through traces of bodily action in archaeological sources (e.g. Borić and Robb 2008; Classen 1993, 1997; Crosslands 2010; Csordas 1994; Hamilakis, Pluciennik and Tarlow 2002; Joyce 2005; Kus 1992; Meskell and Joyce 2003; Renfrew and Morley 2007; Tilley 1996, 2008). Through these theoretical approaches, it has been possible to engage with transitory aspects of bodily experience such as human senses. Indeed, sensory archaeology, the examination of how past societies used bodily experience to interpret the world around them, has had great success in discussing the contextual bodily interactions between physical and social bodies, objects, images and built environments (e.g. Brück 2005; Day 2013b; Gosden 2001; Hamilakis 2002, 2013; Houston and Taube 2000). These studies have demonstrated how archaeological sources can be used in tracing the significance of past bodily experiences, through the touch of a cup (Walsh 2018), the imagined scent of a painted flower (Day 2013a) or through the soundscapes of architecture (Mongelluzzo 2013). Body-centred research provides vital frameworks to build from in approaching gesture, with several chapters in this volume utilizing approaches that have been inspired by these movements.

The study of gesture within archaeology is currently small, but growing. Existing research has focused primarily on representations of bodily action in figural art.[2] Large documentary volumes (with substantial catalogues) have served to illustrate the complexities of gesture repertoires, such as in the contexts of ancient Rome (Brilliant 1963), Greece (Neumann 1965) and Egypt (Dominicus 1994). These works, amongst others, have approached gesture through the lens of 'body language', the way that positions of the limbs and the head can express non-verbal information, with gesture considered as a communication system rather than a matter of style. Other notable works have paid particular attention to how gestures function within ancient pictorial systems. For example, Troike's (1982) study of gestures in Mixtec codices showed how gestures could work as mnemonic guides to facilitate the reader's recall of information (e.g. histories).

Visual recordings of gesture in wall paintings, seals, figurines, statuary and painted pottery continue to be a fundamental part of gesture research in archaeology (e.g. McNiven 1982, this volume), with drawing and (reflexive) cataloguing becoming part of the active process in engaging with gestures in and across visual media (e.g. Maitland Gardner 2017). At the same time, iconographic gestures are increasingly considered through embodied performances and experiences, taking inspiration from the body-centred theories mentioned above. Spearheaded in the work of Morris (2001) and Morris and Peatfield (2002) within the context of the Cretan Bronze Age, the physicality of the

body – feeling and experiencing – has opened up alternative ways to approach imagery, such as dynamics of restricted and open movement in Maya postures and gestures through performability (e.g. Maitland Gardner 2017) and theatrics and emotions in the postures and gestures of Paleolithic figurines (e.g. Schebesch 2013).

As well as engaging with figural art corporeally, iconography, of course, has its own materiality, prompting questions about how materials and surfaces in and on which bodies and gestures were inscribed could be encountered and experienced. For example, a painted ceramic container that would be handled and contents consumed, or a figurine that could be handled or set down individually or as part of a set, reminding us of the complex web of interactions among represented bodies, materials and people. Contributions in this volume develop a diverse range of approaches to the visuality of gesture, offering new insights into gestures for which meanings are not clear (even in well-researched artistic cannons), and – by approaching imagery from various standpoints – showing how iconographic gestures require constant re-evaluation in light of social, cultural, material and temporal contexts.

Despite the increasing popularity of tracing bodily experience through material sources in archaeology as outlined further above, material-based approaches, to gesture specifically, have been extremely sparse. A key work in their development is Matthews's (2005) study of how metal ornaments and weapons in Bronze Age Europe were used to construct performative forms of gesture for walking and fighting that expressed gendered identities. Walsh (2016) has also explored how performative gestures interacting with furniture, cosmetic equipment and palatial architecture were used in constructing courtly gestural vocabularies in Bronze Age court societies in the Mediterranean. Both of these illustrate how gesture has an inherent materiality, through the symbiotic relationships between the body and material culture. A number of chapters in this volume provide innovative material-based approaches to gesture by discussing how gesture can have relationships with the physical environment, materials, architecture and objects, and broadening the scope of archaeological enquiry into gesture.

Archaeology has much to gain by engaging with the interdisciplinary field of gesture studies. This field encompasses research on the role of gesture in communication, cognition, sociality and human development.[3] This volume illustrates successful engagement with this field through the use of seminal works by important gesture scholars. Andrea de Jorio (1832), Adam Kendon (2004) and Marcel Mauss (1935) for example, have provided points of discussion for these contributors in different ways. De Jorio has been found to be particularly relevant for his ethnographic approach in documenting gestures observed in everyday life. He also raised important methodological concerns for approaching cultural representations of gesture in the archaeological record. Kendon's diverse contributions to the field have been influential in expanding the concept of gesture to be inclusive in its role in social interaction. Many chapters in this volume explore Kendon's (2004) discussions of gesture, including what gestures are, what they do, and how they are used in a variety of sociocultural contexts to communicate meaning. Chapters in this volume have also found direct inspiration from the work of the sociologist Mauss. His concept of 'techniques of the body' (1935), has been

particularly influential, especially in how he conceptualized the term 'technique' as being a distinct gestural form used in interacting with specific types of materials and material culture. The work of these scholars has helped to understand the dynamics of the living body when approaching archaeological materials. Archaeology also offers important contributions to the field of gesture studies. The chapters in this volume expand the temporal, cultural and contextual scope of gesture enquiry, through their focus on archaeological materials. They also show how gesture expands beyond the confines of the body into the material world.

Clearly, interdisciplinary dialogues are much needed and would be extremely beneficial. This volume provides the first real steppingstone in stimulating this dialogue by highlighting the vital nature of interdisciplinary and holistic approaches to gesture for future research. It is this interdisciplinary and collaborative spirit that the editors foresee as being perhaps, the most important contribution of *Tracing Gestures*.

Structure of the volume

Tracing Gestures is structured thematically according to methodological and evidence-based approaches to gesture. This thematic structuring facilitates dialogues on gesture across cultural and temporal boundaries. Part I, 'The Materiality of Gesture' (Chapters 1–5), features approaches that consider relationships between gesture and the material world. Part II, 'The Visuality of Gesture' (Chapters 6–10), explores approaches to gesture in visual sources. Part III, 'Interdisciplinary Perspectives on Gesture' (Chapters 11–12), provides viewpoints on the relationship between gesture and archaeological material/concepts. Finally, in the Epilogue, the editors provide observations on the overarching dialogues in this volume and thoughts on the future of archaeological enquiry into gesture. These parts are organized to showcase particular approaches to gesture, but they are not entirely defined by them. Many of the studies in this volume provide holistic considerations of archaeological evidence, such as images, objects, texts, human remains and architecture. These fit into the intents of the volume to stimulate comparative discussions on gesture in the ancient world.

Part I, 'The Materiality of Gesture', features contributions which approach the interconnected relationships between gesture and material things – objects, figural art, built environments and landscapes. Scholars explore how these material aspects are manifested through the material and visual evocation of bodily experience, performance and memory, through the interactions between bodies and materials, and through the design choices of objects and architecture. The first chapter by Christine Morris and Lucy Goodison, 'In Touch with the Minoans: Gestural Performance and Experience in Bronze Age Crete', opens by exploring the embodied performative role of gesture in Minoan seal iconography of the third and second millennium BCE. Morris and Goodison use experimental archaeology and draw upon Laban Movement Analysis (LMA), to focus on how images of gesture communicate embodied haptic experiences through touching baetyl stones, bones and *pithoi* vessels.

The following chapter by Carl Walsh, 'Performing Bodies and Theatrical Palaces: Courtly Gestural Vocabularies at Early Bronze Age Ebla', considers the inherent relationships between gesture, architecture and material culture through a case study of the architectural design and furnishing of a palace at Ebla, Syria during the late third millennium BCE. He takes the concept of Mauss's 'techniques of the body' and argues that these are important embodied social and bodily constructs in the *habitus* of royal courts that are incorporated into the architectural design, layout and placement of material culture, such as furniture. This active embedding of gesture in the design of objects is also explored in Audrey Gouy's chapter, 'Aspects of Non-Verbal Communication and Rituality in Pre-Roman Banquets: The Gestures of Union (Eighth to Fifth Centuries BCE)'. Gouy uses praxeology, the scientific study of human motor action, to examine how coordinated gestures were embedded into the design and form of *doppieri* vessels from the Golasecca culture and the ritualized role of gestures in banqueting scenes. In doing so, Gouy illuminates the role of women in pre-Roman wine rituality.

In 'Gestures and Social Relations: The Late Neolithic Figurines of the Maltese Islands', Isabelle Vella Gregory examines the role of Maltese figurines as social agents connected to gestural performances and social memory embedded into the construction and use of space of Maltese megalithic architecture in the fourth millennium BCE. Her chapter highlights how gesture becomes materially embedded in architecture and objects through the performance of place-making and collective identity. The process of how gesture becomes materially embedded through performance ties into the concluding chapter of Part I by Mireia López-Bertran, 'Gestures of Protection: Clay Masks of the Phoenician-Punic World'. López-Bertran examines the grinning smiles of Phoenician-Punic terracotta masks that date from the sixth to second centuries BCE and shows how the masks materialized transformative life processes, magical protection and actual spontaneous, or induced, grinning smiles, which may result from collective social events.

Part II, 'The Visuality of Gesture' features a variety of approaches to the iconographic repertories of gesture in Greece, the Levant, Mesoamerica and Japan. Contributors adapt various methods from anthropology and linguistics to analyse depictions of the body in particular archaeological contexts, investigating how visual body languages can be used to communicate meaning for diverse intents. This includes the types of information visual gestures can denote, their histories and temporalities, and their contextual functions in social dialogues and in imagery.

In the opening chapter, 'The Pitfalls and Potentials of Visual Evidence for the History of Gestures: The Example of Athenian Pottery', Timothy J. McNiven lays out the inherent complexities in approaching and interpreting ancient gestures through visual sources. He uses lexicography as an analytical tool to record gestures on Athenian pottery dated from the eight to fourth centuries BCE. In particular, McNiven takes the example of the logos gesture, tracing its contextual use through time in ancient Greece and its later adaptation to various contexts in the art of the West. David Calabro's chapter, '*Langue du geste* over the *longue durée*: On the Diachrony of Ritual Gestures in the Near East', builds on the temporal scope of gesture. He does this by examining the use of three ritual gestures (raising one hand, raising both hands, and clapping) from depictions in the ancient Levant to

performance in present-day Syria. Drawing upon 'thick description', Calabro demonstrates the contemporaneous use of ritual gestures through time, highlighting that meaning is constructed through the interplay between gesture and context.

The next chapter, by Amy J. Maitland Gardner, 'Tracing the Semantics of Ancient Maya Gestures', explores the visual language of gesture in Classic Maya art, dated from the fourth to ninth centuries CE. She develops a 'bottom-up' approach to gesture by focusing on how meaning relates to form in gestural expression rather than through the interpretative framework of power. In particular, she examines the semantic contexts of hands in ancient Maya script and the contextual use of palm open hands in painted scenes on Maya ceramics. In doing so, she considers how iconographic gestures could have been drawn from wider social practices, made visible in elite art at a certain point in Maya history. In 'Gesture, Posture and Meaning in the Ulúa Cultural Sphere', Kathryn M. Hudson and John S. Henderson apply a syntactic textuality framework to read figural representations on Ulúa pottery dating from the fifth to eighth centuries CE. They illustrate the importance of how gestures function, which reveals that the body in Ulúa art can be used as a frame to indicate (rather than generate) meaning. In this way, gestures are employed as semantic markers to signal important elements and to guide the viewer. Hudson and Henderson's chapter highlights the dynamic of emic/etic stances in approaching figural art and how the body must be situated within its cultural, visual narratives.

Part II concludes with Christine Kuehn's chapter, 'Idealized Divinity versus Identification: Ancient "Lifelike" Gestures of the Buddhist Sculptures 五百羅漢 (500 Rakan)'. Kuehn explores modern visitors' experiences of Rakan statues in temples in Japan that date from various periods from the sixth century CE onwards. She favours a holistic approach to gesture (beyond codified description), similar to Morris and Goodison (Chapter 1). Through her discussion of the lifelike qualities of the Rakan (facial expressions, pose and gestures), she illustrates the need to recognize gestures' emotional and spiritual aspects as well as their conventionality. Further, Kuehn demonstrates how iconographic gestures influence lived practice (e.g. in contemporary gesture games) and that understandings of visual gestures are shaped by cultural, bodily knowledge.

Part III, 'Interdisciplinary Perspectives on Gesture', provides approaches to gesture by scholars from the fields of psychology, anthropology and art design. It begins with Josef Fulka's chapter, 'Freud's Approach to Gesture and Its Archaeological Inspiration'. Fulka explores the impact of archaeology in Freud's work and lays out Freud's psychoanalytical observations and theories of gesture through his writings on hysteria from the late nineteenth and early twentieth centuries. By discussing a range of Freud's case studies, Fulka shows how gestures can be produced through recalling past experiences (that are repressed and re-emerge in new contexts). Further, he illustrates how Freud's concept of 'overdetermination' (the many overlapping causes of gesture that need to be analysed to deliver meaning) is an impactful conceptual tool in examining bodily communication, resonating with historical and contemporary archaeological and anthropological approaches to gesture.

In the final chapter, 'Gestures of Making: An Exploration of Material / Body Dialogue through Art Process', Alice Clough and Fo Hamblin explore the inherently performative and embodied gestures of making, through the documented experience of their own collaborative art installation. Their chapter highlights that the *chaîne opératoire* or 'process of making', is a continual dialogue between materials and the body, involving a multitude of bodily/material interactions and sensory experiences. The result is a fascinating insight into the sensorial, gestural and emotional experience of making through the documented perspectives of an artist and an anthropologist.

The diversity of evidence and approaches in these chapters demonstrate that tracing gestures through archaeological remains offers exciting new frameworks in exploring the subject. This volume brings together these different approaches, demonstrating how gesture can be further expanded within archaeology and the wider field of gesture studies. It does not intend to be comprehensive in geographical and temporal representation, nor does this volume provide a concise overview of all areas of archaeological enquiry into gesture.[4] Instead, it illustrates how the multiplicity of gesture, in its diverse forms and contexts, requires interdisciplinary and comparative perspectives. In the following chapters, this multiplicity of gesture becomes apparent, as contributors navigate different materials, theories and frameworks in tracing bodily communication throughout the ancient world. Together, these contributions open up new horizons for the study of gesture.

Notes

1. See the International Society for Gesture Studies (2002) for current dialogues and research.

2. Gestures in the medieval and Renaissance periods have been fruitfully explored within the disciplines of history and art history (e.g. Barasch 1976, 1987; Baxandall 1988; Davidson 2001). Bremmer and Roodenburg's (1991) edited volume, *A Cultural History of Gesture*, provides an excellent historical discussion of gesture in Europe from antiquity to the modern period. Notable chapters that focus on representations of gesture within the volume include Spicer's, 'The Renaissance Elbow' (1991), and Roodenburg's, 'The "Hand of Friendship": Shaking Hands and Other Gestures in the Dutch Republic' (1991).

3. See Kendon (1982, 2004: 17–83) for excellent overviews of the history of gesture studies. For studies on the relationship between gesture and speech, see Kendon (1972, 1980) and McNeill (1992, 2000); for cultural studies of gesture, see Efron (1972) and Morris, Collett, Marsh and O'Shaughnessy (1979). See Birdwhistell (1970), for his important contribution to the ethnography of gesture through his development of kinesics – the study of body motion and communication – and Argyle (1988), for the role of bodily movements in socialization and expression. Gesture and its relation to cognition can be found in the work of Goffman (1963); and for the ecology of communication, its production in relation to culture and context, see Kendon (1995, 2004: 349–54). For discussion of the universal and cultural aspects of gesture, including learning and development, see Kita's (2013) edited volume, *Pointing: Where Language, Culture, and Cognition Meet*.

4. Notable archaeological considerations of gesture not discussed include experimental approaches to the *chaîne opératoire* of stone stool production (see Soressi and Geneste 2011), and the depiction of hands in rock art (see Morley 2007).

References

Argyle, M. (1988), *Bodily Communication*, London: Routledge.
Barasch, M. (1976), *Gestures of Despair in Medieval and Early Renaissance Art*, New York: New York University Press.
Barasch, M. (1987), *Giotto and the Language of Gesture*, Cambridge: Cambridge University Press.
Baxandall, M. (1988), *Painting and Experience in Fifteenth Century Italy*, Oxford: Oxford University Press.
Birdwhistell, R. L. (1970), *Kinesics and Context*, Philadelphia, PA: University of Pennsylvania Press.
Borić, D. and J. Robb (eds) (2008), *Past Bodies: Body-Centered Research in Archaeology*, Oxford: Oxbow.
Bremmer, J. and H. Roodenburg (eds) (1991), *A Cultural History of Gesture*, Cambridge: Polity Press.
Brilliant, R. (1963), *Gesture and Rank in Roman Art: The Use of Gestures to Denote Status in Roman Sculpture and Coinage*, New Haven, CT: Connecticut Academy.
Brück, J. (2005), 'Experiencing the Past? The Development of a Phenomenological Archaeology in British Prehistory', *Archaeological Dialogues*, 12 (1): 45–72.
Classen, C. (1993), *Worlds of Sense: Exploring the Senses in History and Across Cultures*, London and New York: Routledge.
Classen, C. (1997), 'Foundations for an Anthropology of the Senses', *International Social Science Journal*, 153: 401–12.
Crosslands, Z. (2010), 'Materiality and Embodiment', in D. Hicks and M. C. Beaudry (eds), *The Oxford Handbook of Material Culture Studies*, 386–405, Oxford: Oxford University Press.
Csordas, T. (1994), 'Introduction', in T. Csordas (ed.), *Embodiment and Experience: The Existential Ground of Culture and Self*, 1–26, Cambridge: Cambridge University Press.
Davidson, C. (ed.) (2001), *Gesture in Medieval Drama and Art*, Kalamazoo, MI: Western Michigan University, Medieval Institute Publications.
Day, J. (2013a), 'Imagined Aromas and Artificial Flowers in Minoan Society', in J. Day (ed.), *Making Senses of the Past: Towards a Sensory Archaeology*, 286–309. Carbondale, IL: Southern Illinois University Press.
Day, J. (ed.) (2013b), *Making Senses of the Past: Toward a Sensory Archaeology of the Past*, Carbondale, IL: Southern Illinois University Press.
de Jorio, A. (1832), *La mimica degli antichi investigata nel gestire napoletano*, Naples: Fibreno.
Dominicus, B. (1994), *Gesten und Gebärden in Darstellungen des Alten und Mittleren Reiches*, Heidelberg: Heidelberger Orientverl.
Efron, D. (1972), *Gesture, Race and Culture*, The Hague: Mouton and Co.
Goffman, E. (1963), *Behavior in Public Places*, New York: Free Press.
Gosden, C. (2001), 'Making sense: Archaeology and esthetics', *World Archaeology*, 33 (2): 163–7.
Hamilakis, Y. (2002), 'The Past as Oral History: Towards an Archaeology of the Senses', in Y. Hamilakis, M. Pluciennik and S. Tarlow (eds), *Thinking through the Body: Archaeologies of Corporeality*, 121–36, New York: Springer.
Hamilakis, Y. (2013), *An Archaeology of the Senses: Human Experience, Memory, and Affect*, Cambridge: Cambridge University Press.
Hamilakis, Y., M. Pluciennik and S. Tarlow (eds) (2002), *Thinking through the Body: Archaeologies of Corporeality*, New York: Springer.
Houston, S. and K. Taube (2000), 'An Archaeology of the Senses: Perception and Cultural Expression in Ancient Mesoamerica', *Cambridge Archaeological Journal*, 10 (2): 261–94.
International Society for Gesture Studies (ISGS) (2002), International Society for Gesture Studies. Available at: at www.gesturestudies.com (accessed 19 January 2022).
Joyce, R. (2005), 'Archaeology of the Body', *Annual Review of Anthropology*, 34: 139–58.

Kendon, A. (1972), 'Some Relationships between Body Motion and Speech: An Analysis of an Example', in A. Siegman and B. Pope (eds), *Studies in Dyadic Communication*, 177–210. Elmsford, NY: Pergamon Press.

Kendon, A. (1980), 'Gesticulation and Speech: Two Aspects of the Process of Utterance', in M. R. Key (ed.), *The Relationship of Verbal and Nonverbal Communication*, 207–27, The Hague: Mouton.

Kendon, A. (1982), 'The Study of Gesture: Some Observations on its History', *Recherches Sémiotiques/Semiotic Inquiry*, 2 (1): 45–62.

Kendon, A. (1995), 'Andrea De Jorio – The First Ethnographer of Gesture?', *Visual Anthropology*, 7: 375–94.

Kendon, A. (2004), *Gesture: Visible Action as Utterance*, Cambridge: Cambridge University Press.

Kita, S. (ed.) (2013), *Pointing: Where Language, Culture, and Cognition Meet*, New York: Psychology Press.

Kus, S. (1992), 'Towards an Archaeology of Body and Soul', in J.-C. Gardin and C. Peebles (eds), *Representations in Archaeology*, 168–77, Bloomington, IN: Indiana University Press.

Maitland Gardner, A. J. (2017), 'Posture and Gesture in Ancient Maya Art and Culture', PhD diss., University College London, London.

Matthews, S. (2005), 'The Materiality of Gesture: Intimacy, Emotion and Technique in the Archaeological Study of Bodily Communication', Position paper presented to the roundtable session, 'The Archaeology of Gesture: Reconstructing Prehistoric Technical and Symbolic Behaviour', at the 11th Annual Meeting of the European Association of Archaeologists, 5–11 September, Cork.

Mauss, M. (1935), 'Les Techniques du corps', *Journal de psychologie normale et pathologique*, 39: 271–93.

McNeill, D. (1992), *Hand and Mind: What Gestures Reveal about Thought*, Chicago, IL: University of Chicago Press.

McNeill, D. (ed.) (2000), *Language and Gesture*, Cambridge: Cambridge University Press.

McNiven, T. (1982), *Gestures in Attic Vase Painting*, Ann Arbor, MI: University Microfilms.

Meskell, L. and R. Joyce (2003), *Embodied Lives: Figuring Ancient Maya and Egyptian Experience*, London: Routledge.

Mongelluzzo, R. (2013), 'Maya Palaces as Experience: Ancient Maya Royal Architecture and Its Influence on Sensory Perception'. in J. Day (ed.), *Making Senses of the Past: Towards a Sensory Archaeology*, 90–112, Carbondale, IL: Southern Illinois University Press.

Morley, I. (2007), 'New Questions of Old Hands: Outlines of Human Representation in the Palaeolithic', in C. Renfrew and I. Morley (eds), *Image and Imagination: A Global Prehistory of Figurative Representation*, 69–82. Cambridge: McDonald Institute Monographs.

Morris, C. (2001), 'The Language of Gesture in Minoan Religion', in R. Laffineur and R. Hägg (eds), *POTNIA: Deities and religion in the Aegean Bronze Age*, 245–51, Liège: Université de Liège.

Morris, C. and A. Peatfield (2002), 'Feeling through the Body: Gesture in Cretan Bronze Age Religion', in Y. Hamilakis, M. Pluciennik and S. Tarlow (eds), *Thinking through the Body: Archaeologies of Corporeality*, 105–20. New York: Springer.

Morris, D., P. Collett, P. Marsh and M. O'Shaughnessy (1979), *Gestures: Their Origins and Distribution*, New York: Stein and Day.

Neumann, G. (1965), *Gesten und Gebärden in der griechischen Kunst*, Berlin: De Gruyter.

Renfrew, C. and I. Morley (eds) (2007), *Image and Imagination: A Global Prehistory of Figurative Representation*, Cambridge: McDonald Institute for Archaeological Research.

Roodenburg, H. (1991), 'The "Hand of Friendship": Shaking Hands and Other Gestures in the Dutch Republic', in J. Bremmer and H. Roodenburg (eds), *A Cultural History of Gesture*, 152–89, Cambridge: Polity Press.

Schebesch, A. (2013), 'Five Anthropomorphic Figurines of the Upper Paleolithic – Communication through Body Language', *Mitteilungen der Gesellschaft für Urgeschichte*, 22: 61–100.

Soressi, M. and J.-M. Geneste (2011), 'The History and Efficacy of the Chaîne Opératoire Approach to Lithic Analysis: Studying Techniques to Reveal Past Societies in an Evolutionary Perspective', *Paleo Anthropology*, 2011: 334–50.

Spicer, J. (1991), 'The Renaissance Elbow', in J. Bremmer and H. Roodenburg (eds), *A Cultural History of Gesture*, 84–128, Cambridge: Polity Press.

Tilley, C. (1996), *A Phenomenology of Landscape*, Oxford and New York: Berg.

Tilley, C. (2008), *Body and Image: Explorations in Landscape Phenomenology 2*, London: Left Coast Press.

Troike, N. (1982), 'The Interpretation of Postures and Gestures in the Mixtec Codices', in E. Boone (ed.), *The Art and Iconography of Late Post-Classic Central Mexico*, 175–206, Washington, DC: Dumbarton Oaks.

Walsh, C. (2016), 'The Transmission of Courtly Lifestyles in the Bronze Age Mediterranean', PhD diss., University College London, London.

Walsh, C. (2018), 'Kerma Ceramics, Commensality, and Sensory Experience in Egypt during the Late Middle Bronze Age', *Journal of Ancient Egyptian Interconnections*, 20: 31–51.

PART I
THE MATERIALITY OF GESTURE

CHAPTER 1

IN TOUCH WITH THE MINOANS: GESTURAL PERFORMANCE AND EXPERIENCE IN BRONZE AGE CRETE

Christine Morris and Lucy Goodison

This chapter explores gestural performance incorporating a tactile element, as expressed through the imagery of the Minoans, the Bronze Age inhabitants of Crete during the third and second millennia BCE. In a modern context, the term 'gesture' typically refers to the movement of hands and arms, and it is often discussed as a form of non-verbal communication that accompanies speech (McNeill 1992; Kendon 2004). Here, we use gesture to refer to expressive, purposeful movements in the wider sense of a whole bodily performance that may include head, body and limbs. And since we are dealing with static artistic images, any language or other sounds that might have been part of such gestures are, necessarily, lost to us.

Gestural behaviours are constrained by human physiology, but they are also culturally and historically shaped. Those studying movement need to keep these two elements in mind; as Hanna has noted, 'it is necessary to accommodate the relationships between body and self that are deeply rooted in biology and the relationships between body and self that are rooted in the social and cultural forms in which phenomenological experience occurs' (1990: 118). In his seminal work on the body, Mauss described it as 'man's first and most natural instrument. Or more accurately, not to speak of instruments, man's first and most natural technical object, and at the same time technical means, is his body' ([1935] 1973: 75). He emphasized that techniques of the body, from our everyday activities of walking and eating through to ritualized actions such as kneeling in prayer or clapping in appreciation, are learned social behaviours; and that these are imprinted on the body, creating muscular memory through rhythmic repetition and sensory experience. The activity of walking provides an example of how an apparently simple movement is culturally shaped and full of communicative potentialities. Mauss, for example, briefly touched upon culturally different styles of walking, contrasting American with French (ibid.: 72), although the subtleties and cultural diversity of 'ways of walking' have only received detailed attention much more recently (Ingold and Vergunst 2008).

Writing about movement in the context of dance, Polhemus has observed that the logocentric worldview of Western culture has biased our perceptions of other cultural systems such that it is not always recognized to what extent physical behaviour can be 'a key component of human expressive and communicative systems' (1993: 3, 6). Movement is imbued with symbolic meaning transmitting all levels of sociocultural information

'including, most importantly, those meanings which exceed the limits of verbal language' (ibid.: 6). Movement in a religious or ritual context would in this case be particularly redolent of symbolic meanings.

The Minoan context

From the Cretan Bronze Age, frescoes, figurines of clay and bronze, sealstones and gold rings, all offer us a dazzling array of Minoan images rich with gesture. Much scholarly work has focused either on seeking to impose some order on this material, generating typologies of gesture which focus mainly on the hands and arms, or trying to isolate gestures which could indicate the status of a figure as human or divine – a remarkably slippery task in Minoan iconography (Wedde 1999; Morris 2001). There have been other scholarly priorities that have tended to limit or eclipse the study of gesture *per se* in the Minoan context. Where an apparently ritual scene includes participants' movement and gesture, these have rarely been investigated as of intrinsic significance, but rather have been seen as secondary – within the scene – to worship of a deity. In some ritual scenes showing extreme postures and gestures, these have been relegated to a category of 'ecstatic' movement as if this placed them beyond the reach of scholarly enquiry, without further investigation of their possible social, cultural or religious meaning. In specific contexts where a gesture is not easy for scholars to 'read', it has sometimes been assumed that it is a secular, everyday or work gesture. All these approaches have served to demote gesture from a central position in the process of enquiry. They have all also been largely ocular-centric, looking at the shape or form of gesture from the outside rather than from the sensory and experiential perspective of the participants.

A more recent strand of Minoan scholarship has, however, shifted attention away from the external to the internal, focusing on 'feeling through' the body rather than looking at it. Morris and Peatfield have, for example, argued that the complex and varied bodily gestures of terracotta peak sanctuary figurines are expressive of a process of bodily action, ritual performance and experience, making them much more than an externalized or symbolic representation of 'worship' (Morris and Peatfield 2002, 2004; Peatfield and Morris 2012; see also Tyree 2001 and Faro 2013 for ritual experience in Cretan caves). Here, we follow that approach by prioritizing physical behaviour and investigating some specific gestural performances, which incorporate contact with an external object. This brings the bodily sense of touch or haptics into the picture: gesture and touch together.

The sense of touch

As we draw touch into our discussion, it will be useful to contextualize it within modern scholarship. Sensory studies have developed as a strong trans-disciplinary field with

researchers challenging and deconstructing many conventional assumptions about the senses. It is clear, for example, that the familiar, Aristotelian 'five senses' (sight, hearing, taste, smell and touch) are by no means a universal set of categories. Although recent work on the senses characterizes this traditional fivefold system as a largely Western sensorium (Hamilakis 2013: 25–6), it is worth noting that non-Western Chinese and Indian philosophical and medical systems also framed the senses in terms of 'fiveness' (Geaney 2002; Jütte 2005: 61–2). In other cultures, the senses may be characterized differently (Geurts 2003; Howes 2010), and scientists and philosophers have argued that other ways in which we experience the world – such as balance, movement, temperature and pain – can be considered as sensory modalities, identifying up to seventeen senses (Macpherson 2011: 20). Similarly, the emergence of a hierarchy of senses, with the proximal senses assigned a lower or more ignoble value, and the distant senses of sight and hearing valued as superior, is a modern, nineteenth-century phenomenon originating in scientific cultures of detached observation (Crary 1992; Classen 2012: 283). Another aspect of the senses, and one that is obvious from our own engagements with the world is that they are interdependent or intermodal, so that, for example, smell affects taste, or touch may modify initial visual impressions (Warren and Rossano 1991).

Within the emerging fields of sensory studies in archaeology, anthropology and history, the sense of touch has garnered relatively little attention. Classen, a key writer on touch, has noted that 'we enter a largely unfamiliar terrain when we ask what histories, what politics, what revelations of touch have animated social life?' (2005: 2). In a paper that explores touch as a 'full-body experience' at Çatalhöyük, Tringham has commented on the relative neglect of touch as an area of study within the emerging field of sensory archaeology (Tringham 2013). Archaeologists and museum curators routinely handle objects (while the public, conversely, is told 'do not touch'), so it is perhaps surprising that the sense of touch is rarely considered in relation to artefacts. Work which does consider artefact handling includes a seminal piece on carved stone balls from Neolithic Scotland (MacGregor 1999), and there is an increasing interest in engaging with the tactile properties – holding, grasping, turning – of clay and stone figurines (Bailey 2014; Peatfield and Morris 2012: 233–5; Goodison and Morris 2013: 272–5, 277–8).

The Cretan material

Returning to our Minoan case studies, the exploration of gesture and touch together invites us to engage with our archaeological material differently, to consider body movement and the sensations of bodily contact with other bodies, with materials and objects, or with the external environment. Our archaeological material from the Minoan Bronze Age comes from a period spanning approximately 3100–1100 BCE. Within this time, Aegean peoples came into increasing contact with their Mediterranean neighbours, especially in the Near East and Egypt, and from c. 1900 BCE they developed complex

'palatial' societies, with writing systems and aesthetic and technological skills across a wide range of materials.

These skills included the production of exquisite miniaturist art in the form of sealstones and gold rings engraved with patterns and figurative scenes. We first consider material from the Neopalatial period (from *c.* 1700 BCE onwards). Representations of figures in movement, perhaps dance, and engaged in activities with trees and boulders, have contributed to scholars categorizing the Minoans as 'nature lovers' and their rituals as 'ecstatic'. But by thinking of Minoans simply as 'tree and rock huggers', we have missed an opportunity to explore these gestural practices more carefully, and we risk producing a 'flattened' and disembodied description and interpretation, especially when a gesture falls outside the comfort zone and experience of contemporary archaeologists (Peatfield and Morris 2012: 235–7).

A gold ring from Archanes near Knossos (Figure 1.1a) illustrates a number of key recurring elements. To the left, a figure leans over a rounded object usually identified as a sacred stone or baetyl (see recently Crooks 2013); on the right, another figure touches or shakes a tree; something or somebody arrives through the air, whether a bird or an insect or a tiny anthropomorphic figure; and, as in this case, a standing figure or figures may be dancing. Such postures/movements have often been described as 'ecstatic' (e.g. by Persson 1942: 42). Here we focus on the figure touching the stone or baetyl.

The texture of 'ecstasy'

In a modern context, the word 'ecstasy' signifies complete abandonment. So, in past interpretations of such postures and gestures as 'ecstatic' – as we have both pointed out – there has been remarkably little curiosity about the techniques or textures of that 'ecstasy' (Morris 2004; Goodison 2009: 234). It is thrust into an amorphous, primitive territory of altered consciousness, which is neglectful both of the high value attached to such 'shamanic' or 'ecstatic' experiences in many cultures, and to the skilled and purposeful techniques employed. It is as if once we depart from rationality, or from patterns of religious behaviour familiar in Western culture, then we are in unchartable waters.

We here suggest a different approach, one that pays full attention to the nuances of gestural performance and touch. Firstly, the gestures need to be seen in the context of the whole body which folds/bends over and touches the baetyl. Scholars have often attributed the scanty clothing or perhaps even nudity (a rare feature in Minoan art) of some of these figures to generalized narratives of sexuality and fertility (see Goodison 2009: 236–7 with references). Rather, perhaps, the motive for the near nudity was that touch, that communion, that sensory contact of skin and body against hard stone (ibid.: 237–9). In the case of Figure 1.1b, a steatite sealstone from Knossos, the rocky edging locates the scene securely within a cave. Here then, physical context, cold, dark and rocky, can be added to the sensorial impact of body and skin embracing stone. To follow Howes'

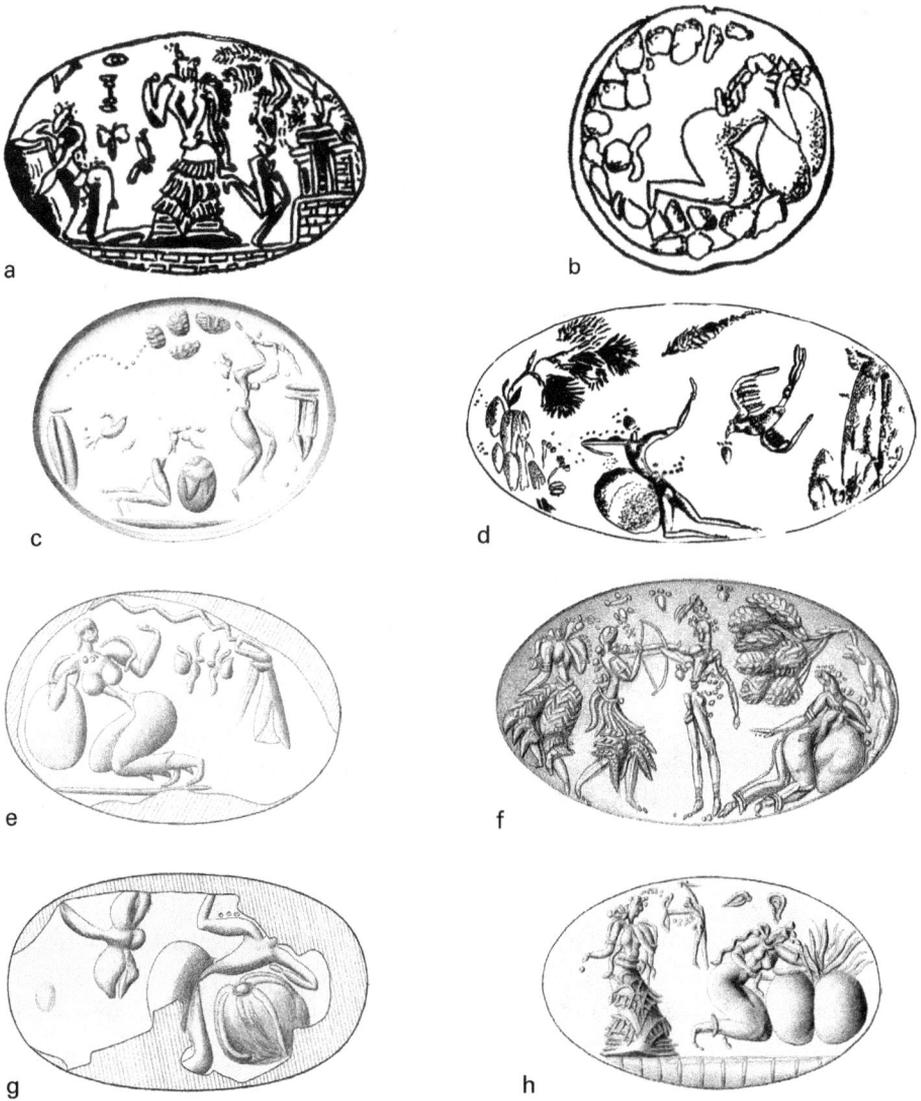

Figure 1.1 Minoan rings and seals from a variety of Cretan sites depicting baetyl stone-hugging: (a) LMIII A1 gold signet ring from larnax at Archanes Phourni necropolis, Crete. Heraklion Museum, No. 989. Drawing by Lucy Goodison after Sakellarakis (1967, fig. 13); (b) Steatite seal from Knossos. Stratigraphical Museum site, Seal 80/1129. Drawing by Lucy Goodison after Warren (1990, fig. 13); (c) Gold ring from necropolis of Kalyvia, Tombe dei Nobili Grave 11. Heraklion Museum. Nikolaos and Pini (1984, no. 114). Produced with permission of the CMS Heidelberg; (d) LMIII A Gold ring from Sellopoulou, Tomb 4. Heraklion Museum, No. 1034. Drawing by Lucy Goodison after Popham and Catling (1974, fig. 14d); (e) Sealing from Aghia Triadha. Heraklion Museum, No. 595, 596. (Müller, Pini and Platon 1999, no. 6). Produced with permission of the CMS Heidelberg; (f) Gold ring, bought in Chania. Staatliche Museen, No. Misc. 11886. (Pini 1988, no. 29). Produced with permission of the CMS Heidelberg; (g) Sealing from Kato Zakro, Palace, Hall of Ceremonies. Heraklion Museum, No. 1154. (Müller et al. 1999, no. 6). Produced with permission of the CMS Heidelberg; (h) Gold ring. Ashmolean Museum, No. 1919.56. Hughes-Brock and Boardman (2009b, no. 278). Produced with permission of the CMS Heidelberg.

terminology, this is a kind of 'skin knowledge', a knowledge of the world acquired and experienced through the skin, whether the cold and damp of a cave, a soft breeze, or the warmth of the sun (Howes 2005: 27). Or, using Rodaway's distinctions, this haptic encounter includes 'global touch', since the specific cave context allows us to consider the body's own sense of its spatial location, such as the difference between open and closed spaces, or the proximity of other objects to the body (Rodaway 1994: 48–50). This approach – thinking about the gestural experience from the perspective of, and through the body of, the performer – enables us to create a narrative of sensation often neglected in archaeological study (Morris 2004).

Using movement analysis

To look further into another aspect of these scenes, the element of movement, it may be useful to draw on a vocabulary developed specifically to annotate and analyse movement. Based on the work of Laban in the early twentieth century (McCaw 2011), Laban Movement Analysis (LMA) is a systematic approach to the analysis and appraisal of movement which has found applications in education (Laban 1948), industry and management (Davies 2001: 72–127; Ramsden 1992), theatre (Laban 2001) and psychotherapy (Bloom 2006: 22–42). While no such system could claim to be culturally universal or definitive, its possibilities as a working model can be explored. It has not to our knowledge previously been used in the field of archaeology, but as it offers criteria for describing, documenting and understanding all types of human movement, it may prove a valuable tool for the study of gestures in antiquity.

The categories that Laban developed through which to consider movement – Body, Effort, Space – were expanded by Lamb (a student of Laban) to include Shape (Lamb 1965). We focus here on one of Laban's categories, 'Effort' (Bradley 2009: 102–5). This tackles subtle characteristics of movement in respect of four separate qualities: Space, Time, Weight and Flow.

'Space' designates the issue of how a body moves through space, whether directly or indirectly. There is also a movement's relationship to 'Time': whether it is sudden/quick or whether it is sustained/lingering. The third category looks at a movement in terms of 'Weight' and its relationship to gravity: in this case describing whether a movement is 'strong' or 'light', where 'strong' is a heavy, forceful, purposeful movement and 'light' is a weightless, lifting, buoyant motion. There is also a register of 'Flow' to assess the quality of a movement on a scale between 'free' and 'bound', where 'bound' denotes a movement that has a clear limit and can stop at any point, while 'free' refers to one that expresses release, is looser and less defined. These different qualities evidently involve different levels of tension in the body and reflect the quality of relationship that a body is expressing with other people and the world around.

With these considerations in mind, we return to the Minoan ritual scenes, for example Figure 1.1c, a gold ring from Kalyvia. In terms of attitude to 'Time', in such scenes, there does not appear to be any suddenness: the position of the 'baetyl-hugger' is a sustained position.

In terms of 'Weight', we can feel that this is not a 'light' movement. It is not vague, buoyant or airy, but rather intense, which in Laban's terms is 'strong'. This reflects intention. These figures are not just leaning on the stones to 'trip out' or let themselves float away. Curious as it may seem to us, they are entering a haptic engagement with the baetyl with purpose. Laban's set of polarities relating to 'Flow' and whether a movement/posture is 'bound' or 'free', seems to be even more informative. The gesture and posture of the 'baetyl-hugger' in Figure 1.1c is not free. It does not tail away into space in a loose, undefined way: i.e. in Laban's terms, it is 'bound'. The conventional interpretation of these scenes as portraying ritual participants in a vague undefined semi-conscious ecstatic state recedes even further.

Thinking about Minoan gestural performance through Laban's language of movement and the way it has been developed by his successors invites us to ask other questions: for example, whether a body is bending, curling in, contracting, closing and shrinking back with a movement towards the body; or whether it is stretching, extending and widening with a movement from in to out. There is also a question of whether body parts move in synchrony, or whether there is fragmentation (e.g. Samuels 1978: 80, 85).

In clinical contexts, these concepts are used to describe whether movements are integrated and 'successive' throughout the whole body, or whether they are sharp and discontinuous, for example showing a fragmentation or disconnect between the upper and lower parts of the body (e.g. Cowan-Jenssen and Goodison 2009: 88). Bringing these concepts to bear on the description and understanding of movement in a non-clinical context, for example Figure 1.1d, one can see that in the baetyl-hugging activity not all the parts of the body are working together. In a number of cases, there is a disconnect, conflict or tension between the strong movement towards the baetyl and another, contradictory movement which reaches back and away. This clear element of tension recurs in a number of representations of this particular ritual (Figures 1.1e–g). Countering the thrust forward, the upper body is turned back in the opposite direction.

Engaging through the body

Having drawn upon Laban Movement Analysis as a potentially useful tool for investigating these gestures, we will now touch on another way of approaching them. Within archaeology, it has seemed paradoxical that while the body has in recent years become a significant theoretical space, it has remained excluded from the process of the construction of knowledge. We became curious as to what might happen if one used an experimental, experiential and physical approach to investigate the baetyl-hugging posture.

While actual baetyls surviving from the Bronze Age have been constructively discussed (e.g. Hood 1989; Warren 1990; Younger 2009; Crooks 2013), engaging physically with them takes us another step closer. There is only one recorded example where this has been done (see Figure 1.2a). We found using experimental archaeology to explore the posture in a more detailed way to be very informative. Far from being an abandoned posture (Figure 1.2b), it emerged that the posture requires a considerable degree of control and

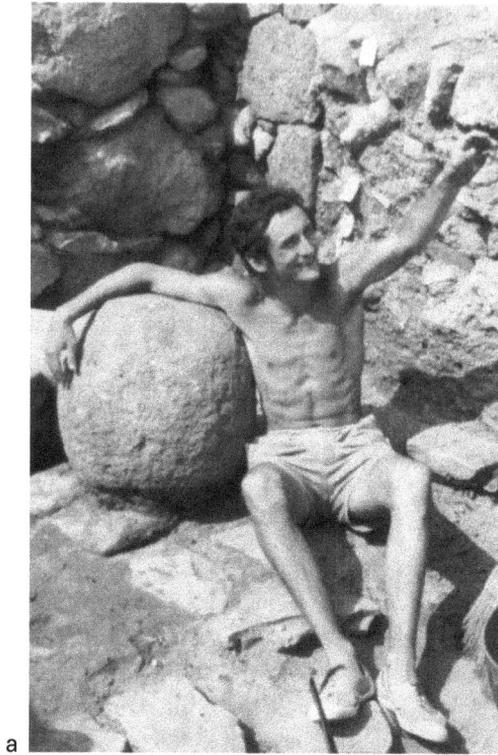

a

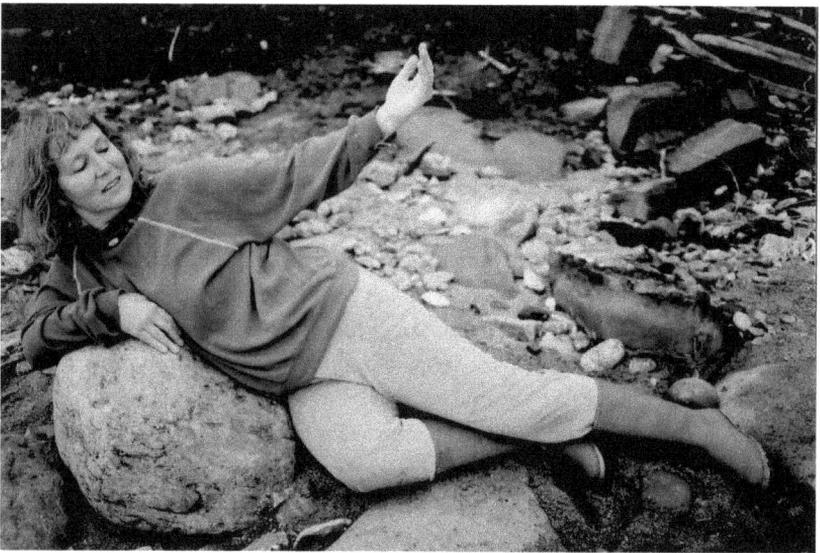

b

Figure 1.2 Photographs of baetyl stone-touching experiments: *(a)* Sebastian Rahtz embracing the Phylakopi *omphalos*. Reproduced from Younger (2009, fig. 4.8). Produced with permission of John Younger; *(b)* Physical experiment following the 'baetyl-hugging' posture with a beach boulder, Dorset, 2009. Produced with permission of Judith Griffies.

contortion to achieve both the primary body contact to the stone and the reverse reach expressing another relationship – perhaps with the bird or other flying object that is arriving, perhaps with an audience. Far from a spontaneous, expressive, undifferentiated sprawl, we can start to see this haptic gesture as a repetitive, purposeful, constructed performance embodying a more complex narrative. The altered state is linked back to the real world such that the results of communion with the stone could have been used – given the elite status of the rings – in the world of social power and human relations.

Divinities or the dead?

Consistent with the *schemata* of Western religion, scenes such as Figure 1.1a–h are often interpreted as a process of summoning an airborne divinity. But only one of our scenes (Figure 1.1h) shows a tiny anthropomorphic figure, and there are other suggestions that have been sidelined. Savignoni (1904: 582–4) and Evans (1901: 21, 1931: 31) have both pointed out that the baetyl had a sepulchral association, opening the possibility that the intense contact with the stone represents communication with the dead. Savignoni suggested that the entity being summoned into the baetyl, sometimes shown as a bird, may not be a deity but rather a spirit of the human dead (1904: 582). Rutkowski (1981: 54) and others have drawn parallels between these baetyls of the Bronze Age and the prophetic *omphalos* or central stone at the oracle of Delphi centuries later in classical antiquity. A similar phenomenon of stones used for divination is also well documented in the Near East (e.g. O'Bryhim 1996). Such possibilities would shift the discourse away from the conventional templates involving deities and towards the possibility, also put forward by Savignoni (1904: 583), that the scenes might show an early process of divination, perhaps – given the baetyls' funerary associations – linked with a cult of the dead.

The recurrent mention of divinities in interpretations of these scenes reflects another approach to haptic elements that perhaps could be questioned. This is the tendency to set such events within the narrow framework of worship. For example, the assumption is sometimes made that the gestural process here, the actual 'doing', is secondary or accessory to a grand religious narrative involving an alleged male deity or 'Great Goddess' who is summoned by the touching (Evans 1931: 13). Or the question is asked whether the baetyl itself is sacred and worshipped; if not, then it is not considered important; as if those were the only two possibilities (Marinatos 1990: 80). The possibility that the process of touch itself – touching and being touched – could be central to a ritual has been neglected and undervalued. Perhaps like the touch of fingers on a smart phone or iPad (and it has to be bare fingers), this touch itself is the crucial pathway that opens a door to another world of communication.

Pithos rituals?

On the gold ring from Archanes (Figure 1.1a), the 'baetyl' on the left has – amidst debate (e.g. Kyriakidis 2000–1) – been identified by some scholars as a large jar or *pithos* (e.g.

Warren 1981: 166). This takes us on to our last section, which draws in material from an earlier period of the Cretan Bronze Age involving a set of Middle Minoan three-sided engraved prism seals. These are engraved with simpler designs than the rings, and are less obviously elite creations. Here, too, it is worth examining gestural performance and touch more carefully.

The type of image shown in Figure 1.3a–d, for example, of which there are a number (Goodison 1989: 39–42, figs 64–71), is regularly interpreted as a potter at work. But closer consideration suggests that this is not a convincing interpretation of what the seated figure is doing. The downward tilt of the head is such that the potter would not be able to see the vessel being made. The posture is curled in, respectful, receptive, not outgoing, active and constructive. Only one hand is used in the designs, whereas two are needed to throw a pot. The vessel is, in any case, always finished, not a work in the process of being made. Moreover, in some cases, such as Figure 1.3e–f, the proportions/positioning are not literal; in others again, the figure may be touching several pots at once, or not actually touching the vessel, when the same gesture becomes a gesture of salute well known in the iconography of the period, or two figures may be processing towards two vessels (Figure 1.3g–i). Moreover, among hundreds of seals, designs indisputably showing everyday secular work – rather than possible ritual activities or mythological scenes – are rare (Crowley 2013: 160–6).

The posture itself is represented on seal designs sufficiently often to be identified as a significant type (Anastasiadou 2011: 679–80, pls 8 and 9), and it is striking to observe that there are other scenes showing exactly the same seated posture and gesture, but the object being touched this time is a severed animal head, apparently a goat (Figure 1.4a–b). We see the same bowed head and bent arm. It seems unlikely that these latter represent an everyday scene or mundane activity. In some scenes the whole animal is present, apparently prone, its legs perhaps trussed, with a seated figure displaying the same posture and gesture (Figure 1.4c–d). Or, sometimes, the animal is even apparently alive, the horns being touched by a figure again in seated position (Figure 1.4e). And, in several of these cases, the figure wears a high collar often taken to signify ceremonial dress. Revisiting the so-called 'potter' scenes we find that some of these also show a raised collar. In some cases, the mouth of the figure touching the vessel appears to be open (Figure 1.3a, e, h, and 1.5d; see also Platon et al. 1977, no. 241; Müller, Pini and Sakellariou 2007, no. 160; Hughes-Brock and Boardman 2009a, nos 29 and 34).

It seems increasingly unlikely, therefore, that the seal designs simply show potters going about their regular work. The presence of a specific, repetitive gesture and its reappearance across several contexts establish it as formal, ritualized gesture also often linked to animal heads. It has been the lack of close attention to the specific bodily gesture and its wider contextual use that has resulted in the 'potter' design being flattened into an everyday scene. We have to ask what might then be the actual significance of these activities?

At this point it is relevant to offer a brief word about Minoan burial practices in this period. At a number of sites these early Cretans practised secondary burial and manipulated bones through a number of activities including handling, separating, grouping, stacking and breakage (Goodison 2006: 327–30 with references). Amongst various containers, *pithoi*

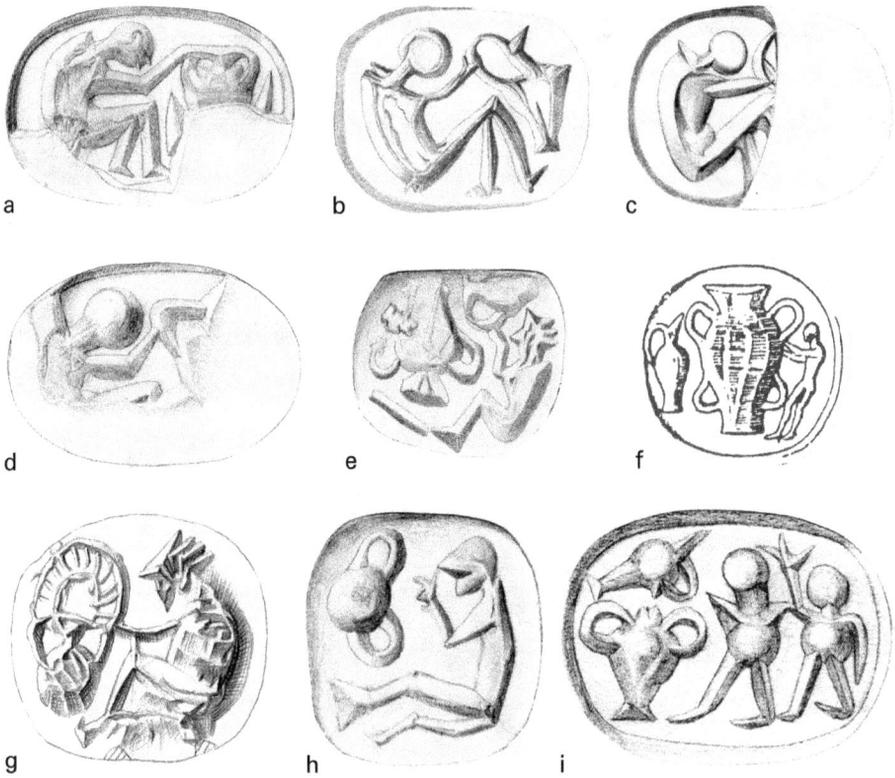

Figure 1.3 Minoan prism seals from a variety of Cretan sites depicting *pithos* and touch: *(a)* Steatite three-sided prism from Stonecutters' workshop, Malia. Heraklion Museum, No. 1851. Platon, Pini and Hellenkemper Salies (1997, no. 179). Produced with permission of the CMS Heidelberg; *(b)* Steatite three-sided prism bead seal. Metropolitan Museum of Art, No. 25.78.105. Kenna (1972, no. 28). Produced with permission of the CMS Heidelberg; *(c)* Steatite, three-sided prism from Stonecutters' workshop, Malia. Heraklion Museum, No.2292. Platon et al. (1997, no. 190). Produced with permission of the CMS Heidelberg; *(d)* Three-sided steatite prism from Stonecutters' workshop, Malia. Heraklion Museum, No. 1850. Platon et al. (1997, no. 178). Produced with permission of the CMS Heidelberg; *(e)* Steatite three-sided prism seal from plain of Malia. Heraklion Museum No. 81. Platon et al. (1997, no. 237). Produced with permission of the CMS Heidelberg; *(f)* Three-sided grey steatite prism seal from Kastelli Pedhiadas in central Crete. Reproduced after Evans (1921, fig 93A, a1); *(g)* Grey-green steatite prism from Kastelli Pedhiadas in central Crete. Ashmolean Museum, No. CS 39 (1938.746). Hughes-Brock and Boardman (2009a, no. 34). Produced with permission of the CMS Heidelberg; *(h)* Steatite three-sided prism from Malia. Heraklion Museum, No. 1506. Platon et al. (1997, no. 235). Produced with permission of the CMS Heidelberg; *(i)* Three-sided steatite prism from Stonecutters' workshop, Malia. Heraklion Museum, No. 1831. Platon et al. (1997, no. 159). Produced with permission of the CMS Heidelberg.

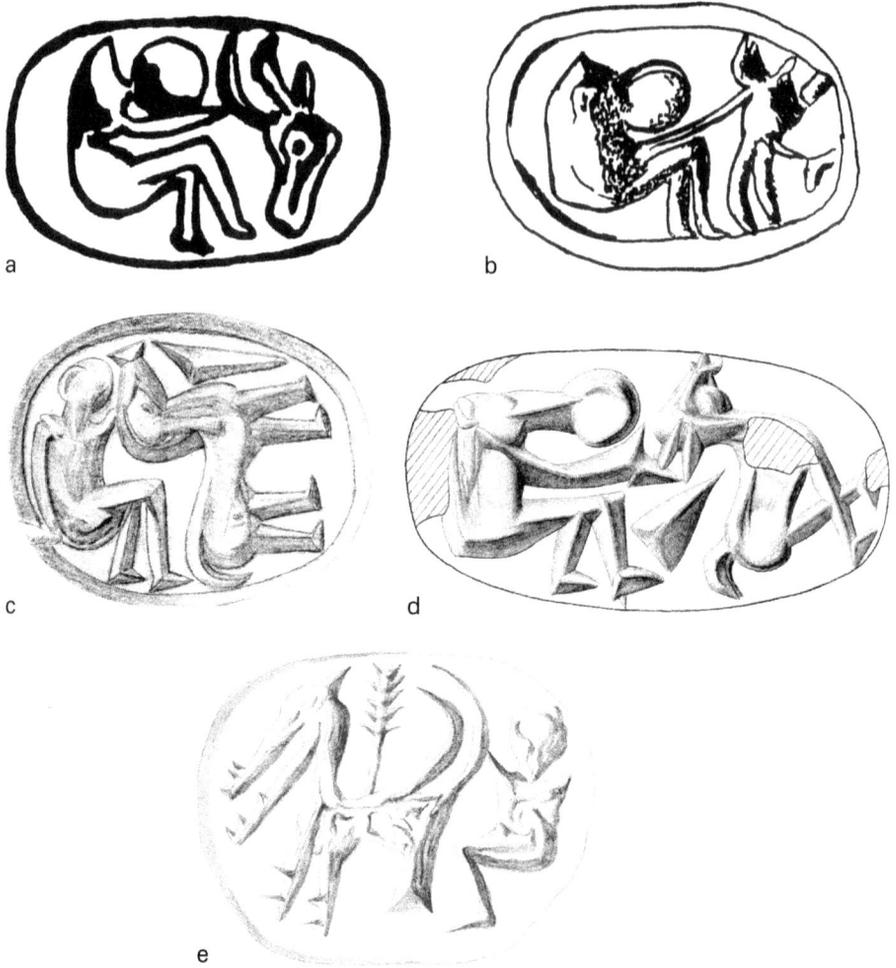

Figure 1.4 Minoan prism seals from a variety of Cretan sites depicting animals and touch: *(a)* Green steatite prism seal from Crete. Ashmolean Museum, CS 51. Drawing by Lucy Goodison after Boardman (1970, B&W pl. 9); *(b)* Protopalatial prism seal from central Crete. Heraklion Museum, No. 2391. Drawing by Lucy Goodison from a photograph by Lucy Goodison; *(c)* Three-sided steatite prism from Stonecutters' workshop, Mallia. Heraklion Museum, No. 1835. Platon et al. (1997, no. 163). Produced with permission of the CMS Heidelberg; *(d)* Steatite prism seal from Crete. Heraklion Museum, No. 3183. Müller et al. (2007, no. 213). Produced with permission of the CMS Heidelberg; *(e)* Brown and black steatite three-sided prism seal. In Metaxas Collection, Heraklion No. 191. Sakellarakis and Kenna (1969, no. 12D). Produced with permission of the CMS Heidelberg.

were used for burials, mostly in central and eastern Crete from the end of the Early Minoan period and the beginning of the Middle Minoan period (Vavouranakis 2014: 200–11). At one Middle Minoan tomb Vorou A, the excavator found a spouted vessel holding a well-preserved skeleton without the head. A skull was found beside the vessel, perhaps belonging to it. Nearby a *pithos* held a skeleton and two skulls, one of which was a child's (Marinatos 1930–1: 151). At several tombs, skulls were found piled up. Figure 1.5a shows a severed skull placed in a small jar, found in Building 6 at the Archanes Phourni cemetery (Sakellarakis and Sapouna-Sakellaraki 1997: 205). At Tomb Krasi A, used during Early and Middle Minoan periods, the excavator found small bones placed within vessels, as well as the severed heads of quadrupeds (Marinatos 1929: 111–12, 123–4, 132–6). At the cemetery at Sissi four burial *pithoi* were found, each containing the bones of several individuals; bones belonging to the same individuals were found both inside and outside the *pithoi* (Vavouranakis 2014: 204, 212). At Vorou Tomb A, empty *pithoi* were found standing upright inside the tomb as if 'ready for the next interment' (ibid.: 212).

Vavouranakis identifies three different types of funerary *pithos* usage – individual burial, collective burial and ossuary for storage of defleshed bones – but he notes that 'these types may have coexisted in the same cemetery or tomb, and some *pithoi* may have been multifunctional' (ibid.: 212). Their use certainly involved a considerable amount of activity placing bones into, and removing them from, the vessels, especially the skulls, which evidently held significance for the tomb users. Might this help to explain what is happening on seal designs such as Figure 1.5b–d, where objects seem to be in the process of being placed in, or taken out of, a *pithos*? Do we have here all the strands together: the focused posture, the *pithos*, perhaps a skull? One wonders whether such activities, for which there is clear archaeological evidence, may be what are shown on such seal designs, for which no satisfactory explanation has been essayed? In these funerary practices, people interacted with the bones of the dead; here, through a focus on the identical ritualized gesture being used in relation to severed animal heads and *pithoi*, it becomes possible to offer the suggestion that the animal head scenes may show rituals at the tombs, and that the 'potter's' vessels may in fact be those which we know played a part in the manipulation of human bones as part of funerary ritual.

Conclusion

In this chapter, we have focused on Cretan Bronze Age examples of gestural performance in which different kinds of touch or haptic actions form an integral element. In the case of the baetylic scenes on Neopalatial gold rings, the full body is engaged in the gestural action of embracing the stone, making it useful to draw upon anthropological ideas of 'skin knowledge' and 'global touch'. The complexity of the gestural performance – simultaneously focused onto and away from the stone – was made clearer by the application of Laban Movement Analysis, which we suggest could be fruitfully applied to other gestural imagery. Our second example of the earlier sealstones involved a more familiar mode of touch, that of reaching out towards something ('reach touch'), but with

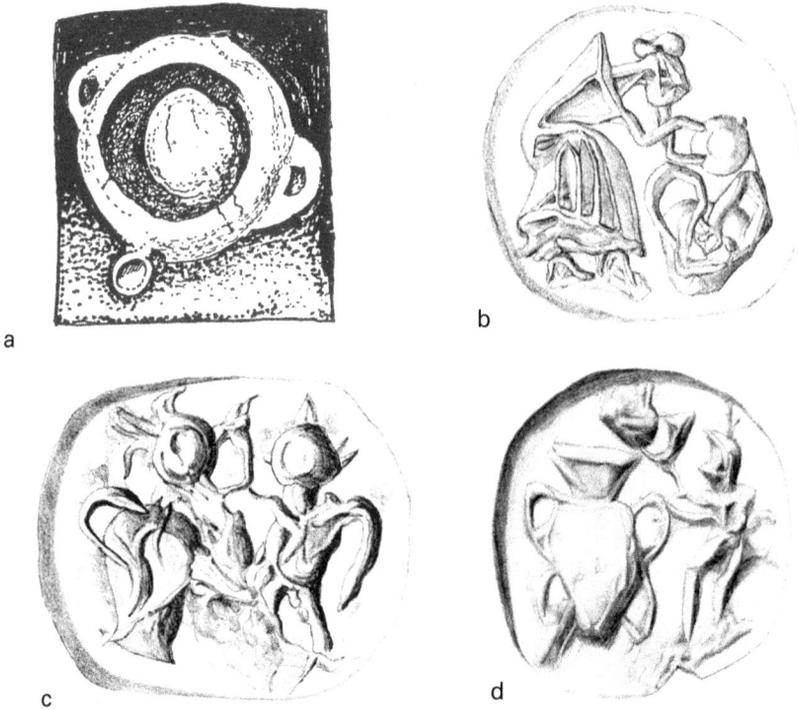

Figure 1.5 Minoan seals depicting placing objects in *pithoi*: *(a)* Skull in spouted jar from Building 6, Archanes-Phourni necropolis. Drawing by Louise London after Sakellarakis (1967: 277). Produced with permission of Louise London; *(b)* Steatite three-sided prism seal. Collection of M. Velay, New York. Kenna and Thomas (1974, no. 80). Produced with permission of the CMS Heidelberg; *(c)* Brown steatite three-sided prism seal. In Metaxas Collection, Heraklion, No. 1255. Sakellarakis and Kenna (1969, no. 10). Produced with permission of the CMS Heidelberg; *(d)* Steatite prism seal of unknown provenance. Collection of H. Wiengandt, Marburg. Pini (1988, no. 122). Produced with permission of the CMS Heidelberg.

the touching action made more purposeful by the bent over body and tilted head. By drawing attention to the repeated gesture as the common thread across these images with animals, animal heads and vessels, we suggest that these gestural performances should be located within extended funerary rituals. Honouring haptic gestures, contextualizing them and using new methodological approaches to investigate them, helps to bring these gestural performances in from a marginal role as an accessory of religious activity to taking up a position as a central and core element of prehistoric ritual which can generate new understandings. Beyond the specific examples discussed here, we suggest that our approach offers a structured way to engage with the experiential and sensory world of the otherwise silent performers in prehistoric imagery, 'feeling through' the bodies in the images as well as looking at them. This, we would argue, is the benefit of bringing touch in from the cold, and of re-centring it within the complex web

of sensory experience. Within this framework of thinking (and feeling) about the haptic gestures of bodies bent over stone, of arm and hand reaching to touch a pot, skull or animal, touch and gesture become purposeful and resonant, part of a rich and nuanced multi-sensory means of communication.

References

Anastasiadou, M. (2011), *The Middle Minoan Three-Sided Soft Stone Prism: A Study of Style and Iconography*, Vol. 1, Corpus der Minoischen und Mykenischen Siegel, Beiheft 9, 1, Mainz: von Zabern.

Bailey, D. (2014), 'Touch and the Cheirotic Apprehension of Prehistoric Figurines', in P. Dent (ed.), *Sculpture and Touch*, 27–44, Farnham: Ashgate.

Bloom, K. (2006), *The Embodied Self: Movement and Psychoanalysis*, London and New York: Karnac.

Boardman, J. (1970), *Greek Gems and Finger Rings*, London: Thames and Hudson.

Bradley, K. K. (2009), *Rudolf Laban*, London and New York: Routledge.

Classen, C. (2012), *The Deepest Sense: A Cultural History of Touch*, Urbana, IL: University of Illinois Press.

Classen, C. (ed.) (2005), *The Book of Touch*, Oxford: Berg.

Cowan-Jenssen, S. and L. Goodison (2009), 'Narcissism: Fragile Bodies in a Fragile World', *Psychotherapy and Politics International*, 7 (2): 81–94.

Crary, J. (1992), *Techniques of the Observer: On Vision and Modernity in the Nineteenth Century*, Cambridge, MA: MIT Press.

Crooks, S. (2013), *What are These Queer Stones? Baetyls: Epistemology of a Minoan Fetish*, BAR International Series 2511, Oxford: Archaeopress.

Crowley, J. L. (2013), *The Iconography of Aegean Seals*, Aegaeum 34, Liège: University of Liège.

Davies, E. (2001), *Beyond Dance: Laban's Legacy of Movement Analysis*, London: Brechin Books.

Evans, A. J. (1901), *The Mycenaean Tree and Pillar Cult and Its Mediterranean Relations*, London: Macmillan.

Evans, A. J. (1921), *Palace of Minos* I, London: Macmillan.

Evans, A. J. (1931), *The Earlier Religion of Greece in the Light of Cretan Discoveries*, London: Macmillan.

Faro, E. (2013), 'Caves in the Ritual Landscape of Minoan Crete', in F. Mavridis and J. T. Jensen (eds), *Stable Places and Changing Perceptions: Cave Archaeology in Greece*, BAR International Series 2558, 166–75, Oxford: Archaeopress.

Geaney, J. (2002), *On the Epistemology of the Senses in Early Chinese Thought*, Honolulu, HI: University of Hawai'i Press.

Geurts, K. (2003), *Culture and the Senses: Bodily Ways of Knowing in an African Community*, Berkeley, CA: University of California Press.

Goodison, L. (1989), *Death, Women and the Sun: Symbolism of Regeneration in Early Aegean Religion*, Bulletin Supplement 53, London: Institute of Classical Studies.

Goodison, L. (2006), 'Re-constructing Dialogues with the Dead', in T. Detorakis and A. Kalokerinos (eds), *Proceedings of the 9th Cretological Congress*, 325–40, Iraklion: Etairia Kritikon Istorikon Meleton.

Goodison, L. (2009), 'Gender, Body and the Minoans: Contemporary and Prehistoric Perceptions', in K. Kopaka (ed.), *FYLO: Engendering Prehistoric 'Stratigraphies' in the Aegean and the Mediterranean*, Aegaeum 30, 233–42, Liège: University of Liège.

Goodison, L. and C. Morris (2013), 'Goddesses in Prehistory', in D. Bolger (ed.), *A Companion to Gender Prehistory*, 265–87, Oxford: Blackwell.

Hamilakis, Y. (2013), *Archaeology of the Senses: Human Experience, Memory and Affect*, Cambridge: Cambridge University Press.

Hanna, J. L. (1990), 'Anthropological Perspectives for Dance/Movement Therapy', *American Journal of Dance Therapy*, 12 (2): 115–26.

Hood, S. (1989), 'A Baetyl at Gournia?', *Ariadne*, 5: 17–21.

Howes, D. (2005), 'Skinscapes: Embodiment, Culture and Environment', in C. Classen (ed.), *The Book of Touch*, 27–39, Oxford: Berg.

Howes, D. (2010), *Sensual Relations: Engaging the Senses in Social and Cultural Theory*, Ann Arbor, MI: University of Michigan Press.

Hughes-Brock, H. and J. Boardman (2009a), *Corpus der minoischen und mykenischen Siegel VI(1). Oxford, The Ashmolean Museum*, Mainz: von Zabern.

Hughes-Brock, H. and J. Boardman (2009b), *Corpus der minoischen und mykenischen Siegel VI(2). Oxford, The Ashmolean Museum*, Mainz: von Zabern.

Ingold, T. and J. L. Vergunst (eds) (2008), *Ways of Walking: Ethnography and Practice on Foot*, Aldershot: Ashgate.

Jütte, R. (2005), *A History of the Senses: From Antiquity to Cyberspace*, Cambridge: Polity Press.

Kendon, A. (2004), *Gesture: Visible Action as Utterance*, Cambridge: Cambridge University Press.

Kenna, V. E. G. (1972), *Corpus der minoischen und mykenischen Siegel XII. Nordamerika I. New York, The Metropolitan Museum of Art*, Berlin: Gebrüder Mann.

Kenna, V. E. G. and E. Thomas (1974), *Corpus der minoischen und mykenischen Siegel XIII. Nordamerika II. Kleinere Sammlungen*, Berlin: Gebrüder Mann.

Kyriakidis, E. (2000–1), 'Pithos or Baetyl? On the Interpretation of a Group of Minoan Rings', *Opuscula Atheniensa*, 25–6: 117–18.

Laban, R. (1948), *Modern Educational Dance*, London: Macdonald and Evans.

Laban, R. (2001), *The Mastery of Movement*, revised by L. Ullman, Plymouth: Northcote House.

Lamb, W. (1965), *Posture and Gesture: An Introduction to the Study of Physical Behaviour*, London: Duckworth.

MacGregor, G. (1999), 'Making Sense of the Past in the Present: Analysis of Carved Stone Balls', *World Archaeology*, 31 (2): 258–71.

Macpherson, F. (2011), 'Introduction: Individuating the Senses', in F. Macpherson (ed.), *The Senses: Classic and Contemporary Philosophical Perspectives*, 3–43, Oxford: Oxford University Press.

Marinatos, S. N. (1929), 'Protominoikos tholotos taphos para to khorion Krasi Pediados', *Archaiologikon Deltion*, 12: 102–41.

Marinatos, S. N. (1930–1), 'Duo proimoi Minoiki taphoi ek Vorou Mesaras', *Archaiologikon Deltion*, 13: 137–70.

Marinatos, N. (1990), 'The Tree, the Stone and the Pithos, Glimpses into a Minoan Ritual', *Aegaeum*, 6: 79–91.

Mauss, M. ([1935] 1973), 'Techniques of the Body', *Economy and Society*, 2 (1): 70–88.

McCaw, D. (2011), 'Editor's Introduction', in D. McCaw (ed.), *The Laban Sourcebook*, London and New York: Routledge.

McNeill, D. (1992), *Hand and Mind: What Gestures Reveal about Thought*, Chicago, IL: University of Chicago Press.

Morris, C. (2001), 'The language of gesture in Minoan religion', in R. Laffineur and R. Hägg (eds), *Potnia: Deities and Religion in the Aegean Bronze Age*, Aegaeum 22, 245–51, Liège: University of Liège.

Morris, C. (2004), '"Art Makes Visible": An Archaeology of the Senses in Minoan Élite Art', in N. Brodie and C. Hills (eds), *Material Engagements: Studies in Honour of Colin Renfrew*, 31–43, Cambridge: McDonald Institute Monographs.

Morris, C. and A. A. D. Peatfield (2002), 'Feeling through the Body: Gesture in Cretan Bronze Age Religion', in Y. Hamilakis, M. Pluciennik and S. Tarlow (eds), *Thinking Through the Body: Archaeologies of Corporeality*, 105–20, New York: Kluwer Academic/Plenum.

Morris C. and A. A. D. Peatfield (2004), 'Experiencing Ritual: Shamanic Elements in Minoan Religion', in M. Wedde (ed.), *Celebrations. Sanctuaries and the Vestiges of Cult Activity*, Papers from the Norwegian Institute at Athens 6, 35–59, Bergen: Norwegian Institute at Athens.

Müller, W., I. Pini and N. Platon (1998), *Corpus der minoischen und mykenischen Siegel II(7). Iraklion, Archäologisches Museum. Teil 7. Die Siegelabdrücke von Kato Zakros, unter Einbeziehung von Funden aus anderen Museen*, Berlin: Gebrüder Mann.

Müller, W., I. Pini and N. Platon (1999), *Corpus der minoischen und mykenischen Siegel II(6). Iraklion, Archäologisches Museum. Teil 6. Die Siegelabdrücke von Aj. Triada und anderen zentral- und ostkretischen Fundorten, unter Einbeziehung von Funden aus anderen Museen*, Berlin: Gebrüder Mann.

Müller, W., I. Pini and A. Sakellariou (2007), *Corpus der minoischen und mykenischen Siegel III. Iraklion, Archäologisches Museum. Sammlung Giamalakis*, Mainz: von Zabern.

Nikolaos, P. and I. Pini (1984), *Corpus der minoischen und mykenischen Siegel II(3) Iraklion, Archäologisches Museum. Teil 3. Die Siegel der Neupalastzeit*, Berlin: Gebrüder Mann.

O'Bryhim, S. (1996), 'A New Interpretation of Hesiod, "Theogony" 35', *Hermes*, 124 (2): 131–9.

Peatfield, A. A. D. and C. Morris (2012), 'Dynamic Spirituality on Minoan Peak Sanctuaries', in K. Rountree, C. Morris and A. A. D. Peatfield (eds), *Archaeology of Spiritualities*, 227–45. New York: Springer.

Persson, A. (1942), *The Religion of Greece in Prehistoric Times*, Berkeley and Los Angeles, CA: University of California Press.

Pini, I. (1988), *Corpus der minoischen und mykenischen Siegel XI. Kleinere europäische Sammlungen*, Berlin: Gebrüder Mann.

Platon, N., I. Pini and G. Hellenkemper Salies (1977), *Corpus der minoischen und mykenischen Siegel II(2), Iraklion, Archäologisches Museum. Teil 2. Die Siegel der Altpalastzeit.*, Berlin: Gebrüder Mann.

Polhemus, T. (1993), 'Dance, Gender and Culture', in H. Thomas (ed.), *Dance, Gender and Culture*, 3–15, London: Macmillan.

Popham, M. and H. W. Catling (1974), 'Sellopoulou Tombs 3 and 4: Two Late Minoan Graves near Knossos', *Annual of the British School at Athens*, 69: 195–258.

Ramsden, P. (1992), 'The Action Profile System of Movement for Self-Development', in H. Payne (ed.), *Dance Movement Therapy: Theory and Practice*, 218–41, London and New York: Routledge.

Rodaway, P. (1994), *Sensuous Geographies: Body, Sense, Place*, London: Routledge.

Rutkowski, B. (1981), *Frühgriechische kultdarstellungen*, Mitteilungen des Deutschen Archäologischen Instituts, Athenische Abteilung, Beiheft 8. Berlin.

Sakellarakis, J. A. (1967), Minoan Cemeteries at Arkhanes, *Archaeology*, 20 (4): 276–81.

Sakellarakis, J. A. and V. E. G. Kenna (1969), *Corpus der minoischen und mykenischen Siegel IV. Iraklion. Sammlung Metaxas*, Berlin: Gebrüder Mann.

Sakellarakis, Y. and E. Sapouna-Sakellaraki (1997), *Archanes: Minoan Crete in a New Light*, Athens: Ammos Publications.

Samuels, A. (1978), 'Movement Change through Dance Therapy – A Study', in M. N. Costonis (ed.), *Therapy in Motion*, 64–88, Urbana, IL: University of Illinois Press.

Savignoni, L. (1904), 'Scavi e scoperte nella necropoli di Phaistos', *Monumenti Antichi*, 14: 501–675.

Tringham, R. (2013), 'A Sense of Touch – The Full-Body Experience – In the Past and Present of Çatalhöyük, Turkey', in J. Day (ed.), *Making Senses of the Past: Towards a Sensory Archaeology*, 177–95, Carbondale, IL: Southern Illinois University Press.

Tyree, L. (2001), 'Diachronic Changes in Minoan Cave Cult', in R. Laffineur and R. Hägg (eds), *Potnia: Deities and Religion in the Aegean Bronze Age*, Aegaeum 22, 39–50, Liège: University of Liège.

Vavouranakis, G. (2014), 'Funerary Pithoi in Bronze Age Crete: Their Introduction and Significance at the Threshold of Minoan Palatial Society', *American Journal of Archaeology*, 118: 197–222.

Warren, D. and M. Rossano (1991), 'Intermodality Relations: Vision and Touch', in M. A. Heller and W. Schiff (eds), *Psychology of Touch*, 119–37, Hillsdale, NJ: Erlbaum.

Warren, P. (1981), 'Minoan Crete and Ecstatic Religion', in R. Hägg and N. Marinatos (eds), *Sanctuaries and Cults in the Aegean Bronze Age*, 155–67, Stockholm: Svenska Institut i Athen.

Warren, P. (1990), 'Of Baetyls', *Opuscula Atheniensa*, 18: 193–206.

Wedde, M. (1999), 'Talking Hands: A Study of Minoan and Mycenean Ritual Gesture, Some Preliminary Notes', in P. P. Betancourt, V. Karageorghis, R. Laffineur and W.-D. Niemeier (eds), *Meletemata: Studies in Aegean Archaeology Presented to Malcolm H. Wiener as He Enters His 65th Year*, Aegaeum 20, 911–20, Leuven: Peeters.

Younger, J. G. (2009), 'Tree Tugging and Omphalos Hugging on Minoan Gold Rings', in A.-L. D'Agata and A. Van de Moortel (eds), *Archaeologies of Cult. Essays on Ritual and Cult in Crete in Honor of Geraldine C. Gesell*, 43–9, Hesperia Supplement, 42: American School of Classical Studies at Athens.

CHAPTER 2
PERFORMING BODIES AND THEATRICAL PALACES: COURTLY GESTURAL VOCABULARIES AT EARLY BRONZE AGE EBLA
Carl Walsh

During the Early Bronze Age IV (2400–2300 BCE), the city of Ebla, modern Tel Mardikh in Syria, was the centre of a prosperous and powerful kingdom. The activities of the Eblaite kings, assemblies and court are extensively documented in the cuneiform archives found in the royal palace at the site (Akkermans and Schwartz 2003: 235–46; Archi 2012: 75–88; Matthiae 2003a: 165–8: Pettinato 1981). Palace G, located on the acropolis, provides invaluable information on the spatial and social context in which the Eblaite royal court operated (Figure 2.1). While only partially preserved, due to later levelling and reworking of the site, a significant part of the palace still remains (Matthiae 1982). These surviving portions of the palace include the most important ceremonial court spaces, including a large open-air plaza, storerooms containing courtly objects and archives, a throne room, traces of upper storeys, and a number of entranceways, connecting corridors and staircases which would have been used to access these spaces. The architecture of this building and the cuneiform archives document that Palace G was an important ceremonial and performative space, a confluence of different social groups and bodies where the drama and theatre of the Eblaite royal court played out.

This chapter examines the performative and experiential role of gesture in the built space and design of Palace G. It is argued that the palace's architecture was intentionally designed to produce forms of gesture, behaviour and experience through the placement of architectural features, such as staircases, daises, columns and doorways. These features worked in conjunction with furniture – as mobile and semi-permanent features – in choreographing gestural performances. These forms of performative gesture were essential parts of the intent of the architectural design of the palace, as they allowed the expression of social hierarchy, power and identity within Palace G at Ebla.

Examining gesture, etiquette and architecture at Ebla

In this chapter, gesture is examined primarily through the concept of body techniques, which Marcel Mauss described as: 'the ways in which men, in every society and in a traditional fashion, know how to make use of their bodies' (Mauss [1935] 1973: 455). These body techniques include a wide array of gestures with embedded social and cultural meaning, including ways of sitting, sleeping, walking and washing. Importantly,

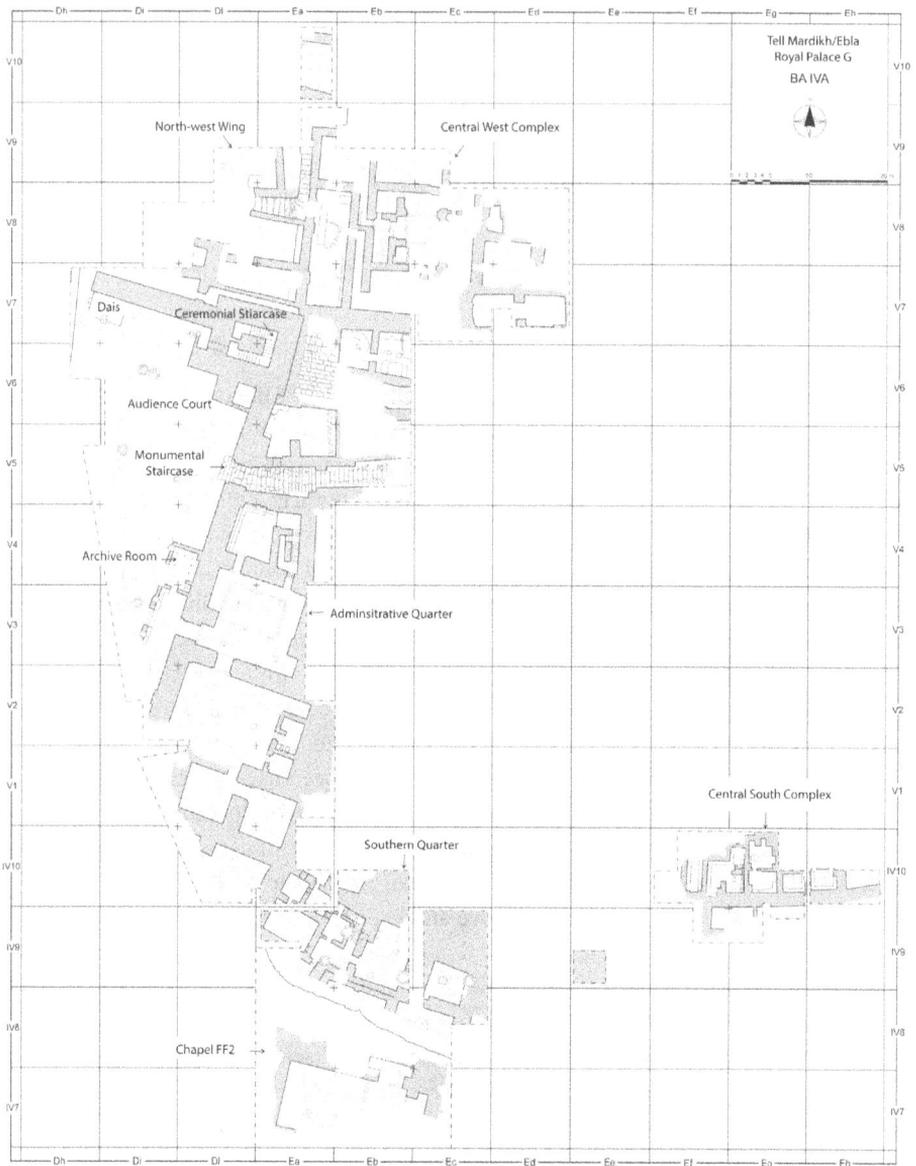

Figure 2.1 Plan of Palace G, Ebla. Produced and modified with the permission of Missione Archeologica Italiana in Siria.

they are culturally and socially distinctive, acting as markers of identity and status within and between societies. As bodily and sociocultural constructions, they have a distinct agency through embodied socio-cognitive processes such as social learning, imitation and deviation (Walsh 2016). These body behaviours can also be intimately intertwined with objects, which are often designed to produce and facilitate these techniques (ibid.).

For example, techniques for sleeping can incorporate a variety of objects including bedframes, mattresses, pillows, headrests, sheets and blankets, all of which interact with the body to produce body behaviours. These objects, materials and body techniques are all bonded together as an assemblage of intertwined relationships (Deleuze and Guattari 2004; Latour 2005).

To a lesser extent, this chapter also consider forms of gesture that are more symbolic and communicative, such as hand gestures. These forms of bodily action, which may be viewed as forms of body language, differ from body techniques in being primarily performative bodily actions that communicate esoteric information (Kendon 2004). However, this distinction between body techniques and communicative gestures is perhaps artificial, as communicative gestures often form key performative parts of contextual social procedures, such as reception, ritual or worship. Symbolic and communicative gestures could also be viewed as being used in conjunction with or even as part of bodily techniques, making strict distinctions between these terms a matter of perspective.

These gestures form parts of the normative forms of behaviour, or *habitus*, of societies (Bourdieu 1977, 1990). Bourdieu noted that these forms of *habitus* comprised of behaviours that were selected and socially reinforced, but also subject to forms of change and resistance over time (Bourdieu 1977: 78–9). Body techniques, as body behaviours within the *habitus* of societies, are often used in the formulation of ritualized behaviour. These behaviours, termed 'etiquette', are highly codified and regulated within certain sociocultural groups, and delineate identities and interactions amongst such groups (Elias [1969] 1983; Goffman 1956). Gestures play a key role in the construction of etiquette as bounded groups of procedures within a given context, developing into distinct modes of performance used in select settings and times (Bryson 1998: 12–13; Goffman 1956). These types of etiquette structure the way people behave and conduct their bodies within social settings, creating codified behavioural rules that express hierarchy and inclusion/exclusion.

Formalized body culture and behaviours are an especially important aspect of royal courts across cultures, where ceremonial etiquette is used in expressing social hierarchy and managing social interactions. Norbert Elias argued that ceremonial etiquette and court body culture, couched in the notion of manners, were powerful social mechanisms in the management of royal court's social hierarchies and interactions (Elias [1939] 2000, [1969] 1983). Court etiquette incorporated forms of gesture as significant forms of theatrical social display (Inomata and Coben 2006). This can be seen in a variety of examples that Elias explored in the context of the French court of Louis XIV, in how body techniques of washing, dressing, eating, sitting and walking by the king and court were managed through highly performative and ritualized etiquettes (Elias [1969] 1983). These ceremonial gestural and behavioural interactions between the king and court were context driven, with complex rules of participation in particular acts, times and spaces that worked to manage social interactions through different degrees of inclusion and exclusion (ibid.).

Elias's observations highlight that court spaces were highly performative, where the body and behaviour were vital mediums in negotiating and expressing social hierarchy and identity. The design of these spaces was therefore also key in facilitating these social goals. Architecture is itself a social construct, that provides both a spatial and social context for human activity. It directly engages with the body through its interior and exterior materiality (the materials and forms of architecture) and spatiality (the atmosphere and space constructed through architecture). The way people move through, interact with, and experience architecture and space are directly managed and informed through the design of the structure (Bille and Sørenson 2016; Etlin 1998; Heidegger 1971; Hillier and Hanson 1984; Pallasmaa 2005; Rapoport 1969; Schmarsow 1994). Structures should be viewed in a holistic manner, taking into account the full range of human sensory experiences. This allows fuller understanding of the intentionality of the design and how it enables social ideas, politics and practice (Bille and Sørenson 2016; Pallasmaa 2005, 2014). Such an approach also allows a consideration how built environments are interactive and mnemonic devices of social and bodily actions, designed to manipulate and facilitate certain forms of behaviour (Rapoport 1969, 1977, 1982, 2005a, 2005b).

These phenomenological and behavioural theories place the embodied human experience of built space, particularly through bodily action, the senses and the concept of spatiality, as the forefront purpose of architecture. Architecture shapes and is shaped by desired cultural forms of bodily action and behaviour. In this manner, architecture is a social construct that engages with sociocultural practices and experiences, including forms of gesture and etiquette. The physical remains of architecture provide material traces of the designed engagements between architectural features, space and the body. These aspects are particularly important in the design of court spaces such as palaces, which are highly dynamic and contested social arenas (Elias [1939] 2000, [1969] 1983). Analysing the architecture of Palace G at Ebla will determine how the design of the palace space and placement of features worked to construct and manage forms of gesture and etiquette in expressing social hierarchies and identities.

In order to examine how the relationship between architectural design, gesture and etiquette within Palace G facilitated the expression of status, hierarchy and identity, this chapter is split into two sections examining different court activities: processions and social reception. The first section examines the role of court processions and the types of gestures and etiquettes involved in moving through the palace. Processions are considered a type of ceremonial behaviour, that incorporated different bodily techniques such as walking and standing, as well as communicative bodily actions such as hand gestures, the opening and closing of doors, and the holding of objects such as standards. Texts, iconographic sources and material objects documenting processional activities are discussed to provide a contextual and holistic body of evidence for this activity and illustrating the types of body techniques and communicative gestures used in processions in Palace G. The architectural design and placement of architectural features are then be discussed, examining how these aspects allowed the construction of zones of delineated and directional movement and liminal areas of

inclusion/exclusion that could reorder and renegotiate the composition and body techniques of processions.

The second section examines the role and interplay of body techniques of sitting and standing in social reception spaces within the palace. This is achieved through a holistic analysis of architectural features such as daises, material remains of furniture, and iconographic choices in glyptic and statuary, in which the juxtaposition of different sitting and standing techniques were means to express status. These two contextual examinations of the architecture, material culture, texts and art of Palace G will demonstrate how gesture and etiquette were used in expressing and experiencing social hierarchy, identities, and power at Ebla.

Processions and movement in Palace G

Techniques for 'movement', such as walking and running, can be highly ceremonial and ritualized. A modern audience would recognise various different ways the body techniques for movement can differ according to social context, from everyday walking, to military marching, to wedding processions. Different techniques for movement can be culturally and socially distinct, involving both obvious and minute gestural details, from raising the knees, flicking the heels, prolonging a step, and performing accompanying gestures of the hands, arms, torso and head (Mauss [1935] 1973). Thus, movement is a gestural performance, in which techniques for moving the body can be exhibited for a variety of intents.

Processions are particularly elaborate forms of ritualized and performative movement. They consist of a group of individuals who usually move in an ordered, linear form, with a starting point and directionality to an ending point. These forms of movement often incorporate transitionary stopping 'stations' where social and bodily action is performed (Ashley 2001; Gilibert 2011: 107–8; Flanigan 2001: 35–7; Grimes 2003). Due to their highly theatrical and performative nature, processions are multi-sensory, including different forms and types of costume, objects, music, singing/chanting, smells, food and drink, in a synaesthesia of sensory experiences (Boogart 2001: 72, 80–6). Participants in processions include not only those who are within the procession, but also audiences. Audiences participate in the overall experience, spectacle and intention of the procession, while also being excluded from full and/or direct participation in the procession itself (Ashley 2001: 14). These ritualized behaviours are intentionally performative, in a similar fashion to how we would view dance or other performance, movement-based activities (Huopalainen 2015; Parviainen 2003; Smith 2009).

Processions formed important parts of court life at Early Bronze Age Ebla. Records in the cuneiform archives found in Palace G contained many administrative and ritual texts which describe the routes and actions involved in processions at the site. These include both daily processions and special events that extended over days. Important court and public events involving the royal family and deities, such as festivals, marriages, coronations, funerary ceremonies and official visits to royal residences and temples in

Ebla, the surrounding landscape and other cities (Archi 2013: 228–33; Pettinato 1992; Ristvet 2014: 68–9). These processions involved specific timings of ritual action, liminal stopping points in the built environment, and different audiences. For example, tablets ARET 11.1 and 11.2 document the ritual of the royal wedding or renewal of kingship of the Eblaite kings Irkab-damu and Išar-Dagan, including specific mentions to how acts of entering, walking through and exiting buildings were key liminal phases in the ritual processions. These were often accompanied by ritual bodily actions such as eating, drinking, chanting, anointing, sitting, dressing and washing (Fronzaroli translation with additions by Biga in Biga 2009: 36–40; Fronzaroli 1992; Archi 2013: 228–33). An example from ARET 11.2 describes how the Ebla queen was dressed in specific clothes after entering the city gate but before entering the temple of Kura:

The queen enters through the gate of Kura
And the clothes are received, the red one, the magnificent one, and that multi-coloured one;
And the golden chain is received
And the queen is dressed.
And the clothes are distributed
And she enters the temple of Kura.

Fronzaroli translation with additions by Biga in Biga 2009: 38

ARET 11.2 illustrates how movement through the built environment was highly choreographed and ritualized, with architectural features marking liminal zones for participants. The archives also reveal that the processions incorporated different types of movement and transportation. While walking was a primary means of movement, vehicles such as wagons and chariots were also utilized by members of the royal family and for transporting divine statues. These vehicles allowed individuals to stand or to sit while participating in the procession. An example can be seen in tablet ARET 11.2, where the king and queen are mentioned as traveling in a cart with divine statues while performing a royal ritual of renewal over a series of days: 'They travel in a carriage together with the statues of the gods' (Fronzaroli translation with additions by Biga in Biga 2009: 38). Members of Ebla's court, who were likely from important elite families, are also mentioned as participants of processions in these texts (Porter 2011: 232–3). These individuals had official titles and professions relating to the palace and temples, and had particular duties attending to divine statues and documenting and administering the procession and rituals (Archi 2013: 229–30). Courtiers composed part of the main body of the procession, walking in front or behind of the wagons and carriages transporting the standing and sitting king, queen and divine statues.

Different types of body techniques and communicative gestures in processions are also illustrated in scenes in the 'Syrian Ritual' motif found on cylinder seals and sealings at Ebla and other important Early Bronze Age Syrian sites such as Mari, Tell Brak and Tell Beydar (Ristvet 2014: 72). These scenes vary considerably in their composition across Early Bronze Age Syria and northern Mesopotamia, but all communicate activities

of religious and political authority. These include banquets, presentation of individuals before a deity or king, military battles and ritual processions. The procession scenes are characterised by a linear row or sequence of individuals, royalty and/or deities/divine statues on wagons, who raise their arms forward in supplication, sometimes towards a seated deity or tower, which may be a temple (Jans and Bretschneider 1998: 162–6; Ristvet 2014: 72; Figure 2.2). The activity illustrated in these scenes appears to correlate with many of the processional events documented in the archives, with movement in a structured, linear form, with both walking and sitting or standing participants in vehicles directed towards figures or buildings of religious or political authority. These scenes again highlight that status and identity was negotiated through the bodily techniques of participants, with high-status individuals standing or sitting in vehicles, while lower status individuals walk. However, they also all perform the same type of communicative gesture, with arms upraised in adoration, linking them together in a shared embodied experience and lower status in relation to the deities and sacred buildings they are moving towards.

Material culture associated with processions is scant at Ebla, but the remains of two possible royal standards at Ebla might provide evidence that these were processional equipment. The two standards have been reconstructed as poles bearing symbolic and figural imagery at their crown. The *maliktum* standard, thought to belong to queen Tabur-Damu, consisted of bronze fragments of a miniature scene depicting a seated

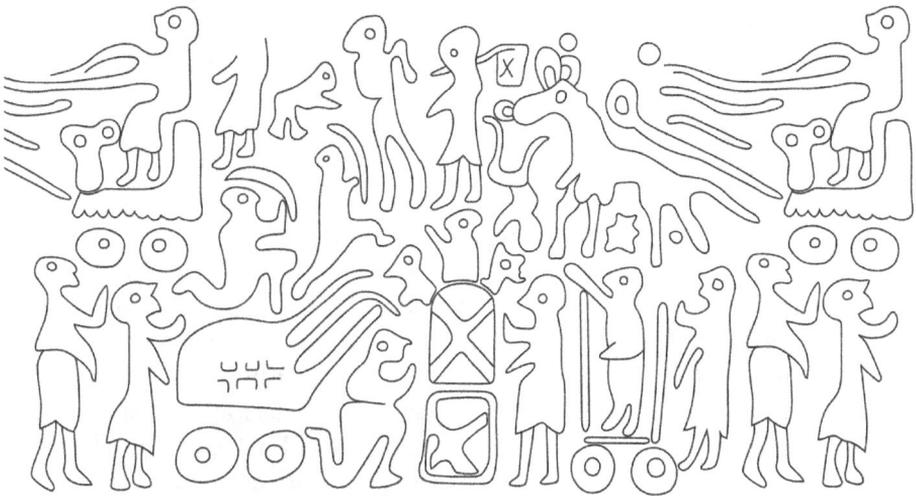

Figure 2.2 Drawing of scene from Beydar seal 4 from Tell Beydar of a procession of the Syrian Ritual type. The top register consists of battle scenes with seated individuals in wagons, running figures with weapons and trampled figures. The bottom register has a central tower with three figures protruding from the top with arm(s) raised. On either side of the tower, individuals face towards the tower, either walking, kneeling or standing in a wagon with arms upraised. Drawing by Carl Walsh after Jans and Bretschneider (1998: 188). Produced with permission of Joachim Bretschneider and Greta Jans.

female figure facing an incense burner with a larger female standing figure, attached to the remains of a wooden pole (Matthiae 2009). This standard is thought to illustrate a funerary ritual being performed by the queen before a seated ancestral queen. The other standard is larger and composed of steatite and lapis lazuli figural remains and gold gilding consisting of figures of bull men and humans (Pinnock 2015). Pinnock suggests that such standards were important parts of processions in Palace G, with a hierarchy of standard types used by royalty and courtiers to express status during processions around the palace and in the wider urban environment (ibid. 2012: 276–7, 2015: 20–1). These paraphernalia are interesting, because they place emphasis on the action and technique of holding them. Some of the presentation scenes in the 'Syrian Ritual' seals depict standard bearers standing behind seated authority figures, holding the standards using a two-handed grip in front of the body. This technique was likely necessitated through their weight, but also potentially to allow better control over walking tempo in processions.

It is clear from the textual, iconographic and material evidence at Ebla and other Early Bronze Age Syrian sites that processions incorporated performative gestures to express identity and status. Crucially, the sources document the intimate relationship between processions and the built environment, in the way that architecture was designed to construct, direct and interact with bodily action and movement. This intentionality in interacting with the body can also be seen directly through the design and layout of Palace G itself. The final form of the palace, preserved before its destruction, is an amalgamation of different phases of construction (Porter 2011: 210). It is therefore not a single designed and constructed building, but the result of continual remodelling, so as to fit the needs and requirements of its users. While only part of the palace survives, the final form of the preserved section is clearly monumental and ceremonial in nature, creating performative and theatrical ceremonial social spaces for processions (Pinnock 2012, 2015; Porter 2011: 206).

Palace G has two primary areas that are defined through different architectural features and layouts (Figure 2.3). The Audience Court (L.2752) consists of a large open-air plaza with porticos along the north and eastern walls, a variety of doorways and staircases, and a stepped dais against the north wall. Connected to the Audience Court is the Administrative Quarter, which consists of a series of rooms (L.2875, L.2769, L.2913, L.2764, L2866, L.2982, L.2984) east of the plaza. These two areas were physically connected through a single sequence of doorways and corridors, allowing the spaces to both work in conjunction and separately as distinct enclosed and open spaces (Pinnock 2015: 12–14). Due to their size, the Audience Court (42 metres wide; and length projected to be not less than 60 metres) and the two main rooms of the Administrative Quarter, Hall L.2913 and the Throne Room L.2866, appear to be the primary social reception spaces that would have been key starting, stopping or terminal points for processions.

The three proposed starting points for processions entering this area were placed at the key doorways and staircases located in the Audience Court. These are only partial reconstructions of the entire processional routes that must have been designed in the building, as the architecture beyond these doorways is either poorly preserved,

unexcavated or is located on a different terrace elevation of the tell mound. The directionality of these points as 'starting points' is in their directional and axial relationship to the large primary social reception spaces in the Audience Court, Hall L.2913 and the Throne Room. As Porter has argued, the directionality and intent of the architecture and the performative nature of the space indicates a focus on the movement of bodies out of the building rather than inwards (Porter 2011: 200). The main doorways and staircases are largely located in the northern wall and corner of the Audience Court; a doorway along the northern wall, a doorway coming out of a tower staircase in the north-eastern corner, and a doorway at the base of a monumental staircase (Figure 2.3).

It is likely that other routes came from the western and southern part of the plaza, but currently this is impossible to determine. Matthiae has suggested the plaza was trapezoidal in shape and would have been only partially enclosed, with access to the lower town from the west (Matthiae 1991; Porter 2011: 210; Ristvet 2014: 63–5). The Audience Court would have been a public plaza space, providing a venue for interactions between the king, court and inhabitants of the lower town, as well as a ceremonial and ritual space for the court. However, even if there was no enclosure wall, this space could still have been highly regulated in access through the placement of guards and semi-permanent structures such as screens and fences. Given the number of doorways and access to important court spaces, it seems to be highly unlikely that the court was completely open access (Pinnock 2012: 274; Porter 2011: 210–11). This would have allowed too much physical, sensory, and social permeability between the palace and the lower town. The desire for privacy and security in palatial buildings is evident from the enclosure walls and the depth of social reception spaces within many Early Bronze Age palatial buildings such as at Tell Beydar (Ristvet 2014: 57–61). This suggests that there was some kind of enclosure wall or fencing with doorways on the southern and western sides, which acted as important entry points for routes climbing up the tell mound from the lower town.

The southern and western doorways and entrances would have been points where large processions could enter and depart Palace G, connecting the palace with processional routes through the city and further beyond to other cities. They were liminal stopping points, marking the transition between the palace and city, and would have been places for the reconfiguration of procession participants. The need to reconfigure would be particularly necessary if vehicles were involved. Wagons and chariots would not have been able to be used within the palace, requiring the king and queen to disembark. This would require a transition from sitting/standing to walking, though it could also involve transference of the king and queen onto a palanquin or even an equid mount to enter into the palace. This would have allowed the king and queen to retain a sitting position as opposed to walking. This reconfiguration of body techniques at the Audience Court would create a distinct theatrical display and experience of entering into the plaza and palace by participants and audiences.

The three doorways in the northern part of the Audience Court were primary entry points leading from within the palace and likely used by the court and royal family during processions. The northern doorway is the least preserved, but is located right

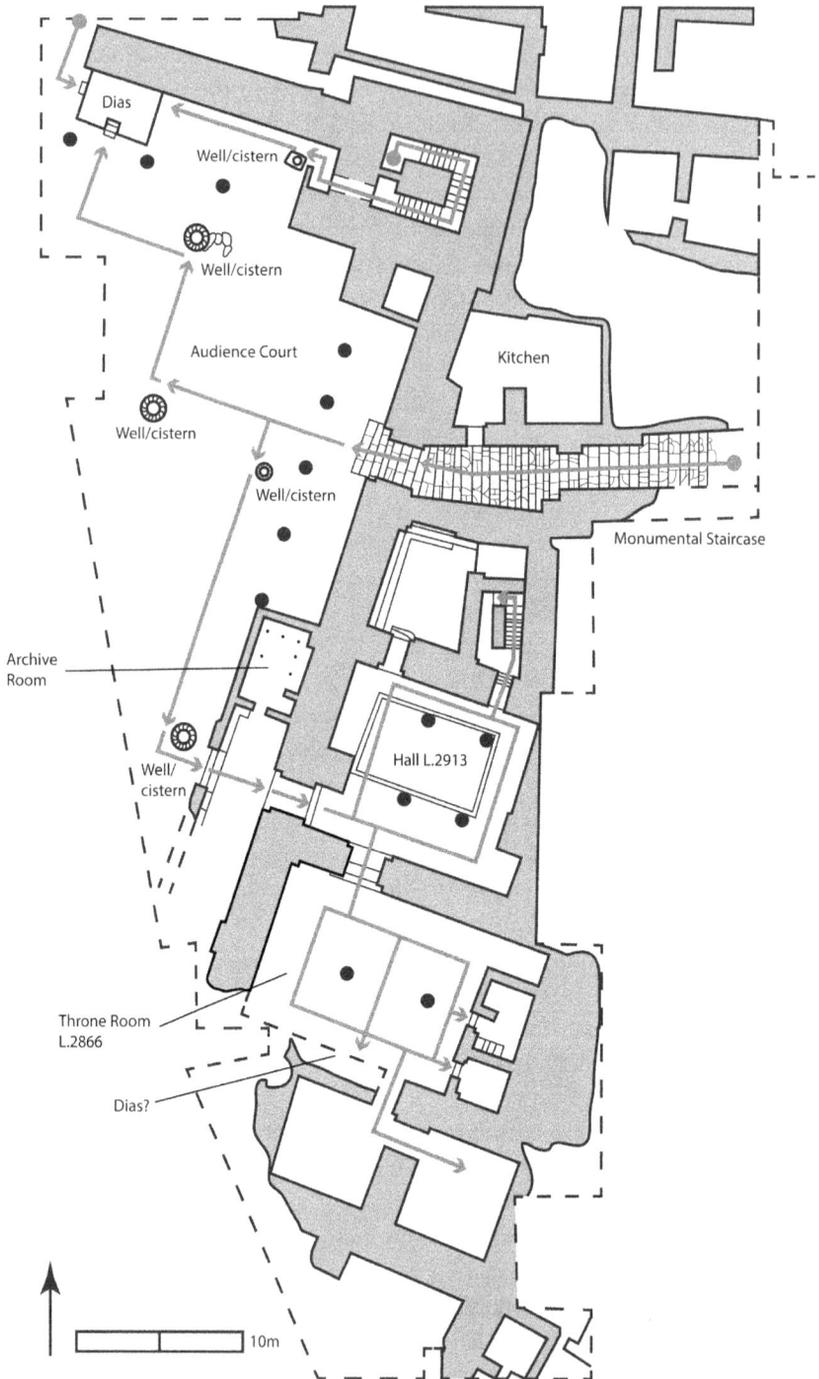

Figure 2.3 Reconstruction of the main processional routes in the Administrative Quarter, with starting points marked with a circle and stopping/terminal points with an arrow. Drawing by Carl Walsh based on plan produced with permission of Missione Archeologica Italiana in Siria.

next to a stepped dais, which was the focal directional point of the Audience Court. This dais was likely a space for the royal family to sit and receive members of the court, officiate over important religious, legal and social events, and may have been used for the placement of divine statues and performance of rituals (Porter 2011: 212–19). Since the northern doorway provides direct access to the dais, with a step on the west side of the dais, it would likely have been the main private route for the royal family and members of the court. Similarly, the ceremonial staircase, whose prestigious function is clear from preserved wooden steps with inlaid shell, opens in direct alignment with the dais, indicating another private access point for the royal family (Matthiae 1989: pl. 8; Pinnock 2012: 273, 276). This is further suggested by the placement of a screening wall in front of the doorway, allowing greater privacy and for members of the royal family to suddenly appear and disappear before an audience. The portico, which runs along the northern wall and covers the dais and both doorways, also delineates space and directionality of movement between the dais and the doorways. The lack of a step on the eastern side of the dais is curious, as this disrupts a direct alignment with the ceremonial staircase doorway. Porter has suggested that this is an argument against the dais being used by the royal family, and instead for divine statues (Porter 2011: 204–5). However, it is likely that the dais was used by both divine statues and royalty, depending on the ceremonial context.

The directionality and alignment of the portico, staircase, doorways and dais together with the small size of the doorways, staircases, screening wall and dais indicate that the body techniques for movement used in this space were highly formalized and choreographed. They construct a route for a walking individual or very small group in single file, with a brief horizontal movement route to the dais. The dais is a clear terminal point in which walking procession transitioned to sitting positions facing into the plaza, with this reconfiguration of the body being a performative act focusing on the changing gestures of the king or royal family. This will be further discussed below in relation to social reception.

The monumental staircase, in contrast to the private north wall routes, was clearly designed to facilitate large-scale processions. It is by far the largest entranceway to the Audience Court, with a width between 3 and 4 metres, being over 22 metres long with a rising elevation of 5 metres, and steps of worked basalt and limestone with a roofed portico at its base (Figure 2.3). The staircase opens onto the northern corner of the east wall and connects the plaza with an upper portion of the palace, which currently little is known of (Matthiae 2013: 50). The verticality of the staircase architecture, with high walls and likely ceiling, provided a sense of imposing scale would have made individuals appear and feel small in comparison. The width of the staircase, 2 to 4 metres, could easily accommodate different procession configurations and sizes. These could include single file or up to four people side by side, facilitating different volumes of traffic into and out of the Audience Court. The construction of a small landing at the base of the staircase, possibly a later addition, suggests that there was a marked stopping point for the reconfiguration of the procession and that there might have been a door at the staircase base which would be opened outwards to the plaza (Porter 2011: 210).

The regular size and spacing of the basalt and limestone steps, with each step being roughly 0.8 metre deep, indicates that the staircase was designed to be easily navigable. This would allow the management and coordination of participant movement, in order to maintain the structure and order of the procession. It would be particularly necessary for participants carrying standards or furniture such as a palanquin, where coordination would be vital in moving in conjunction with others. The regular central row of three stone blocks for each step might even have been used as a way to align procession participants in rows of three. The care taken in the construction of the staircase with a gentle gradient, low step height, and spacious steps support this idea, indicating a clear desire to manipulate movement and construct an emotive and theatrical space. In this manner, the staircase can be viewed as a stage for the performance of processions, with the portico at the staircase base providing a shaded area where audiences were able to observe processions entering and exiting the plaza (Pinnock 2012: 276). If the top of the staircase opened into a plaza, this would allow the morning sun to create a brilliant backdrop for processions on the staircase, obscuring figures and creating a distinct atmosphere for audiences and participants.

Processions walking down the staircase could branch into a number of different routes. Participants could enter into the main space of the Audience Court, exit the palace to the south or west, or turn and walk towards the dais to the north to be received by the king. They could also turn southwards to a doorway on the western side of the Audience Court, which led to the Administrative Quarter (Figure 2.3). This entranceway, lined in stone and featuring wooden inlaid mother of pearl steps, has a width of about 2.5 metres, and would allow a single or perhaps double file procession. Small processions would be able to keep their configuration, but a larger size, with multiple rows of participants, might have to stop to reconfigure their composition. The liminal nature of this doorway makes it likely to be a processional stopping point, further suggested by the presence of a door which had to be opened and a descending step into the lower floor of the vestibule room L.2875. The steps are particularly interesting, because they are slightly rounded, inlaid with bands of shell inlay, and are located within the vestibule room (Porter 2011: 211). This would have required a specific technique and awareness for stepping on them and reaching the floor, suggesting that the act of moving into and out of this space involved a specific body technique that was experiential in nature. In addition, the ornate inlaid decoration also only became visible when the door was opened, pointing to the act of opening and closing the door being important in the procession. The incorporation of a step, lower floor, door and inlaid decoration enhanced the liminality and performative act of crossing the threshold. The features would have created contrasting sensory and bodily experiences of moving from an open, hot and bright plaza into a lower, enclosed, cool and dark room.

Large doorways are a recurring feature in the Administrative Quarter, and clearly materialize a guiding directionality for processions, channelling and constructing movement. The main processional route appears to be marked by these doorways, leading from the vestibule doorway, into Hall L.2391, and into the Throne Room (Figure 2.3). Each of these doorways could act as a liminal point, in which doors or

screens had to be opened. At these points, a theatrical act could be performed such as opening doors, the procession being reconfigured, or for other forms of ritual and gestural action.

The terminal points for the processions within the Administrative Quarter are the social reception spaces: Hall L.2913 and the Throne Room L.2866. The movement into these spaces saw the transition from the linear movement of the procession to new etiquettes and gestures governing social reception, which are discussed further in the following section. Moving through the doorway from the vestibule room, Hall L.2913 could function as both a social reception space and a liminal stopping point (Figure 2.3). Procession participants could join activities within the hall, move upstairs through another staircase, or turn to the throne room doorway to the south. The hall contained evidence both of life-sized statuary and inlaid objects, suggesting it was an important room that may have included ritual actions, such as acts of dressing, offering or anointing the large statues. These may have been performed by processions before entering into the Throne Room (Matthiae 2003b; Porter 2011). Within the Throne Room, two small rooms, built as additions, may have been used as stopping points to place divine/royal statuary, material paraphernalia such as standards and cuneiform tablets. The terminal point in the processions appears to have been the south wall, which unfortunately is only partially preserved. Matthiae reconstructs a similar dais or throne being placed here, which seems very likely. The southern wall seems to be the emphasis of directionality in the room, with the two central columns directing movement towards the south wall. In addition, there are a group of private rooms to the south which could be for storage of court and processional equipment. They could also be private rooms for royalty, who would then proceed into the Throne Room in a similar fashion to the dais in the Audience Court (Figure 2.3). The former interpretation seems more likely given the finding of a large amount of raw lapis lazuli and the previously discussed king's standard in these rooms. The depth of the Throne Room within the building and the single point of entry indicate that this was a tightly regulated space, while the ancillary rooms and columns emphasize its importance as a social reception space.

The architectural features employed in the design of the Audience Court and Administrative Quarter were clearly intended to choreograph the human body and movement in the performance of processions. The placement of daises, staircases, porticos and doorways illustrate a carefully planned design to create highly ritualized and codified ways of moving through the palace. Particular emphasis is placed on the transitions and reconfigurations of body techniques of walking, sitting and standing, regulating the visibility and flow of participants, creating linear, directional movement routes and delineating movement between the royal family and court. The architecture of Palace G clearly reflects the desire to make processions theatrical bodily performances, a fact supported by the textual, iconographic and material sources found at Ebla and other Early Bronze Age Syrian and Mesopotamian sites. Significantly, these gestures were vital tools in intimately linking the performative bodies and behaviours of the court with the built environment of the palace.

Standing and sitting in court receptions

The performative movement of processions transitioned into new gestural vocabularies relating to social reception. The aforementioned 'presentation' and 'introduction' motifs found in the 'Syrian Ritual' glyptic scenes document these key moments of liminal transitions into new sets of bodily actions for reception. Within the context of royal courts, receptions can refer to and include a number of different activities such as feasting, banquets, receiving guests, and weddings, and legal, economic and ritual events. Such events would have involved a complex array of etiquettes involving different gestures, but the limited range of information within Syrian iconographic depictions and textual descriptions of such events makes it difficult for us to reconstruct these behaviours with any exact certainty.

However, in the case of Palace G at Ebla there is clear evidence of how social receptions spaces were designed to create different spatial and social zones, sometimes across different elevations, which were managed and negotiated through specific body techniques. Sitting, particularly using a ninety-degree technique using a piece of furniture, is a widespread and important social authority marker in court societies of the Bronze Age eastern Mediterranean (Cranz 1998, 2000; Walsh 2014, 2016). The ninety-degree sitting technique, which is commonly used in Western societies today, involves positioning the thighs parallel to the floor with the lower legs turned ninety degrees at the knee to place the feet directly on the floor (Cranz 2000: 92; Opsvik 2008: 49–55). Sitting using this technique is not a physiological adaption, as evidenced by the growing problem of physiological problems cause by prolonged sitting in modern society, but rather a social and cultural construction (Cranz 2000; Opsvik 2008: 12–29; Rybczynski 2016: 196–8). This technique had a strong association with royal and court body culture during the Bronze Age due to the fact that it usually required a piece of sitting furniture, which was a high-status prestige object, in order to create this particular body position. The social and cultural nature of this sitting technique was further elaborated by the construction of different etiquettes around acts of sitting, particular in regard to seating plans, timing of sitting, different techniques of sitting and furniture types, and who is allowed and not allowed to sit.

The importance of sitting etiquettes in the reception spaces of Palace G is apparent through a number of architectural features, material remains of furniture and iconographic depictions of court reception and furniture. Within the Audience Court, I noted earlier that the primary orientation and termination points of the processional routes was the dais located along the northern wall. Daises, as a type of platform, function to elevate human bodies and material bodies such as statues, emphasizing their primary importance and status, literally, over others. They also act as performance spaces, delineating zones of activity and emphasizing where particular performative action will take place. In the case of the Audience Court, the alignment of the dais with the communicating private staircase and doorway, points to a function in elevating the body of royal occupants, though it is possible that statuary could have also been placed here. This feature constructed juxtapositions of sitting and standing bodies and as a primary orientation and directional point in social reception spaces.

While on the dais, royal figures would have been able to employ the ninety-degree sitting technique with an accompanying piece of furniture, emphasizing their status and position over the court. The employment and performance of this particular sitting technique is almost certain, given the rich iconographic sources from Syrian and Mesopotamian glyptic and statuary which depict royal figures using this sitting position on furniture. Returning to the 'Syrian Ritual' found on glyptic sources, there is clear evidence for the use of this sitting technique in formal ceremonial events, with images of authority figures, flanked by standard bearers sitting on thrones (Matthews 1997: 113). In the Ebla archives, there is also emphasis on the act of sitting on thrones during court rituals. The extract below details how the act of sitting by king and queen on the thrones of ancestors was a significant part of the ritual of renewal of kingship and marriage:

And the king enters his room. And the queen enters her room. When they rise from the linen sheets the king and queen leave, they sit on the thrones of their fathers.

Fronzaroli translation with additions by Biga in Biga 2009: 39

These sources highlight that the act of sitting using the ninety-degree technique was a highly significant body behaviour associated with expressing power and status at Ebla, and would have been a primary gestural performance in social reception.

The importance of this technique in social reception is highlighted through a slightly later Early Bronze Age source, Akkadian and Ur III 'introduction' and 'presentation' scenes found on cylinder seals in Mesopotamia (Figure 2.4). These scenes are a further development of older presentation motifs found on the 'Syrian Ritual' scenes. They depict courtiers or royal figures being led by an interceding deity and presented before an enthroned deity or royal figure (Eppihimer 2013; Winter 1986, 1991). The scenes therefore have a definite sense of linear, ordered, directionality, with a lower-status individual being led by a high-status individual into the presence of another high-status individual. The lower status, and sometimes interceding, figure often perform supplication gestures of forward upraised hands, the pouring of a libation or drink, and sometimes is held by the arm or hand by the leading interceding figure (Eppihimer 2013: 40). These glyptic scenes are religious and cosmological in nature, depicting the social, ritual and gestural dynamics of a courtier or king (the seal owner) interacting with a deity, or a king (ibid.: 39–41). They are interesting because they specifically illustrate the interactions between individuals who are socially and cosmologically unequal (Pinnock 2006: 498). In addition, these scenes are clearly referring to and operating within the framework of living practices regarding processions in court spaces such as palaces (Winter 1986: 253, 1991: 75). In this manner, the presentation scenes offer intriguing glimpses into comparable conceptions of social reception etiquette, with some potential communicative gestures that might have been performed in appearing before a high-status individual, such as hand holding, the pouring of a libation or drink, and an upraised hand. It is unclear exactly if these types of gestures would have been practiced at Ebla, but it is certainly a possibility.

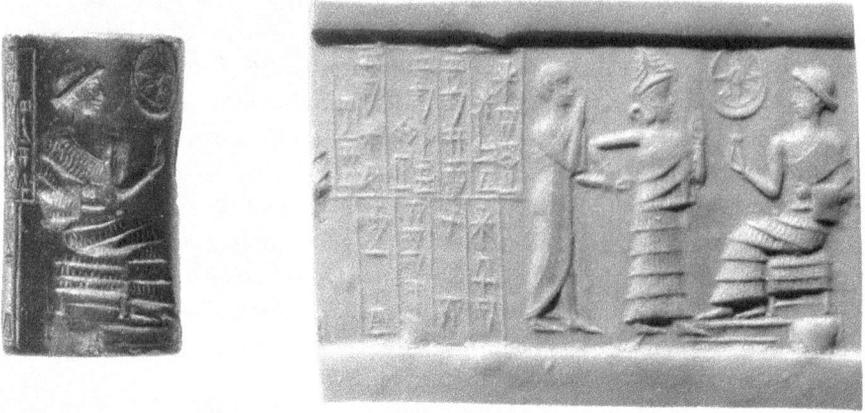

Figure 2.4 Cylinder seal and modern impression dating to the Ur III period, depicting a presentation scene. Metropolitan Museum of Art, No. 1988.380.2. Produced with permission of the Metropolitan Museum of Art, New York.

That a piece of ornate sitting furniture was placed on the dais in the Audience Court is further suggested from the actual finding of furniture remains in the northern section of the palace, to the north of the dais and Audience Court. These consist of carved wooden figural elements that would have been components of one or two high backed chairs and a table (Dolce 2006; Evans 2003a: 174; Matthiae 1992). Interestingly, high backed chairs do not feature prominently in glyptic iconography, with stools being the more common furniture type, perhaps suggesting a very limited and prestigious use to this furniture type. The high degree of craftsmanship on these pieces, featuring openwork carving and shell inlay, as well as depictions of fierce animals such as bulls, lions and panthers associated with royalty, clearly point to these being pieces of royal furniture. These pieces of furniture could have been actual pieces brought out to be used on the dais or in the Audience Court during court events, though they could have also been used in the rooms in which they were found. However, they at least exhibit the use of elaborate sitting furniture in Palace G.

The furniture remains and iconographic evidence along with the placement of the dais indicates that when members of the royal family attended receptions in the Audience Court, they primarily sat using a ninety-degree technique, facing into the plaza, with an audience that was assembled before the dais. The seated royal figures upon the dais acted as the primary social and bodily orientation point for the rest of the court. This is also suggested to be the spatial and bodily configuration in the Throne Room, given its similar movement orientation to the Audience Court (Figure 2.3). Unfortunately, the part of the southern wall where a dais would be expected has not been preserved, but it seems very likely that a similar arrangement would be in place as in the Audience Court, with a sitting figure before a standing audience.

As pieces of furniture are mobile objects, there are a number of different possibilities for others to be sitting using different techniques and etiquettes, negotiated through seating plans and orders and different furniture types. The previously discussed glyptic sources and *makilitum* standard would suggest that those brought into the presence of a high-status sitting figure were not afforded a seat, instead standing. However, this etiquette probably varied according to context, with some events such as banquets and feasting involving a combination of royal/court/non-court sitting and standing figures. Contemporary Syrian and Early Dynastic Mesopotamian cylinder seals from sites such as Mari, Um el-Marra, Tell Brak and Tell Beydar (Matthews 1997; Pinnock 1994; Porada 1993: Zajdowski 2013), depict more widespread use of sitting furniture and ninety degree sitting techniques by members of the court or perhaps city elders and assemblies, particularly during commensality events. The ubiquitous banqueting scenes from this period indicate potentially different context-related seating etiquettes, often with participants alone or in pairs (though the presence of multiple drinking straws might indicate a larger implied group) facing each other while sitting and drinking from straws from a shared beer jar (Figure 2.5; Costello 2018; Pollock 2003; Marchetti 1998: 123; Matthews 1997; Schmandt-Besserat 2001). The positioning of seated figures of the same size facing each other implies a conception of similar status. However, in some cases there is a larger seated figure, which suggests a higher status individual. These figures often occupy central placement in these scenes, which may be a stylistic convention, or communicate a sitting etiquette and spatial orientation of sitting figures around a high-status individual (Costello 2018: 77). The inclusion of more than one seated individual in these scenes and the juxtaposing of sitting and standing figures indicates that there was a wider utilization of ninety-degree sitting postures in certain contexts, which allowed the construction of etiquettes on who was allowed to sit in these events. In addition, these seated figures are often served drink and food by standing and moving

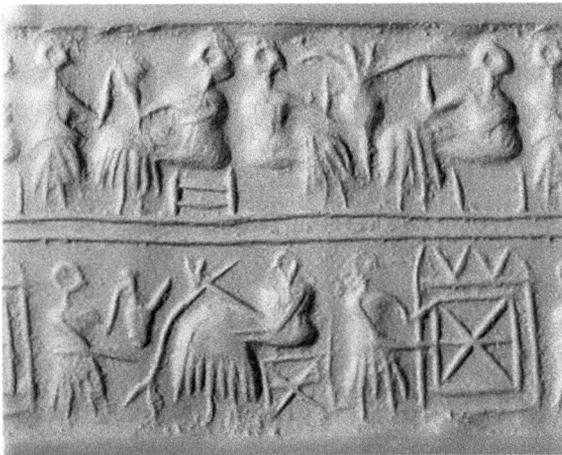

Figure 2.5 Early Dynastic cylinder seal depicting a banqueting scene. Metropolitan Museum of Art, No. 56.157. Produced with permission of the Metropolitan Museum of Art, New York.

individuals, indicating again the theatrical and hierarchical juxtapositions of sitting and standing figures (Pollock 2003: 25; Costello 2018: 71–3).

The depiction of tables in these banquet scenes indicate that sitting furniture was sometimes intended to work in conjunction with tables. Tables construct an elevated surface accessible to a sitting figure where food, tableware and drinking vessels could be interacted with. The identification of these motifs as tables is certain because they have objects or food placed on them and feature the same types of wooden construction as chairs, in rare cases even having the feet depicted (Figure 2.5; Marchetti 1998: 123). Tables are significant to consider because they are not only surfaces to interact with, but bodily and social orientation points that can be used to construct social space. In a similar manner to a dais, tables can be used as points to arrange bodies around or orientate bodies towards and provide mobile and adaptable options in constructing different configurations of social space. The glyptic scenes suggest that tables played a role in constructing commensality events, with sitting figures arranged around them or towards them, though the positioning is not always consistent. Tables also allow the construction of etiquettes around seating plans, managing social interactions and expressing hierarchy by choreographing who was included at which table or at a table at all. Evidence for the concern around who was placed at which table at court commensality events is abundantly clear in the later Middle Bronze Age archives found at Mari, where Mari diplomats wrote to the king of Mari noting the special seating arrangements they were given:

> Having left Andarig, I entered Kurda. At nightfall, I was called for the meal and I went there. None among the auxiliary forces had a place seated before him (i.e. the king of Kurda), except me. And Yashub-Dagan, servant of my lord, was with me, but he remained apart, on a seat at the side.
>
> *Charpin 2010: 101*

At Palace G, remains of a table found alongside a chair were found in the Northern Quarter, which further underlines the spatial and bodily association between these two furniture forms in court life. Tables such as this could be used in social reception spaces to construct space in different ways and manipulate bodily orientations and sitting/standing juxtapositions. Commensality events do appear to have important activities in the Audience Court as it had access to a nearby kitchen and contained a number of wells/cisterns, which would provide food and water for large social gatherings. The Ebla archives also make mention of banquets which were held in the palace, and which were important aspects of international diplomacy and court ceremony (Archi 1999: 148). The Audience Court was a large and adaptable social reception space that was clearly intended for large social gatherings and commensality. Tables would have been useful in both providing a surface for food and drink, creating different gestural performances of sitting and standing, and for choreographing social space.

The glyptic scenes illustrate that sitting and standing etiquettes were reconfigured to accommodate different types of gestural performance according to reception context. A wider inclusion of the court using sitting techniques would be expected, though it was

likely that orientation around the royal figures was still the normative etiquette. The mobile nature of furniture allowed the space to be reconfigured and adaptable to suit these needs and preferences. Different configurations of furniture types and floor sitting could also mediate social hierarchy and status. Tables, chairs, stools and cushions or carpets could be used in these contexts to create contrasting sitting techniques with different elevations. Lower chairs and stools can construct a more flexed sitting position with the knees drawn closer to the chest, compared to the ninety-degree technique used with a high chair with an average height of 45 centimetres or greater (Cranz 2000). Benches, stools and block-like seats are all common motifs found in cylinder seal iconography and statuary, illustrating a diversity of sitting furniture and possible techniques. The existence of other sitting techniques is exemplified by a statuette from Early Bronze Age Mari (Syria), which depicts a court singer named Ur-Nanshe in a cross-legged sitting technique on a floor cushion (Evans 2003b: 152). The ninety-degree sitting posture dominates most of these court scenes, indicating that this was the highest status sitting technique. Clearly, status and rank were performed and expressed through hierarchies of sitting techniques using different types of furniture and floor coverings. Different ways of sitting could be used in conjunction with standing to create complex gestural etiquettes and vocabularies that express status and identity within the court.

Cylinder seals materialize and propagate these body techniques as images through their portable nature as personal adornments. However, images of sitting and standing figures were also propagated through large monumental wall decorations and statuary which decorated court reception spaces. For example, in Hall L.2913, fragments of lapis lazuli statuary and shell and limestone inlays depicting high relief figural images were found (Matthiae 2003a: 166). The statuary fragments comprise mostly of elaborate hairstyles which might be associated with royalty, but certainly seem to be courtly (ibid. 2003b: 169–72). The inlays, which likely decorated the walls, have been reconstructed as being a combination of military, mythological and court scenes (ibid. 1992). This iconography and the quality of materials and craftsmanship point to this being an important visual arena for the display of court and royal bodies, identity and status. Indeed, while the composition and postures of the figures are hard to reconstruct due to only certain elements surviving, they likely formed scenes utilizing court and royal iconographic compositions such as banquets, military conflict and mythological scenes, similar to the scenes found in the Early Bronze Age standards of Ur and Mari, and a limestone inlay panel found in the eastern portion of Palace G (ibid.). Sitting and standing figures must have played important roles in such scenes, given their important role in royal and court iconography.

Depictions of court events such as banquets and receptions would have acted as powerful mnemonic devices that would have reinforced the gestural etiquettes and actions regarding sitting and standing within actual reception spaces. Court members would be able to observe and identify with the images on the walls, and perhaps would even be mirroring the types sitting techniques found in these visual displays. In this manner the figural images would act as a mnemonic and propagative device to reinforce specific forms of gestures, presenting them in a medium that was relatable and understood by those who were part of court society. To an individual entering this space who was not

a member of the court, it would no doubt have been an intimidating and alien experience, creating a definite sense of 'us' and 'them', 'court' and 'non-court'.

It is clear that social reception within Palace G at Ebla was negotiated and navigated through gestural vocabularies and performances involving the juxtaposition of sitting and standing participants. In some cases, the execution of these gestures was in specific architectural spaces, reinforced through the permanent placement of architectural features, such as daises. In cases of initial reception and audience of guests and receiving of processions there were strict etiquettes involving who sat and who stood, with royal figures usually being the primary, but not necessarily the exclusive, sitting figures. In other contexts, there seems to be the possibility for very different configurations in which there were more widespread uses of furniture and sitting techniques, particularly in regards to commensality, which could take place in large reception spaces, such as the Audience Court, Hall L.2913, and the Throne Room. These different etiquettes indicate that the way in which sitting and standing was orchestrated and performed in court activities was highly choreographed and tightly monitored, which would stem from the manner in which these courtly gestures were intimately tied to court behaviour and identity.

Conclusions: Performing bodies and theatrical palaces

This chapter has illustrated how different forms of gesture, such as walking, sitting, standing and even holding, played important performative roles in court life at Ebla. These gestural vocabularies, built from and incorporated into the *habitus* of court, formed essential aspects of court identity through their embodied performance in court activities and events. Performing and exhibiting these gestures constructed and reinforced a sense of embodied commonality and community amongst courtiers, while also excluding those who were not members of the court and unfamiliar with the contextual meaning of these forms of body communication. The courtly nature of these gestures and behaviours was underlined through the designed contextual spatial relationships between these body behaviours and the built environment of the palace; through its architectural features, furnishings and art.

In addition to creating a sense of commonality amongst members of the Ebla court, these gestures also facilitated a number of contextual opportunities to further express hierarchy and status within the court, through the construction of etiquettes which provided a social and behavioural framework in which these gestures operated and were employed. Who participated in events, what equipment they were given or allowed to use, and the order and timing of participation would have been highly social and political actions, and markers of position and status within court life at Ebla (Walsh 2014, 2016).

This chapter has also worked to demonstrate that gesture, as a form of bodily action, is inherently inseparable from the context of the embodied experience of the built environment. Architecture is not simply a container for the bodily actions of its users, but one of the active actors in the interactions between the human body, behaviour, materials, objects and images. Recognising the inherent bodily and social agency of

architecture works to demonstrate how gesture is intimately tied and embedded into the built environment of human societies.

References

Akkermans, P. and G. Schwartz (2003), *The Archaeology of Syria: From Complex Hunter-Gatherers to Early Urban Societies (ca. 16,000–300 BC)*. Cambridge: Cambridge University Press.

Archi, A. (1999), 'The Steward and His Jar', *Iraq*, 61: 147–58.

Archi, A. (2012), 'History of Syria in the Third Millennium: The Written Sources', in W. Orthmann, M. al-Maqdissi and P. Matthiae (eds), *Archéologie et Histoire de la Syrie, Vol. I: La Syrie de l'époque Néolitque à l'âge du Fer*, 75–88, Wiesbaden: Harrassowitz Verlag.

Archi, A. (2013), 'Ritualization at Ebla', *Journal of Ancient Near Eastern Religions*, 13: 212–37.

Ashley, K. (2001), 'The Moving Subjects of Processional Performance', in K. Ashley and W. Hüsken (eds), *Moving Subjects: Processional Performance in the Middle Ages and the Renaissance*, 7–34, Amsterdam: Rodopi.

Biga, M. (2009), 'Discovering History through the Ebla Tablets', in G. Servadio (ed.), *Ancient Syrian Writings: Syrian Preclassical and Classical Texts*, 29–56, Damascus: General Secretariat of Damascus Arab Capital of Culture.

Bille, M. and Sørenson, T. (2016), 'Into the fog of architecture', in M. Bille and T. Sørenson (eds), *Elements of Architecture: Assembling Archaeology Atmosphere and the Performance of Building Spaces*, 1–29, New York: Routledge.

Boogart II, T. (2001), 'Our Saviour's Blood: Procession and Community in Late Medieval Bruges', in K. Ashley and W. Hüsken (eds), *Moving Subjects: Processional Performance in the Middle Ages and the Renaissance*, 69–116, Amsterdam: Rodopi.

Bourdieu, P. (1977), *Outline of a Theory of Practice*, Cambridge: Cambridge University Press.

Bourdieu, P. (1990), *The Logic of Practice*, Stanford, CA: Stanford University Press.

Bryson, A. (1998), *From Courtesy to Civility*, Oxford: Clarendon Press.

Charpin, D. (2010), *Writing, Law, and Kingship in Old Babylonian Mesopotamia*, London: University of Chicago Press.

Costello, S. (2018), 'Rematerializing the Early Dynastic Banquet Seal', in M. Ameri, S. Costello, G. Jamison and S. Scott (eds), *Seals and Sealing in the Ancient World: Case Studies from the Near East, Egypt, the Aegean, and South Asia*, 68–80, Cambridge: Cambridge University Press.

Cranz, G. (1998), *The Chair: Rethinking Culture, Body and Design*, New York: W. W. Norton.

Cranz, G. (2000), 'The Alexander Technique in the World of Design: Posture and the Common Chair', *Journal of Bodywork and Movement Therapies*, 4 (2): 90–8.

Deleuze, G. and F. Guattari (2004), *A Thousand Plateaus: Capitalism and Schizophrenia*, London: Continuum.

Dolce, R. (2006), 'Ebla and Akkad: Clues of an Early Meeting: Another Look at the Artistic Culture of Palace G', in F. Baffi, R. Dolce, S. Mazzoni and F. Pinnock (eds), *Ina Kibrat Erbetti. Studi di Archeologia Orientale Dedicati a Paolo Matthiae*, 127–206, Rome: Casa Edtrice, Universita Degli Studie 'La Sapienza' Roma.

Dolce, R. (2014), 'Equids as Luxury Gifts at the Centre of Interregional Economic Dynamics in the Archaic Urban Cultures of the Ancient Near East', *Syria*, 91: 55–75.

Eco, U. (1980), 'Function and Sign: The Semiotics of Architecture', in G. Broadbent, R. Bunt and C. Jencks (eds), *Signs, Symbols and Architecture*, 11–69, Chichester: David Fulton Publishers.

Elias, N. ([1939] 2000), *The Civilizing Process*, revd edn, Oxford: Blackwell Publishing.

Elias, N. ([1969] 1983), *The Court Society*, Oxford: Blackwell Publishing.

Eppihimer, M. (2013), 'Representing Ashur: The Old Assyrian Rulers' Seals and Their Ur III Prototype', *Journal of Near Eastern Studies*, 72 (1): 35–49.

Etlin, R. (1998), 'Aesthetics and the Spatial Sense of Self', *Journal of Aesthetics and Art Criticism*, 6 (1): 1–19.

Evans, J. (2003a), 'Inlaid Open-Work Furniture Panel', in J. Aruz and R. Wallenfels (eds), *Art of the First Cities: The Third Millennium B.C. from the Mediterranean to the Indus*, 174, New York: Metropolitan Museum of Art.

Evans, J. (2003b), 'Seated Figure and Torso Fragment of the Singer Ur-Nanshe', in J. Aruz and R. Wallenfels (eds), *Art of the First Cities: The Third Millennium B.C. from the Mediterranean to the Indus*, 152, New York: Metropolitan Museum of Art.

Flanigan, C. C. (2001), 'The Moving Subject: Medieval Liturgical Processions in Semiotic and Cultural Perspective', in K. M. Ashley and W. Hüsken (eds), *Moving Subjects: Processional Performance in the Middle Ages and the Renaissance*, 35–51, Amsterdam: Rodopi.

Fronzaroli, P. (1992), 'The Ritual Texts of Ebla', in P. Fronzaroli (ed.), *Literature and Literary Language at Ebla*, 163–85, Firenze: Università di Firenze.

Gilibert, A. (2011), *Syro-Hittite Monumental Art and the Archaeology of Performance: The Stone Reliefs at Carchemish and Zincirli in the Earlier First Millennium BCE*, New York: De Gruyter.

Goffman, E. (1956), 'The Nature of Deference and Demeanor', *American Anthropologist*, 58 (3): 473–502.

Grimes, R. (2003), 'Ritual and Performance', in G. Laderman and L. León (eds), *Religion and American Cultures: An Encyclopedia of Traditions, Diversity, and Popular Expressions*, 515–28, Santa Barbara, CA: ABC Clio.

Heidegger, M. (1971), 'Building, Dwelling, Thinking', in A. Hofstadter (ed.), *Poetry, Language, Thought*, 145–61, New York: Harper and Row.

Hillier, B. and J. Hanson (1984), *The Social Logic of Space*, Cambridge: Cambridge University Press.

Huopalainen, A. (2015), 'Who Moves? Analyzing Fashion Show Organizing through Micro-Interactions of Bodily Movement', *Ephemera*, 15 (4): 825–46.

Inomata, T. and L. Coben (2006), 'Overture: An Invitation to the Archaeological Theatre', in T. Inomata and L. Coben (eds), *Archaeology of Performance, Theatres of Power, Community, and Politics*, 11–46, New York: Altimira Press.

Jans, G. and J. Bretschneider (1998), 'Wagon and Chariot Representations in the Early Dynastic Glyptic, "They Came to Tell Beydar with Wagon and Equid"', *Subartu*, 4 (2): 155–94.

Kendon, A. (2004), *Gesture: Visible Action as Utterance*, Cambridge: Cambridge University Press.

Latour, B. (2005), *Reassembling the Social: An Introduction to Actor Network Theory*, Oxford: Oxford University Press.

Marchetti, N. (1998), 'The Mature Early Syrian Glyptic from the Khabur Region', in M. Lebeau (ed.), *About Subartu: Studies Devoted to Upper Mesopotamia*, Vol. 2: *Culture, Society, Image*, 115–54, Turnhout: Brepols.

Matthews, D. (1997), *The Early Glyptic of Tell Brak: Cylinder Seals of Third Millennium Syria*, Fribourg: University Press/Göttingen: Vandenhoeck and Ruprecht.

Matthiae, P. (1982), 'The Western Palace of the Lower City of Ebla: A New Administrative Building of Middle Bronze I–II', *Archiv für Orientforschung*, 19: 121–9.

Matthiae, P. (1984), 'New Discoveries at Ebla: The Excavation of the Western Palace and the Royal Necropolis of the Amorite Period', *Biblical Archaeology*, 47: 19–32.

Matthiae, P. (1989), *Ebla: Un impero ritrovato. Dai primi scavi alle ultime scoperte*, 2nd edn. Einaudi: Torino.

Matthiae, P. (1991), 'Architettura e urbanistica di Ebla paleosirian', *La Parola del Passato*, 46: 304–71.

Matthiae, P. (1992), 'Figurative Themes and Literary Texts', in P. Fronzaroli (ed.), *Literature and Literary Language at Ebla*, 219–41, Firenze: Università di Firenze.

Matthiae, P. (2003a), 'Ebla and the Early Urbanization of Syria', in J. Aruz and R. Wallenfels (eds), *Art of the First Cities: The Third Millennium B.C. from the Mediterranean to the Indus*, 165–8, New York: Metropolitan Museum of Art.

Matthiae, P. (2003b), 'Headdresses for Composite Statues', in J. Aruz and R. Wallenfels (eds), *Art of the First Cities: The Third Millennium B.C. from the Mediterranean to the Indus*, 169–72, New York: Metropolitan Museum of Art.

Matthiae, P. (2008), 'Furniture Inlay', in J. Aruz, K. Benzel and J. Evans (eds), *Beyond Babylon, Art, Trade, and Diplomacy in the Second Millennium B.C.* 37, New York: Yale University Press.

Matthiae, P. (2009), 'The Standard of the *Maliktum* of Ebla in the Royal Archives Period', *Zeitschrift für Assyriologie und vorderasiatische Archäologie*, 99 (2): 270–311.

Matthiae, P. (2013) 'The Royal Palace: Functions of the Quarters and the Government of the Chora', in P. Matthiae and N. Marchetti (eds), *Ebla and Its Landscape: Early State Formation in the Ancient Near East*, 49–65, Walnut Creek, CA: Left Coast Press.

Mauss, M. ([1935] 1973), 'Techniques of the Body', *Economy and Society*, 2 (1): 70–88.

Opsvik, P. (2008), *Rethinking Sitting*, New York: W.W. Norton.

Pallasmaa, J. (2005), *The Eyes of the Skin*, Chichester: John Willey and Sons.

Pallasmaa, J. (2012), 'In Praise of Vagueness: Diffuse Perception and Uncertain Thought', in P. MacKeith (ed.), *Encounters*, 2, 224–308, Helsinki: Rakennustieto Publishing.

Pallasmaa, J. (2014), 'Space, Place and Atmosphere: Emotion and Peripherical Perception in Architectural Experience', *Lebenswelt*, 4 (1): 230–45.

Papaconstantinou, D. (2005), 'Constructing Identities in the Neolithic Eastern Mediterranean', in J. Clarke (ed.), *Archaeological Perspectives on the Transmission and Transformation of Culture in the Eastern Mediterranean*, 11–17, Oxford: Oxbow Books.

Parviainen, J. (2003), 'Dance Techne: Kinetic Bodily Logos and Thinking in Movement', *Nordic Journal of Aesthetics*, 27–8: 159–75.

Pettinato, G. (1981), *The Archives of Ebla: An Empire Inscribed in Clay*, New York: Doubleday.

Pettinato, G. (1992), *Il rituale per la successione al trono ad Ebla*, Rome: Universita Degli Studie 'La Sapienza' Roma.

Pinnock, F. (1994), 'Considerations on the "Banquet Theme" in the Figurative Art of Mesopotamia and Syria', in L. Milano (ed.), *Drinking in Ancient Societies: History and Culture of Drinks in the Ancient Near East (Papers of a Symposium held in Rome, May 17–19 1990)*, 15–26, Padova: Sargon.

Pinnock, F. (2006), 'Paying Homage to the King', in F. Baffi, R. Dolce, S. Mazzoni and F. Pinnock (eds), *Ina Kibrat Erbetti. Studi di Archeologia Orientale Dedicati a Paolo Matthiae*, 487–505, Rome: Casa Edtrice Universita Degli Studie 'La Sapienza' Roma.

Pinnock, F. (2012), 'Colours and Light in the Royal Palace of Early Syrian Ebla', in R. Matthews and J. Curtis (eds), *Proceedings of the 7th International Congress on the Archaeology of the Ancient Near East 12 April–16 April 2010, the British Museum and UCL, London, Volume 2*, 273–86, Wiesbaden: Harrassowitz Verlag.

Pinnock, F. (2015), 'The King's Standard from Ebla Palace G', *Journal of Cuneiform Studies*, 67 (3): 3–22.

Pollock, S. (2003), 'Feasts, Funerals and Fast Food', in T. L. Bray (ed.), *The Archaeology and Politics of Food and Feasting in Early States and Empires*, 17–38, New York: Plenum.

Porada, E. (1993), 'Why Cylinder Seals? Engraved Cylindrical Seal Stones of the Ancient Near East, Fourth to First Millennium B.C', *Art Bulletin*, 75: 563–82.

Porter, A. (2011), *Mobile Pastoralism and the Formation of Near Eastern Civilizations: Weaving Together Society*, Cambridge: Cambridge University Press.

Rapoport, A. (1969), *House Form and Culture*, Englewood Cliffs, NJ: Prentice-Hall.

Rapoport, A. (1977), *Human Aspects of Urban Form: Towards a Man–Environment Approach to Urban Form and Design*, Oxford: Pergamon Press.

Rapoport, A. (1982), *The Meaning of the Built Environment: A Nonverbal Communication Approach*, London: Sage.

Rapoport, A. (1998), 'A Framework for Studying Vernacular Design', *Journal of Architectural and Planning Research*, 16 (1): 52–64.

Rapoport, A. (2005a), *Culture, Architecture, and Design*, Chicago, IL: Locke Science Publishing Company.

Rapoport, A. (2005b), 'Systems of Activities and Systems of Settings', in S. Kent (ed.), *Domestic Architecture and the Use of Space: An Interdisciplinary Cross-Cultural Study*, 9–20, Cambridge: Cambridge University Press.

Ristvet, L. (2014), *Ritual, Performance, and Politics in the Ancient Near East*, Cambridge: Cambridge University Press.

Rybczynski, W. (2016), *Now I Sit Me Down, From Klismos to Plastic Chair: A Natural History*, New York: Farrar, Straus, and Giroux.

Sanders, D. (2005), 'Behavioral Conventions and Archaeology: Methods for the Analysis of Ancient Architecture', in S. Kent (ed.), *Domestic Architecture and the Use of Space: An Interdisciplinary Cross-Cultural Study*, 43–72, Cambridge: Cambridge University Press.

Schmandt-Besserat, D. (2001), 'Feasting in the Ancient Near East', in M. Dietler and B. Hayden (eds), *Feasts: Archaeological and Ethnographic Perspectives on Food, Politics, and Power*, 391–403. Washington, DC: Smithsonian Institution Press.

Schmarsow, A. (1994), 'The Essence of Architectural Creation', in H. Mallgrave and E. Ikonomou (eds), *Empathy, Form, and Space, Problems in German Aesthetics, 1873–93*, 281–97, Chicago, IL: University of Chicago Press.

Smith, P. (2009), 'Theatrical-Political Possibilities in Contemporary Procession', *Studies in Theatre and Performance*, 29 (1): 15–31.

Walsh, C. (2014), 'The High Life: Courtly Etiquette in the Late Bronze Age Eastern Mediterranean', in K. Acetta, R. Fellinger, P. L. Gonçalves, S. Musselwhite and W. P. van Pelt (eds), *Current Research in Egyptology 2013: Proceedings of the Fourteenth Annual Symposium*, 201–16, Oxford: Oxbow Books.

Walsh, C. (2016), 'The Transmission of Courtly Lifestyles in the Bronze Age Mediterranean', PhD diss., University College London, London.

Weber, J. (2008), 'Elite Equids: Redefining Equid Burials of the Mid-to-Late 3rd Millennium BC from Umm el-Marra, Syria', in E. Vila, L. Gourichon, A. M. Choyke and H. Buitenhuis (eds), *Archaeozoology of the Near East VIII*, Vol. 2, 499–520, Lyon: Maison de l'Orient et de la Méditerranée-Jean Pouilloux.

Winter, I. (1986), 'The King and the Cup: Iconography of the Royal Presentation Scene on Ur III Seals', in M. Kelly-Buccellati (ed.), *Insight through Images: Studies in Honor of Edith Porada*, 253–68, Malibu, CA: Undena.

Winter, I. (1991), 'Legitimation of Authority through Image and Legend: Seals Belonging to Officials in the Administrative Bureaucracy of the Ur III State', in M. Gibson and R. Biggs (eds), *The Organization of Power: Aspects of Bureaucracy in the Ancient Near East*, 59–100, Chicago, IL: Oriental Institute.

Zajdowski, K. (2013), 'Transformations of the Mesopotamian Banquet Scene into the Presentation Scene in the Early Dynastic, Akkadian, and Ur III Periods', *Akkadica*, 134: 1–16.

CHAPTER 3

ASPECTS OF NON-VERBAL COMMUNICATION AND RITUALITY IN PRE-ROMAN BANQUETS: THE GESTURES OF UNION (EIGHTH TO FIFTH CENTURIES BCE)

Audrey Gouy

The consumption of wine that we identify as the *symposium* – such as how Torelli defined it (literally 'drinking together', Torelli 1989) – constitutes one of the privileged themes in classical studies due to the numerous remains discovered and the importance accorded to the consumption of wine in Antiquity. The modalities of the Etruscan banquet do not seem to differ at first glance from the Greek banquet from which it was inspired. The Etruscan practice uses similar postures and material equipment such as Greek-formed vases, most of which were imported. From the eighth century BCE, the recourse by the Etruscan elite of utensils linked to the Greek consumption of wine illustrated the diffusion in pre-Roman Italy of typically Greek modes of conviviality (on Etruscan banqueting practices, cf., for example, Bartoloni, Acconcia and Ten Kortenaar 2014; Riva 2010; Tuck 1994). Earlier on, the banquet, one of the principal forms of expression of the elite in Etruria (such as in the Greek world), goes beyond the simple concept of a shared meal. Most significantly, it constitutes a ceremony charged with symbolic social and sacred values.

Moreover, the adoption of such habits by Etruscans could express a particular kind of luxury, ritual and ceremony that the native elite was seeking. Thus, the material equipment such as table sets, drinking vessels, craters, *amphorae* and tripods found in funerary furniture highlight the affiliation of the dead to an aristocratic social class, with constant allusions to the banquet, alongside the rite of preparation and the consumption of wine. In parallel to social, civic and political practices, the banquet responded also to ritual practices. Furthermore, it became the frame for the observance of a codified gestural communication between humans, and between humans and gods. This chapter examines some key aspects of gesture between humans in pre-Roman banqueting through a number of unusual but typical pre-Roman drinking vessels forms found in sites in Cerveteri and around Como alongside iconic manipulation found in Etruscan wall painting.

Etruscan banqueting

One of the first and oldest Etruscan representations of banqueting appears on the Montescudaio funerary urn, which dates from the second half of the eighth century BCE

(see Bonfante 1986: 99; Torelli 1989). On the lid, a male figure is sat down on a seat in front of a table covered with meals. To his right, there stands a female figure, who is characterized by her long dress, the allusion to breasts on the upper part of the chest and the long braid on her back (Bonfante 1975: 31–5). From the sixth century BCE, under the impulsion of oriental influences and the diffusion of a model of royal exaltation and glorification, the Etruscan forms of consumption of wine were modified. From then on, the participants no longer sat down, but lay down on beds.

Greek banquets tended to only include male participants. Women seem to have had instrumental roles and functions relating to entertaining male participants (Lissarrague 1987: 27), such as musicians, singers, servants and *hetairai*. However, Etruscan banqueting practices noticeably differ from the Greek and wider Mediterranean forms of banqueting. Indeed, in Etruria, the Greek ritual was adapted to native practices. The Etruscan banquet introduced specific new forms of vases as well as the regular participation of Etruscan women, which triggered violent reactions by some Greek and Latin writers (Liébert 2006: 73–94). These accounts make clear that it was common for women to lie down with their husbands on the same *klinai*, or on beds with other men. However, these violently critical, indirect accounts of Etruscan practices by classical writers should be treated with caution, due to their cultural bias. Instead, the numerous Etruscan iconographical remains provide clearer direct evidence of equal participation of men and women in Etruscan banquets. In particular, the female figures appear to be lying down with men in a similar and equal posture.

Thus, the various terracottas, painted tombs, urns and sarcophagi recall Greek and Oriental traditions but also crucially highlight their adaptation to local customs. The strong and powerful significance attributed to the banquet can be seen in funerary contexts and furniture where we find its most important evidences from the eighth century BCE. Moreover, the banquet seems to have become an integrated part of the funerary celebrations organized for the dead, in part influenced by the Greek *symposium*. In this light, this chapter aims to understand and focus on an aspect of wine rituality and gestuality in Etruscan ritual practices through two different archaeological materials: objects and iconography. It also focuses on Etruscan women in order to fully understand some of the native practices alongside their place and function in pre-Roman wine rituality.

Ceremonial handlings in wine rituality: The case of some multi-user vases

As mentioned above, the most important evidence for wine consumption in pre-Roman Italy appears in funerary contexts, and marks the high social status of the dead. Among the vases used for wine consumption, some were imported from the Mediterranean, whilst others were made in pre-Roman Italy and were inspired by foreign forms, or clearly indigenous and with no comparison with other Mediterranean productions. This chapter focuses on these local vase productions, and thus on the indigenous substratum we can glimpse in wine rituality. In these local productions, a particular type of vase

appears frequently in female tombs and seems to be closely associated with female roles and consumption in banqueting.

The particular vases examined are called *doppieri*, a distinct vessel type characterized by what appears to be a propensity to be used by a number of individuals at the same time. The vases are defined by their very unusual and specific form, which comprises a base that branches into a U-shape, with each terminal end supporting two open form cups (Figure. 3.1). The two cups are not fixed to the base; instead, they only rest upon it. Thus, the bottom of each cup has a little heel to adapt and maintain it on each arm of the foot, illustrating how the cups are specifically made with the base.

This kind of multi-user vase appeared around the ninth century BCE in northern Italy, from the Golasecca culture and especially around Como, and it was widely used until the fifth century BCE. It is also particularly notable by the fact that it is not included in all elite tombs. Indeed, these vases appear only in tombs of women, especially those of very high status (Lorre and Cicolani 2009). Despite their unusual form, these objects have not been studied extensively, therefore their precise use and function is still not currently clear. However, their link to the consumption of wine seems to be beyond doubt, as they are normally part of assemblages of other utensils linked to the consumption of liquids. Their rarity has led to them being considered linked to ritual functions (ibid. 2009).

At this stage, a number of questions are raised. What could be the precise function of this type of object and what is their internal use logic? Why are they exclusively deposited in female tombs? What can this kind of object tell us about women's role in wine rituality?

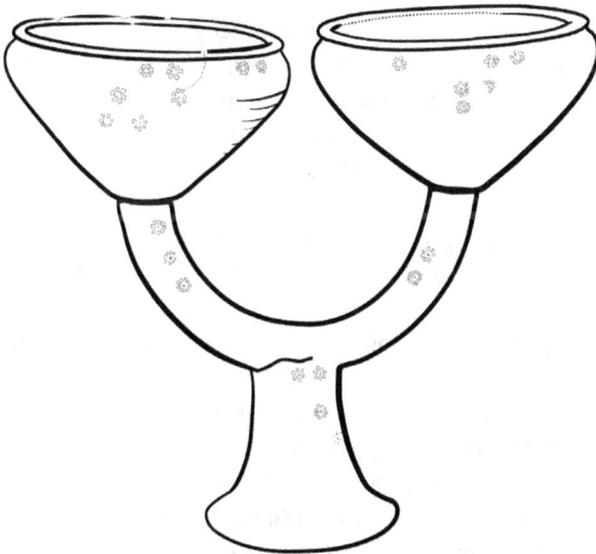

Figure 3.1 *Doppiere* from Ca' Morta, tomb 130. Terracotta. Museo Civico Archeologico 'Paolo Giovio', Como. Drawing by Amy J. Maitland Gardner after Lorre and Cicolani (2009: 38).

The use of motor praxeology in archaeology

The use of these utensils implies gestuality and a manipulation determined by the form of these objects and the context in which they are used. Thus, their form might permit us to interpret their use. However, the comprehension of the ritual in which such an object is inserted can slip from our grasp. To overcome the difficulties of understanding some utensils and objects, the application of different methodologies and the introduction of auxiliary sciences are needed. The handling of the different objects used within the framework of ritual consumption of wine in pre-Roman Italy has not been the subject of much work or research (see the latest work by Shipley 2015, and the bibliography outlined at the end). Therefore, the question of the gestures that these objects generate, the interactions they could create between individuals, and the place they had in social relations, alongside exchanges and rituals, needs to be examined much more extensively.

Motor praxeology appears as a potential tool for the analysis of archaeological artefacts. Theorized in the 1980s by Parlebas (see Parlebas 1981), this method of analysis is the scientific study of motor action. Furthermore, enriched by logic, sociometric, semiotic and linguistic methods, it aims to formalize movements. The objective is thus to analyse body tactics and technics, and to take in consideration the decision-making mechanisms, or 'semiotors', to report the nature of the motor interactions, alongside the system of success, and the communication networks involved. It is also possible to understand the social conditions of production of the motor action. Parlebas proposes a classification of body actions based on three criteria: (1) the presence of a partner, (2) the presence of an opponent and (3) the uncertainty linked to the environment.

Thus, two terms are put forward: 'psychomotricity', which means acting alone, and 'social motricity', which means acting with others. From studying sports in particular, Parlebas revealed the base semiotic units of the functioning of all participants playing sports, alongside all of their movements. These semiotic units are based on a semiotor code, considered as 'the system of signs and their combination produced and/or interpreted by active subjects' (Parlebas 1999: 62). Moreover, we can distinguish two types of semiotor codes: (a) gestems and (b) praxems. Gestems correspond to attitudes, gestures and expressions, which are accomplished with the aim to transmit a demand, an indication, a tactic or relational order as a simple substitution to speech (ibid.: 155). Therefore, they are purely conventional and are placed in forefront of the action but do not directly participate to the motor realization of the task.

Praxems, however, are inseparable from the action itself. A praxem is the 'motor conduct of a player interpreted as a sign of which the signifier is the observable behaviour and the signified constitutes the tactical project corresponding as it has been perceived' (see ibid.: 260). A praxem is the base semiotic unit.

In the frame of the analysis of the ancient use of objects, the contribution of motor praxeology permits researchers to restore what Parlebas defines as praxems, in so far as they constitute the action relating to the object itself. In an archaeological context,

gestems are not perceptible in the sense that they are in parallel to the base action and unique to each actor. Only the base semiotic units can be perceived. So praxems constitute the base of every planned action and from them it is possible to understand the frame and the environment in which the action is inserted. In addition, these praxems constitute a temporality of action. In this light, the dimensions of every object have to be taken in consideration in the interpretation and the restitution. Crucially, weight and form, for example, determine the action related to the object.

This method of analysis has not been used in archaeology before, and provides an experimental methodology to find out how the *doppieri* were used alongside the gestuality and rituality in which the objects were inserted. Therefore, the aim is to consider every activity first as a situation offering an interlacing of interdependent factors, and thus to highlight their internal logic and their roles' network.

Doppieri and the reconstruction of ritual gestures: Praxems and decision-making

The two cups of the *doppieri* are placed on the same foot, which is divided into two parts and are removable (Figure 3.1). The cups are positioned at the same height, in order that they are placed in a perfect equilibrium. From a decision-making point of view, the most plausible use is that only one person would be in charge of the handling of the two cups. The consequence of this disposition is that if we take one of the two cups first, it creates an imbalance and breaks the stability of the object. The result is that it falls, destabilized by the weight of the second cup. Regarding the motor action, we can propose that the person who was using the object had to raise the two cups at the same time and in perfect coordination. Thus, each cup, full of liquid, was maintained in each hand. This reconstruction and manipulation involves one person only. However, the participation of two individuals would be significantly more difficult, with a higher degree of dexterity and mutual coordination in terms of 'psychomotricity'.

Once the two cups are held, we can talk about 'social motricity'. In the common ritual of wine consumption, only one cup is normally held by each participant. The holding of two cups can be understood in the framework of a ritual sharing. Motor praxeology provides an understanding of the action and motor psychology behind this ritual. Therefore, we can easily imagine the manipulation of the object as reported in Table 3.1. The ritual begins with a period of short consideration, adaption, and bodily coordination of the action (Phase 1); then the execution of taking the two cups (Phase 2); followed by the giving of one cup to another person (Phase 3); and finally, two persons sharing together the same liquid and accomplishment of the ritual (Phase 4). In this context, we can also observe that if the two cups were replaced on the base during the drinking ritual, the amount of wine drunk by the two individuals had to be strictly the same, otherwise this risked the destabilization of the object. To sum up, the entire manipulation from the beginning to the end thus implies a perfect mutual coordination and sharing.

Table 3.1 Motor praxeology in object manipulation

MOMENT	PHASE 1	PHASE 2	PHASE 3	PHASE 4
ACTION	Valuation	Manipulation	Gift	Drinking
INTERPRETATION	Psychomotricity *– Determination and Adaptation of the Handling*	Psychomotricity *– Execution of the Handling*	Social Motricity *– Exchange of Cups, Sharing*	Social Motricity *– Performance of Sharing, Accomplishment of the Ritual*

Questions on social motricity: Vases for unions?

The manipulation of the *doppieri* understood through motor praxeology raises a number of important questions. How can we interpret the sharing of cups and beverages? The manipulation implies a single use of the object first and then the offering of a cup to a selected person. This offering implies the presence and participation of two individuals. The first phases of the manipulation imply a decision-making and are led by one person, which I identify as the initiator. The second individual to whom the second cup was handed would have the role of a receptor. I distinguish then two opposed but complementary roles: (a) an initiator and (b) a receptor.

In this light, we can address the interpretation and function of this ritualized exchange. Is it the formalizing of a pact, economic or political, between two individuals? Were *doppieri* handled and used during any particular rituals of alliance or union? The archaeological context must, on this point, provide some clarity. I have previously highlighted the systematic and exclusive presence of these *doppieri* in some female tombs, especially those of the wealthiest. Thus, the vessels seem to be contextually associated with a particular female section of the population. In Greece, there are comparable examples of vases which belong to the female *kosmos,* such as the *lebes gamikos,* vase linked to toilette and offered to the new spouses at the moment of their wedding. Considering the *doppieri,* is it possible to imagine a function in the framework of matrimonial union? This interpretation is interesting but raises the issue of the exact role of female individuals. Were they initiators or receptors? Were some high-status women holders of a particular ritual power? Furthermore, the object itself does not reveal the kind of union or alliance that would be taking place, if it would be matrimonial, political, territorial or religious in nature. What we can only highlight ostensibly is that it may have created a situation of choosing a partner and constructing a type of special social link between two persons.

The *doppieri* are not entirely unique in Etruscan banqueting equipment as being a vessel that could involve more than one person. In the South of Etruria, three cups in funerary contexts have been discovered, all dated from the end of the seventh century BCE; one in Satricum and two in Cerveteri, such as in the Monte dell'Oro tumulus (see Gaultier and Haumesser 2013: 133). Their form is particularly relevant, and their use can be understood in parallel to the *doppieri.* These vessels are all divided across their centre

by a partition placed between the handles and thus creating two different parts inside each cup (Figure 3.2). The two divided parts are each accompanied by a system of three tubes. One tube is oriented to the interior of the cup. It is attached to the lip and gets in to the bottom of the cup. The two other tubes are oriented to the exterior. They are linked to the lip and tend to join each other. These devices seem to be forms of straw creating together a system for sucking and drinking. The two tubes on the lip that are oriented to the exterior were certainly put in a user's mouth while the third tube was used to suck the liquid from the deep bottom of the cup.

In contrast to the *doppieri*, which are characterized by two cups on one foot, these three objects from Southern Etruria are single vessels divided in two parts. From a decision-making perspective and in regard to motor praxeology, the most plausible use is that one person takes the cup and presents it to another person in order to drink together facing each other, or the two persons raise the cup together before drinking face to face. Thus, the manipulation implies one or two persons; whereas the drinking implies two persons taking part and facing each other. Importantly, if the cup would have been shared between several persons, all of them drinking one after another, the division into two cups would not have been necessary at all, unless different beverages were being drunk at the same time. Thus, the structure of the cup implies a mutual and contemporary phase of drinking, which raises again interesting questions regarding social motricity. Were these cups used for particular unions or alliances? We must highlight the inscription *mini kaisie thannursiannas mulvannice* present on the lip of one of these vessels, which has been interpreted as an indication of a gift (Gaultier and Haumesser 2013: 133; see also Bonamici 1974: 19–20; Cristofani and Rizzo 1985: 151–2). Undeniably, this further

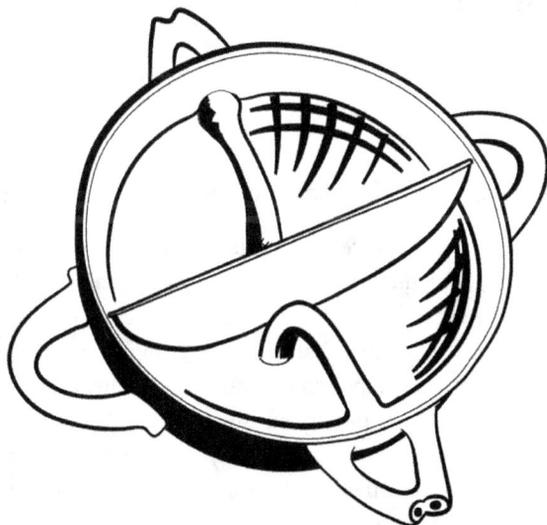

Figure 3.2 Cup from Cerveteri, Bucchero. End of seventh century BCE. Musées royaux d'Art et d'Histoire, Bruxelles. Drawing by Amy J. Maitland Gardner after Gaultier and Haumesser (2013: 133).

suggests an active social dimension to the vessel. As a gift, it was exchanged between individuals, perhaps at similar ceremonial union events that have been suggested for the *doppieri*.

Visual rituality: Non-verbal communication and gestures in representations of wine consumption

Ancient gestuality in visual arts has been the subject of several important publications over many years and several key works are particularly relevant for the current analysis of Etruscan banqueting. The first important study is by Durand (1984), on the question of ancient gestures and above all their representations in iconography. Durand considers images as productions, which fix gestures in one-shot moments from which they can be best recognized. These gestures tend to be 'iconic' because they are extracted from the entire gestuality of a precise action and become signs of culturally embedded information (ibid.: 30–1). More recently, Jannot has highlighted that the Etruscan banquets in funerary context are marked by guests who are, surprisingly, not eating or drinking, even if food and drink are present (Jannot 2006). The few *phiales* (shallow bowls) represented are held as if the holder, such as a priest dedicated to perform sacrifices, was executing a libation. Davies has also examined representations of some banqueting couples (Davies 2006), which is particularly interesting to discuss through the lens of wine rituality and the role of women, but the interpretation of gestures could be investigated further.

In order to newly explore gestuality in Etruscan banqueting, and to complement the archaeological analysis above, I would like to examine the iconographical sources to further our understanding of some crucial aspects of wine rituality and the role of women in wine consumption. I focus this analysis on the Monterozzi necropolis in Tarquinia (Italy), as it has a rich record of banquet representations on tomb walls, which depict figures executing various gestures.

A ritual of couples? Gestures of exchange in wine consumption

The Etruscan iconography of banquets correlates in many ways to the Greek accounts and from the archaeological contexts of Etruscan banqueting equipment, with a seemingly equal participation of men and women. Within these scenes, one type is particularly important in discussing gesture and social motricity. It depicts a man and woman facing each other, with both executing responding gestures. The scheme differs from the usual representations of a banquet: it is usually an isolated and alternative pattern. The only guests present are two figures forming a couple lying on a bed. The scenes of banquet usually comprised three beds on which two persons were lying down. Particular examples of this unique couple used as a central decorative element can be found in Tomba del Vecchio, Tomba dei Vasi Dipinti, Tomba della Caccia e Pesca and Tomba 4780.

The Tomba dei Vasi Dipinti is a key illustrative example that dates from the end of sixth century BCE. The representation of the banquet is located on the back wall of the

Figure 3.3 Tomba dei Vasi Dipinti, Monterozzi Necropolis. Back wall. 510–500 BCE. *In situ.* Drawing by Carl Walsh.

tomb and features two adult figures reclining on a *kline* (Figure 3.3). Two young persons are sat down on a chair towards the left. A young boy, on the right, is oriented toward the adult couple and is holding tools for the consumption of wine. The male figure represented on the bed raises a wine cup in front of a female figure dressed in aristocratic clothes (see Bonfante 1975; Lubtchansky 2006). The two figures are executing various gestures. The man is holding a cup of wine with his left hand and touching the chin of the woman placed in front of him. This female figure is raising her right hand in front of her and holding a garland in her left hand.

The visual psychology – or episemiotic – allows us to question the gestures represented alongside their visuality and to distinguish a visual progress on the couple. The gestures represented here are considered as fundamental visual elements in the representation. As Catoni remarkably presented it, the *schemata* – that we also can compare to gestems according to Parlebas' definition – had an outstanding role in non-verbal communication in social life and in pictures (Catoni 2005). They were fundamentally expressive and constituted in this sense a form of visual and bodily language (ibid.; Hölscher 2015). In the visual system constituted by pictures, the gestures – or *schemata* – are organized in terms of visuality and hierarchy.

Consequently, on the back wall in the Tomba dei Vasi Dipinti, the eyes execute first a general analysis of the scene and identify it as a banquet (Figure 3.3). It turns around the scene, on the couple, at the centre of the picture, thus creating a circular movement. The visual position of all the arms and hands guides the eye across the image. Moreover, the eyes are first attracted by the most visible details. The first one appears to be the cup held by the man. This cup is clearly placed in the centre, emphasized by its important dimension and bright colour. This contrasts with the scheme of ochre colours that

resembles the rest of the picture. The eyes are then guided around the cup; they continue on the male body and arrive on his right hand, which is touching the chin of the woman facing the man. The eyes drift then to the female figure.

They arrive on the face and fall down her body. The eyes are guided to the hands of the figure. The first gesture is characterized by the right hand, of which the fingers seem to form a circle. The second gesture is the left hand holding a garland. The positioning of the two arms on the female body does not appear to be anatomically possible. The gestures are depicted as being pulled down on the abdomen, not on the same horizontal line, which is a visual device for comprehending in two dimensions a movement that is normally executed in three dimensions. This device permits the placement of a gesture in a higher position and another gesture in a lower position. The composition and artistic convention of rendering the figures gestures serve to guide the overall gaze direction of the viewer, to create a visual temporality and most significantly to generate meaning in the whole picture.

Finally, the gestures executed by the couple seem to have a specific visual choreography: (1) the man holding a cup with his left hand, (2) the man touching the woman's chin with his right hand, (3) the woman closing her right hand – the fingers tend to form a circle and lastly (4) the woman holding a garland in her left hand.

From seduction to union: Discursive dimension of visual gestures

The tomb scenes discussed above are visual constructions and are subject to their own conventions (Durand 1984). In this context, the gestures depicted are iconic, and in a visual and discursive framework, they are particularly meaningful. From these considerations, the meaning of the gestures executed by the two persons lying on a bed in the Tomba dei Vasi Dipinti can be drawn; with the wine rituality arguably offering a propitiatory and significant act alongside the women's role.

Baggio has recently studied seduction gestures in Greek iconography and has proposed and confirmed some interpretations regarding particular examples (Baggio 2004). Among these, Baggio has highlighted that the gesture executed by the man – which consists in touching the woman's chin – would be a gesture of seduction, and particularly would suppose a demand (ibid.: 95–9; Neumann 1965: 68; Tanabe 2010). In this context, a key question emerges; namely how can we interpret the cup placed in the centre of the couple?

In the relations between men and women in Tarquinian iconography from the sixth and fifth centuries BCE, the wine cup seems to have a particular function. In parallel to the isolated couple lying on a bed, a similar pattern features the same figures, a man accompanied by a woman wearing aristocratic clothes. However, these figures are standing and usually engaged in a dance linked to the consumption of wine that resembles the Greek *komos*. In the Tomba Cardarelli, for example, a man and a woman are depicted on the left wall surrounded by young individuals and moving towards each other (see Lubtchansky 2005: 182, fig. 94). On the right wall, there is another kind of dance linked to the consumption of wine, comprising only male figures, which are also

surrounded by young individuals and arranged in two groups. On both walls, a man is raising a cup, and another person is dancing in front of him, creating a mirroring response or a visual game between the two walls.

The man on the right wall is holding his cup in a manner which correlates with the *kottabos* game and which consists of throwing the last drop of wine on a person to make this person known as his desire and sexual interest (Lissarrague 1987: 81–2). Evidently, this game offered a clear seductive and erotic dimension. The meeting between the man and the woman on the left wall has to be understood in parallel with the erotic game of *kottabos* held on the right wall. The raised cup on the left wall might indeed have a similar function of seduction. D'Agostino evokes a family dance – a family *komos* – in which the wife and the husband are dancing together and reunited with their children (see D'Agostino and Cerchiai 1999: 29, 36). The cup, around which the family is displayed, arguably appears to be the decisive element which has contributed to the creation, unification and continuation of the family. In the Tomba dei Vasi Dipinti, the cup appears to create a first contact, to attract attention, and to show the desire and the interest of the man. The second gesture, touching the woman's chin, goes further. In this gesture, the physical contact appears to be oriented as a demand.

In this light, the woman's attitude can be seen as her reply to the man sharing her *kline*. While her gestures have not been the subject of thorough academic study, some interpretations can be proposed. The first gesture consists of folding down the fingers in order to create a circle. In Greek iconography, the finger circle gesture is quite common in Attic black-figure vases, dated from the sixth century BCE, and in pictures composed of Ariadne and Dionysos. Dionysos usually raises a cup of wine while Ariadne/Semele raises her hand and executes the gesture to close the fingers in a circle as a sign of acceptance and union (see Villanueva-Puig 2009: 41–50). Therefore, I propose to identify these representations as possible scenes of marriage. The second gesture executed by the female figure resembles holding a crown or a garland. These specific objects are very often used to materialize a union with someone, or with a deity in the context of alcohol consumption (Otto 1960: 164). Furthermore, it also can symbolize a passage and change of state (Lissarrague 1987: 82).

In summary, it is conceivable to propose the following sequences, as reported in Table 3.2: (1) act of seduction, opening the exchange and dialogue, the man tries to attract the woman's attention, (2) the act of seduction is pushed further, act of demand, (3) woman's reply, acceptation of the union and (4) officialization and realization of the union.

Visual gestures in funerary context: Ritual and propitiatory acts?

These visual sources, like most of the sources found in Etruria, are linked to a funerary context, and thus inevitably to eschatological beliefs. The main images examined in this chapter depict a man turning toward a woman as he tries to reach, affect, seduce and unify himself with her. According to Torelli, in Latium in particular, the female statuettes

deposited close to the dead in some tombs during the Geometric Period would symbolize the divine wife, who the dead according to very ancient eschatological beliefs, was supposed to join in the afterlife (Torelli 1997: 25–7). Therefore, this female presence in the tomb would symbolize then his marriage in the afterlife, mark his definitive aggregation to the world of the dead, and thus his change of state and social status.

Is it possible to think that these eschatological beliefs were so important that they could continue until the sixth and fifth centuries BCE? What we can underline is the importance that some female figures seem to have in the frame of other specific rituals in the seventh and sixth centuries BCE. These individuals could indeed appear as tutelary figures, like in Rome where we know a religious episode in which the king Tarquinius Superbus would parade through the city on his chariot with a female figure by his side who was crowning him, performing again, in a way, the apotheosis of Heracles (Briquel 1998). Can we thus propose to see that some female individuals played a fundamental role in the accession to power of some Etruscan chiefs?

In other cases, some high-status Etruscan women seem to have been considered as resembling hypostasis of deities, as we can suggest about Larthia, 'princess' of the Regolini-Galassi tomb in Cerveteri dated to the seventh century BCE. The main deceased seems indeed to raise many issues. She is presented as a very wealthy woman, surrounded by atypical vases for wine and defensive weapons. Her room was rectangular and evoked a consecrated space. Its door had a triangular window which is seen by Colonna and Di Paolo as an essential element that indicated a *thalamos*, a sacred and consecrated space for female deities already in Greece and Italy from the ninth to seventh centuries BCE (Colonna and Di Paolo 1997). I find it a convincing suggestion to see in this structure a sign of the fundamental and religious role of some women in pre-Roman ritual practices.

Conclusion: A female wine ritual?

From this short study, we can suggest that the 'banqueting' couple which regularly appears in Tarquinian tombs in sixth and fifth centuries BCE could be linked to and understood through real models, and political and religious rites in which Etruscan women could have had a leading ritual function of passage. Most significantly, the Tarquinian iconic couple responds also to eschatological beliefs and funerary customs: the aggregation of the dead to the afterlife symbolized by the couple's union. At the same

Table 3.2 Sequence of consideration in object manipulation

MOMENT (*Schemata*)	*SCHEMA* 1	*SCHEMA* 2	*SCHEMA* 3	*SCHEMA* 4
ACTION	Man raising a cup	Man touching woman's chin	Woman stretching a circle with her hand	Woman holding a garland
INTERPRETATION	Act of seduction	Act of demand	Reply and acceptance	Officialization and realization

time, we can finally underline that the permanence of indigenous rituals in spite of the adoption of foreign practices and their adaptation to a model of Greek consumption clearly demonstrates Etruscan originality.

This chapter also demonstrated how indigenous rituals were adapted and modified with foreign Greek practices to create new forms of Etruscan ceremonial and ritual practices regarding banquets and wine drinking. In this way, we are able to move away from the Greek accounts of Etruscan women as figures of ill-repute and 'huge drinkers' – the visual sources never depict women holding a cup of wine. Instead, we can gain a better understanding of the role of women in Etruscan ritual and society from available Etruscan sources. We know how much the Greek sources were biased. In conclusion, it is plausible that the poor presentation of the Etruscan women by the Greeks was an attempt to criticize and distort the leading ritual functions of Etruscan women in wine consumption and in rituals in general.

References

Baggio, M. (2004), *I gesti della seduzione*, Rome: L'Erma di Bretschneider.

Bartoloni, G., V. Acconcia and S. Ten Kortenaar (2014), 'Le Service du vin en Etrurie méridionale à l'époque orientalisante', in L. Ambrosini and V. Jolivet (eds), *Les Potiers d'Etrurie et leur monde*, 51–8, Paris: Armand Colin.

Birdwhistell, R. (1952), *Introduction to Kinesics*, Louisville, KY: University of Kentucky Press.

Bonamici, M. (1974), *I buccheri con figurazioni graffite*, Florence: L. S. Olschki.

Bonfante, L. (1975), *Etruscan Dress*, London: Johns Hopkins University Press.

Bonfante, L. (1986), *Etruscan Life and Afterlife: A Handbook of Etruscan Studies*, Warminster: Aris and Phillips.

Briquel, D. (1998), 'Les Figures féminines dans la tradition sur les rois étrusques de Rome', *Comptes rendus des séances de l'Académie des Inscriptions et Belles-Lettres*, 142 (2): 397–414.

Catoni, M. L. (2005), *Schemata: comunicazione non verbale nella Grecia antica*, Pisa: Ed. Della Normale.

Colonna, G. and E. Di Paolo (1997), 'Il letto vuoto, la distribuzione del corredo e la "finestra" della Tomba Regolini-Galassi', in G. Nardi (ed.), *Etrusca et Italica. Scritti in ricordo di Massimo Pallottino*, 131–72, Pisa: Istituti editoriali e poligrafici internazionali.

Cristofani, M. and M. A. Rizzo (1985), 'Iscrizioni vascolari dal tumulo III di Cerveteri', *Studi Etruschi*, 53: 151–9.

D'Agostino, B. and L. Cerchiai (1999), *Il Mare, la morte, l'amore. Gli Etruschi, i Greci e l'immagine*, Rome: Donzelli.

Davies, G. (2006), 'Etruscan Body Language', in E. Herring, I. Lemnos, F. Lo Schiavo, L. Vagnetti, R. Whitehouse and J. Wilkins (eds), *Across Frontiers – Etruscans, Greeks, Phoenicians and Cypriots: Studies in Honour of David Ridgway and Francesca Romana Serra Ridgway*, 401–12, London: Accordia Research Institute, University of London.

Dentzer, J. (1982), *Le Motif du banquet couché dans le Proche-Orient et le monde grec du VIIe au IVe siècle avant J.-C.*, Rome: Ecole française de Rome/Paris: de Boccard.

Durand, J. (1984), 'Le faire et le dire: Vers une anthropologie des gestes iconiques', *History and Anthropology*, 1: 29–48.

Gaultier, F. and L. Haumesser (2013), *Les Étrusques et la Méditerranée: La Cité de Cerveteri*, Paris: Somogy.

Hölscher, T. (2015), *La Vie des images grecques: Sociétés de statues, rôles des artistes et notions esthétiques dans l'art grec ancien*, Paris: Hazan.

Jannot, J.-R. (2006), 'Gestes de banqueteurs', in L. Bodiou, D. Frère and V. Mehl (eds), *L'Expression des corps, gestes, attitudes, regards dans l'iconographie antique*, 213–31, Rennes: Presses Universitaires de Rennes.

Liébert, Y. (2006), *Regards sur la truphè étrusque*, Limoges: Presses Universitaires de Limoges.

Lissarrague, F. (1987), *Un Flot d'images: Une Esthétique du banquet grec*, Paris: A. Biro.

Lorre, C. and V. Cicolani (2009), *Golasecca: Du Commerce et des homes à l'âge du fer (VIIIe–Ve siècles av. J.-C.)*, Paris: Réunion des Musées Nationaux.

Lubtchansky, N. (2005), *Le Cavalier tyrrhénien: Représentations équestres dans l'Italie archaïque*, Rome: École française de Rome.

Lubtchansky, N. (2006), 'Divines ou mortelles? Les Femmes de la Tombe du Baron à Tarquinia', in F. Massa-Pairault (ed.), *L'Image antique et son interprétation*, 219–36, Rome: Bibliothèque des Écoles Françaises d'Athènes et de Rome.

Neumann, G. (1965), *Gesten und Gebärden in der griechischen Kunst*, Berlin: W. de Gruyter.

Otto, W. (1960), *Dionysos, le mythe et le culte*, Francfort: Vittorio Klostermann.

Parlebas, P. (1981), *Contribution à un lexique commenté en science de l'action motrice*, Paris: I.N.S.E.P.

Parlebas, P. (1999), 'Les Tactiques du corps', in M. Julien and J. Warnier (eds), *Approches de la culture matérielle: Corps à corps avec l'objet*, 29–43, Paris: L'Harmattan.

Riva, C. (2010), 'Nuove tecnologie del sé: il banchetto ritual collettivo in Etruria', *Saguntum Extra: Papeles del Laboratorio de Arqueologia de Valencia*, 9: 69–80.

Shipley, L. (2015), *Experiencing Etruscan Pots: Ceramics, Bodies and Images in Etruria*, Oxford: Archeopress.

Tanabe, T. (2010), 'Diffusion of the Greek Gesture of Touching Another's Chin with Raised Hand in the East', *Parthica. Incontri di culture nel mondo antico*, 12: 81–94.

Torelli, M. (1989), 'Banchetto e simposio nell'Italia arcaica: qualche nota', in O. Longo and P. Scarpi (eds), *Homo Edens: regimi, miti e pratiche dell'alimentazione nella civiltà del mediterraneo*, 301–10, Verona: Diapress-documenti.

Torelli, M. (1997), *Il rango, il rito e l'immagine. Alle origini della rappresentazione storica romana*, Milan: Electa.

Tuck, A. (1994), 'The Etruscan Seated Banquet: Villanovan Ritual and Etruscan Iconography', *American Journal of Archaeology*, 98 (4): 617–28.

Villanueva-Puig, M.-C. (2009), *Ménades: recherches sur la genèse iconographique du thiase feminine de Dionysos des origins à la fin de la période archaïque*, Paris: Les Belles Lettres.

CHAPTER 4

GESTURES AND SOCIAL RELATIONS: THE LATE NEOLITHIC FIGURINES OF THE MALTESE ISLANDS

Isabelle Vella Gregory

Located about eighty kilometres south of Sicily, the Maltese Islands have a complex Neolithic divided into eight phases (Table 4.1). The Late Neolithic (Figure 4.1) landscape of the archipelago is distinctive for its dense concentration of megalithic sites (conventionally termed 'temples' when overground and 'hypogea' when underground and functioning as aggregation sites), which, among other things, raise questions about social complexity. These complexes have dominated discourse since their discovery in the seventeenth century. They were created, modified and enlarged over a millennium, a process which required a continuous engagement with the community and the materialization of its ideals. The process included the materialization of gesture, in this context defined as an intrinsic part of performance and examined via figurative representation. The approach to gesture is contextual and rooted in secondary agency, which was a key element of Late Neolithic performances.

The Late Neolithic aggregation sites were arenas for multiple acts of performance, some tied only to the building itself and, in the case of funerary ritual, they involved moving from one persistent place to another (i.e. 'temple', mortuary site, and another 'temple', see Vella Gregory 2013). Within these sites, a variety of material has been found, including stone tools, burnt animal bones, figurines and a large number of ceramics. The latter were not produced on site, although the locations of pottery production sites remain elusive (Vella Gregory 2017a). The figurine corpus has previously been viewed through the lenses of art (Bonanno 1993; Malone 2008) and worship (Malone et al. 1993; Malone 1998). A focus on practice and a shift in research focus more broadly (Stoddart and Malone 2008; Skeates 2010; Vella Gregory 2016, 2017b) reveals that domains of action are often entangled, even if specific domains have their own rules. In this context, figurines can be situated within a discussion of secondary agency exercised relative to and by things (Gell 1998). Gell's (ibid.) view that every artefact is a performance provides a useful starting point, although it is noted that figurines are not just about visual consumption. This discussion takes Mauss ([1935] 1973) as a starting point in that action is seen within the context of socially normative patterns of behaviour. Gesture is seen in terms of how actions were understood by intended audiences.

Mauss (ibid.) recognized the materiality of gesture – his *techniques du corps* are part of a system of social relations. As such, these form part of the material culture that, in turn, is part of the structures in which gestures operated. This discussion focuses on

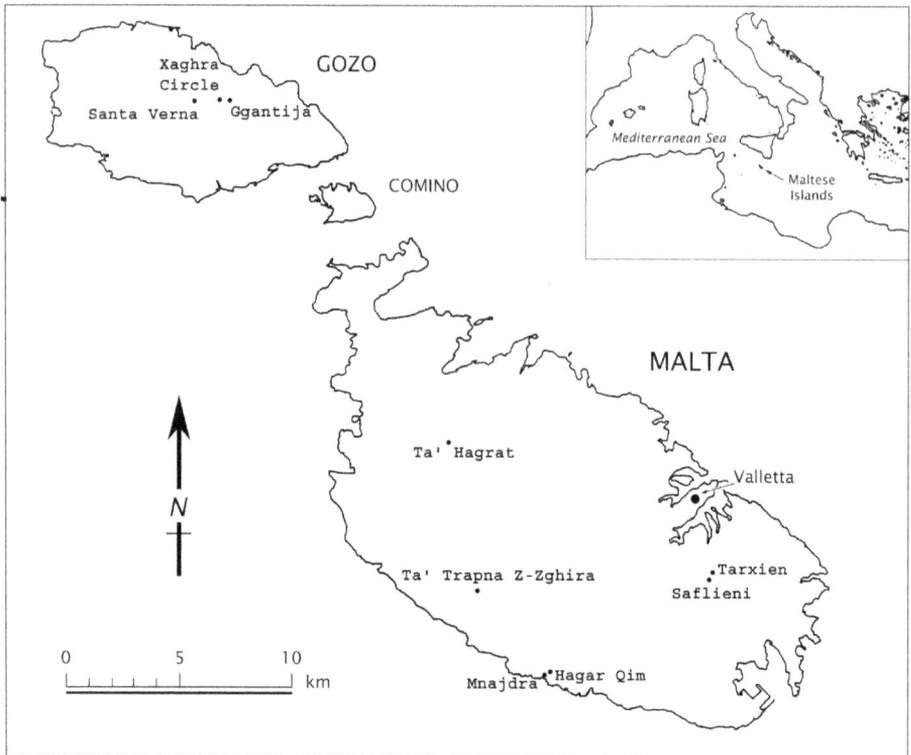

Figure 4.1 Map of the Maltese Islands showing the sites mentioned in the text. Map drawn by Isabelle Vella Gregory.

gestures as seen on the created body (figurines). Gell (1998: 16) attributes agency to 'those persons (and things) who/which are seen as initiating causal sequences . . . by acts of mind, will or intention'. Crucially, he notes that the immediate other in social relationships does not have to be another human being; agency can be exercised relative to and by 'things'. Further, as Gell notes, persons form social relations with 'things', but 'things' on their own cannot, by definition, have intentions, even if they are essential to the exercise of agency. Thus, while objects are not self-sufficient agents, they are a channel of agency. He terms this kind of agency secondary agency, noting that this assignation in no way concedes that objects are not agents at all. This is particularly relevant to figurines deposited in aggregation sites, where people congregated to perform a number of acts, many of which involved the use of figurines. As Gell notes, these artefacts are not just used, but they are connected to social others.

While Gell (ibid.: 121–3) discusses the worship of images or indexes of the divine presence, this discussion moves away from seeing Late Neolithic figurines as 'deities'. Although they have been often championed as fertility goddesses (Bonanno 1993), these objects are viewed as secondary agents used by people to bridge the gap between what they know and what they seek to understand. These figurines are seen as part of the

Table 4.1 Chronology and key events in the Maltese Neolithic

	Phase	Dates, BCE	Main events	Social relations
Early Neolithic	Ghar Dalam	5000–4500	Initial settlement from Sicily, farming communities.	Small-scale social relations, localized ritual.
	Grey Skorba	4500–4400	Village life.	
	Red Skorba	4400–4100	Continuation of village life, communal shrines, clay figurines.	
Middle Neolithic	Żebbuġ	4100–3800	Considered start of Temple Period. No temples. Beginning of collective burials.	Start of extension of life cycle and creation of new narrative.
	Mġarr	3800–3600	Poorly known phase, mostly known through ceramics.	
Late Neolithic	Ġgantija	3600–3000	Beginning of 'temple' building.	Extension of life cycle becomes increasingly elaborate. Redefinition of time and space. Focus on community and memory.
	Saflieni	3300–3000	Transitional phase, overlapping.	
	Tarxien	3000–2500	Apex and eventual decline of temples. Restriction of areas within temples.	

wider concerns of a society and firmly embedded in the network of social relations. Bearing in mind that these figurines had a long biography, one in which they were touched, handled, moved around and sometimes eventually deposited in a special area, these were not passive actors. At times, they did not require the constant presence of a human agent to exercise the secondary agency and this is particularly seen in figurines related to childbirth (discussed below).

Gesture and acts in megalithic spaces

The study of Neolithic societies has raised a number of key questions regarding social organization and the nature of hierarchies and power, especially when confronted with megalithic remains. Scholars have particularly questioned whether some Neolithic societies had centralized power structures along the lines of 'chiefdoms' (Renfrew 1973).

Tracing Gestures

Recent scholarship has allowed for more flexible and fluid forms of social organization and focused on a broader range of materiality (for example, Stark, Bowser and Horne 2008; Neitzel and Earle 2014). The view that power and social relations are multi-faceted actions is particularly apposite for the Maltese Neolithic, particularly since actions comprise many elements, including gestures, and can have a material dimension and/or be materialized in various forms. Therefore, while there has been extensive focus on megalithic buildings, essentially large spaces related to community aggregation and performances, there has been very little discussion on the representation of the gestures and acts that occurred within these spaces, or indeed experience in daily practice. Indeed, any reference to gesture has tended towards the simplistic, for example catalogue entries mentioning the position of limbs in figurines. More recently, figurines have been viewed in relation to trance experiences, based on their final depositional context (Malone and Stoddart 2017). However, the materialization of acts is a key element of Neolithic social relations, and this chapter considers aspects of these relations through the lens of gesture.

By 3600 BCE, communal acts were considerably elaborated with the addition of new arenas for performance above ground and involving even grander gestures. This slow process was carefully maintained over 1,100 years. The finer details of this process are hard to trace, particularly since Maltese archaeology lacks a refined chronology within each phase. Not all 'temples' continued to be elaborated over time, for example the main temple at Ta' Ħaġrat dates to the Ġgantija phase while the second, smaller building may be slightly later (Pace 2004a). Yet, Ta' Ħaġrat never reached the size of Ġgantija temples in terms of area and architectural complexity. Other temples, such as Ħaġar Qim and Mnajdra, were slowly expanded over time. The act of building and maintaining these structures kept the community engaged with this process, particularly with the notion that these buildings belonged to a collective past, and were being maintained in the present and for the future. In itself, this was a performative act that included other acts discussed below. Moreover, this encompassed gesture on a societal level, with these gestures being socially embedded actions that had to occur in specially constructed places, contributing towards place-making.

These gestures required space, in various dimensions, to be effective at modulating different performances. While megaliths may make temples appear visually similar, there is no canonical temple layout. There are, however, some important points of commonality, such as larger open spaces that could accommodate a sizeable number of people and smaller apses for small-scale gatherings. Doorways and thresholds are important in all temples and demarcate specific zones. Grima (2001) has identified three repeated demarcation devices. First, the elevation of thresholds marks the transition from the central court to surrounding apses. Second, screening is a commonly employed device in the Tarxien phase and boundaries are much more elaborate, demarcated by screens or partitions. Third, the latter are often associated with sculptural elements and elaborate surface treatment, such as patterns of drilled holes or carved spirals. Similarly, burial sites also have demarcated spaces. The two main burial sites are the Saflieni hypogeum in Malta and the Xagħra Circle in Gozo. The former is a vast complex dug

into the rock comprising over forty rooms over three storeys across an area of 500 metres squared. The lowest level is now at a depth of about 11 metres below the road surface and the upper level may originally have consisted of natural caverns that were altered (Pace 2004c). A similar modification of natural caverns is seen at the Xagħra Circle (Pace 2004b). While lacking the depth of Saflieni, megalithic elements (altars and blocking arrangements) were added to the site. Both sites have strong relationships with above-ground megalithic structures (Saflieni-Tarxien, Xagħra Circle-Santa Verna-Ġgantija).

These multiple spatial relationships that constituted the Late Neolithic world cannot be seen as entirely separate from how the body was represented and manipulated. The relationships concerning megalithic structures and notions of community pervaded the daily experience. Lefebvre (1991) notes that through work, people transform both nature and their own nature. The notion of 'work' is read more broadly here to take into account a range of actions at Neolithic sites. These include acts related to performance, such as the killing and burning of animal bones around 'altars', acts involving figurines, the making of tools (objects at hand) and the discard of associated debris, the use of vessels for drinking and other acts, and the creation of specific pathways between sites. Seen in the Maltese Neolithic context, Lefebvre's (ibid.) dialectic between social practices, bodies and nature (read here as the wider landscape) is particularly useful for a reading of space and figurative representation. On a broad level, living bodies in megalithic sites generated space in multiple ways, depending on their social role. By the Tarxien phase, this generation of space was transformed with the addition of physically restricted zones.

Below ground, the dead body continued to generate space, specifically the space related to the construction of memory. Beyond temples, spatial practice (the space created via everyday practices) is seen in daily activities related to food acquisition, the production of ceramics and stone tools, the maintenance of households, etc. These activities occurred in a landscape that had a cosmological dimension. As Grima (2005) notes, monumental buildings were sited in proximity to plains and near thresholds between land and sea. They were not sited in marginal areas but in locations which are tied to daily life, making them part of daily practice. These acts are also gestural in nature, including the act of traversing the landscape as part of every day actions and during performances within the sites.

Gesture and Late Neolithic figurines

In the Late Neolithic, figurines are found exclusively in aggregation sites, both above and below ground. These bodies cannot always be disentangled from the human body. In mortuary ritual, the human body was systematically broken down and fragmented, removing traces of the individual living body. This practice fits within the broader social structures focused around the ideas of community and collectivity, and thus mortuary sites were focal points for the living, who participated in the fragmentation of the body. The reconfiguration of the body is a gestural act in itself. The figurative repertoire has a similar emphasis on a lack of specific individuality, but in much more complex ways.

Figurines range in size from 1.2 centimetres to approximately 3 metres and are made out of clay, stone and, less frequently, bone. Some figurines clearly reference secondary sexual characteristics; others are very deliberately ambiguous. The body is represented in a range of styles, from naturalism to complete abstraction. Bodily proportions range from biologically realistic to extremely large, with a focus on mounds of flesh. Bodies are sometimes partially clothed. Figurines can be seated, standing or lying down. Arms and legs (where present) are placed in various positions. Some figurines could be moved, while others were meant to be viewed in a static manner (Vella Gregory 2005). The majority of figurines have elements of ambiguity, even when secondary sexual characteristics are present. For this reason, this discussion eschews the traditional distinction between 'sexed' and 'unsexed' bodies and instead focuses on acts. There is a range of gestures set within a complex visual landscape, which is also comprised of broader gestures, seen at a communal level.

Broadly speaking, the figurine corpus includes explicitly female figurines, phalli, and bodies showing varying degrees of ambiguity. Female figurines are nude or mostly nude and include women who have given birth. These are represented via varying degrees of naturalism. Phalli are the only direct representation of biological males. They are made out of clay, stone and bone. Deliberately sexless large bodies comprise of two types: Type A and Type B. Type A are extremely large, with exaggerated proportions, and a focus on mounds of flesh and Type B are of a more reduced stylized type, still showing large bodies, but ones which are more visually defined. The former are found in aggregation sites above and below ground and the latter are, thus far, only known from the Xagħra Circle mortuary site. Beyond this, there are multiple combinations of body size and degrees of ambiguity.

Birth

Three representations are explicitly related to acts of motherhood and birth. One from the Saflieni hypogeum shows a female's upper body (ht. 1.6 cm; Figure 4.2a), with drooping breasts and a swollen belly indicative of pregnancy. The other two figurines are from temple contexts. The first of these two figurines from temple contexts is a figurine of poorly fired clay from Tarxien (ht. 5.9 cm; Figure 4.2b), which depicts a woman with pendulous breasts, a swollen belly and vulva, and a stretched belly button. Pieces of shell were inserted before firing in key areas, including on each side of the groin, above the vulva, and between the breasts, directing focus on pregnancy/birth. This is further emphasized with one arm pointing to the vulva and another to the head, a faceless pinch of clay with a shell inserted in the 'face'. The figurine's gestures and shell inserts direct the viewer's focus to acts of pregnancy and medicine, and the lack of face shifts the primary focus on these acts, rather than an individual woman.

The second is a conceptually similar figurine (ht. 5.2 cm; Figure 4.2c) that was found at Mnajdra, below the floor of the South temple's inner right-hand apse, in a pit that contained traces of burning. The large rounded breasts, pinnacle-shaped head, intentionally cropped arms and legs, distended abdomen and deeply-incised vulva all

focus the attention on acts of motherhood and birth. This is further emphasized by a spine rendered as a raised rectangle of clay, with deep incisions marking the ribs. This figurine was accompanied by five roughly worked lumps of clay, described by Evans (1971) as twists of clay. However, these very likely represent foetuses at various stages of development, with the smallest perhaps corresponding to between ten and twelve weeks gestation and the largest at around fourteen weeks. Essentially, these are gestures of childbirth, motherhood, and attendant consequences and experiences.

A standing female from Ħaġar Qim (ht. 13 cm) is the most naturalistic representation out of the entire repertoire (Figure 4.2d). Popularly known as the 'Venus' of Malta, it was found in the nineteenth century by J. G. Vance in the temple's first room beside a stone slab decorated with spirals. The figurine depicts a curvaceous naked body with traces of red pigment on the surface. One hand rests on the thigh and the other is folded across the abdomen. This is a very rare example of naturalism in the Late Neolithic and its rarity is an act of choice, rather than a question of technical ability. The missing head means it is unknown whether this had an equally individual face. The proportions and style would suggest this is a possibility.

The long tradition of relating Neolithic figurines to fertility continues to persist in some narratives, even if it has been clear since at least 1962 that this is not always the case (Ucko 1962). While it is clear that figurines can and do mean many things (for a comprehensive world survey see Insoll 2017), it is also clear that research into childbirth

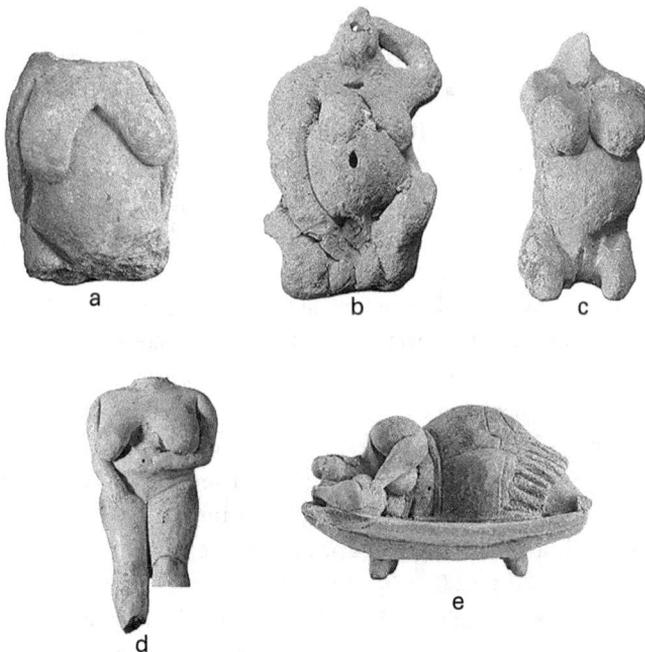

Figure 4.2 Female figurines from: *(a)* Saflieni; *(b)* Tarxien; *(c)* Mnajdra; *(d)* Ħaġar Qim; and *(e)* Tarxien. Photographs by Daniel Cilia.

and motherhood remains in its infancy (see for example Rebay-Salisbury 2017a, 2017b). This research focuses on skeletal data and at some point will hopefully converge with figurine studies. A detailed study of skeletal material relating to birth and motherhood from the Maltese Islands remains in its infancy. However, the figurative repertoire indicates a strong concern with the matter. Interestingly, the examples related to birth are distinguished by a focus on secondary sexual characteristics, the act of birth, and deliberately ambiguous faces. The concern is not with depicting a specific, individual woman giving birth, but with conceptualizing birth and society more broadly.

Death and beyond

The Late Neolithic is marked by the extension of the human life cycle (Malone et al. 2009). Burial was not the final act in the life cycle, both for the deceased and the community at large. Bodies were left to deflesh and then reconstituted and stacked into three piles (skulls, longbones and smaller bones packed densely in the middle). This process involved a lengthy engagement with both human remains and the burial site, located between the above-ground aggregation sites of Ġgantija and Santa Verna (Stoddart and Malone 2008; Stoddart et al. 2009). These acts profoundly transformed society. Figurines embody many of the acts and gestures involved in these processes, and were understood in multiple ways by people. These figurines became part of the mortuary life cycle through the act of deposition and this discussion focuses on meaning within this context.

A figurine of a sleeping woman (ht. 7 cm) found in a deep pit in the Saflieni hypogeum, combines elements of exaggeratedly large bodies with a fine naturalism (Figure 4.2e). It depicts a woman asleep on a bed, her head supported by a pillow. There are traces of red pigment across the body and bed. The luxuriously large proportions create visual curves, a small head leads to large arms, a small waist, very large curved hips and tapering to small feet. One arm is tucked under her head. The top half of the body is bare, showing full breasts. The lower body is clothed in a pleated skirt. The facial expression indicates sleep or relaxation. The face is framed by long hair, shaved at the forehead and along the top and sides of the crown. Unlike the female figurines discussed in the section above, this example relates to the latter parts of the life cycle, primarily death and the beyond. This is due to its context, the gesture of sleeping and the rare combination of exaggerated body proportions combined with clear female sexual characteristics.

Gestures relating to death rituals are very specific. Death rituals involved a multiplicity of gestures both by humans (primary agents) and figurines (secondary agents). Figurines with large bodies appear in both funerary and non-funerary contexts, but one type is exclusive to the Xagħra Circle. These figurines combined large bodily proportions in a very reduced and stylized way. The figurines (Figure 4.3a) are seated figures, ranging from 4 to 7 centimetres in height, with all the detail on the frontal view. The backs are smooth and intended to be placed against a vertical surface, enabling a primary focus on the body and posture. Gestures include an upright posture with head tilted upwards and a leaning forward posture with the head slightly tilted downwards. The arms are generally

a b

Figure 4.3 Corpulent representations from: *(a)* the Xagħra Circle; *(b)* Ħaġar Qim. Photograph by Daniel Cilia.

crossed horizontally against the torso or, less commonly, stretched outwards and placed on the thigh. The other figurine type with large bodily proportions (Figure 4.3b, discussed below) has a wider distribution.

A bundle of nine figurines from the Xagħra Circle in Gozo (Figure 4.4) embodies the acts related to the life cycle. This group was found at the very heart of a complex burial site and close to a monumental statue with large bodily proportions and no secondary sexual characteristics. The bundle consists of small figurines that can be held in the hand, moved around or inserted into soft ground. Six of these figurines reference the human form and range in height from 15 to 18 centimetres. The bodies are rectangular and the viewer's focus is on the head. The faces are in different stages of 'completion', with the two wearing skirts having the most facial detail. The other three (ht. range 5.5 cm to 9 cm) show a human head on a vertical stand with a flat bottom, the head of a pig on a vertical stump and a human-like head on a two-legged stand. These were found at the very heart of the Xagħra Circle burial site, in the proximity of megalithic screens, troughs and very rare intact burials (Malone et al. 2009).

These figurines are a materialization of the life cycle and they must be understood in terms of primary gesture and secondary gesture (via secondary agency). In the Late Neolithic, the focus is entirely on the community and keeping the idea of community alive over a period of 1,100 years. This involved the building and constant maintenance and reconfiguring of aggregation sites, the breakdown of the body in collective burial,

Figure 4.4 Bundle of figurines from the Xagħra Circle. Photograph by Daniel Cilia.

and creating links between temples and tombs, the domains of the living and the dead. Death was lengthened by a process of waiting for the flesh to decay and breaking down the body and reconfiguring it into different piles of body parts. Both above- and below-ground sites required people to constantly traverse a landscape orchestrated in such a way as to keep these places at the forefront of consciousness, making them an integral part of habitus.

In a context where people were required to visit a site multiple times and physically handle the remains of their dead, many figurines were used very effectively to illustrate the long process of bodily transformation. They could be used to engage with any point of the process, moving the objects in a number of configurations, and thereby creating multiple narratives that materialize the various stages of the life cycle.

Across different realms

The figurines with very large bodily proportions provide a link between different realms. These figurines are found both in temples and hypogea (Figure 4.3b). They are

distinguished by exaggerated bodily proportions, contrasted with very small and almost delicate hands and feet. These figurines are mostly unclothed or partially clothed and range in size from 20 centimetres to 40 centimetres in height, with one notable exception from Tarxien that is approximately 3 metres high. Many have removable heads depicting highly individualized faces, with a varied range of facial features, expressions and hairstyles. The figurines with removable heads are primarily made of stone, whereas the figurines without removable heads can be made out of either stone or clay. There does not appear to be a clear reason for the difference in materials used, other than endowing the former with the added element of being heavy and harder to shift. However, the idea of large immovable bodies is also seen in clay representations.

A stone figurine from the burial site of Saflieni (ht. 38.9 cm) was found in close association with two stone heads. The figurine is extremely smooth and has traces of red pigment. It cannot stand upright unaided, but can be placed in the earth or held in various positions. One head has a full oval face framed by short wavy hair. A hole under the head acted as a socket and could be fitted on the body and rotated by using a piece of wood. Wear and tear indicates that it was turned around many times. The second head has a similar, but fuller and fatter, face framed by wavier hair. This has a long neck that fits in the upper part of the body and would have moved in a different way. In this instance, two visually similar heads had different associated movements, creating different performances and narratives.

The majority of figurines with exaggerated proportions were found at the 'temple' of Ħaġar Qim. One group of seven figurines (ht. 19.2 cm to 38 cm) was found during the initial clearance of the temple. Contextual details are scarce, but some of the seven figurines were found in the temple's first apse. While visually similar, they all exhibit some degree of variation. Not all appear to have had removable heads. Five are seated and two are standing. Two are clothed, one is seated and wears a plain skirt and what appears to be unusually long hair in a plait starting from the neck, winding down along the spine and coiling to the left beneath the buttocks. The other is standing and appears to be wearing a dress. Another group of five figurines (ht. 24.3 cm to 59cm) were found in 1949 in a space beneath a high step leading to an inner chamber (Vella Gregory 2005). One is a badly preserved fragment, two are seated and two are standing. One of the standing figurines (ht. 48.6 cm) is unusually standing on a stone slab with drilled holes, similar to some of the stone-blocking arrangements in temple apses. It has drilled holes for interchangeable heads. Unlike others of its type, this is very thin in section, with a depth of 11.5 centimetres and the focus is on a flatter, more two-dimensional body rather than the typical all-over roundedness.

There are other figurines of this type, not all of which have removable heads (for a full discussion see Vella Gregory 2005). The largest ambiguous figure is the previously mentioned large figurine from Tarxien. The statue had a long biography and shows signs of deliberate eventual mutilation. Traces of burning are probably related to the Bronze Age cremation cemetery. The colossal figure served as a marker for a ritually complex area, the first apse of the South Temple. Its base is carved with egg-shaped motifs – similar motifs are found in nearby areas, particularly low-lying stones marking the

interface between the interior of apse 2 and court 1. This area was used for particularly intricate performances, as indicated by the architecture (notably the thresholds) and the spiral-decorated altar inside the apse. Unusually, this contained sheep and ox bones, marine shells, a bone spatula, thirteen flint knives and ceramics. The hole inside this altar was closed with a stone plug, also decorated with spiral motifs. This contextual information on both image and space is a reminder that gesture cannot be fully understood from image alone. This particular example points to a complexity of performance that required multiple elements.

While there are differences, these large bodies fall within a broad category defined by its sexual ambiguity, an immovable body and the changing of heads (and identities, messages, etc.). In many ways, it does not matter whether a body is male or female because the focus is on the idea of community and its continuity, and this message is further amplified by the use of gesture. Despite this immovability, these representations were able to create multiple gestures both through acts of performance and the physical acts of removing and changing heads.

Gesture and collective identity

This discussion has focused on aspects perhaps beyond the more recognized and usual concept of gesture. However, gesture in this context has to be seen within the more multi-faceted concept of bodily communication. As with everything, gesture is contextual. There is no universal meaning for raised arms or hands placed on hips. The figurines discussed here make us confront broader discussions. As such, any discussion goes beyond than mere relationships between people and objects. These figurines encompass the world in which people dwell, a world that is informed and maintained by gestures.

The Neolithic Maltese communities' evolution towards a monumentalized and highly ordered landscape is tied to gesture and performance. Starting in 4100 BCE there is a gradual shift towards the practice and construction of communal memory, seen via small-scale collective burials. By 3600 BCE it started its gradual transformation into monumental architecture, particularly above ground, reaching its floruit in 3000 BCE and ending in 2500 BCE. The construction of memory cannot be solely crafted by verbal narrative. Certainly, the idea of narrative was prevalent and is identifiable both in the extension of the life cycle and in the maintenance of aggregation sites, in which many aspects of performance made use of a materialized narrative. This narrative had very specific material elements and relied on gesture and a continual engagement with community ideals. Rituals, repeated actions and gestures were fundamental elements of this way of being and were entangled with multiple types of performance.

In the Maltese context, these relationships are seen via aggregation and mortuary sites and a complex visual narrative that intersects multiple domains. Thus, while the majority of figurines do not show specific signified practices, they very much reflect broader social practices. The body was central to all domains, from daily life and the

maintaining of aggregation sites to the processing of the body after death and the creation of multiple corporeal forms. Viewing power as an institutional phenomenon (Foucault 1977) enables a reading of the body as a surface on which social practices can be inscribed, and which can be inscribed on many types of bodies. The fragmentation of the dead body, an act carried out by the living, was one way of performing the idea of community. The lack of individuality transcended the domains of life and death.

Taken as a whole, the figurine repertoire shows a remarkable lack of a specific 'deity'. The large sexless bodies reference the human form, or the notion of being human, without referring to a specific human or entity. There is a focus on gargantuan, sexless bodies, which can be further emphasized in the physical sizes of the figurines. Heads and faces can be changed, moved and manipulated at will, creating multiple narratives. As a whole, the repertoire shows a preference towards abstraction, but where present, naturalism is reserved for the female form and phalli.[1] The former is used to depict a concern with motherhood and in the case of the 'Venus' from Ħaġar Qim a naturalistic representation of the female body.

The domains of collectivity and sexed bodies combine in the form of the Saflieni 'Sleeping Lady'. Found in the deepest part of the burial site, it is reasonable to link this image with the extension of the life cycle. Less clear is why it takes the female form. While there are no figurative comparanda from Gozo, the rare individual burials comprise of a male dating to the Żebbuġ phase and up to thirteen known individuals dating to the Tarxien phase. Of these, five are female, six are male or possibly male, one is a child and another is unknown. One of the females was buried on top of a male and one mature woman had a cowrie-shell headdress (Stoddart et al. 2009: 321–5). The significance of these burials requires further review, although comparisons with Saflieni skeletal data are not possible since the latter was cleared in the early twentieth century. The figurative repertoire could indicate that some of the death rituals were linked to women but the mortuary remains indicate a preference for age over gender in terms of single burial.

A focus on gesture in aggregation and mortuary sites thus enables a reading of the construction of knowledge beyond the domain of everyday practices. It occurred in large-scale arenas and was firmly embedded in their habitus, in the way their group culture shaped social actions and its material presentations thereof. The sites and figurines act as conduits for the distribution of knowledge and contribute to the creation of a collective identity based on memory. This knowledge becomes increasingly restricted in the Tarxien phase and by 2500 BCE it is rejected by the community. While the precise reasons require further investigation, these practices were sustained over a period of 1,100 years through the perpetuation of collective identity materialized in the figurine repertoire.

Acknowledgements

The author is grateful to Heritage Malta and the National Museum of Archaeology, and particularly to Sharon Sultana and Vanessa Ciantar for their continued support, and to

Daniel Cilia for providing images. The author would like to thank the anonymous reviewer and editors for their helpful comments.

Notes

1. There is a small number of phalli made of stone, bone and clay. These representations show a keen awareness of differences in the male biology (see discussion in Vella Gregory 2005).

References

Baldacchino, J. G. and J. D. Evans (1954), 'Prehistoric Tombs near Żebbuġ', Malta, *Papers of the British School at Rome*, 22: 1–21.

Bonanno, A. (1993), 'Maltese Megalithic Art: Fertility Cult or Sexual Representation?', in R. Ellul-Micallef and S. Fiorini (eds), *Collected Papers Published on the Occasion of the Collegium Melitense Quatercentenary Celebrations (1592–1992)*, 75–91, Msida: University of Malta.

Evans, J. D. (1971), *The Prehistoric Antiquities of the Maltese Islands: A Survey*, London: Athlone Press.

Foucault, M. (1977), *Discipline and Punish*, London: Allen Lane.

Gell, A. (1998), *Art and Agency: An Anthropological Theory*, Oxford: Clarendon Press.

Grima, R. (2001), 'An Iconography of Insularity: A Cosmological Interpretation of Some Images and Spaces in the Late Neolithic Temples of Malta', *Papers from the Institute of Archaeology*, 12: 48–65.

Grima, R. (2005), 'Monuments in Search of a Landscape: The Landscape of Monumentality in Late Neolithic Malta', PhD diss., University College London, London.

Insoll, T. (ed.) (2017), *The Oxford Handbook of Prehistoric Figurines*, Oxford: Oxford University Press.

Lefebvre, H. (1991), *The Production of Space*, Oxford: Blackwell.

Malone, C. (1998), 'God or Goddess: The Temple Art of Ancient Malta', in L. Goodison and C. Morris (eds), *Ancient Goddesses: The Myths and the Evidence*, 14863, London: British Museum Press.

Malone, C. (2008), 'Metaphor and Maltese Art: Explorations in the Temple Period', *Journal of Mediterranean Archaeology*, 21: 81–109.

Malone, C. and S. Stoddart (2017), 'Figurines of Malta', in T. Insoll (ed.), *The Oxford Handbook of Prehistoric Figurines*, 729–54, Oxford: Oxford University Press.

Malone, C., A. Bonanno, T. Gouder, S. Stoddart and D. Trump (1993), 'The Death Cults of Prehistoric Malta', *Scientific American*, 269 (6): 110–17.

Malone, C., A. Bonanno, D. Trump, J. Dixon, R. Leighton, M. Pedley, S. Stoddart and P. J. Schembri (2009), 'Material Culture', in C. Malone, S. Stoddart, A. Bonanno, and D. Trump (eds), *Mortuary Customs in Prehistoric Malta: Excavations of the Brochtorff Circle at Xagħra (1987–94)*, 219–313, Cambridge: McDonald Institute for Archaeological Research.

Mauss, M. ([1935] 1973), 'Techniques of the Body', *Economy and Society*, 2 (1): 70–88.

Neitzel, J. and T. Earle (2014), 'Dual-Tier Approach to Societal Evolution and Types', *Journal of Anthropological Archaeology*, 36: 181–95.

Pace, A. (2004a), 'Ta' Ħaġrat, Mġarr', in D. Cilia (ed.), *Malta Before History: The World's Oldest Free-Standing Stone Architecture*, 149–52, Silema: Miranda.

Pace, A. (2004b), 'The Ġgantija cluster', in D. Cilia (ed.), *Malta Before History: The World's Oldest Free-Standing Stone Architecture*, 166–99, Silema: Miranda.

Pace, A. (2004c), 'The Tarxien Cluster', in D. Cilia (ed.), *Malta Before History: The World's Oldest Free-Standing Stone Architecture*, 44–97, Silema: Miranda.

Rebay-Salisbury, K. (2017a), 'Breast is Best – and are there Alternatives? Feeding Babies and Young Children in Prehistoric Europe', *Mitteilungen der Anthropologischen Gesellschaft in Wien*, 147: 13–30.

Rebay-Salisbury, K. (2017b), 'Bronze Age Beginnings: The Conceptualization of Motherhood in Prehistoric Europe', in D. Cooper and C. Phelan (eds), *Motherhood in Antiquity*, 169–96, London: Palgrave Macmillan.

Renfrew, C. (1973), *Before Civilization: The Radiocarbon Revolution and Prehistoric Europe*, London: Penguin.

Skeates, R. (2010), *An Archaeology of the Senses: Prehistoric Malta*, Oxford: Oxford University Press.

Stark, M., B. Bowser and L. Horne (eds) (2008), *Cultural Transmission and Material Culture: Breaking Down Boundaries*, Tucson, AZ: University of Arizona Press.

Stoddart, S. and C. Malone (2008), 'Changing Beliefs in the Human Body in Prehistoric Malta 5000–1500 BC', in D. Boric and J. E. Robb (eds), *Past Bodies: Body-Centered Research in Archaeology*, 19–28, Oxford: Oxbow Books.

Stoddart, S., G. Barber, C. Duhig, G. Mann, T. O'Connell, L. Lai, D. Redhouse, R. Tykot and C. Malone (2009), 'The Human and Animal Remains', in C. Malone, S. Stoddart, A. Bonanno and D. Trump (eds), *Mortuary Customs in Prehistoric Malta: Excavations of the Brochtorff Circle at Xaghra (1987-94)*, 315–40, Cambridge: McDonald Institute for Archaeological Research.

Ucko, P. J. (1962), 'The Interpretation of Prehistoric Anthropomorphic Figurines', *Journal of the Royal Anthropological Institute of Great Britain and Ireland*, 92: 38–54.

Vella Gregory, I. (2005), *The Human Form in Neolithic Malta*, Sta Venera: Midsea Books.

Vella Gregory, I. (2013), 'Life and Death on the Xaghra Plateau', in G. Vella (ed.), *Ġgantija: The Oldest Free-Standing Building in the World*, 148–74, Kalkara: Heritage Malta.

Vella Gregory, I. (2016), 'Immensity and Miniaturism: The Interplay of Scale and Sensory Experience in the Late Neolithic of the Maltese Island', *Oxford Journal of Archaeology*, 35 (4): 329–44.

Vella Gregory, I. (2017a), 'The Application of Pottery Attribute Analysis: A Case-Study from the Neolithic Complex of Kordin, Malta', *Journal of Archaeological Science Reports*, 14: 543–56.

Vella Gregory, I. (2017b), 'Tradition, Time and Narrative: Rethinking the Late Neolithic of the Maltese Islands', *Malta Archaeological Review*, 11: 16–24.

CHAPTER 5
GESTURES OF PROTECTION: CLAY MASKS OF THE PHOENICIAN-PUNIC WORLD
Mireia López-Bertran

Masks are among the most puzzling materials of the Phoenician-Punic world. Certainly, the main reason is due to their exaggerated gestures, and, as such, they have attracted particular attention ever since the early stages of Phoenician and Punic studies. In this chapter, I focus exclusively on masks that present exaggerated facial gestures. Big mouths, grotesque gesticulation and grinning expressions are features commonly used to define these materials since the mid-twentieth century, when Cintas (1946) established a first classification and described them all as grimacing masks (Figure 5.1). The grinning masks portray faces with moon crescent-shaped eyes, discs on the forehead, chin and cheekbones, horizontal or wavy grooves, and open mouths sometimes showing their teeth. This facial expression is not crafted on clay by chance. In this chapter, gestures are understood as visible body actions that are socially shared communicative codes and,

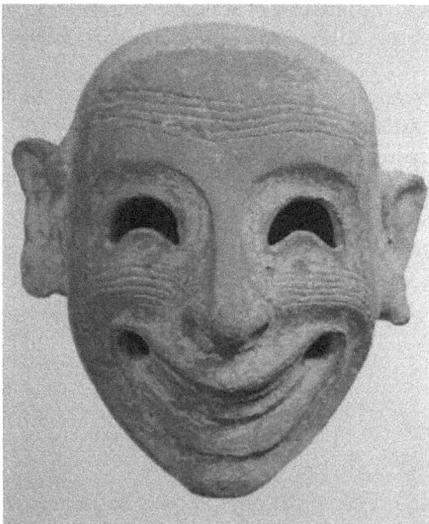 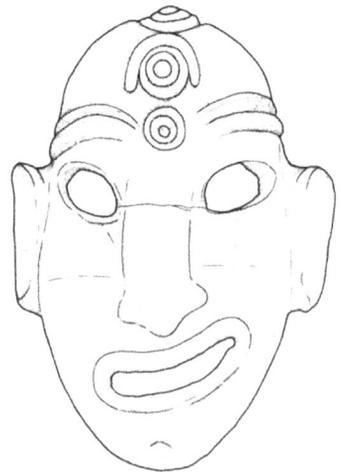

a b

Figure 5.1 Grimacing masks from the western Mediterranean: *(a)* Mask from tophet at Mozia, Sicily. Copyright by the Sezione per i Beni Archeologici della Soprintendenza di Trapani; *(b)* Mask from tomb 10, Necropolis of Dermech, Carthage. Drawing by A. Guari, produced with permission of Adriano Orsingher.

thus, they do not possess universal meaning. Instead, they are socially constructed (Kendon 2004: 2–5). I argue that the gestures of the masks are clear communicative signals with magico-religious features.

I review the so-called 'grimacing' masks from two perspectives: on the one hand, I focus on the masks' facial expressions as materializations of rituals that involve a high degree of sensory alteration. Following my analysis of the masks' gestures and decoration, I also suggest that the masks constructed a corporeality of protection. On the other hand, by exploring this association further through a careful examination of their contexts of recovery, I suggest that these grimacing masks can be interpreted as ancestors watching over their relatives. Before moving on to these topics, the materials will be contextualized, and a comprehensive outline of the previous interpretations will be also undertaken.

The Phoenician-Punic world

The Phoenician trade diaspora from the eastern Mediterranean to the Atlantic was a movement of people driven mainly by economic needs (see Vives-Ferrándiz 2015 for an overview). It is roughly dated to between the mid-ninth century and the seventh century BCE, and the subsequent Punic period to between the sixth and the second century BCE. The term Punic implies a chronological distinction between the earlier Phoenicians – people from the Levant and the earliest settlers in the Mediterranean – and their descendants, who populated the western Mediterranean and the Atlantic coast from the sixth century BCE. This separation is rather artificial as there is no significant difference between the Greek *Phoinix* and the Latin *Poenus* in so far as both words signify outsiders' perceptions (i.e. those of the Romans and Greeks) of these groups (Prag 2014). The separation has also been criticized for suggesting that these ethnicities and cultures were static and for ignoring the uninterrupted exchanges between the east and the west (Quinn 2013: 23–8). As it will be explained, one of the examples of these interactions are the clay masks, whose existence in the western Mediterranean has its roots not in Greek coroplastic samples, but in the Levant (see Orsingher 2018a, 2018b; Fariselli 2014; Morstadt 2010 for recent reviews of the materials with detailed references).

Masks in the Phoenician-Punic world: An overview

The label 'mask' not only includes specimens with suspension holes and with pierced eyes, noses and mouths, but also coroplastic objects that are not considered formally as masks because they are not pierced in the eyes, nose or mouth, although it is likely that these specimens were also hung or worn. Equally, the main classifications (Cintas 1946; Picard 1965–6; Stern 1976) also include *protomai* or busts whose eyes and mouths are not perforated. Accordingly, all the terracotta objects representing faces belong conceptually to this group.

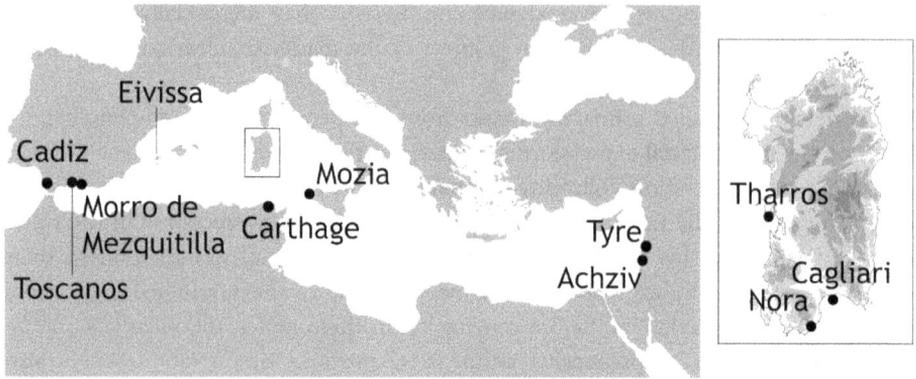

Figure 5.2 Map of the Mediterranean with the sites mentioned. Copyright by Mireia López-Bertran.

The production of anthropomorphic clay masks in the Phoenician Levant began in the Late Bronze Age (1300–800 BCE) and continued throughout the Iron Age (1200–600 BCE). A recent classification of the Levantine artworks has created six groups: female, beardless male characters, short-bearded male characters, long-bearded male characters, wrinkled male characters and Silenic male characters (Orsingher 2018a: 278).

From the seventh century BCE onwards, masks appear in the central Mediterranean (Carthage, Sicily and Sardinia) and western Mediterranean (the south Iberian Peninsula and Eivissa in the Balearic Islands) in connection with the Phoenician trade diaspora (Figure 5.2). They have also been newly classified in six groups: female, long-bearded, grinning, Black African and Silenic (ibid.: 282).

Phoenician and Punic grimacing masks in context

The corpus of grimacing masks analysed here includes the eastern wrinkled ones as well as the western grinning and Black African specimens. In all, they are a small corpus, with less than fifty specimens, in comparison with other coroplastic materials such as wheel-made or bottle-shaped figurines, and incense burners in the shape of a female head, the so-called *thymiateria*. The fragmented nature of the evidence is also remarkable, as they have been found in an isolated manner at particular sites or within a considerable time lapse at a given site, such as at the necropoleis of Carthage or Puig des Molins (Eivissa).

The grimacing western masks simultaneously maintain features of the Levantine wrinkled male characters but also include new types such as the grinning, Black African and Silenic types (Orsingher 2018a: 283). Indeed, the connections between the eastern and the western specimens are exemplified not only in the vivid facial expressions but also in the use of the same decorative patterns, such as clay discs. For example, some oriental ones have a grimacing gesture or clay-discs decoration on the forehead. On the one hand, the grinning gesture is recorded in so-called 'grimacing wrinkled mask', which

was found in tomb 3 at Akhziv, and dates to between the eighth and the fifth century BCE. On the other hand, the disc on the forehead appears on a miniature male mask found in Khaldé cemetery. This miniature male mask was found in a child's grave, with no reliable date (Culican 1975–6: 55–6; Fariselli 2014: 151–2). However, the context – in a child's grave – is valuable, because it is the only case so far where the deceased's age is defined.

The facial expressions of the masks have been the key feature in the earliest classificatory attempts. As I mention above, Cintas published the first mask classification in 1946 and included the specimens found in the western Mediterranean, mainly at Carthage. Under the generic label of grimacing masks, Cintas distinguished four types. Cintas I includes grinning, beardless, young people with big noses; Cintas II is represented by grinning elderly people with tattoos; Cintas III presents the same features as Cintas II, but the features are more exaggerated and in some cases with detailed representations of the teeth; and finally Cintas IV are grotesque masks, anticipating Greek types. Chronologically, the oldest type (Cintas I) dates from the seventh century BCE, Cintas II and III date from the sixth to the end of the third century BCE, and Cintas IV dates from the third and second centuries BCE.

Twenty years after Cintas' work, Picard established a new classification (Picard 1965–6). She included the entire repertoire under the generic label 'demonic masks', in which she distinguished two subgroups: grotesque and satirical. Stern (1976) proposed another classification with two groups: the grotesque family, which includes masks and the *protomai*.

Recently, Orsingher (2014: 149–51) published a chrono-typological sequence of the grimacing mask on the basis of the few pieces that have a clear context (Figure 5.3). In many instances, no specific context is available, especially in the case of pieces found in excavations of cemeteries at the end of the nineteenth century and the beginning of the twentieth, during which time reliable stratigraphic information was not recorded. For instance, the provenance of the tomb is only rarely provided and, in general, no information on the human remains accompanying these materials is given. Based on the discoveries of the German excavations in Carthage, Orsingher dates the beginning of mask production to around the mid-seventh century BCE. In the second phase, the types of mask increase, and they are found further afield, in Sardinia, Sicily and Eivissa between the second half of the sixth century and the early decades of the fifth century. The third stage runs through the fifth century BCE and the start of the fourth century BCE; the only exemplar of the last stage is the Carton mask, which was found in the Roman destruction level of Carthage, and therefore dates between the end of the third century and the beginning of the second century BCE.

Masks from Phoenicia establish the connection of these materials to ritual sites, especially cemeteries. But masks are also found in other contexts. The case of Sarepta is particularly striking: five samples have been located along the main street that joined the city to the harbour, and eight more in undetermined areas of the city. It has been suggested that masks might have been placed at the entrances of houses and workshops as talismans to ward off evil (Pritchard 1988: 68). Two other fragments of masks have

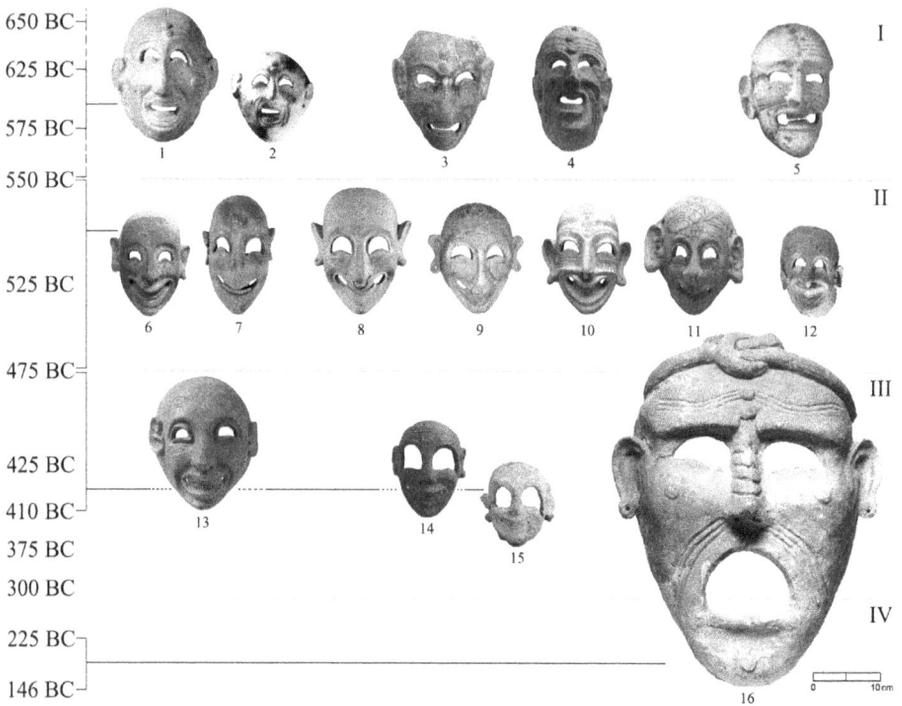

Figure 5.3 Chrono-typological sequence of the grimacing masks. After Orsingher (2014). Produced with permission of Adriano Orsingher.

also been associated with urban areas: one is dated to the mid-ninth century and it was located in the city of Tyre. The other mask was found in Beirut, apparently in a storage area (Badre 1997: 88); interestingly, this mask also presents a clay disc on the forehead.

Moving to the western Mediterranean, masks have also been found in domestic contexts. It is significant that the earliest masks are recorded in dwellings. In Morro de Mezquitilla (Málaga, Spain), a small fragment of a grimacing type dates to the eighth or seventh century BCE (Schubart 1979) and in Carthage, some samples found below the *decumanus maximus* belong to phase IIIA of the city (*c.* 700–675 BCE; Niemayer and Docter 1998). Other samples that have not been associated with either shrines or cemeteries include a fragment of a mask located at the pottery workshop of Villa Maruja (Cádiz), which has been reliably dated to the end of the fifth century BCE (Bernal et al. 2005: 74). Furthermore, a small fragment has been located in a domestic context in Toscanos, and dates to the end of the seventh or beginning of the sixth century BCE (Schubart and Mass Lindemann 1985). In Carthage, three fragments of the same mask were recovered beneath the *cardus maximus* dating from the beginning of the sixth century BCE (Acquaro 1990). In Nora, a fragment of a mask was found in the pre-Roman level of the houses and is dated between the end of the sixth and the beginning of the

fifth century BCE (Campanella 2007: fig. 5). Finally, another fragment of unknown provenance was found in Trebujena, Jerez de la Frontera (Ferrer, Sibón and Mancheño 2000: 597).

This overview suggests the idea that, first, masks are common, although scarce in number in Phoenician and Punic material repertoire and, second, that masks are not exclusively associated with sanctuaries or with burials.

Possible functions and identifications

Several hypotheses have been put forward to explain the role of the masks. It is generally agreed that they were not placed on people's faces, or on corpses because of their size (around 20 cm) and because of the material used (clay). The presence of a single top hole suggests that they were suspended rather than worn. Furthermore, the absence of nasal and mouth openings would have made it difficult to breath (Orsingher 2014: 147). One tentative explanation is that these masks might have been copies of other masks made out of perishable materials, but there is no evidence so far to support this suggestion (Ciasca 1991). The masks with one or more holes on top may have been hung on the walls, pillars or doors of houses and tombs for protective reasons. Another suggestion is that these masks were placed on statuettes of divinities (especially the ones with several holes along the edge) or attached to the robes of priests while they performed rituals (ibid.: 149; Garbati 2016: 217–19).

This latter idea has been elaborated upon recently by Fariselli (2011: 167–8), who argues that these priests might be associated with the god Baal Hammon[1] and that the masks might be a visual expression of their high-rank social position. For instance, some of the decorations on the masks have been interpreted as clay imitations of precious stones and metal decorations, particularly gold bandeaux as seen in masks from Tharros and San Sperate (Sardinia, Italy). It has been suggested that the mold and tools used for crafting clay patterns on masks would have been identical to the moulds and tools used in making jewellery (Pisano 1995; see Figure 5.4). Furthermore, other decorations such as a lunar-crescent-above-a-disc may indicate that these priests were in charge of mystic or initiation rites devoted to Baal, an iconography often associated with this god. Accordingly, these objects have not been found on a large scale, as only a select group of people would have been allowed to possess them. It also explains why they are located in houses and sanctuaries and in a small number of tombs acting as emblems in the grave goods. This leads to the suggestion that these masks were heirlooms (Orsingher 2014: 149), which is why they are found in tombs.

Another hypothesis that links the masks to Baal is their presence at *tophets*. *Tophets* are open-air, sacred sites dedicated to the god Baal Hammon and the goddess Tanit and located inside cities but often in a liminal position, for instance, close to the walls. *Tophets* contain urns with cremated bones of children and animals, mostly lambs, and sometimes the same urn contains bones of both animals and infants. The urns were surmounted by stelae incised by votive inscriptions or depictions of humans, plants or geometric forms,

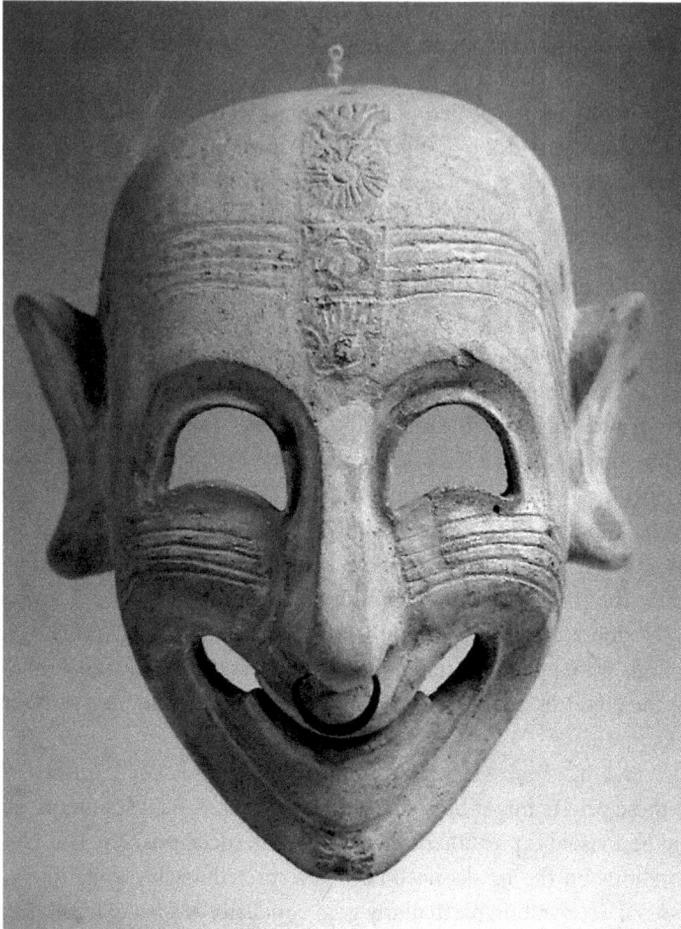

Figure 5.4 Mask with possible representation of gold bandeaux. San Sperate, Cagliari, Sardinia. Image adapted after Moscati (1988). Produced with permission of the Museo Archeologico Nazionale Cagliari.

among others. *Tophets* also contained small chapels and other facilities such as places for incineration (see Xella 2013 for a recent compilation on the topic).

The masks found at *tophets*, at Mozia and possibly at Tharros, have oversized ears, which have been interpreted as visual representations of the votive inscriptions on the stelae of *tophets* that translate 'indeed the good (Baal Hammon) has heard the voice of his words' (Orsingher 2014: 158; Amadasi-Guzzo and Zamora López 2013: 175–6). The Carton mask also suggests an identification with Baal Hammon because it was recovered in the *Chapelle Carton*. This shrine is attributed to Baal Hammon and Tanit and the mask itself may have been a representation of the god, given its vast size (51 cm) compared with the other pieces, which are generally around 20 centimetres in length (Orsingher 2014: 157).

Recently, other hypotheses have been put forward. On the one hand, it has been suggested that masks represent neither humans nor divinities, but liminal beings. This

idea is based on the iconography of these objects 'which seems to be positioned between the human and non-human-specifically transfiguring certain natural features' (Garbati 2016: 221). On the other hand, the masks have been defined as representations of mourners who would have wounded their own faces in order to express their grief. Hence the horizontal or wavy grooves on the forehead and cheekbones that most masks feature (Escacena Carrasco and Gómez Peña 2016: 66–76).

The masks present a considerable diversity of decorations and techniques applied, engraved or stamped on the forehead, cheeks and chin. The most common decorations are clay pastilles known as discs, mainly distributed on cheekbones and foreheads. They feature on the earliest and latest masks and have been interpreted either as warts (Cintas 1946: 37) or as astral symbols, especially the ones surmounted by a crescent that turns the disc into the sun, the moon, or even Venus. In the middle period, other symbols appeared such as crossed discs, lotus-flower, ears, rosettes and apexed triangles or cruciform forms. The Tanit symbol, Gorgon's mask, *uraeus*[2] disc and a lion's head protome appear only rarely (Orsingher 2014: 154; Culican 1975-6: 67). Again, these decorations have been interpreted as astral symbols or as symbols of fecundity associated with the goddess Tanit.

The apotropaic values of masks have been repeatedly highlighted (Cintas 1946; Culican 1975-6; Moscati 1968; Bénichou-Safar 1982; Ciasca 1991; Fariselli 2011; Garbati 2016; Orsingher 2014, 2018a). Their protective role is suggested by their finding contexts, mostly in tombs close to the deceased, and by the fact that their facial gestures are also portrayed on mural paintings, amulets or other coroplastic objects related to protection. Equally, the decorative pattern is analysed as entailing protection value. Thus, gestures and decoration have played a key role in this line of study in support of the apotropaic value of these materials. In the following section, I develop these ideas further.

Embodying protection

Although it is generally agreed that masks served to protect, it has not been satisfactorily explained how this warding off of spirits actually worked or what the grimacing gestures communicated (Vella 2012: 302). Looking at the masks through the lenses of embodiment and materiality opens up new ways to interpret the masks and explore how facial gestures and decorations were appropriated for protection. Starting from the idea that masks do indeed have apotropaic features, I explore how people might have created and understood protection from a corporeal and material point of view. I consider that these theoretical tools allow us to understand facial decorations and gestures not as mere representations, but as strategies to create and codify bodily expressions in ritual practices.

Punic people may have conceived protection in connection to an array of decorations and gestures commonly used on a variety of objects other than masks. Regardless of what they represent (gods, death, demons, monsters, the old), masks reveal that the idea of protection is physically and materially represented on the head and in its decoration. These materials may also shed light on the rituals that took place in funerary rites or other enactments.

Gestures

Gestures of grimacing and grinning are strategies used to materialize a pronounced smile: mouths are drawn up at one side or at both in a grimace or a grin, with deep wrinkles, furrowed foreheads and cheeks (see Figure 5.1). Some wrinkles created by facial expression, like crow's feet, push up the cheeks and the crescent-shaped eyes may indicate the facial contractions of strong laughter (Orsingher 2014: 154).

This grinning smile is also known as *risus sardonicus* or a Sardonic laugh, and currently has two meanings. Especially in medicine, this kind of laugh is used to designate an involuntary smile due to a facial contraction caused either by tetanus or by the consumption of a drug (Appendino et al. 2009). It also designates an ironic, spontaneous smile (Ribichini 2003: 5). Ancient sources make several references to this gesture (see ibid. for an exhaustive compilation) and it is especially well known due to a passage in *The Odyssey* when Odysseus 'smiled in his anger a very sardonic smile' (Homer 2016: XX, 301). In fact, several ancient writers associate this kind of smile with Sardinia. For instance, in the second century CE, Pausanias (Description of Greece X, 17, 13) noted that 'the whole island is free of lethal drugs except one weed; the deadly herb looks like celery, but they say if you eat it you die of laughing' (Appendino et al. 2009: 962). Claudius Aelianus (Varia Historia IV, I, third to second centuries CE) also said that in Sardinia, elderly people unable to support themselves were intoxicated by their children with a sardonic herb and then thrown off a high rock or beaten to death.

Recent botanic studies have shown that the herb causing the Sardonic laugh might be *Oenanthe fistulosa*, which is among the most poisonous species of European flora. This plant bears a general resemblance to parsnip and carrot and remains a cause of fatal human poisonings even today. Unlike other plant toxins, the consumption of the plant does not present an unpleasant taste or odour (Appendino et al. 2009).

With the archaeological data available to date it is impossible to make a firm relationship between the masks and the botanic cause of the sardonic smile. However, this line of enquiry is interesting because it shows that some ancient people were aware that the consumption of some herb provoked toxic effects in relation to the smiling gesture. Regardless of the cause of grinning (i.e. due to muscular contraction or to a genuine smile), in my view the Sardonic laugh allows the exploration of possible sensory alterations in specific situations. I consider that the grimacing masks embody gestures and rituals performed by the Punic people. The smile is a bodily action as well as a cultural code with a variety of meanings, and in these contexts it may be representing specific attitudes of protection, probably related to the achievement of altered states of consciousness. Indeed, it has been already suggested that the use of painting on masks, especially on eyes, mouths and ears, could have been used to emphasize the important role of the senses (Orsingher 2018b: 58).

Cemeteries and shrines reveal materials that may have been linked to sensory alterations. The consumption of some herbs and beverages or the inhalation of certain odours may have been indicated by the bowls and jugs found in the ritual contexts. Perfume bottles, oil-lamps and bowls indicate practices of burning certain oils and resins (López-Bertran

2007: 145–68). For instance, we know that resin panels or wood remains of pine or olive trees have been identified and which were used to perfume the funerary chambers. Oils and animal fats for anointing corpses have also been found and aromatic wooden trees such as almond, plum, olives and cherry trees were used to cremate the deceased (Bénichou-Safar 1982; López-Bertran in press). The consumption of plants with psychoactive properties in Phoenician-Punic studies has been an almost unexplored topic. In spite of this, a terracotta representation of a poppy in La Algaida, a Punic shrine in south-western Iberia, has been interpreted in this way (López-Bertran and Vives-Ferrándiz 2009: 182–4).

Music and dancing are also important according to the material culture and the written sources (Fariselli 2007). Figurines of musicians have been found deposited in tombs from Eivissa, Sardinia and Carthage, among others (see López-Bertran and Garcia-Ventura 2012 with detailed references). Although these figurines play various instruments and might be understood in local understandings of music (ibid. 2014: 63–6), they make clear the importance of music in rites, more concretely funerary ones, across the Phoenician and Punic Mediterranean. Some of the musician terracottas feature marching poses, and there are also representations of dancers. Furthermore, direct evidences of music are recorded in Puig des Molins (Eivissa) and Carthage where some tombs contained bronze cymbals and small bells (Fantar 1995: 85; Fernández 1992: 197). This evidence suggests that one of the funerary rituals might have been a march or procession leading the deceased to the cemetery. In this procession, music, walking and dancing would have been significant activities and it has been established that some dancing would have been performed using masks (López-Bertran and Garcia-Ventura 2008: 30).

Some figurines from Cyprus, for instance, capture the moment at which the characters represented put on their masks. In Sardinia, at the site of Tharros, a memorial stone in the cemetery (dated between the fifth and fourth centuries BCE) features a dancing scene that involves four people – three women and one man. The women appear to be naked and the man is wearing a skirt with a bull mask; all of them are dancing around a phallus-like pillar stone (Manfredi 1988). In fact, the Old Testament (I Kings 18: 28–9) explains how supporters of Baal dance ecstatically on Mount Carmel, and Heliodorus of Emesa (Aethiopica, IV, 17) tells how Tyrian merchants dance in honour of Melqart (Fariselli 2007: 136).

In all, dancing, singing, smelling certain odours and consuming certain substances might have contributed to altering the senses and it is quite possible that one of these alterations involved grinning or smiling which is clearly depicted on the masks. In these convivial contexts, the facial expression of smiling would not have been linked necessarily to positive emotions, but may have contributed to the creation and reinforcement of the social bonds of the members of the community, as has been suggested for the bared teeth motif in the Precolumbian Caribbean (Samson and Waller 2010). This interpretation can be clearly applied to funerary rites in the Phoenician-Punic world, which served to manage a critical moment in the lifecycle of social groups, such as death.

Another possible explanation for the open, exaggerated mouths may be the role of the voice in rites. It is likely that the open mouth embodies singing, lamenting or praying activities. It is also feasible that recitation of magical formulae for good luck occurred,

according the magical formulae, which have been discovered in amulet-cases or the curses inscribed in tombs (Mazza 1975: 27–8).

Sensory alteration embodied in facial expression can also be seen in the large, open eyes. I argue that these have a protective function as well, and it is important to explore how the eyes are depicted on the masks. The size could be intended to reinforce the importance of sight in protecting people. They could also represent lunar crescents, a cosmic shape related to magic and ritual practices (Bénichou-Safar 2008). In fact, in Phoenician-Punic communities, the eyes are powerful instruments for expelling bad luck and exerting magical powers. The most common kind of talisman is the Egyptian *wadjet* eye amulet, found in a variety of contexts of the Phoenician and Punic sites, particularly in tombs among grave goods (Cintas 1946; Jiménez Flores 2004: 146).

The presence of similar gesticulations on other objects strongly supports the connection between these gestures and protection (Culican 1976; Del Vais and Fariselli 2012: 77). The clearest cases are anthropomorphic amulets known as small apotropaic heads (Velázquez Brieva 2007: 109–10; see Figure 5.5a, c and d). These amulets were presumably hung on necklaces and, in some cases, present features similar to those of the masks: wrinkled faces, broad noses or grimaces, reminding us that these gestures act as amulets or talismans. In some cases, connections with the Greek gorgons have also been suggested (Martin 2014). Other items have been regarded as Phoenician demons because of their grotesque appearance, with horned and bearded beings with gaping grins revealing gnashing teeth, a broad nose, and animal ears (Culican 1976). This iconography has also been associated with Mesopotamian demons like Humbaba, with large eyes, a grimacing mouth, a wide nose, and whiskers or wrinkles, and Pazuzu, with leonine and possibly canine elements (Graff 2014: 264). This resemblance is clearly seen in an amulet found in a cremation tomb in Cadiz (Spain) dated to the sixth century BCE, which presents large ears and horns, and in another in Carthage, beneath the *Decumanus maximus* (Perdigones Múñoz 1990: 59, fig. 6A; Niemayer and Docter 1998: 92; Figure 5.5a).

Faces with prominent eyes painted on fragments of ostrich eggshells are also worth considering. They are identified as masks in spite of their flat shape and the absence of holes (Astruc 1956; Pisano 2004), and to date, have been exclusively recovered from cemeteries. The eggshells were cut in a circular or ovoid shape and painted in black and red. Generally speaking, the faces are marked with a circular stroke that surrounds the egg and to create a face-like decoration. The hair is also represented, in red, black or brownish pigments. The eyes are carefully painted: they are almond-shaped, containing black irises with eyebrows and sometimes detailed eyelashes, all painted in black. Mouths are painted with two parallel red lines imitating lips and two red circles represent the cheeks. The noses are painted faintly with horizontal lines. These pieces show a nice link to the gestures of the clay masks. Expressive eyes with black irises and eyebrows, curly hair, and the presence of painted red discs on cheeks suggest a similar way of embodying protection.

All existing interpretations have in common the notion that the ostrich eggshell faces have magical and apotropaic features and are considered as amulets (Astruc 1956: 44–7; Spanò Giammellaro 1995; Savio 2004). Two arguments support this idea. First, the

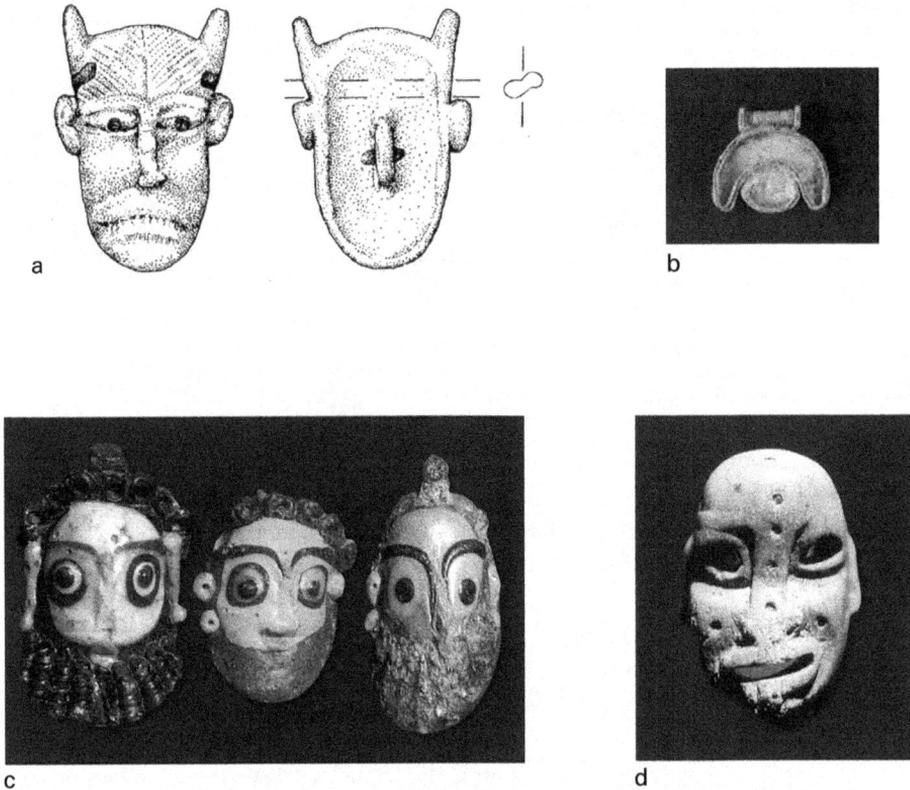

Figure 5.5 Objects with protective features: *(a)* Pendant of a Phoenician demon, Carthage. After Niemayer and Docter (1998); *(b)* Gold pendant of a lunar-crescent above a disc; *(c)* Small apotropaic heads; *(d)* Bone amulet. After Bartoloni (2012). Produced with permission of Roald Docter and the Museo Archeologico Nazionale Cagliari.

substrate itself because eggs are considered significant objects in Phoenician and Punic eschatology, not only as food offerings, but also as symbols of regeneration and birth that contain life. These objects have been found in cemeteries in Carthage placed close to hands, heads and knees (Savio 2004). Furthermore, in the necropolis of Palermo in Sicily, a single tomb was found to contain ten faces (Spanò Giammellaro 1995: 42–3), a discovery that stresses the protective role of these materials.

Finally, the mural paintings and engravings of some funerary chambers also represent faces with exaggerated smiles. Their location, either inside the chamber or at the entrance, underlines their protective role. In the Tuvixeddu necropolis in Cagliari, Sardinia, a face sculpted in relief can be included in the Gorgonic style with strange eyes, large deformed ears and a grinning mouth with a large protruding tongue (Moscati 1988: 451). In another tomb, dating from the fourth century BCE, another Gorgonic head is found at either end of the wall and a central *uraeus* on one of the chamber walls (Mattazzi-Paretta 2004–5). In a tomb in Tharros, a grotesque head is sculpted on the door (Culican 1976).[3]

Tracing Gestures

This array of material culture makes it clear that these gestures embody a specific protective corporeality, a specific facial language to ward off evil beings that is widespread and clearly understood in Phoenician and Punic culture. The combination of grinning and large, open eyes underlined the relevance of the expressive head as whole. They may be simultaneously scaring away bad luck or evil otherworldly beings and also protecting the people close to the masks, engravings or amulets, either dead or alive. This is why these masks would have been hung at the entrances of either chamber tombs or houses. In this regard, it is possible that the Phoenician and Punic people used certain sensory alterations to remain alert in order to control the otherworldly forces.

Meaningful decorations

As already mentioned above, masks feature diverse decorations, including lotus flowers, rosettes, ears and apexed triangles (see Orsingher 2014: fig. 4 for a chronological classification). These symbols may have had religious significance, as they have also been identified on other objects such as funerary stelae, other terracotta figurines and mural paintings in burial chambers.

Simple and crossed discs outnumber other representations. They are clay buttons applied to the core, but they are also painted in red. These circles are located on different parts of faces, principally on the cheeks but also on the chin and forehead. This decorative pattern also appears on other anthropomorphic objects, such as ostrich-eggshell faces, clay busts and female musician figurines and is commonly defined as makeup (López-Bertran and Garcia-Ventura 2016: 210–11). When found on the terracotta masks, the discs have been interpreted either as warts, probably to represent old age (Cintas 1946: 37), or as astral symbols, especially, in the latter case, when surmounted by a crescent that turns the disc into the sun, the moon, or even Venus. The so-called lunar-crescent-above-a-disc, an icon associated with the Phoenician and Punic deities Astarte and Tanit, both goddesses of fertility (Figure 5.5b), is ubiquitous in Phoenician and Punic material culture. It is commonly found on personal adornments made of gold, considered as amulets, and engraved on funerary stelae in both cemeteries and *tophets*. Decorations on masks were part and parcel of the array of Phoenician-Punic decorative patterns for conceiving protection.

These adornments were probably considered to be very effective, especially considering that they are placed directly on the skin. Amulets with these facial traits pending on necklaces are the clearest example. Assuming that these patterns might have also been used to decorate peoples' bodies, masks also provide an interesting case study because they express the idea that protection is inscribed on the skin through jewels and facial makeup, or even through scarification, tattoos or piercings as Cintas (1946: 37) already noted. The horizontal or wavy grooves on the forehead and cheekbones may be decorations, tattooed, scarified or painted, although wrinkles due to smiling are also suggested by Orsingher (2014: 154). Although direct evidence of facial transformation through painting or tattooing does not currently exist, indirect evidence is abundant in the form of cosmetic boxes, razors, tweezers and spatulas, which are part of a material

culture concerned with the care of the body.[4] Furthermore, in funerary contexts the presence of red ochre in relation to body decoration is attested. There is evidence of the use of this colour as funerary makeup, as certain bones in Carthaginian cemeteries present traces of red-ochre (Bénichou-Safar 1982: 260). Recently, some analyses of red pigments found inside wooden boxes or on ostrich-eggshell containers from Carthaginian tombs show that they contained fragments of ochre and cinnabar used as funerary or cosmetic makeup (Alatrache, Mahjoub, Ayed and Ben Younes 2001). Particularly significant is the painted and engraved sculptured pillar found at the entrance of funerary chamber 7 at Sulky (Bernardini 2005: 76). The figure holds a balm bottle and presents red makeup on the hair, lips, ears and nipples.

More precisely, traces of red and black pigments on masks suggest that they were probably painted. Interestingly, the coloured parts are the protective decorations. It is likely that painting clay discs or lunar-crescent-above-a-disc painted in red reinforced their role and entailed meanings of potency and power (Culican 1976). Decorating masks turns them into active materials in protective rituals, and one could argue that it is these decorations and gestures that make the masks suitable materials for expelling evil. As suggested by materiality and embodiment perspectives in the study of figurines (Weismantel and Meskell 2014; Nanoglou 2009), masks may well have been more than merely passive objects; they were engaged with the material world, and their use had material effects through their active participation in protecting people. Facial tattoos might have been vital in the corporeal protection. Some ethnographic studies have shown that celestial symbols tattooed on the skin were designed to cure and conjure, and tattooing was strongly associated with magical practices. This is the case in Medieval Ireland as recorded in written sources (MacQuarrie 2000). Recently, the location of ancient tattoos identified on mummies is supposed to have curative purposes because they are placed on the arthritic joints (Schildkrout 2004: 325–6).

According to Turner (1980), these decorations create a social skin on which issues of membership and transitional periods of person's life are displayed. The skin presents liminal qualities and is the ideal place to perform rituals of transformation and inscribing personal or communal rites and stories. Decorating the skin is a strategy not only for negotiating relations between individuals in terms of gender, age or status, but also for negotiating relations between people and other beings (for instance, divinities, demons, ancestors, the dead; Gell 1993; Schildkrout 2004). It is highly possible that the ornaments on masks would have embodied facial decoration carried out in the rites described above with sensory alterations and exaggerated gestures.

Final thoughts: Masks as ancestors?

In the previous sections, I have argued that masks might have embodied facial gestures and decorations that entailed culturally appropriated meanings. At this point, it is my intention to shed some light on their social role. I argue that, through their gestures and decoration, masks embody a shared way of protecting certain members of the Phoenician

and Punic populations, and that they focus on communities and family groups rather than individuals. The contexts in which they were found, at the entrances of funerary chambers with several tombs and over the doors of houses or in shrines, suggest that masks may be reinforcing a group identity. This supposition is borne out by the relatively small number of masks in comparison with the thousands of tombs that have been excavated so far in the cemeteries.

This scenario shows that only a small community of Punic people embodied their identity through the use of masks. In my view, the lack of any specific decorations associated exclusively with areas such as Carthage, Sardinia or Eivissa reinforces the idea that these decorations materialize an identity that was related to certain Punic diasporic communities of the western Mediterranean and not to specific regions.

Assuming that masks have a protective role, we might wonder who is being called upon to provide protection. Both the contexts of recovery – chamber tombs, doors of houses, shrines – and their gestures and decoration, give some clues to understand masks as representations of ancestors. Indeed, the Phoenician word *RP'M* meant not only dead people or ancestors (Ribichini 1987: 150) but also to heal and to protect (Xella 2001). The protective capacities of the Phoenician ancestors have been put forward in the erection of the temple of Bitia (Sardinia). The building, labelled as a healing sanctuary, was devoted to the god Bes. It was constructed on the former Phoenician necropolis probably because of the protective and curative features of the buried ancestors (Garbati 2014: 298–9).

Masks make clear the corporeal processes that turn a person into an ancestor, as ancestorhood is an achieved status and not all the dead could be ancestors (Whitley 2002: 122). In this case, people became an ancestor through their associations to otherworldly beings such as monsters, divinities and gorgoneia. What all the types of decoration on the masks show is, that in this process, it is important to write the biography on the surface of the skin. Furthermore, becoming an ancestor qualifies a person to protect the community, because they have already experienced death, had contact with otherworldly beings in the afterlife, and possesses the knowledge, techniques, gestures and rituals that ward off evil and bring welfare and protection to their descendants. This idea is supported by the interpretation of masks as portraits of elderly people. Regardless of whether the grooves are depictions of wrinkles or decorations, the point here is that both possibilities reinforce the idea that ancestors have suffered a process of facial and vital transformation through rites of passage with a high degree of sensory alteration or through the passage of time.

The standardized way of constructing and understanding the physical appearance of ancestors through the iconography of the masks stresses the possibility of labelling them as remote or of understanding them as a part of a collective (Whitley 2002: 122; Insoll 2011: 1044). This way of materializing common ancestors may have been created in the Levant and brought to the western Mediterranean by the first Phoenician inhabitants. Interestingly, the oldest masks are located in houses or domestic contexts rather than cemeteries or shrines. This is clearly seen at the site of Morro de Mezquitilla, one of the oldest Phoenician colonies in Iberia dated to the end of the ninth or the beginning of the eighth century BCE. Despite the changes in the decorative motifs and in the expressions

of grimacing, this way of conceiving protection in relation to ancestors met with success and was transmitted and adapted across the Phoenician world. Among the examples are the apotropaic-faced amulets widespread throughout the western Mediterranean from the fifth century onwards (Velázquez Brieva 2007: 125).

Conclusions

Phoenician-Punic masks emphasize the importance of gestures in archaeology because they shed light on the way certain attitudes are embodied in material culture; in this case, they embody gestures that ward off evil. Grinning masks present expressive heads through their gestures and decoration and this corporeality is common to other objects such as amulets, faces on mural paintings of burial chambers, or faces painted on ostrich eggshells. All of them have in common an apotropaic role, where the protective elements are emphasized though exaggerated gestures such as large, open eyes and grimacing, as well as decoration that represents makeup, tattoos or scarification. I have also considered that these ornaments and gestures would have occurred in ritual practices, where the exaggerated gestures would have embodied sensory alterations. Grinning can be considered as such and, at the same time, it could have reinforced the bonds of the participants. All in all, people may have attached power to these objects because they may have conceived protection in relation to representations of ancestors. Thus, the facial gestures and decorations are not simply representations but entail culturally appropriate meanings widespread across the Mediterranean and clearly understood by the Phoenician and Punic communities.

Acknowledgements

The first draft of this chapter was written in 2015, during my stay at the Joukowsky Institute for Archaeology and the Ancient World, Brown University, supported by the Secretariat for Universities and Research of the Ministry of Economy and Knowledge of the Government of Catalonia and the seventh programme Marie Curie COFUND Contract No. 6000385. I would like to thank the editors and anonymous reviewers who helped to improve the manuscript. I am also indebted to the Sezione per i Beni Archeologici della Soprintendenza di Trapani and the Museo Archeologico Nazionale Cagliari for their kind permission to publish images from their collections. I would like to thank Adriano Orsingher and Roald Docter for providing me with their drawings and figures.

Notes

1. Baal Hammon was considered the chief god of Carthage together with his partner Tanit, face of Baal. He is portrayed as a bearded old man seated on a throne decorated with sphinxes. He

is normally represented with an upraised arm in a blessing gesture while he holds ears or other fertility symbols in the hand of his other arm. For a comprehensive study of this divinity see Xella (1991).

2. A *uraeus* is a visual element typical of Egyptian iconography which represents a stylized, upright cobra, symbolic of royal and divine authority in ancient Egypt.

3. It is worth mentioning that different facial gestures are recorded in other cemeteries. The sculpted faces of the burial chamber of Qallilija (Malta) and Monte Sirai (Sardinia) present faces with eyes and mouth closed. Shut mouths are considered to keep the vigour of the body from its final breath or to stop the enemy from taking the body from its resting place (Vella 2012). This heterogeneity shows the diversity of gestures in connection to death.

4. Schildkrout (2004: 331–3) reviews ethnographic case studies in Africa and Australia where people decorate houses, baskets, pottery and textiles using the same patterns used in body painting.

References

Acquaro, E. (1990), 'Una maschera púnica trovata soto il cardine IX romano', *Mitteilungen des Deutschen Archaeologische Institut. Römische Abteilung*, 97: 54–6.

Alatrache, A., H. Mahjoub, N. Ayed and H. Ben Younes (2011), 'Les Fards rouges cosmétiques et rituels a base de cinabre et d'ocre de l´époque punique en Tunisie: Analyse, identification, et caractérisation', *International Journal of Cosmetic Science*, 23: 281–97.

Amadasi Guzzo, M. G. and J. A. Zamora López (2013), 'The Epigraphy of the Tophet', in P. Xella (ed.), *The Tophet in the Phoenician Mediterranean*, 159–92, Verona: Essedue Edizioni.

Appendino, G., F. Pollastro, L. Verotta, M. Ballero, A. Romano, P. Wyrembek, K. Szczuraszek, J. W. Mozrzymas and O. Taglialatela-Scafati (2009), 'Polyacetylenes from Sardinian *Oenanthe fistulosa*: A Molecular Clue to *risus sardonicus*', *Journal of Natural Products*, 72 (5): 962–5.

Astruc, M. (1956), 'Traditions funéraire de Carthage', *Cahiers de Byrsa*, 6: 29–58.

Badre, L. (1997), 'Bey 003 Preliminary Report. Excavations of the American University of Beirut Museum 1993–1996', *BAAL*, 2: 6–94.

Bartoloni, P. (2012), *Fenici al volo. La Sardegna fenicia e punica*, Sassari: Carlo Delfino.

Bénichou-Safar, H. (1982), *Les Tombes puniques de Carthage: Topographie, Structures, Inscriptions et Rites Funéraires*, Paris: Éditions du Centre National de la Recherche Scientifique.

Bénichou-Safar, H. (2008), 'Une Stele carthaginoise bien prolixe', *Ephesia Grammata, Revue d'études des magies anciennes*, 2: 1–30.

Bernal, D., A. Sáez Romero, J. J. Díaz Rodríguez, J. A. Expósito Álvarez, L. Lorenzo Martínez, A. Sáez Espligares and R. García Jiménez (2005), 'Gadir y la manufactura de máscaras y terracotas. Aportaciones del taller isleño de Villa Maruja', *Madrider Mitteilungen*, 46: 61–86.

Bernardini, P. (2005), 'Recenti scoperte nella necropoli punica di Sulcis', *Rivista di Studi Fenici*, 33: 63–80.

Campanella, L. (2007), 'Una maschera fittile dall'area dell'abitato preromano del foro', *Quaderni Noriensi*, 2: 189–201.

Ciasca, A. (1991), *Protomi e Maschere Puniche*, Rome: Libreria dello Stato.

Cintas, P. (1946), *Amulettes Puniques*, Tunis: Institut des Hautes Etudes.

Culican, W. (1975–6), 'Some Phoenician Masks and Other Terracottas', *Berytus*, 24: 47–87.

Culican, W. (1976), 'Phoenician Demons', *Journal of Near Eastern Studies*, 35: 21–4.

Del Vais, C. and A. C. Fariselli (2012), 'Le maschere nella Sardegna punica: contesti, modelli e valore iconologico', in H. Meller and R. Maraszek (eds), *Masken der Vorzeit in Europa, II*.

Internationale Tagung vom 19.bis 21. November 2010 in Halle (Saale), 71–9, Halle: Landesamt für Denkmalpflege und Archäologie Sachsen-Anhalt, Landesmuseum für Vorgeschichte.

Escacena Carrasco, J. L. and Á. Gómez Peña (2016), 'Símbolos de duelo. Sobre el mensaje de las máscaras gesticulantes fenicias', *Madrider Mitteilungen*, 56: 62–87.

Fantar, M. H. (1995), *Carthage. La cité punique*, Paris: Éditions du Centre National de la Recherche Scientifique.

Fariselli, A. C. (2007), 'Musica e danza in contesto fenicio e punico', *Itineraria*, 6: 9–46.

Fariselli, A. C. (2011), 'Maschere puniche. Aggiornamenti e riletture iconologiche', *Ocnus. Quaderni della Scuola di Specializzazione in Beni Archeologici*, 19: 155–70.

Fariselli, A. C. (2014), 'Maschere antropomorfe in terracotta nell'Oriente fenicio. Riflessioni per la redazione di un *corpus*', in A. Lemaire (ed.), *Phéniciens d'Orient et d'Occident. Mélanges Josette Elayi*, 147–67, Paris: Collège de France.

Fernández, J. H. (1992), *Excavaciones en la necrópolis del Puig des Molins (Eivissa). Las campañas de D. Carlos Román Ferrer: 1921–1929*, Eivissa: Museu Arqueològic d'Eivissa i Formentera.

Ferrer, E., F. J. Sibón and D. Mancheño (2000), 'Máscaras púnicas de Gadir', in M. E. Aubet and M. Barthélemy (eds), *Actas del IV Congreso Internacional de Estudios Fenicios y Púnicos, Vol. II*, 593–605, Cádiz: Universidad de Cádiz.

Garbati, G. (2014), 'Il tempio "di Bes" e i "devoti sofferenti" di Bitia. Memorie locali e attualità del culto', in T. Tortosa (ed.), *Diálogo de Identidades. Bajo el prisma de las manifestaciones religiosas en el ámbito mediterráneo (s. III a.C.- s. I. d. C.)*, Anejos de AEspA LXXII, 289–302, Mérida: Consejo Superior de Investigaciones Científicas.

Garbati, G. (2016), '"Hidden Identities". Observations on the "grinning" Phoenician masks of Sardinia', in G. Garbati and T. Pedrazzi (eds), *Transformation and Crisis in the Mediterranean and Interculturality in the Levant and the Phoenician West during the 8th–5th Centuries BCE*, 209–28, Roma: CNR-Istituto di Studi sul Mediterraneo Antico.

Gell, A. (1993), *Wrapping in Images: Tattooing in Polynesia*, Oxford: Clarendon Press.

Graff, S. B. (2014), 'Demons, Monsters, and Magic', in J. Aruz, S. B. Graff and Y. Rakic (eds), *Assyria to Iberia at the Dawn of the Classical Age*, 263–71, New York: Metropolitan Museum of Art.

Homer (2016), *The Odyssey*, trans. A. Verity, Oxford: Oxford University Press.

Insoll, T. (2011), 'Ancestor Cults', in T. Insoll (ed.), *Oxford Handbook of the Archaeology of Ritual and Religion*, 1043–58, Oxford: Oxford University Press.

Jiménez Flores, A. M. (2004), 'Aegyptiaca: datos sobre la espiritualidad en la necrópolis de Gadir', *SPAL*, 13: 139–54.

Kendon, A. (2004), *Gesture: Visible Action as Utterance*, Cambridge: Cambridge University Press.

López-Bertran, M. (2007), 'Ritualizando cuerpos y paisajes: un análisis antropológico de los rituales fenicio-púnicos', PhD diss., Universitat Pompeu Fabra, Barcelona.

López-Bertran, M. (in press), 'La muerte como experiencia sensorial: rituales funerarios entre fenicios y púnicos', in A. M. Niveau de Villedary (ed.), *Nuevas perspectivas de investigación en arqueología funeraria*, Supplemento Rivista di Studi Fenici.

López-Bertran, M. and A. Garcia-Ventura (2008), 'Materializing Music and Sound in Some Phoenician and Punic Contexts', *Saguntum*, 40: 27–36.

López-Bertran, M. and A. Garcia-Ventura (2012), 'Music, Gender and Rituals in the Ancient Mediterranean: Revisiting the Punic Evidence', *World Archaeology*, 44 (3): 393–408.

López-Bertran, M. and A. Garcia-Ventura (2014), 'Las terracotas de instrumentistas de la Ibiza punica: consideraciones organologicas y apuntes para su interpretación', *Rivista di Studi Fenici*, 42 (1): 49–71.

López-Bertran, M. and A. Garcia-Ventura (2016), 'The Use of Facial Characteristics as Engendering Strategies in Phoenician-Punic Studies', *Near Eastern Archaeology*, 79 (3): 206–13.

López-Bertran, M. and J. Vives-Ferrándiz (2009), 'Menjar, beure, cremar. Els rituals com a pràctiques relacionals durant l'Edat del Ferro', in J. Diloli Fons and S. Sardà Seumà (eds),

Ideologia, pràctiques rituals i banquet al nord-est de la península Ibèrica durant la protohistòria. V Cicle de conferències CITERIOR 5, 163–89, Tarragona: Arola Editors.

MacQuarrie, C. W. (2000), 'Insular Celtic Tattooing: History, Myth and Metaphor', in J. Caplan (ed.), *Written on the Body: The Tattoo in European and American History*, 32–45. Princeton, NJ: Princeton University Press.

Manfredi, M. I. (1988), 'Su un monumento punico di Tharros', *Studi de Eggitologia e Antichitá Puniche*, 3: 93–109.

Martin, R. S. (2014), 'From the East to Greece and Back Again: Terracotta Gorgon Masks in a Phoenician Context', in A. Lemaire (ed.), *Phéniciens d'Orient et d'Occident. Mélanges Josette Elayi*, 289–99, Paris: Collège de France.

Mattazzi, P. and V. Paretta, V. (2004–5), 'Le tombe puniche decorate di Tuvixeddu a Cagliari', *Byrsa*, 3–4: 37–92.

Mazza, F. (1975), 'Le formule di maledizione nelle iscrizioni funerarie votive feniche e puniche', *Rivista di Studi Fenici*, 3: 9–30.

Morstadt, B. (2010), 'Phönizische Masken- zwischen Abbild und Abschreckung', in H. Meller and R. Maraszek (eds), *Masken der Vorzeit in Europa, I. Internationale Tagung vom 20. bis 22. November 2009 in Halle (Saale)*, 203–23, Halle: Landesamt für Denkmalpflege und Archäologie Sachsen-Anhalt, Landesmuseum für Vorgeschichte.

Moscati, S. (1968), *I Fenici in Sardegna*, Milano: Bompiani.

Moscati, S. (1988), *I Fenici*, Milano: Bompiani.

Nanoglou, S. (2009), 'The Materiality of Representation: A Preface', *Journal of Archaeological Method and Theory*, 16: 157–61.

Niemayer, H. G. and R. F. Docter (1998), 'Excavación bajo el Decumano maximo de Cartago durante los años 1986–1995: informe preliminar', in M. Vegas (ed.), *Cartago fenicio-púnica. Las excavaciones alemanas en Cartago 1975–1997*, 47–110, Barcelona: Publicaciones del Laboratorio de Arqueología de la Universidad Pompeu Fabra.

Orsingher, A. (2014), 'Listen and Protect: Reconsidering the Grinning Masks after a Recent Find from Motya', *Vicino Oriente*, 18: 145–71.

Orsingher, A. (2018a), 'Ritualized Faces: The Masks of the Phoenicians', in A. Berlejung and J. E. Filitz (eds), *The Physicality of the Other: Masks as a Means of Encounter*, Orientalische Religionen in der Antike, 27, 265–305, Tübingen: Mohr Siebeck.

Orsingher, A. (2018b), 'Across the Middle Sea: The Long Journey of Phoenician and Punic Masks', in M. Barbanera (ed.), *La medesima cosa sono Ade e Dionisio. Maschere, Teatro e Rituali Funerari nel Mondo Antico*, Scienze dell'Antichità, 24, 3, 51–68, Roma: Edizioni Quasar.

Perdigones, L. and Múñoz, A. (1990), 'Excavaciones arqueológicas de urgencia en un solar de la calle Tolosa Latour. Extramuros Cádiz', *Anuario Arqueológico Andaluz 1987*, 3: 59–70.

Picard, C. G. (1965–6), 'Sacra Punica. Étude sur les masques et rasoirs de Carthage', *Karthago*, 13: 1–115.

Pisano, G. (1995), 'Considerazioni sui gioielli fenici alla luce delle nuove scoperte', *Studi de Eggitologia e Antichitá Puniche*, 14: 63–73.

Pisano, G. (2004), 'Beni di lusso nel mondo punico. Le uova di struzzo III – Volti o maschere?', *Saguntum*, 36: 47–52.

Prag, J. R. W. (2014), 'Phoinix and Poenus: Usage in Antiquity', in J. C. Quinn and N. C. Vella (eds), *The Punic Mediterranean. Identities and the Identification from Phoenician Settlement to Roman Rule*, 11–23, Cambridge: Cambridge University Press.

Pritchard, J. B (1988), *Sarepta IV. The Objects from Area II, X*, Beirut: Publications de l'Université Libanaise.

Quinn, J. C. (2013), 'Tophets in the "Punic World"', in P. Xella (ed.), *The Tophet in the Phoenician Mediterranean*, 24–48, Verona: Essedue Edizioni.

Ribichini, S. (1987), 'Concezioni dell'oltretomba nel mondo fenicio e punico', in P. Xella (ed.), *Archeologia dell'inferno*, 147–61, Verona: Essedue Edizioni.

Ribichini, S. (2003), *Il riso sardonico. Storia di un proverbio antico*, Sassari: Carlo Delfino.

Samson, A. V. and B. M. Waller (2010), 'Not Growling but Smiling: New Interpretations of the Bared Teeth Motif in the Pre-Columbian Caribbean', *Current Anthropology*, 51 (3): 425–33.

Savio, G. (2004), *Le uova di struzzo dipinte nella cultura punica*, Madrid: Bibliotheca Archaeologica Hispana 22 / Studia Hispano-Phoenica 3, Real Academia de la Historia.

Schildkrout, E. (2004), 'Inscribing the Body', *Annual Review of Anthropology*, 33: 319–44.

Schubart, H. (1979), 'Morro de Mezquitilla. Informe preliminar sobre la campaña de excavaciones de 1976', *Noticiario Arqueológico Hispánico*, 6: 177–218.

Schubart, H. and G. Maas Lindemann (1985), 'Toscanos. El asentamiento fenicio occidental en la desembocadura del río Vélez. Excavaciones de 1971', *Noticiario Arqueológico Hispásnico*, 18: 137–39.

Spanò Giammellaro, A. (1995), 'Aspetti inediti di cultura materiale dalla necropoli punica di Palermo', *Cuadernos de Arqueología Mediterránea*, 1: 33–3.

Stern, E. (1976), 'Phoenician Masks and Pendants', *Palestine Exploration Quarterly*, 108: 109–18.

Turner, S. T. (1980), 'The Social Skin', in J. Cherfas and R. Lewin (eds), *Not Work Alone: A Cross-Cultural View of Activities Superfluous to Survival*, 112–40. London: Temple Smith.

Velázquez Brieva, F. (2007), 'Los amuletos púnicos y su función mágico-religiosa', in B. Costa and J. H. Fernández (eds), *Magia y superstición en el mundo fenicio-púnico*, XXI Jornadas de arqueología fenicio-púnica, 97–142, Eivissa: Treballs del Museu Arqueològic d'Eivissa i Formentera.

Vella, N. C. (2012), 'A Face from the Past: Death Ritual in Punic Malta', in C. Del Vais (ed.), *EPI OINOPA PONTON. Studi sul Mediterraneo antico in ricordo di Giovanni Tore*, 379–90, Oristano: S'alvure.

Vives-Ferrándiz, J. (2015), 'Mobility, Interaction and Power in the Iron Age Western Mediterranean', in A. B. Knapp and P. van Dommelen (eds), *The Cambridge Prehistory of the Bronze and Iron Age Mediterranean*, 299–316, Cambridge: Cambridge University Press.

Weismantel, M. and L. Meskell (2014), 'Substances: "Following the Material" through Two Prehistoric Cases', *Journal of Material Culture*, 19 (3): 233–51.

Whitley, J. (2002), 'Too Many Ancestors', *Antiquity*, 76: 119–26.

Xella, P. (1991), *Baal Hammon: Recherches sur l'identité et l'histoire d'un dieu phénico-punique*, Roma: Consiglio Nazionalle delle Ricerche.

Xella, P. (2001), 'Baal di Ugarit e gli dèi fenici: una questione di vita o morte', in P. Xella (ed.), *Quando un dio muore. Morti e assenze divine nelle antiche tradizione mediterranee*, 73–96, Verona: Essedue Edizioni.

Xella, P. (ed.) (2013), *The Tophet in the Phoenician Mediterranean*, Verona: Essedue Edizioni.

PART II
THE VISUALITY OF GESTURE

CHAPTER 6
THE PITFALLS AND POTENTIALS OF VISUAL EVIDENCE FOR THE HISTORY OF GESTURES: THE EXAMPLE OF ATHENIAN POTTERY

Timothy J. McNiven

In studying gestures in archaeology, there is a wide variation in the amount of resources available. Some scholars work with both images and texts; some have only images. Some cultures have left tantalizingly few examples to work with; others have left more. The culture that is the object of this study, ancient Greece, left an extensive literature as well as a large body of images. My own work examines gestures in images on pottery made in Athens from roughly 750 to 300 BCE, a body of some 80,000 objects from a wide range of contexts. Many of these images tell stories, and gestures are often used to develop the narrative by adding emotional responses and portraying certain kinds of communication. With such an extensive body of well-dated images, it is often possible to interpret the meaning of a gesture and trace its appearance, development and disappearance. But the problems of interpretation still arise. Ancient images are never objective documentation; they are subject to their own conventions, and the images may vary according to who was using the object, and why.

Difficulties with the evidence

Archaeologists, of course, deal with dead cultures. We cannot ask informants to explain a gesture or run surveys on what particular gestures mean like Morris's team did in modern Europe (Morris, Collett, Marsh and O'Shaughnessy 1979). Some scholars have made the very natural assumption that a gesture that looks familiar had the same meaning in the past. For example, a dancing woman painted in the Etruscan 'Tomb of the Lionesses' at Tarquinia extends her index and little fingers [Cat. 1]. This has been interpreted by comparison to the 'Horns of the Bull' gesture that is still used in Italy today to indicate a cuckold (Morris et al. 1979: 128). However, there is no evidence of continuity for this gesture between the sixth century BCE and the discussion of it in 1832 by Andrea de Jorio, who recorded the gesture in Naples, 250 miles south of Etruria (de Jorio [1832] 2000).

In addition, two-dimensional images cannot render the motion, duration or amplitude in the performance of a gesture (Settis 1984: 209–10). Modern technology, such as Kendon's video recordings, allows investigators to study the gestural language they are trying to understand in detail (Kendon 2004: 109–11). Archaeologists, of course,

deal with hand-made objects where the traditions of figuration and style were strong. Understanding the conventions takes a great deal of familiarity with the range of imagery in order to avoid misunderstanding. Sometimes aesthetic concerns affect the depiction of gestures. In symmetrical compositions, as with the birth goddesses who surround Zeus at the birth of Athena on a black-figure *pyxis* in Paris (Figure 6.1) [Cat. 2], the same gesture can be made with opposite arms, making moot any discussion of the handedness of the gesture. Likewise, gestures may not be shown at all. There are references in both Greek and Latin literature to the *digitus impudicus*, the shameless middle finger extended in contempt, but we do not have a single illustration of it (Corbeill 2003: 6). Finger gestures, in general, are rather rare in art, since most artists are not dealing with that level of detail.

Also, there is the issue of lost evidence. Any conclusions that we draw must recognize that we are looking at an unknown sample of what was originally produced. With Athenian pottery, the 80,000 pots that exist today are estimated to be between one per cent and a half of a per cent of the original production (Bentz 1998: 17; Sapirstein 2014: 184). What images have been lost completely? How is the evidence skewed by the accidents of preservation and excavation? This is, of course a problem in all archaeology.

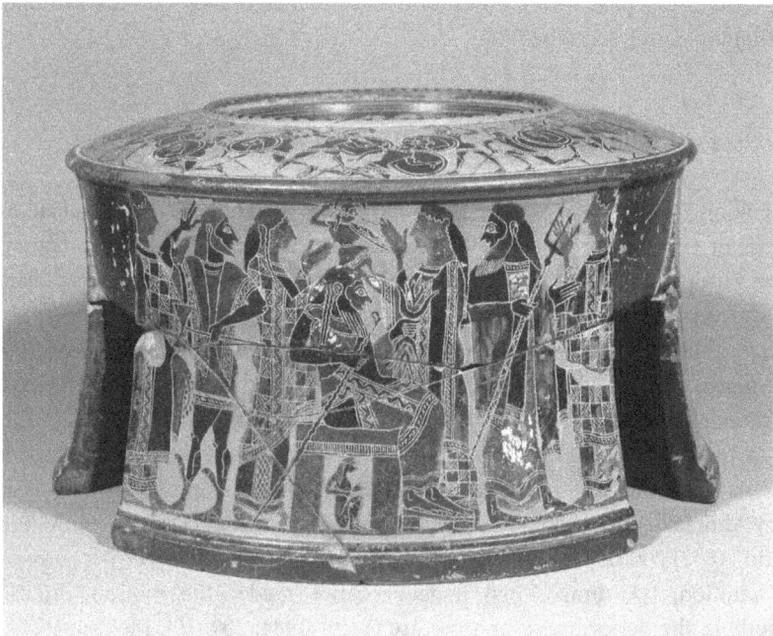

Figure 6.1 Birth of Athena, *c.* 570–560 BCE, Athenian black-figure *pyxis* attributed to the C Painter. Louvre, Paris, No. CA 616. Photograph: © Erich Lessing/Art Resource, New York.

Methods of interpretation

Previous scholarship on gestures in Greek art examined a few clear examples and made sweeping conclusions about the meaning of the gesture depicted. Neumann in 1965 divided gestures first into deliberate, conscious communications such as handshakes, which he labelled *Gesten*, and unconscious emotional reactions such as signs of fright, which he called *Gebärden* (Neumann 1965: 12). Gombrich made a similar distinction between ritualized gestures and expressions of emotion (1979). (This is similar to the distinction made between 'gesture' and 'gesticulation' in Kendon 2004: 716, 99.) I would argue that, like language, all gestures are learned and conscious to some degree, and only become unconscious through time. Children learn to gesture before they are able to speak, and we are constantly developing and attempting to control the vocabulary of gestures in our culture (McNiven 2007). In dealing with images, as opposed to actual practice, the distinction between communicative and expressive gestures is often ambiguous. Since the two types of gestures are the starting points for Neumann's classification, in his work gestures that look very similar are classified differently because they are interpreted differently. In order to classify a gesture, one must have already interpreted it.

My methodology, on the other hand, is based on the methods of lexicography, especially those developed to create dictionaries of unwritten languages (McNiven 1982, based on Zgusta 1971). That is, the first requirement was for a code that could serve as a lemma, under which examples of a gesture that looked alike would be grouped, in advance of any interpretation. (In a language, this would be the spelling.) Each code isolated a particular form of gesture, as seen on Athenian pottery, without referring to its meaning. These basic forms are here labelled *schemata* (sing. *schema*), using the ancient Greek term for recognizable visual patterns, including gestures (Catoni 2005). Thus, there are finger and hand *schemata*, ones made with the left or right arms, or both at the same time. These limbs are depicted being raised or lowered, and bent in various ways. In semiotic terms, this was an attempt to isolate the signifier from the signified, as the first step in the process of definition. It will be noted that this system is derived from the material itself, that it is empirical rather than theoretical, and is not intended to be universally applicable. As many examples of gestures as possible were then collected, along with other reference information, such as museum number, date and so on, and this information was written on an individual card. At this point, there are 16,000 of these 'slips', as they are called in lexicography, filling a library cabinet and now on a database. (For comparison, the *Oxford English Dictionary* boasts 3 million quotations, which include only the most relevant examples.) The point of all this drudgery is to collect comparable examples together in order to interpret them, for that is the real goal here.

Interpretation is a demanding yet fickle lover. Scholars argue about the meaning of particular gestures, often basing their views on a few examples or a particularly significant single example. Even with a larger sample, and with a culture that mentions gestures in its texts, problems persist. Like words, some *schemata* have multiple meanings: the index

finger points but also signals 'one'. Some *schemata*, especially those involving fingers, remain unexplained. Interpretation usually derives from context, but this can also be ambiguous, as when a scene involving a youth and a young woman is seen by different scholars as showing respectable courtship or soliciting for prostitution. Narrative scenes, such as those from Greek mythology, provide a much more specific context for the gestures that appear in them. Keeping this in mind, and examining the widest range of examples, is most likely to produce the correct meaning.

Interpretation: Successes and failures

Sometimes interpretation is simple. On disappointingly few pots, we have captions that make the meaning of a gesture obvious, as on a red-figure *pelike* in St. Petersburg, where a three-sided conversation is recorded, along with three gestures [Cat. 3]. The young man on the left points at a bird flying above and says, 'Look, a swallow!' The pointing man in the centre answers him, 'Yes, by Herakles!' The boy on the right waves and says, 'It's Spring!' Such cartoon bubble dialogue is rare on Athenian pottery, so it is particularly disappointing that this is so banal. We have little trouble interpreting these gestures; only the species and significance of the swallow are explained (Immerwahr 2010). Elsewhere, as in scenes from the gymnasium, as on a cup in London [Cat. 4], we have a gesture we know from our historical sources. In the free form of boxing known as the *pankration*, the contest only ended when one of the fighters submitted by raising his finger, and that gesture is nicely displayed.

Most gestures must be interpreted on the basis of context. An obvious example of this is one of the many scenes of funerals that we have from ancient Athens (Kurtz and Boardman 1971; Shapiro 1991; Pedrina 2001). On a funerary plaque in Paris, the men stand together on the left and raise their right arms to sing the dirge for the dead youth (Figure 6.2) [Cat. 5]. The women encircle his corpse and beat their heads or pull their hair in grief. The women's gestures have parallels around the eastern Mediterranean going back hundreds of years, as, for example, on the Egyptian funerary papyrus of Hunefer, dated *c.* 1310 BCE [Cat. 6].

Greek art is unusual for its fascination with depicting myths, and these allow us to interpret gestures with some subtlety, knowing not just the actions of the characters, but also their motivations and dilemmas. In a famous image in a cup in the Vatican, for example, Oedipus ponders the riddle of the sphinx [Cat. 7]. His hand under his chin is a familiar gesture for a thinker used much later by Rodin (Settis 1984). When a similar gesture is used on a *hydria* in Cambridge for one of the daughters of Pelias [Cat. 8], who is looking at the sword her sister is holding, we can understand that she has some misgivings about dismembering their father.

Sometimes, the use of a gesture in one of these clear mythological scenes provides the key to a gesture whose meaning is otherwise ambiguous. In a depiction on a cup in Vienna of the contest between Ajax and Odysseus for the arms of Achilles, we see the actual vote (Figure 6.3) [Cat. 9]. Odysseus stands on the left, with his hands raised in

Figure 6.2 Funeral of a youth, *c.* 500 BCE, Athenian black-figure plaque attributed to the Sappho Painter. Louvre, Paris, No. MNB 905. Photograph: © Erich Lessing/Art Resource, New York.

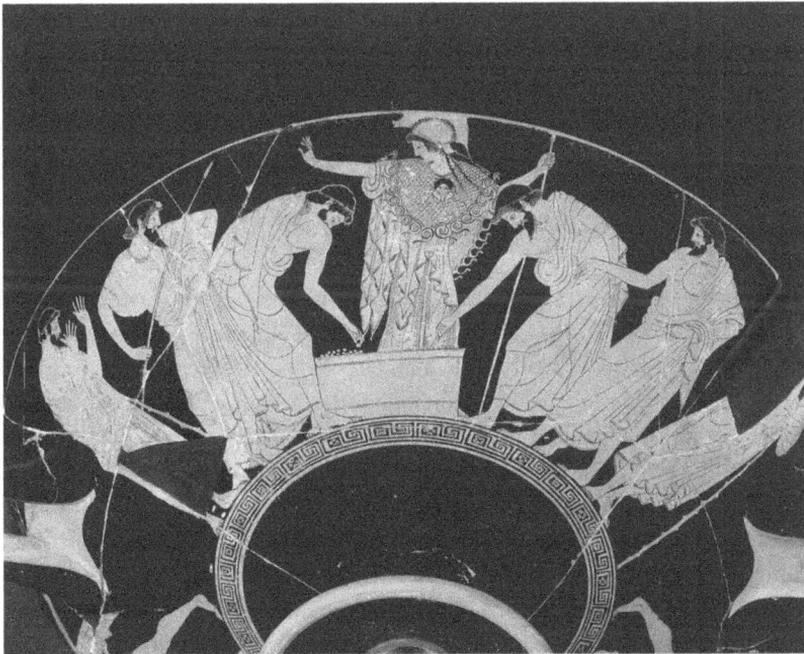

Figure 6.3 Voting for the armour of Achilles, *c.* 490 BCE, Athenian red-figure cup signed by Douris. Kunsthistorisches Museum, Vienna, No. 3695. Photograph: © Erich Lessing/Art Resource, New York.

delight at his higher tally of votes, while Ajax lowers his head in shame and rests it on his hand on the right. From the story, we know what led up to this point and that Odysseus' triumph will be tempered when Ajax commits suicide. The same gesture as Ajax exhibits also appears in a depiction of a music school also in Vienna [Cat. 10], where scholars have interpreted it as a sign that the listener on the left is rapt in the music. I would argue, on the basis of parallels such as the figure of Ajax, that the man is distressed by what he hears, and the teacher in the centre of the scene is stopping the lesson. Without attention to the parallels, the gesture has been misinterpreted and the humour of this image has escaped us completely.

Gestures, of course, have multiple and overlapping meanings, and this must be taken into account. The handshake, for example, is a much discussed and problematic gesture in ancient Greece. It was a form of greeting, as is clear in an image of Herakles and Pholos in London [Cat. 11]. By the end of their story, when Herakles leaves, the centaur is dead, so they cannot be saying goodbye. But the handshake could also be used in farewells, as on another *amphora* in London, where Theseus says goodbye to his grandfather Pittheus [Cat. 12]. This ambiguity has plagued the interpretation of the handshake on Athenian grave stelai, where figures seated and standing join hands [Cat. 13]. It is often unclear which figures are the deceased, and who the others are. Does the gesture indicate a farewell at the departure of the dead, or the greeting given at the reunion of family members on the other side? For an answer to this we must look to examples of the gesture on pottery, such as an *amphora* in the Vatican, where Herakles shakes hands with Athena [Cat. 14]. She cannot be welcoming him to Olympus, since his mortal nephew Iolaos is standing behind him. Nor does a farewell make much sense between these two. Rather, their handshake should be seen as a sign of their unity and common purpose, a meaning the gesture is explicitly given in treaty reliefs such as one in Athens, showing Athena shaking hands with Hera to symbolize the agreement between Athens and Hera's city of Samos [Cat. 15] (Lawton 1995: 88–89). Understood this way, handshakes make sense both as greetings and as farewells, since both re-assert the commonality between two individuals at times of stress (Lawton 1995: 368; Bergemann 1997: 612, 93).

At least that is how our species sees it. On a drinking cup by the Triptolemos Painter, a boy shakes hands with a dog [Cat. 16] (Pevnick 2014). We can all recognize this gesture across 2,500 years, but do we really understand it? Dogs do not raise a paw in friendship, but as a sign of submission, acknowledging another's dominance (Abrantes 1997: 78, 193). The boy may be signalling unity here, but his pet is recognizing the boy's position as top dog in the pack. Even when we think we understand a gesture, there are always subtleties that need to be taken into account.

Finger gestures can be the most difficult to interpret, because they are clearly arbitrary and culturally specific. Even within one's own culture they can be tricky to execute properly. Margaret Thatcher, for example, thought she was giving her supporters the victory sign after her first election, but she got it backwards and unknowingly made the British two-fingered version of the *digitus impudicus* (Morris et al. 1979: 229). Some ancient finger gestures can be quite easily understood today, such as the ones made by a

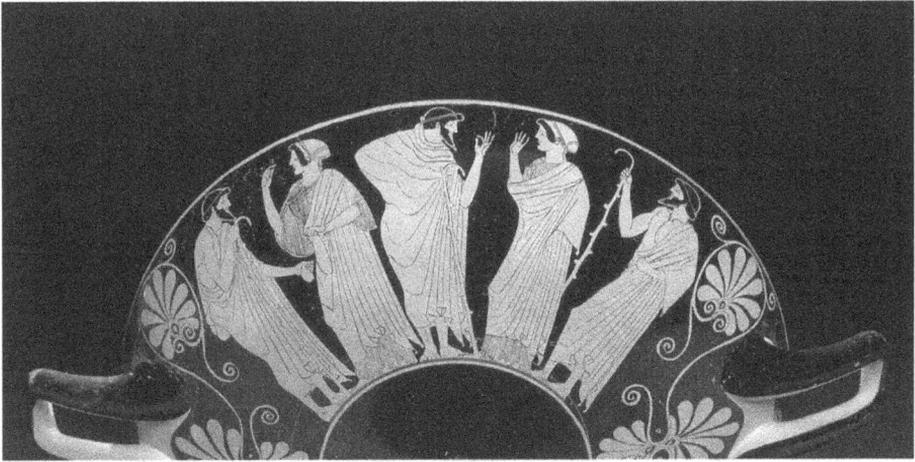

Figure 6.4 Men soliciting prostitutes, *c.* 480 BCE, Athenian red-figure cup attributed to the manner of Douris. British Museum, London, No. 1843,1103.94 (E51). Produced with permission of The British Museum.

prostitute and her customer, who bargain with their fingers on a cup in London (Figure 6.4) [Cat. 17]. He offers 'three' but she wants 'five', and we can accept that the final price will be four. Without a textual explanation, we will probably never know why Herakles extends his ring and little fingers to hold the ankle of the Nemean Lion on an *amphora* in Brescia [Cat. 18]. And why does Dionysos extend his little finger like a proper Victorian tea-drinker, as on an *amphora* in Los Angeles [Cat. 19]?

One of the most common finger gestures found on Athenian pottery (second most common after pointing) appears in so many different contexts that I originally despaired of finding an interpretation. A clear and early example of it appears in a depiction the birth of Athena on the *pyxis* in Athens discussed earlier (Figure 6.1) [Cat. 2]. On the left, the smith god Hephaistos has just split open Zeus's head with his axe so that Athena can be born. He walks away from the scene with his arm raised, ring and little fingers closed against his palm. There are many possible interpretations for this gesture in such a clear context: is it alarm at the miraculous birth, praise for the newborn goddess or something else? None of those interpretations make sense in the light of another example, a *hydria* in Toledo, where women fetch water from a fountain (Figure 6.5) [Cat. 20]. Here the gesture appears in a lively, but ordinary, genre scene. Alarm and praise are out of place. What these women do, as they walk home with their filled water jars on their heads, is talk. Considering this meaning for the gesture, not obvious from the more specific interpretations of the previous example, the gesture can be recognized as one that is still familiar. It has a long history in art, literature and ritual continuing to the present day, where it is used in the Roman Catholic mass. This is the 'logos gesture', named by L'Orange, in which the extended index and middle fingers indicate speech (L'Orange 1953: 171–97; Gombrich 1979: 638).

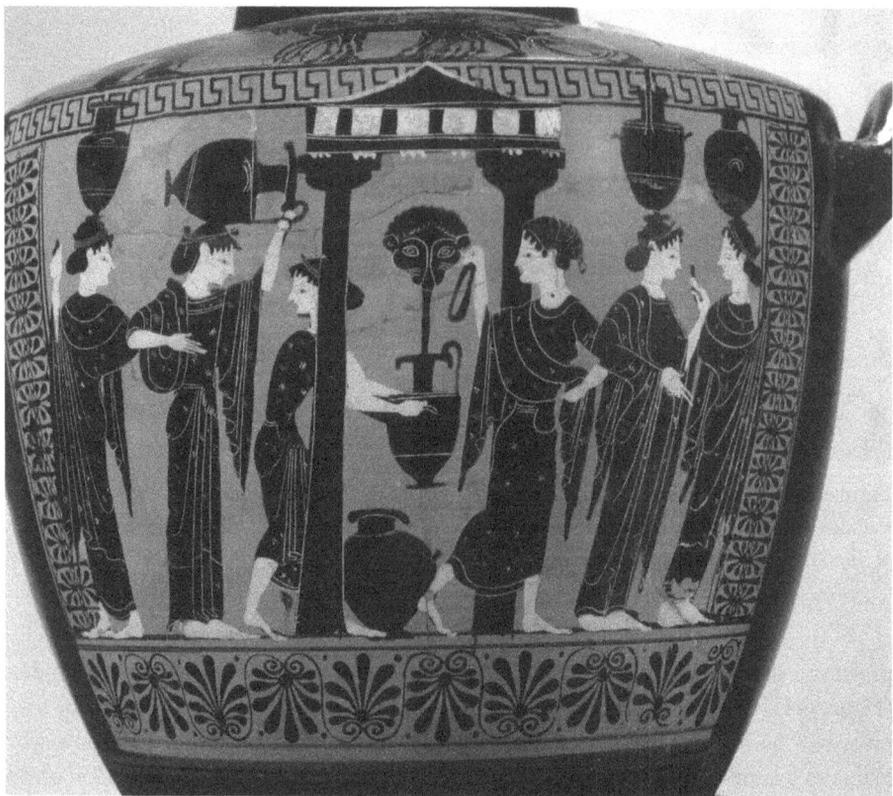

Figure 6.5 Women at a fountain house, *c.* 510 BCE, Athenian black-figure *hydria* attributed to the A D Painter. Toledo Museum of Art, Ohio, No. 1961.23. Produced with permission of The Toledo Museum of Art.

Diachronic change in the meaning of a gesture

The logos gesture demonstrates another aspect of my lexicon. Since Athenian pottery can be closely dated, it is possible to trace the history of a gesture through time. The logos gesture, in fact, can be traced from the sixth century BCE in ancient Greece up to the present day as its contexts broaden and its meanings shift. The gesture first appears in Greek art around 570 BCE on an enormous *krater* for mixing wine and water now in Florence [Cat. 21]. The François *krater* is covered with an array of mythological scenes, including a depiction of the Return of Hephaistos on the reverse. As the crippled smith god on his mule is led by Dionysos towards Olympus, he extends his index and middle fingers horizontally to the right. His unhappy bride-to-be, Aphrodite, echoes the gesture, as she stands on the left before Zeus and Hera on their thrones. Behind the king and queen of the gods, Artemis confronts a crouching Ares, who had wished to marry Aphrodite but was beaten and chained up by his lame brother. Artemis sets her right arm

in front of her chest and displays the two-finger gesture. In this earliest appearance of the gesture in Greek art, it appears three times in one scene, linking the Dionysiac procession on the right with the family grouping on the left. The concatenation of speech here, which may express the varied reactions of the different characters – triumphant, appalled, taunting – is amazingly sophisticated. As with the slightly later example made by Hephaistos at the birth of Athena, the meaning is not clear from the context, however, and can only be supplied in retrospect.

The god who is shown making the logos gesture most often is Hermes, the messenger god. On a *krater* attributed to Lydos in London, he leads the three goddesses to the Trojan prince, Paris, who must decide which is most beautiful [Cat. 22]. Speaking the commands of Zeus is what Hermes does, so the logos gesture is particularly apt for him. Another, human, messenger depicted with two fingers extended is shown on this fourth century Apulian *krater* in Naples [Cat. 23]. The messenger stands on a podium and addresses the Persian king Darius and his councillors with his right hand raised and two fingers extended.

On Apulian pottery, elaborate compositions such as this are often linked with specific tragedies, suggesting that this gesture may also have been used in the theatre. On a volute *krater* in Naples attributed to the Ilioupersis Painter [Cat. 24], for example, Iphigeneia addresses her brother Orestes in a scene that closely follows events in Euripides' play *Iphigeneia in Tauris*. Likewise, in a much later image of a performance of Terence's *Andria*, one of the actors makes the logos gesture [Cat. 25]. Since theatre was an invention only of the late sixth century BCE, and the logos gesture first appears at least a half-century earlier on pottery, theatre is clearly not the original source of the gesture, although it may have been an important vehicle for its dissemination.

Another important context for the two-finger gesture was philosophy and rhetoric. Sculpted portraits of philosophers from the third century BCE onwards show them expounding their ideas using the logos gesture. Such statues are often restored, but we can see a particularly clear depiction of one on a Roman terracotta medallion with a portrait of a philosopher [Cat. 26]. The sense of lecturing or teaching broadens the meaning of the gesture in important ways. Romans, who wanted to display their education, could be portrayed surrounded by philosophers, one of whom executes the logos gesture on a third century sarcophagus in Rome [Cat. 27] (Ewald 1999: 945, 1234). Two hundred years earlier, in his handbook on rhetoric, Quintilian described the logos gesture as the proper gesture for public speaking, the earliest textual reference to the gesture (Quintilian 1920: 2945). In Apuleius' novel *The Metamorphoses*, a man telling a story at a dinner party raised his right hand and 'having bent his two lower fingers in, he stretched the others out at long range and poised the thumb upwards.' Apuleius specifically says he is 'shaping his fingers to resemble an orator's' (Apuleius 1915: 801).

This philosophical and rhetorical use of the logos gesture influenced some of the earliest images of Jesus, shown as a teacher, as on a polychrome relief of the Sermon on the Mount dated about 300 CE [Cat. 28]. Jesus is portrayed as a Greek philosopher, his muscular chest bared, with a scroll in his left hand and his right raised to address the crowd, fingers extended (L'Orange 1953: 172). The gesture, though not the costume, will continue in art for a very long time (Grabar 1964: 323, 412, 712). Codified into the

liturgy, it is most visibly used during a spoken blessing, and that is how it is usually interpreted when it appears in Renaissance and later paintings. Sometimes, the gesture still signified speech, as when it is made by the angel Gabriel addressing the Virgin in the Annunciation.

This discussion of the logos gesture has ignored many subtleties: whether the thumb is folded in or extended, the fingers straight or bent, the hand vertical or horizontal. In the Orthodox liturgy, for example, the thumb holds down the ring finger with the little finger extended. But still it is clear that artists depicted the logos gesture as early as 570 BCE in Athens, and it has continued as part of the iconography of Western art up to the present. It seems to have been used in the theatre and on the podium to indicate a speaker, in schools of philosophy as a sign of a teacher, and then was absorbed into Christian imagery and liturgy as a sign of speech, especially the spoken blessing. Before Quintilian mentioned it around 100 CE, however, we do not know whether, and to what degree, the logos gesture was actually used as a sign of speech. Was it an everyday gesture, or only used formally? Only the images remain.

Like some of the other Greek gestures I have been discussing, there may also be a pre-Greek history to the logos gesture. On an Assyrian relief from Sennacherib's palace at Nineveh, fifty years older than the François *krater*, two scribes record the booty of a Chaldaean city [Cat. 29]. The eunuch in the foreground raises his right hand, clutching his styluses and extending his first two fingers. This seemingly unique image suggests that the logos gesture may have been much older, and used in a wider area, than we know. Was this a diplomatic gesture linked to messengers and officials in the Near East long before the Greeks began to use it? Or was it just a counting gesture since these scribes are counting booty? The isolated example makes it impossible to know.

Conclusion

The decorated pottery of ancient Athens provides a large body of well-dated images of gestures from a culture that is well understood from its literature. Athenian artists developed a sophisticated conventional language of gestures that allows modern scholars to interpret the meanings and trace the histories of gestures over centuries. This wealth of data also allows us to explore the process of interpretation, and to be aware of some of its limitations. At the same time, more information makes us more aware of the inability of any visual representation to match the subtlety and complexity of human non-verbal communication.

Catalogue

Abbreviations

ABV Beazley, J. (1956), *Attic Black-Figure Vase-Painters*, Oxford: Clarendon Press.

ARV2 Beazley, J. (1963), *Attic Red-Figure Vase-Painters*, 2nd edn, Oxford: Clarendon Press.

BAPD (date unknown), Beazley Archive Pottery Database. Available at: http:// www.beazley. ox.ac.uk/carc/pottery (accessed 19 January 2022).

CVA *Corpus Vasorum Antiquorum* (various places, publishers and dates).

LIMC *Lexicon Iconographicum Mythologiae Classicae* (1981–2009), Zürich: Artemis.

Para Beazley, J. (1971), *Paralipomena*, Oxford: Clarendon Press.

RVAp Trandall, A. D. and A. Cambitoglou (1978), *The Red-Figured Vases of Apulia*, Vol. 1, Oxford: Clarendon Press.

Catalogue numbers

1. Tarquinia, Tomb of the Lionesses: Pallottino 1952: 45.
2. Paris, Louvre CA 616: *ABV* 58.122 (C Painter); BAPD 300499; Beazley 1986: pl. 20.2; fig. 1.
3. St. Petersburg, Hermitage 615; *ARV2* 1594.48 (Pioneer Group); BAPD 275006; Neumann 1965: 20, fig. 7.
4. London, British Museum 1867,0508.1060 (E39): *ARV2* 430.29 (Douris); BAPD 205073; *CVA* British Museum 9: pl. 25a (Great Britain 801).
5. Paris, Louvre Museum MNB 905: attributed to the Sappho Painter by Haspels; BAPD 463; fig. 2.
6. London, British Museum EA 9901, sheet 5: Taylor 2001: fig. 133.
7. Vatican, Museo Etrusco: *ARV2* 451.1 (Oedipus Painter); BAPD 205372; Boardman 1975: fig. 301.2.
8. Cambridge, Fitzwilliam Museum GR 12.1917: *ARV2* 623.66 (Villa Giulia Painter); BAPD 207220; *LIMC* 7 (1994) pl. 213 Peliades 12.
9. Vienna, Kunsthistorisches Museum 3695: *ARV2* 429.26 (Douris); BAPD 205070; fig. 3.
10. Vienna, Kunsthistorisches Museum 3698: *ARV2* 471.93 (Makron); BAPD 204875; *CVA* Vienna, Kunsthistorisches Museum 1: pl. 13.1–2 (Austria 13).
11. London, British Museum 1837,0609.42 (B226): *ABV* 273.116 (Antimenes Painter); BAPD 320127; Neumann 1965: 51, fig. 23.
12. London, British Museum 1843,1103.42 (E264): *ARV2* 579.1 (Oinanthe Painter); BAPD 206694; *CVA* British Museum 3: pl. 7.1a (Great Britain 172).
13. Malibu, J. Paul Getty Museum, inv. No. 71.AA.121, grave stele of Mynnia: Reeder ed. 1995: 336 no. 104.
14. Vatican, Museo Etrusco 16573: *ARV2* 182.3 (Kleophrades Painter); BAPD 201656; Neumann 1965, 54: fig. 25.
15. Athens, Acropolis Museum 1333: Lawton 1995: pl. 7, #12.
16. Athenian red-figure cup attributed to the Triptolemos Painter, present whereabouts unknown, formerly in the Hunt Collection, confiscated from G. Medici and returned to Italy: unknown to Beazley; BAPD 8843; Pevnick 2014: 155, fig. 1.
17. London, British Museum 1843,1103.94 (E51): *ARV2* 449.4 (manner of Douris); BAPD 205338; fig. 4.
18. Brescia, Museo Civico: *ABV* 292.1 (Psiax); BAPD 320347; *LIMC* 5 (1990) pl. 43, Herakles 1861.
19. Los Angeles, County Museum of Art 50.8.21: *ARV2* 500.28 (Deepdene Painter); BAPD 205127; *CVA* Los Angeles County Museum of Art 1: pl. 23 (USA 863).
20. Toledo Museum of Art 1961.23: *Para* 147.5ter (A D Painter); BAPD 351088; fig. 5.
21. Florence, Museo Archeologico 4209: *ABV* 76.1 (Kleitias); BAPD 300000; *Bolletino d'Arte* 62 (*Serie speciale* 1) (1977) pl. 90–2.

22. London, British Museum 1948,1015.1: *ABV* 108.8 (Lydos); BAPD 310154; *LIMC* 5 (1990) pl. 238, Hermes 455b.
23. Naples, Museo Archeologico inv. 81947: *RVAp* 2, 495, 18/38, pl. 176.1–3 (Darius Painter); Trendall 1989: fig. 203.
24. Naples, Museo Archeologico inv. 82113; *RVAp* 1, 193/3 (Ilioupersis Painter); Trendall and Webster 1971: 92.
25. Terence miniatures in the Vatican, Vat. lat. 3868: Dodwell 2000: pls 19 and 29a.
26. Athens, Agora Museum P22351: *American Journal of Archaeology* 57 (1953) pl. 29, fig. 8.
27. Rome, Torlonia Collection 424, sarcophagus of L. Pullius Pellegrinus: Zanker 1995: 273, fig. 147.
28. Rome, Terme Museum 67606/7: Zanker 1995: 301, fig. 162.
29. London, British Museum WA 124955–6: Reade 1983: 43, fig. 61.

References cited

Abrantes, R. (1997), *Dog Language*, Naperville, IL: Wakan Tanka Publishing.

Apuleius (1915), *Metamorphoses*, trans. S. Gaselees, Cambridge, MA: Harvard University Press.

Beazley, J. (1986), *The Development of Attic Black-Figure*, revised edn, Berkeley, CA: University of California Press.

Bentz, M. (1998), *Panathenäische Preisamphoren*, Basel: Vereiningung der Freunde antiker Kunst.

Bergemann, J. (1997), *Demos und Thanatos. Untersuchungen zum Wertsystem der Polis im Spiegel der attischen Grabreliefs*, Munich: Biering and Brinkmann.

Boardman, J. (1975), *Athenian Red Figure Vases: The Archaic Period*, London and New York: Thames and Hudson.

Catoni, M. (2005), *Schemata. Comunicazione non verbale nella Grecia antica*, Pisa: Edizioni della Normale.

Corbeill, A. (2003), *Nature Embodied: Gesture in Ancient Rome*, Princeton, NJ: Princeton University Press.

de Jorio, A. ([1832] 2000), *Gesture in Naples and Gesture in Classical Antiquity*, trans. A. Kendon, Bloomington, IN: Indiana University Press.

Dodwell, C. (2000), *Anglo-Saxon Gestures and the Roman Stage*, Cambridge: Cambridge University Press.

Ewald, B. (1999), *Der Philosoph als Leitbild*, Mainz: P. von Zabern Verlag.

Gombrich, E. (1979), 'Ritualized Gesture and Expression in Art', in E. Gombrich (ed.), *The Image and the Eye*, 63–77, Oxford: Phaidon.

Grabar, A. (1964), *Early Christian Iconography,* Princeton: Princeton University Press.

Immerwahr, H. (2010), 'Hipponax and the Swallow Vase', *American Journal of Philology*, 131: 573–87.

Kendon, A. (2004), *Gesture: Visible Action as Utterance*, Cambridge: Cambridge University Press.

Kurtz, D. and J. Boardman (1971), *Greek Burial Customs*, Ithaca, NY, and New York: Cornell University Press.

L'Orange, H. P. (1953), *Studies in the Iconography of Cosmic Kingship in the Ancient World*, Oslo: H. Aschehoug.

Lawton, C. (1995), *Attic Document Reliefs: Art and Politics in Ancient Athens*, Oxford: Oxford University Press.

McNiven, T. (1982), *Gestures in Attic Vase Painting*, Ann Arbor, MI: University Microfilms.

McNiven, T. (2007), 'Behaving Like a Child: Immature Gestures in Athenian Vase-Painting', in A. Cohen and J. Rutter (eds), *Constructions of Childhood in Ancient Greece and Italy*, 85–99, Princeton, NJ: Princeton University Press.

Morris, D., P. Collett, P. Marsh and M. O'Shaughnessy (1979), *Gestures: Their Origins and Distribution*, New York: Stein and Day.

Neumann, G. (1965), *Gesten und Gebärden in der griechischen Kunst*, Berlin: De Gruyter.

Pallottino, M. (1952), *Etruscan Painting*, trans. M. Stanley and S. Gilbert, Geneva: Skira Editions.

Pedrina, M. (2001), *I gesti di dolore nella ceramic attica*, Venice: Istituto Veneto di scienze, lettere ed arti.

Pevnick, S. (2014), 'Good Dog, Bad Dog: A Cup by the Triptolemos Painter and Aspects of Canine Behavior on Athenian Vases', in J. Oakley (ed.), *Athenian Potters and Painters*, Vol. 3, 155–64, Oxford and Philadelphia, PA: Oxbow Books.

Quintilian (1920), *Institutio Oratoria*, Vol. 4, trans. H. Butler, Cambridge, MA: Harvard University Press.

Reade, J. (1983), *Assyrian Sculpture*, London: British Museum Press.

Reeder, E. (ed.) (1995), *Pandora: Women in Classical Greece*, Princeton, NJ: Princeton University Press.

Sapirstein, P. (2014), 'Demographics and Productivity in the Ancient Athenian Pottery Industry', in J. Oakley (ed.), *Athenian Potters and Painters*, Vol. 3, 175–86, Oxford and Philadelphia, PA: Oxbow Books.

Settis, S. de (1984), 'Images of Meditation, Uncertainty and Repentance in Ancient Art', *History and Anthropology*, 1: 193–237.

Shapiro, H. A. (1991), 'The Iconography of Mourning in Athenian Art', *American Journal of Archaeology*, 95: 629–56.

Taylor, J. H. (2001), *Death and the Afterlife in Ancient Egypt*, London: British Museum Press.

Trendall, A. (1989), *Red Figure Vases of South Italy and Sicily*, London: Thames and Hudson.

Trendall, A. and T. B. L. Webster (1971), *Illustrations of Greek Drama*, London: Phaidon.

Zanker, P. (1995), *The Mask of Socrates: The Image of the Intellectual in Antiquity*, trans. H. A. Shapiro, Berkeley, CA: University of California Press.

Zgusta, L. (1971), *Manual of Lexicography,* Prague: Academy.

CHAPTER 7
LANGUE DU GESTE OVER THE *LONGUE DURÉE*: ON THE DIACHRONY OF RITUAL GESTURES IN THE NEAR EAST

David Calabro

Concepts of gesture diachrony feature prominently in some influential studies of Near Eastern ritual gestures. These studies promulgate the notion that ritual gestures are constantly undergoing a process of entropy, attenuating from a state of spontaneity to one of habit, eventually becoming conventional signs and sometimes disappearing entirely from the realm of physical practice. According to Keel, proskynesis begins as a genuine emotional response but subsequently 'pales into a conventional gesture'; and raising the hand in smiting position begins as a utilitarian smiting gesture but eventually becomes an 'Ideogramm', a sign representing the concept of victory (Keel 1974: 18–21, 82, 1997: 310). In Gruber's analysis, ritual gestures begin as emotional expressions and then transition to symbolic signs, which may eventually be replaced by verbal idioms (Gruber 1980: 7–8). It is interesting to note that the ultimate destinies of ritual gestures in these two formulations match the scholars' specialties: for Keel, a specialist in iconography, it is an 'Ideogramm'; while for the philologist Gruber, it is a verbal phrase.

It is my purpose in this chapter to demonstrate that the study of gesture diachrony, being fundamentally a project of cultural history, must incorporate the perspectives to be gained from thick description of modern practices. One must bring these perspectives into dialogue with the ancient material, including both iconographic and textual sources. In order to demonstrate this, I describe a rally that took place in Syria in 2011 as an example of modern ritual practice that starkly points out the problematic nature of the notion of entropy applied to ritual gestures. Then, through an examination of some gestures attested in Northwest Semitic iconographic and textual sources from the Middle Bronze Age through the Persian period (*c.* 2000 to 330 BCE), I show how the modern ritual also carries lessons for a sounder analysis of gesture diachrony. In brief, I argue that ritual gestures develop not by entropy, but rather by strategic interplay between gesture and context.

The Homs rally

On 27 December 2011, a large group gathered on the streets of Homs, in western Syria, to take part in a communal covenant ceremony. This was part of a series of rallies led by former soccer goalkeeper Abdulbaset Sarout in December 2011 as part of the nascent

rebellion against the Syrian regime. The event was videotaped and subsequently published on YouTube.[1] The event might have appeared to uninformed outsiders to be a mere political demonstration, but despite its spontaneous character and fervour, it was filled with ritual content. It consisted of five clearly demarcated stages, each with a distinct ritual gesture and a distinct type of speech act. In the first stage, the people, prompted by Sarout (who stands on a podium at the centre of the crowd), raise their right hands high above their heads (Figure 7.1) while uttering in unison an oath to defend their loved ones 'until the last drop of blood'. The oath concludes with an invocation of God as witness to the oath. In the second stage, Sarout tells the people to lift up their hands; some raise both, making the 'V' sign for 'victory' with the forefinger and middle finger of each hand, while others make this sign with just the right hand. The people covenant to triumph or die, and they call upon God as a witness. Then follows a third stage in which Sarout elicits expressions of commitment from the crowd without any formal gesture. In the fourth stage, again prompted by Sarout, the people raise both hands above their heads while chanting Surah 110 from the Qur'an. Finally, in the fifth stage, the crowd, this time without any prompting, breaks out in rhythmic clapping while chanting with hands raised between claps, 'O God, there is none other than you, O God!' (For a more detailed description of the rally, see the Appendix below.)

Three of the main gestures in the Homs rally – raising the right hand in oath, raising both hands in prayer and clapping in acclamation – have a rich past going back to ancient times, as I explain below. But notwithstanding the long history of these gestures, their use in the Homs rally is anything but attenuated. On the contrary, the gestures are deployed with intense fervour. The fervour is linked to the form of the gesture, with the hands fully extended, not just casually raised.

In defence of the concept of entropy, one could argue that these gestures would normally be performed in an attenuated manner bespeaking their ancient origins, but that the fervour of the occasion resuscitates them. The oath gesture with raised hand, for example, is usually performed in a more relaxed manner in Syrian society, as described by Barakat: 'Hold right hand before right shoulder with palm facing forward' (Barakat 1973: 772). This, however, highlights one of the main problems with the notion of gesture entropy. Just as the gesture can seem to instantly revive in a socially charged context, it can also instantly revert to a relaxed form in a non-charged context. The form of the gesture seems to be determined not so much by gradual processes as by its close relationship to context, where 'context' means specifically the instantiation in actual living practice. This suggests that the extended and relaxed forms of the oath gesture, rather than being diachronically related, are synchronically available modulations of the gesture specific to different contexts.

How, then, should we describe the diachrony of these gestures? In the following sections, I compare the gestures in the Homs rally with antecedents of these gestures from the ancient Levant, the physical and cultural environs of Homs. The comparison suggests that while a ritual gesture's form and basic nature may be consistent across time, the relationship between the gesture and its context is subject to change.

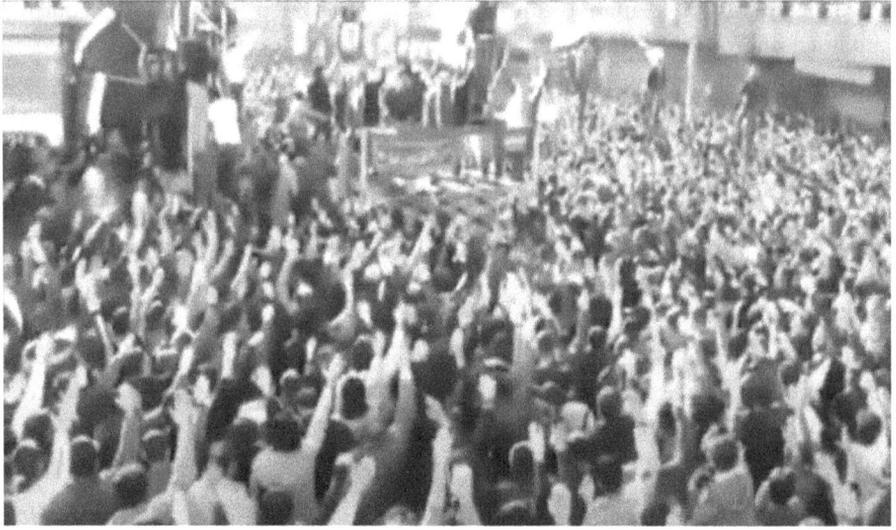

Figure 7.1 Gesture performed during Stage 1 of the Homs Rally in Syria. Still image taken by David Calabro at 28 seconds from YouTube video, www.youtube.com/watch?v=aWH41GVbtus.

The ideal approach to this issue would be to trace each gesture from its earliest attestations through the various historical periods, from texts and art of the Bronze Age through Hebrew, Greek, Jewish Aramaic, Syriac and premodern Arabic sources and finally to modern times. However, the state of research on gestures in the various periods is far from even, and to follow just one gesture through the primary sources of all these periods would be a project of enormous size. I confine my comparative scope, therefore, to Northwest Semitic sources from before the Hellenistic period, employing data from my research on Northwest Semitic ritual gestures (Calabro 2014). In my estimation, the strength of the comparisons implies that these gestures are historically related, and examples I have collected from the intervening periods support such a connection. But a complete diachronic account of these gestures will have to await future studies.

The performative raising of one hand

The raising of the right hand in taking an oath, as seen in the Homs rally and in the gesture described by Barakat, has an antecedent in the ancient Levantine gesture of raising the hand to accompany an oath or other performative act (that is, an act that not only communicates but also brings about a new state of affairs for the participants; on this concept in ritual, see Bell 1992: 72–3, 113). Twenty-two passages of the Hebrew Bible mention this gesture, using the Hebrew phrases *nāśāʾ yād* 'lift up the hand', *nātan yād* 'put forth the hand', *hērîm yād* 'raise the hand' and *hēnîp yād* 'elevate the hand' (for extensive discussion of the relevant examples, see Seely 1995; Calabro 2014: 53–7, 59–66, 87–108, 118–23, 223–32). Many of these examples describe Yahweh lifting his hand in oath to Israel's forefathers to give them the Promised Land, as in this example from Exodus:

I will bring you into the land which I lifted up my hand (*nāśāʾtî ʾet-yādî*) to give to Abraham, Isaac, and Jacob. I will give it to you as an inheritance. I am Yahweh.

Exodus 6.8

Based on similarity of contextual factors such as the agent and target of the gesture, the setting in which it is performed, and the content of accompanying inscriptions, the four Hebrew phrases most likely describe a gesture that is also portrayed in Levantine iconography, with the right hand held up and the palm facing outward (for description of the iconographic examples and argumentation, see Calabro 2014: 393–493). There are about 230 clear examples of this gesture on Levantine figurines, stelae, ivories, cylinder seals, stamp seals, metal bowls and plaques. Space does not permit a review of these here; instead, I focus on a few examples that are representative of the corpus as a whole and that serve to illustrate the points being made.

In most examples of the iconographic motif, the hand is raised to about shoulder height, like the usual form of the oath gesture as described by Barakat and unlike the form used in the Homs rally. An example of this 'lowered form' is a gold-plated figurine of the god Ilu from Ugarit (Figure 7.2a). This figurine was excavated from a Late Bronze Age foundation deposit. The god is here shown wearing a crown and seated as if on a throne. The left hand is perforated, perhaps indicating that the god originally held a staff or sceptre (Galliano and Calvet 2004: 260).

Seated figures like this one typically occur in Levantine art in scenes of a seated deity or king receiving homage from a confronted standing figure. In these scenes, the seated figure, the standing figure, or both may be performing this gesture, raising one hand in a performative act. Studies of Near Eastern iconography traditionally refer to this and similar gestures as a 'gesture of greeting or blessing' or 'of adoration', often depending on who performs it (among the many examples, see Winter 1986: 262). While these interpretations seem appropriate in some instances, none of them fits the full range of contexts in which the gesture is used, so they fall short of the gesture's basic function. Taking into account the range of contexts and reconciling the interpretation with textual sources, the gesture is best interpreted as performative, variable in propositional meaning, and indexically related to context (Frechette 2012; Calabro 2014: 457–93, 636–51). Thus, the seated Ilu figure is best understood as engaging in a performative act, perhaps one that is similar to that of Yahweh in Exodus 6:8.

Levantine art also depicts standing figures performing this lowered form of the gesture, sometimes before deities (who may be either seated or standing, and who may or may not be performing the same gesture). The standing figure may also face another mortal, as in the 'Covenant Stela' from Ugarit that shows two rulers facing each other, both of them making this gesture (Galliano and Calvet 2004: 160; Figure 7.2b). The standing figure may also be the only figure portrayed on the piece, as with many Iron Age stamp seals that feature a standing figure holding a staff in one hand and performing this gesture with the other (Gubel 1993; Calabro 2014: 444–52; Figure 7.2c).

In these iconographic examples, we see the lowered form of the gesture in the context of hierarchically structured institutional orders; the gesture is often (though not always)

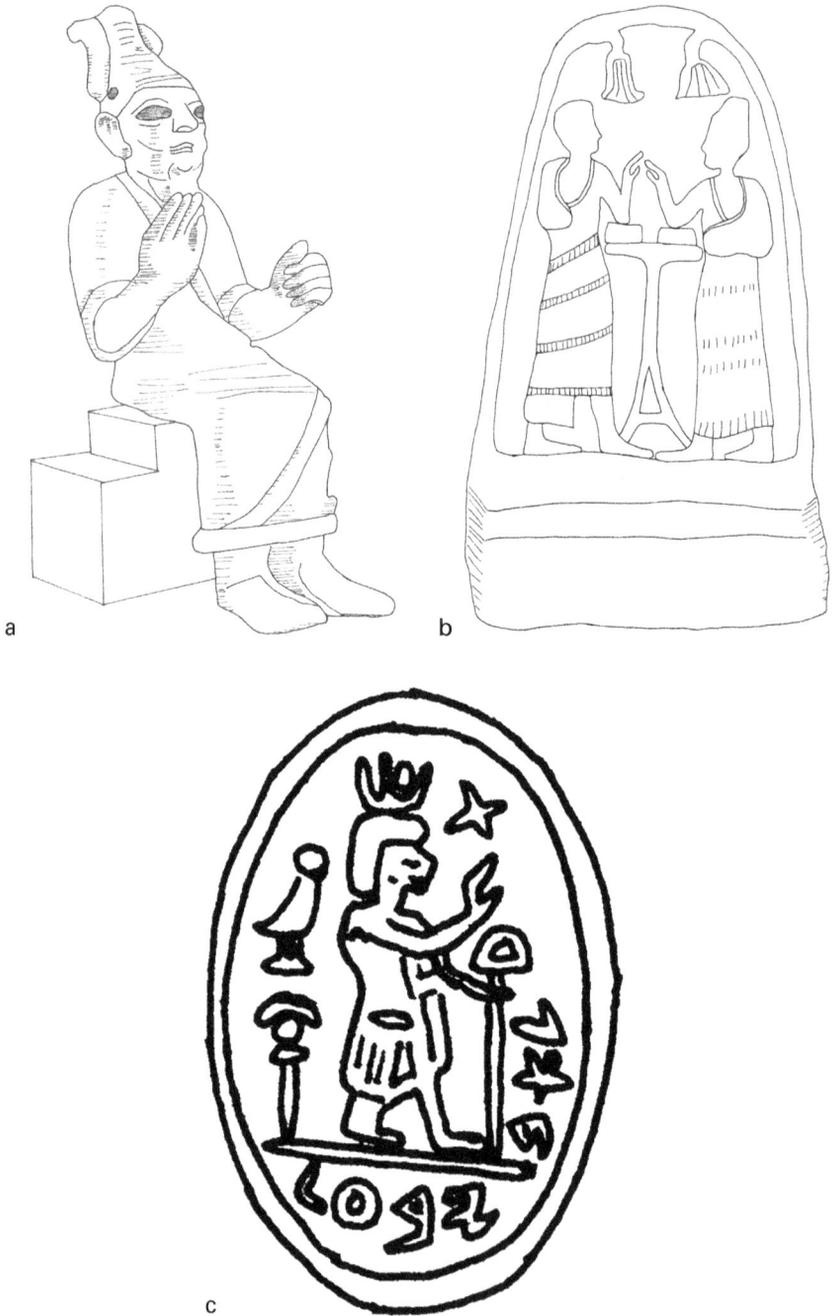

Figure 7.2 Iconographic examples of the 'lowered form' of raising one hand: *(a)* Statuette of the god Ilu from Ugarit, Late Bronze Age. Drawing by David Calabro; *(b)* 'Covenant Stela' from Ugarit. Drawing by David Calabro after Galliano and Calvet (2004: 160); *(c)* Iron Age stamp seal of Abibaal. Drawing by David Calabro after Avigad (1998: 426).

directed from the top down. This authoritative aspect is reflected in the nature of the objects themselves: figurines of deities, carvings on objects designed for display in sacred and elite space, and officials' seals. In the case of the figurine from Ugarit discussed above, the aged appearance of Ilu, father of the gods in the Ugaritic/Canaanite pantheon, evokes attenuated traditionalism: the hand, the posture and the lines of the face are all drooping downward. Yet there is also a sense of supreme authority within a patriarchal structure.

Although comparatively rare, there are also attestations of this Levantine gesture that are closer to what we see in the Homs rally, with the hand held high as if reaching to heaven. One example is a Middle Bronze Age scarab seal of 'Hyksos' style[2] excavated at Tell el-'Ajjul in the southern Levant (Figure 7.3). This seal from Tell el-'Ajjul shows a standing male figure facing toward a scene in which a lion pounces on an ibex. The standing figure raises his right hand, palm outward, the hand held high. The precise interpretation of the scene is elusive, but we can at least say that it evokes a sense of excitement, like the Homs rally and unlike most examples in which the lowered form of the gesture occurs. This raised form is attested mainly on 'Hyksos' scarabs and occasionally in other glyptic art. There is no specific type of scene in which this raised form recurs, although many examples have a *uraeus* motif[3] underneath the raised hand (Calabro 2014: 439–44).

This raised form of the gesture may also be indicated in texts referring to an oath gesture with the hand raised 'to heaven' or 'to God in heaven'. In these passages, the

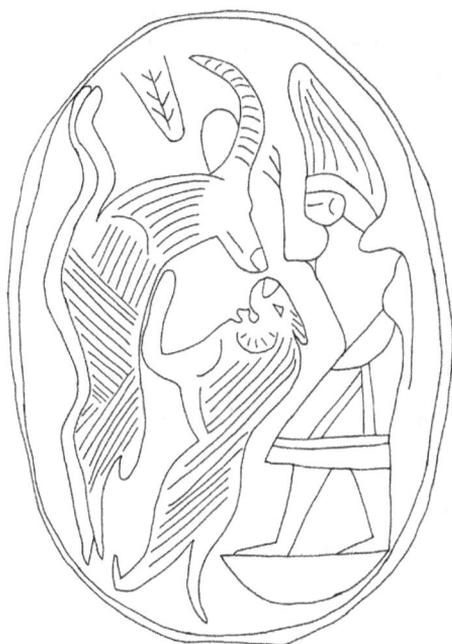

Figure 7.3 'Hyksos' scarab seal, Middle Bronze Age. Drawing by David Calabro.

utterance accompanying the gesture tends to impart a sense of fervour. An example of this is found in Genesis:

> Abram said to the king of Sodom, 'I raise my hand (*hărîmōtî yādî*) to Yahweh El Elyon, creator of heaven and earth: If, from a thread to a sandal-thong, I take anything of yours, (may the unspeakable happen to me)! You shall not say, then, "I made Abram rich."'

Genesis 14.22

Similarly, when Yahweh performs this gesture, it takes on an overpowering, even violent connotation, as in this example from Deuteronomy:

> For I lift up my hand to the sky (*'eśśā' 'el-šāmayim yādî*) and say, 'By my life forever, if I whet my flashing sword, and my hand takes hold of judgment, I will bring down vengeance on my adversaries, with those who hate me I will get even.'

Deuteronomy 32.40–1

The lowered and raised variants of this gesture exist roughly contemporaneously from the earliest attestations in the Middle Bronze Age. There is no basis for the idea that the raised form is historically primary. This evidence suggests that the ancient performative gesture with palm outward involved two synchronic modulations, a raised and a lowered form, each of them associated with a specific kind of context. The raised form is rarer, while the lowered form seems to be the more common one. This situation precisely parallels the modern situation as seen in the Homs rally and in the common oath gesture documented by Barakat. The synchronic lesson from modern practice, therefore, is also true diachronically: gesture relates closely to context.

Raising both hands in prayer

The raising of both hands in prayer is another frequently-occurring gesture in Levantine sources. Synonymous phrases denoting this gesture in the Hebrew Bible include *nāśā' yādayim* 'lift up the hands', *nāśā' kappayim* 'lift up the palms' and *pāraś kappayim* 'spread the palms', among others, with about twenty-five total instances. Cognates of *nāśā' yādayim* also occur in Ugaritic and Aramaic with reference to the same prayer gesture (for discussion of the relevant texts in Hebrew, Ugaritic and Aramaic, see Gruber 1980: 25–50; Calabro 2013, 2014: 68–70, 108–18, 124–36, 240–59). A typical textual example is this one from the Psalms, where the context of the gesture is the temple, the quintessential locus of standard, traditional practice:

> Hear my supplicating voice when I cry to you for help, when I lift up my hands (*bənos'î yāday*) to the cella of your sanctuary!

Psalm 28.2

The two-handed prayer gesture in iconography, which can be matched to the textual examples based on context, involved raising both hands with the palms facing outward (Keel 1997: 308–23; Calabro 2013, 2014: 525–72). There are about seventy-five occurrences in Levantine iconography, including attestations on stone reliefs, ivories, various forms of glyptic art, metal bowls and an engraved bronze axe head. (Metal figurines are conspicuously absent.)

Precisely parallel to the one-handed oath gesture, the prayer gesture of raising both hands has a lowered form and a raised form. Once again, it is the lowered form that is the most common in Levantine art. Figure 7.4 shows a typical example from an Iron Age stamp seal. This seal is unprovenanced but is Phoenician in style (Gubel 1993: 116–17). In the middle register, two male figures kneel before a winged scarab, each performing the lowered form of the prayer gesture.

The extended form of this gesture, in which the hands are held high above the head as in the Homs rally, occurs only rarely. As far as Levantine art goes, I am aware of only one example of the raised form of the prayer gesture, which is on a Middle Bronze Age scarab seal from Jericho that shows a lone male figure performing the gesture (Kenyon 1965: 648–9). Egyptian art of the New Kingdom, however, does portray Levantine people performing this raised form of the gesture. The example shown in Figure 7.5 is from a relief in the tomb of Horemheb in Egypt (eighteenth Dynasty), which shows conquered

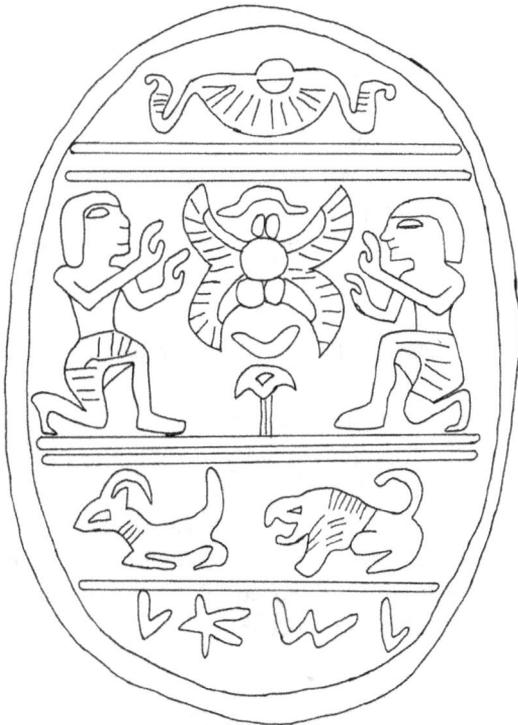

Figure 7.4 Stamp seal of Šaʾūl, Iron Age II. Drawing by David Calabro.

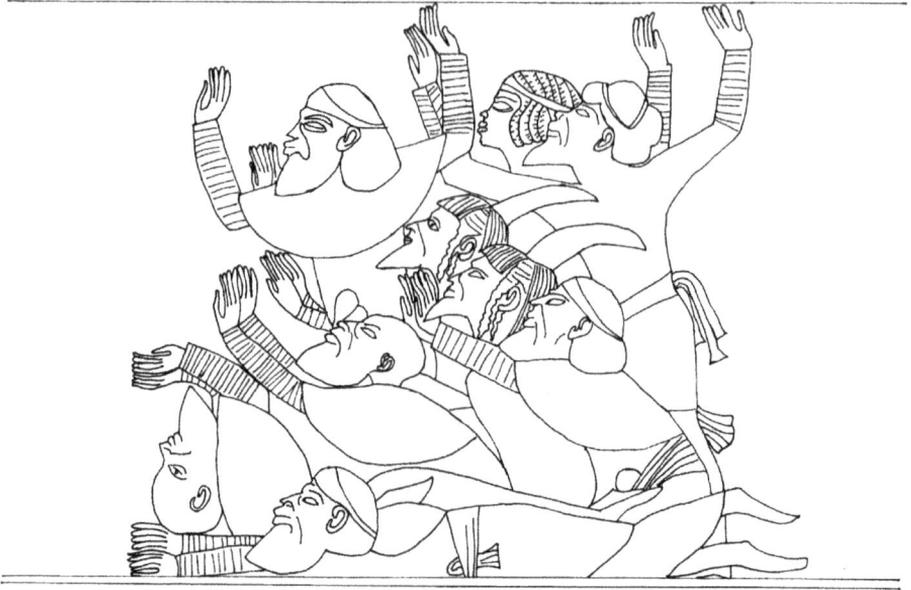

Figure 7.5 Relief from the tomb of Horemheb, Late Bronze Age. Drawing by David Calabro.

people from the Levant (as well as from other regions) pleading for their lives from the Pharaoh via an unnamed official and the general Horemheb, all of whom are to the left of the petitioners. The hieroglyphic inscription accompanying the scene reads, 'The chiefs of every foreign land come to beg for life from him [i.e. the Pharaoh] by means of the hereditary prince, the sole companion, the royal scribe Horemheb, justified' (Boeser 1911: 7, pl. 24). In the battle reliefs at Medinet Habu, inhabitants of besieged Levantine cities, menaced on all sides by Egyptian soldiers, raise their hands high. The cities include Tunip, an unnamed Syrian city and a city in the land of Amurru. In the latter scene, a hieroglyphic caption above the besieged inhabitants describes them begging for 'the breath of life' (Nelson et al. 1932, pls 88–9, 90, 94–5).

In the New Kingdom reliefs just described, the raised form of the prayer gesture consistently occurs in the context of a desperate plea to a higher authority for succour. This may explain the extreme rarity of this form in native Levantine iconography as opposed to the Egyptian sources, since Levantine people may not have been inclined to memorialize themselves in a state of extreme need, while portraying Levantine people in this way would tend to serve the purposes of Egyptian royal ideology. The raised form of the prayer gesture calls attention to the agent, functioning as the visual equivalent of a loud cry. It also seems to reach toward a hoped-for deliverance from the status quo. This contrasts with the lowered form, which occurs in ceremonial contexts characterized by conformity to institutionalized practice.

Ancient Northwest Semitic textual sources also bear witness to a lifting of the hands 'to heaven', perhaps denoting the raised form of the prayer gesture. The context in these examples includes an urgent plea for succour. Biblical instances include Lamentations

2.19 and 3.41, in which the idiom is *nāśā' kappayim 'ēlâw/ 'el-'ēl baššāmayim* 'lift up the hands to him/to God in heaven'. In addition, there is an Ugaritic example (*KTU* 1.14 iv 2–8), in which the hero Kirta 'lifts his hands to heaven' (*nša ydm šmm/šmmh*) in a desperate plea for a way of bringing forth an heir. There is also one Old Aramaic example, an inscription of king Zakkur (eighth century BCE), found at Tell Afis, near Homs:

> All these kings laid siege to Hadhrak. They raised a wall higher than the wall of Hadhrak, they dug a ditch deeper than its ditch. I lifted up my hands to Bʿel-shmayn (*w'š' ydy 'l b'lšmyn*). Bʿel-shmayn answered me, Bʿel-shmayn spoke to me through seers and through diviners.
>
> *Old Aramaic Zakkur inscription, KAI 202 A: 9–12*

In this example, the name of the deity, Bʿel-shmayn, means 'Lord of Heaven', suggesting an upward directionality for the gesture.

As with the one-handed performative gesture, the modular character of the raising of both hands in prayer is exactly parallel in ancient and modern times. The ancient lifting of hands high above the head in situations of intense desperation contrasts synchronically with the more relaxed ceremonial prayer gesture. In similar fashion, the raised form in the Homs rally contrasts with the much more common raising of hands in the Muslim prayer or *ṣalā*. The latter, performed five times daily, includes a lifting of the hands to the level of the ears or shoulders (Chelhod 1959: 171). As with the one-handed gesture, there is a basic continuity of gesture forms.

The use of the raised-hands prayer gesture in the Homs rally carries an additional lesson about the diachrony of gesture. When Sarout urges the people to raise their hands at the beginning of the third stage of the ritual, the words they speak are not explicitly a prayer. It is only in the fourth stage, when the people cry out, 'O God, there is none other than you, O God!' that God is directly addressed. There is an implicit plea for 'help' (*naṣr*) in the repeated exchange between Sarout and the crowd immediately after the lifting of hands: 'Help comes from where? / From God!' However, there is more going on with the lifting of hands here. The text recited during this stage is Surah 110 of the Qur'an, called Sūrat al-Naṣr. The Arabic word *naṣr* has a dual meaning: both 'help, aid' and 'victory, triumph' (Wehr 1994: 1138). This Surah says: 'When God's help/victory (*naṣr*) and conquest have come ... then praise your Lord with thanksgiving and ask forgiveness of him.' The lifting of hands, carried out both before and during the recitation, shapes the meaning of the rite as the speech progresses. At the beginning of the fifth stage, it seems as if the people are petitioning God for help. But when they mention the command to praise the Lord and ask forgiveness, the lifting of hands becomes the physical acting-out of this commandment. This is a performative act. Although victory has not yet been achieved, the people are praising the Lord and asking forgiveness as if it has been achieved. The lesson we learn here is that the gesture is not just fitted to the context; rather, it shapes the context. Without the lifting of hands, the recitation of Surah 110 would simply serve as an exhortation to faith, but the gesture shapes this into a performative act. This suggests that the true story to be told with regard to gesture

diachrony is the story of evolving strategies for applying stable gesture forms to constantly shifting contexts.

Clapping the hands

In the Homs rally, the clapping of hands is performed in a fully raised position, like the two gestures discussed previously. Being performed at the finale of the rally, the clapping intensifies the fervour in at least two ways. First, it increases the overall degree of movement. Second, it increases the number of sensory modes being employed: now the gestures come into play not only in the visual sphere, but also in the auditory sphere. All of this gives the Homs rally a sense of building up to a climax: first one hand, then two, then clapping.

Ancient Akkadian, Egyptian and Hebrew textual sources portray the clapping of hands as an expression of grief or anger (Fox 1995: 49–55; cf. Hallo 1997: 86; Numbers 24.10). The Hebrew Bible contains one example of clapping in a ritual context. This is in the description of the coronation of Joash, the king of Judah, which takes place at the temple of Solomon. Here the clapping seems to be an expression of acclamation:

> He brought out the king's son, placed the crown on him, and gave him the document of the covenant. They made him king and anointed him. Then they clapped their hands (*wayyakkû kāp*) and said, 'Long live the King!'
>
> *2 Kings 11.12*

There is also a possible example of clapping in an Ugaritic prescriptive ritual text. Unfortunately, this example is uncertain due to the fragmentary condition of the tablet. According to one reading of the text, the king is said to clap his hands before entering the temple in an autumnal celebration of the grape harvest (Hallo 1997: 299).

To my knowledge, no iconographic examples of clapping have so far been discovered in Levantine art. However, there are examples in Egyptian and Mesopotamian art, including some that show clapping in ritual contexts (Dominicus 1994: 168, 175; Fox 1995: 51–60). In the Mesopotamian and Egyptian examples, the hands are held in front of the torso or the face, but no higher.

The form of clapping in the Homs rally, with the hands stretched almost vertically in the air and alternating with the raised form of the lifted-hands gesture, is not attested in ancient Near Eastern sources. However, it is identical to a form of cheering practiced by spectators at sports events in the Middle East. In this form of cheering, the crowd claps rhythmically in unison three times, then chants with the hands raised high in the air, and then repeats, exactly as in the Homs rally (I found one example from a Syrian soccer game on YouTube in June 2015, now removed). The invoking of a sports gesture in this rally could be connected with the popularity of the leader, Abdulbaset Sarout, as a goalkeeper in the Homs-based Al-Karamah Sports Club. Thus, while the act of clapping in a communal covenant ceremony seems to go back to ancient Near Eastern ritual, the precise form of the gesture is not from the ancient Near East but from the modern sports world.

What is seen in the clapping at the end of the Homs rally is a strategic merging of contexts, exploiting the close association between gesture and context. Clapping in this kind of ritual context is sanctioned by ancient tradition; but by making the clapping like sports cheering, the crowd at Homs invokes the scenario of a sports match, implicitly pitting God as a champion against the ruling powers named in Stage 3 of the ritual: the Arab League, the Syrian regime, the United States of America, President Barack Obama, President Nicolas Sarkozy and President Recep Erdogan. The clapping, then, becomes an expression of loyalty as well as an expression of joy at God's victory (which, as I discuss above, is enacted performatively in the course of the ritual). This is an instructive example of the use of gesture to shape the ritual context. In this case, the shaping is accomplished by using a very specialized modulation of the gesture to invoke an outside context, effectively recreating the present context in the image of the outside one. This can have a lasting diachronic impact on the interface between gesture and context. To name one example, Ehrlich has shown how the act of standing at attention with the hands clasped in front of the torso, invoking the pose of a servant before the master, was adopted in the Jewish prayer form known as the Amidah. The significance of this posture is made clear in the Babylonian Talmud, in which Raba son of Rabbi Huna is said to have 'clasped his hands and prayed, saying, "[I pray] like a slave before his master"' (*bShabb.* 10a, quoted in Ehrlich 2004: 110–11).

Conclusions

The comparison I have drawn between the Homs rally and ancient Levantine sources carries at least four lessons for the study of the diachrony of ritual gestures. First, as is evident from a juxtaposition of the fervently executed gestures in the rally with their ancient antecedents, a model based on entropy is not the best way of explaining how ritual gestures develop over time. Ritual gestures, at least the ones performed in the rally, are basically stable over time in terms of their form. Indeed, given this similarity of gesture forms across millennia, gesture diachrony does not seem amenable to description by means of formal laws of change, unlike histories of other sign systems, such as historical linguistics and palaeography.

Second, ritual gestures have formal modulations that relate closely to context. This is evident from a comparison of the ancient and modern instantiations of the raised hand accompanying performative utterances. The modulation of this gesture with the hand raised only to shoulder level corresponds to repeated ceremonial contexts, while this is not true of the modulation with the hand raised high. This relationship to context seems to be essential to gesture diachrony. Connerton has already written of the role of ritualized bodily practices in preserving cultural memory; they do so by virtue of their habitual relationship to a network of rules and concepts, which are represented in the contexts of performance (Connerton 1989: 72–104).

Third, the development of ritual gestures has to do with their ability to shape the ritual context (Bell 1992: 81–3). We see this shaping potential at work in the Homs rally in the raising of hands, which transforms the Qur'an recitation into a performative victory

celebration. In my study of Northwest Semitic ritual gestures, I likened the relationship between gesture and context to the shaping actions of a potter's hands in contact with the clay (Calabro 2014: 623–4). We can say that the potter's hands shape the clay into a specific kind of pot; we can also say that the potter's desire to create a specific kind of pot constrains him/her to apply certain movements to the clay as it turns on the wheel. The creative task requires the potter's hand motions to follow a fixed pattern from one pot to the next, rather than succumbing to entropy. Yet, the potter can also create new styles of pottery by applying modulations of the hand movements to the clay; as these new styles become popular, they require the application of these modulations by other potters who desire to create the new styles. Gesture diachrony can be described in the same way, in terms of the strategic application of gesture forms to shape ritual contexts. Broad trends of change in political, religious and other institutions impact the relationship between formal modality and context by imposing new parameters for the creative application of gesture.

Fourth, change in the relationship between gesture and context may be brought about by a specific gesture modulation that invokes an outside context. In effect, this merges the two contexts, casting the present context in the image of the outside context. We see this in the sports-like form of clapping in the Homs rally, as also in the actions of the Amidah prayer studied by Ehrlich. These examples demonstrate the diachronic potential of Goffman's concept of 'footing', the strategic performance of context-specific styles of behaviour (Goffman 1979).

Overall, this study shows the relevance of modern practice to the cultural history of gesture. An itinerary that includes not only ancient texts and images but also ethnographic research is a desideratum for future work in gesture studies. Furthermore, giving attention to the ways in which modern gestures transform as they pass into texts and visual media in modern cultures may refine our approach to the ancient primary sources. The understanding to be gained from this research goes beyond mere conversation between specialists; in order for the patterns to become clear, in-depth study of practices both past and present must be brought into a single focus.

Appendix: Description of the Homs rally

Note: All lines in the following translation are spoken by the leader Abdulbaset Sarout in the centre and repeated by the crowd, except where indicated thus: L = leader; C = crowd. My translation from the Arabic differs from the English subtitles in the video.

Stage 1 (00:08–00:35)

Gesture: Lifting the right hand high in the air.

Speech act: Oath-taking.

We swear by the Great God,
we will not be silent concerning the martyrs.
We swear by the Great God.

We swear by the Great God.
We swear by the Great God
that we will protect our wives,
our sons,
our young children,
our old men,
and our martyrs,
until the last drop of blood.

Stage 2 (00:35–01:00)

Gesture: Lifting both hands or lifting the right hand high in the air, making 'V' sign for 'victory' with forefinger and middle finger.

Speech act: Oath-taking.

L Up, up, up! [L is here directing C to keep their hands raised.]

L The dream of the people of Homs
is that either we triumph or we die.
We will triumph or we will die!
We will triumph or we will die!
And God is witness over what we say.
God is witness over what we say.
God is witness over what we say!

Stage 3 (01:00–01:28)

No formal gesture.
The leader incites the crowd and invites the uncommitted to leave.

L The Arab league, the observers, the Syrian regime, America, Obama, Sarkozy, everyone listen! Help comes from whom?

C From God!

L Guys, as we're here now, I'm talking now to a lot of people. The whole world will hear and see you. Is anybody waiting for help from Obama?

C No!

L Is anybody waiting for help from Erdogan?

C No!

L If anybody is waiting for help from any person, any council, or the Arab league, he can leave. Help comes from where?

C From God!

Tracing Gestures

Stage 4 (01:28–02:14)

Gesture: Lifting both hands high, palms forward.

Speech acts: Naming authenticator of oath, reciting Qur'an.

L Now up, up, (put) your hands up – to the Lord of the worlds only, only to the Lord of the worlds. Help comes from where?

C From God!

L Help comes from where?

C From God!

L [*in slower tempo of speech*] In the name of God, the Merciful, the Compassionate.

L and C [*in unison*] When God's help and conquest have come,

C And you see the people entering into God's religion in multitudes, then praise your Lord with thanksgiving and ask forgiveness of him, for he is one who accepts repentance (Qur'an, 110).

L In the name of God, the Merciful, the Compassionate.

Stage 5 (02:14–02:30)

Gesture: Lifting both hands high, clapping the hands three times quickly between each line.

Speech act: Chanted prayer/acclamation.

L All of you, up, up, up, up! [*L is directing C to keep their hands raised.*]

C O God, there is none other than you, O God! [*Three claps.*]

C O God, there is none other than you, O God! [*Three claps.*]

C O God, there is none other than you, O God! [*Three claps.*]

(Etc.)

Notes

1. See Ugarit News – English (2011).
2. Note that the conventional name 'Hyksos' for this type of scarab, which has reference to the Hyksos dynasty of Northwest Semitic rulers of Egypt, is a misnomer, as seals of this type are most likely of local Canaanite manufacture and style (see Ben-Tor 2007: 175, 177–8, 186–7, 2011: 27–30).
3. See López-Bertran, this volume, for additional description and discussion of the *uraeus* motif.

References

Avigad, N. (1998), *Corpus of West Semitic Stamp Seals*, Jerusalem: Israel Academy of Sciences and Humanities.

Barakat, R. (1973), 'Arabic Gestures', *Journal of Popular Culture*, 6: 749–93.

Bell, C. (1992), *Ritual Theory, Ritual Practice*, Oxford: Oxford University Press.

Ben-Tor, D. (2007), *Scarabs, Chronology, and Interconnections: Egypt and Palestine in the Second Intermediate Period*, Göttingen: Vandenhoeck and Ruprecht.

Ben-Tor, D. (2011), 'Egyptian–Canaanite Relations in the Middle and Late Bronze Ages as Reflected by Scarabs', in S. Bar, D. Kahn and J. Shirley (eds), *Egypt, Canaan and Israel: History, Imperialism, Ideology and Literature*, 23–43, Leiden: Brill.

Boeser, P. (1911), *Die Denkmäler des neuen Reiches, Erste Abteilung: Gräber*, Haag: Martinus Nijhoff.

Calabro, D. (2013), 'Gestures of Praise: Lifting and Spreading the Hands in Biblical Prayer', in D. Seely, J. Chadwick and M. Grey (eds), *Ascending the Mountain of the Lord: Temple, Praise, and Worship in the Old Testament*, 105–21, Provo, UT: Brigham Young University Press.

Calabro, D. (2014), 'Ritual Gestures of Lifting, Extending, and Clasping the Hand(s) in Northwest Semitic Literature and Iconography', PhD diss., University of Chicago, Chicago.

Chelhod, J. (1959), 'Les Attitudes et les gestes de la prière rituelle dans l'Islam', *Revue de l'histoire des religions*, 156: 161–88.

Connerton, P. (1989), *How Societies Remember*, Cambridge: Cambridge University Press.

Dominicus, B. (1994), *Gesten und Gebärden in Darstellungen des Alten und Mittleren Reiches*, Heidelberg: Heidelberger Orientverlag.

Ehrlich, U. (2004), *The Nonverbal Language of Prayer: A New Approach to Jewish Liturgy*, Tübingen: Mohr Siebeck.

Fox, N. (1995), 'Clapping Hands as a Gesture of Anguish and Anger in Mesopotamia and Israel', *Journal of Ancient Near Eastern Studies*, 23: 49–60.

Frechette, C. (2012), *Mesopotamian Ritual-Prayers of 'Hand-Lifting' (Akkadian Šuillas): An Investigation of Function in Light of the Idiomatic Meaning of the Rubric*, Münster: Ugarit-Verlag.

Galliano, G. and Y. Calvet (2004), *Le Royaume d'Ougarit: Aux origines de l'alphabet*, Paris: Somogy.

Goffman, E. (1979), 'Footing', *Semiotica*, 25 (1–2): 1–29.

Gruber, M. (1980), *Aspects of Nonverbal Communication in the Ancient Near East*, Rome: Biblical Institute Press.

Gubel, E. (1993), 'The Iconography of Inscribed Phoenician Glyptic', in B. Sass and C. Uehlinger (eds), *Studies in the Iconography of Northwest Semitic Inscribed Seals*, 101–29, Göttingen: Vandenhoeck and Ruprecht.

Hallo, W. (ed.) (1997), *The Context of Scripture, Volume 1: Canonical Compositions from the Biblical World*, Leiden: Brill.

Keel, O. (1974), *Wirkmächtige Siegeszeichen im Alten Testament: Ikonographische Studien zu Jos 8:18-26; Ex 17:8–13; 2 Kön 13:14–19 und 1 Kön 22:11*, Göttingen: Vandenhoeck and Ruprecht.

Keel, O. (1997), *The Symbolism of the Biblical World: Ancient Near Eastern Iconography and the Book of Psalms*, Winona Lake, IN: Eisenbrauns.

Kenyon, K. (1965), *Excavations at Jericho, Volume Two: The Tombs Excavated in 1955-8*, London: British School of Archaeology.

Nelson, H., K. Seele, J. Wilson, H. Leichter, A. Morrison, A. Bollacher, V. Canziani, J. Chubb, L. Longley and D. Wilber (1932), *Medinet Habu, Volume 2: Later Historical Records of Ramses III*, Chicago, Il: University of Chicago Press.

Seely, D. (1995), 'The Raised Hand of God as an Oath Gesture', in A. Beck, A. Bartelt, P. Raabe and C. Franke (eds), *Fortunate the Eyes that See: Essays in Honor of David Noel Freedman*, 411–21, Grand Rapids: Eerdmans.

Ugarit News – English (2011), 'Tens of Thousands Giving a Collective Oath in Homs, Al-Khaldiyah', 27 December. Available at: www.youtube.com/watch?v=aWH41GVbtus (accessed 1 June 2015).

Wehr, H. (1994), *A Dictionary of Modern Written Arabic*, Wiesbaden: Otto Harrassowitz.

Winter, I. (1986), 'The King and the Cup: Iconography of the Royal Presentation Scene on Ur III Seals', in M. Buccellati (ed.), *Insight through Images: Studies in Honor of Edith Porada*, 253–68, pls 62–4, Malibu, CA: Undena Publications.

CHAPTER 8
TRACING THE SEMANTICS OF ANCIENT MAYA GESTURES

Amy J. Maitland Gardner

Classic Maya art preserves one of the most detailed gestural languages in the ancient world. The archaeological corpus from the Classic period (*c.* 300 to 800 CE) is rich with figural art in a variety of mediums. From polychrome pottery to carved stelae, scenes show figures engaged in a variety of situations and interactions. Detailed representations of arms, hands and fingers give the strong impression that what is being shown are people engaged in moving their arms and hands as if they are gesturing. Movements of the arms and hands are used to communicate meaning – either in accompaniment to speech or in place of it – in a variety of contexts and exchanges (Kendon 2004: 15; McNeill 2000: 1). To the modern observer of ancient visual sources, however, the physical aspects of gesture (handshape and arm position) are what remain. The question is, how do we trace meanings associated with these silent actions?

The main approach to gesture in Maya studies has been a top-down model, which sees gesture – depicted in stone and on ceramics – in terms of status and power, framed within the courtly sphere (e.g. Baudez and Mathews 1978; Ancona-Ha, de Lara and Van Stone 2000; Jackson 2009). Here, in my study of the same visual material, a bottom-up approach is favoured. A bottom-up approach leaves aside the paradigm of courtly interaction and draws upon interactions in everyday encounters with focus on engagements with objects that shape communicative hand actions. Central to a bottom-up approach is a focus on the dynamic relationship between form and meaning; the formal aspects of gesture are depicted and preserved, but it is the meanings that these gestures communicated that is the aim of this endeavour. Complementing the study of gesture in ancient Maya pictorial sources is an examination of hands as graphic elements in the writing system: their selection in particular semantic fields is significant, and points to the gestural language having wider use and deeper history than is currently thought.

The Maya context

The Maya region covers modern-day Guatemala, Mexico (the states of Yucatán, Chiapas, Quintana Roo and Campeche), Belize and the northern parts of Honduras and El Salvador. During the Classic period, there were a number of polities across the region, each headed by a ruler, and interconnected through a complex web of warfare, trade and

alliances (Martin and Grube 2008). Throughout the Early and Late Classic period (*c.* 300 to 800 CE), figural representations were produced on stelae, panels, tablets, lintels and other stone monuments (Schele and Miller 1986; Miller and Martin 2004); these carvings were produced at several cities across the Maya region and were positioned in and around plazas where people would gather, as well as in structures accessed by the upper tier of Maya society.

Fine polychrome ceramics with figural scenes were produced in the Middle to Late Classic period (*c.* 500 to 800 CE). These vessels are connected to the elite sphere of material culture through their illustration of high-status individuals and deposition, where known, in elite burials. Although many pots lack secure provenance due to looting and illegal trade, stylistic analysis and Neutron Activation Analysis place the production of several vessels in Petén in northern Guatemala and at Nebaj and Chama in the Guatemalan highlands (Reents-Budet, Bishop and MacLeod 1994: 166–9). Vessels include plates, cylindrical containers, dishes and bowls. Many vessels are not ornate in shape but instead are simple, which serves to provide maximal area to images painted on the surface (Reents-Budet 1994: 7, 16).

In addition to the diversity of figural representations and the use of fine polychrome ceramics with figural scenes later on, the Classic period is defined by extensive use of texts and dates, with many inscriptions continuing to enrich an understanding of many aspects of ancient Maya life. Although there are no known specific descriptions of gesture, two Classic Maya terms highlight the visuality of bodily performance and interaction – *cha'nil* and *y-ichnal*. The former translates as 'something to be watched', i.e. a public performance or ceremony, which was identified by Tokovinine (2003) in inscriptions at the ancient Maya cities of Yaxchilán, Calakmul and on an unprovenanced stela currently housed in the Stendhal Galleries in Los Angeles. The use of this term (although limited to only four known occurrences in the textual corpus) suggests that certain choreographed movements, such as dance, were to be watched by an audience.[1] The second term, *y-ichnal*, refers to a corporal field of vision (possessed by deities and rulers) that embraced other persons and their actions and is a term that is still used among Yucatec Maya speakers today (see Houston, Stuart and Taube 2006: 173–5). These textual references to the visuality of bodily acts in the Classic period highlight that there was awareness about the significance of performative bodily actions and spheres of interaction in ancient Maya culture. However, to understand the variety of arm and hand movements shown in visual sources, we must delve into the language of gesture, which is shown most explicitly in representations of the body.

Gesture, power and the court

The complexities of the gestural repertoire in Classic Maya art have long been noted. Benson (1974: 109) observes that 'many Maya figures look as if they were speaking sign language' and Houston (2001: 209) points out that 'there existed a rich gestural language, yet … the system underlying this language has proven strikingly resistant to

interpretation', resulting in Maya gesture being labelled 'extremely enigmatic' (Houston et al. 2006: 31). Historically, gestures have been labelled in fairly broad terms, namely relating to social status (Ancona-Ha et al. 2000; Perez de Lara n.d.) and power, including gestures of submission and surrender (Baudez and Mathews 1978; Miller 1981). One example which occurs widely in depictions in stone and on ceramics is a gesture that features one (or both) arms placed across the chest with hand(s) resting on the shoulder, or under the arm. In addition to submission, this crossed-arm(s) gesture has been interpreted as a respectful salutation (Seler 1908; Miller 1983), a gesture of respect (Benson 1974) or humility (Seler 1908).

While it is not refuted that the arm(s) placed in this manner could be interpreted in any one of these terms, we might ask what the *source* is for meaning. In addition to deducing meaning from the fact that the arm or arms are crossed by non-central figures (as per scholars above), or from the fact that the act of placing a hand on a shoulder shows that the weapon-bearing hand is empty as noted by Seler (1908), a point we will return to, it can be hypothesized that the basis for this gesture – and specifically forms with the arms crossed – is in the notion of binding (Maitland Gardner 2017: 698–704). Binding is important in ancient Maya culture, whereby stelae and chert eccentrics, among other items, were bound with cloth and tied (Houston et al. 2006: 83; Meadows 2001). Figures are shown with rope around their upper arms, forearms and wrists.[2] Positions in which the body is physically bound resemble positions that do not feature ropes. These formal similarities between positions with rope and those without (including the arms-across-chest position) suggest a metaphorical extension, whereby the physical act of tying up an object or person transfers to bodily acts that indicate the presence of rope and feature restricted movement.

Correspondence between the physically bound and metaphorically bound body is observed in other cultures, whereby bodily positions executed with physical restraint have developed into gestures of humility, reverence, obligation and piety. One example would be the Chinese gesture of humility, which involves putting the hands together in front of the body and bending forwards, literally signifying, 'I submit with tied hands' (Argyle 1988: 204). Physical binding as the source or base for the meaning communicated by placing the arms across the chest does seem relevant for the ancient Maya case. However, figures also display particular handshapes while placing the arms across the chest, such as with an extended index finger (see Maitland Gardner 2019: 104, figs 3a and 3b) or flat-hand, palm up (e.g. the action shown in Figure 8.3b). These subtleties – different handshapes produced with the crossed-arms position – require closer consideration to fully explore their dynamics and meanings.

Within the top-down approach, Classic Maya gestures have been grouped and labelled as 'a complex elite gestural language' (e.g. Boot 2003: 26) with interpretation tied to 'courtly status' and 'courtly bodies' (e.g. Jackson 2009: 75). This is a logical inference, given that ceramics and stone monuments depict royal life (Houston and Inomata 2009). Political hierarchies are important themes in Classic Maya art: many representations centre on rulers with attendants and subordinates, such as the depiction on Lintel 1 from La Pasadita (see Golden 1999: 5, fig. 2). 'Power over' is expressed through body

positioning. Statements of power are most explicit is the depiction of rulers standing with their feet positioned on top of a prone or crouching captive. One example is the image on Stela 24 from Naranjo in Guatemala; this composition is prevalent on stelae across the Maya region. Power and hierarchy are also expressed through the action of hair grasping, such as in the depiction on Lintel 15 from Yaxchilán in Mexico (see Benson 1974: 112). In these acts – standing on/over and hair grasping – the body is at centre in the expression of power, able to carry out certain actions (owing to one's status) or power over others (signalling hierarchy). Yet, status and power, perhaps unexpectedly, constitute a fairly narrow part of the gestural spectrum. The fact remains that many gestures are yet to be understood, and handshapes are thought by some to be too particular and their contexts too varied to deduce meaning (e.g. Ancona-Ha et al. 2000).

Courtly, or not? Alternative frameworks for gesture

Looking at the art almost twenty years on from Ancona-Ha and colleagues' (ibid.) study, it is clear that their observations are still entirely relevant: handshapes are particular; contexts vary. Two vessels, K764 (in the Museum of Fine Arts, Boston) and K1222 (a Codex Style vessel; see Kerr Archives),[3] each show a figure with an arm–hand configuration with hand lateral, palm down, index finger and little finger extended, middle and ring fingers bent in toward the palm and touching the thumb, arm by the side of the body, hand positioned by the hip. However, the contexts for this gesture are different. The scene on vessel K764 shows a 'preparation' or 'dressing' scene in which all but one figure stand; the kneeling figure applies body paint to a standing figure, who displays this action and who looks over his left shoulder to a mirror held by an attendant; two women are present, one of whom holds a mask and both are dressed in colourful, patterned *hupils*. The scene on vessel K1222 shows the figure producing the arm-hand configuration seated in a context of action with two kneeling figures, with a stack of cloth and bundle of feathers situated between them, making it difficult to elicit meaning.

Context, of course, is important; a gesture has relevance in its production in relationship to surrounding elements, themes and narratives (in both social and pictorial realms). However, rather than start with context, I examine particularities of form in detail before integrating them into contextual narratives. I leave aside the paradigm of a courtly language in order to explore engagements and various types of information that can be communicated through handshape and arm/hand actions. One example detailed in research elsewhere (Maitland Gardner 2019: 108–10) is the centrality of gesture in the communication of spatial and temporal information. These gestures may be used by royals (such as marking ruler succession and the completion and renewal of time cycles) but they are drawn from wider cultural concepts and practices that also have parallels in gestures used in Maya communities today. These types of actions may be employed in elite art earlier in Maya history, but they need not be bound by elite depiction, entailing questions of where this gestural language comes from, and how it came to be used in figural art in the Classic period to serve in appropriate semantic and iconographic contexts.

Formational characteristics of gesture: Implications for tracing meaning

Before looking at the representation of hands and arms in Maya imagery in more detail, it is important to layout the theoretical and methodological approaches that underpin my study. The first approach concerns recording gestures; the second, the relationship between form and meaning in gestural actions; the third, gesture families, which are groupings of gestures that share formal properties and semantic themes. Here, these approaches are outlined to demonstrate how they are helpful in examining the material.

Recording gestures

As a starting point, gestures must be recorded according to their physical properties, minimizing interpretative categories (as much as possible) from the outset. Terminology is also important. Following Cooperrider, Abner and Goldin-Meadow (2018: 3), *form/handshape/shape* refer to the physical aspect of gesture (i.e. what is produced/depicted); *gesture* refers to pairings of form and meaning. This distinction should be maintained because the same form or shape may have more than one meaning, resulting in different gestures. Details of finger positioning are important to record, along with other elements such as palm orientation and the extension or flexion of the wrist. These elements are the formational characteristics of arm and hand gestures. Particularities and variations in form serve to establish contrasts in meaning (see Sutton-Spence and Woll 1999 for examples in British Sign Language; see Stokoe 1960 for sign classification; for a classic example, consider the 'thumbs up' and 'thumbs down' actions that differ in meaning based on hand rotation, as well as on historical context).

Form and meaning

The relationship between form and meaning in all forms of communication – spoken, signed and gestured – is of longstanding enquiry (Cooperrider et al. 2018: 3). Writing in the early nineteenth century on gestures in Naples and gestures in antiquity (in the art of Pompeii and Herculaneum), Andrea de Jorio ([1832] 2000: 31) notes that gestures consist of two parts: one, the manner by which movement and arrangement of the hand and fingers is physically executed, and two, the idea that is attached to the manner of execution. The first – physical action – is 'not only of great advantage, but is absolutely necessary for the understanding of the second [the idea, meaning]' (ibid.: 31). De Jorio refers to this coupling as 'the double aspect of gesture'. For archaeologists, this double aspect is central in developing an approach to depictions in which only the *physical* traces of action remain; the meanings and dialogues associated with these actions have become silent through time and lost to the modern observer.

De Jorio's early observations have led to further investigations on this topic in gesture studies (e.g. McNeill and Levy 1982; McNeill 1992), drawing inspiration from the field of semiotics (such as the work of Peirce 1940/1965). For Peirce, the relationship between sign[4] (in Saussure's term, 'signifier') and idea/meaning (for Saussure, the 'signified')

could be divided according to certain qualities: resemblance or likeness (icons), contiguity and causality (indexes), and conventional link (symbols; see Hodge and Kress 1988: 21–2 for discussion). In a similar sense, gestures can be iconic, motivated or arbitrary. 'Iconic' means that the physical action is a picture of some aspect of the thing that is being expressed (the 'object, action, or motion', Mittelberg and Evola 2014: 1733). 'Motivated' means that the form is somehow caused by its meaning, however complex this link or cause may be (Kendon 1988b: 164–5; see Maitland Gardner 2019: 111–12; cf. Fulka, this volume). 'Arbitrary' means that the form does not reflect the thing that it denotes; there is no discernible relationship between form and meaning (for examples in Polish Sign Language, see Tomaszewski 2006; for examples in British Sign Language, see Perniss, Thompson and Vigliocco 2010).

This approach – iconic, motivated, arbitrary – cross-cuts typical gesture categories, from gesticulations to pantomime gestures, emblems and signs,[5] allowing for nuanced explorations of gesture: how they are physically executed and the types of meanings communicated through such physical formations. Notions of iconicity and arbitrariness are considered properties (rather than categories) in order to address the fact that gestures are, and do, many things at once (Mittelberg and Evola 2014: 1732) with these features best understood as a continuum (Perniss et al. 2010: 4).

In recent years, researchers have paid attention to the importance of the graphics of Maya script for investigating whether there are correspondences between graphics of logograms and phonemes and meaning (e.g. Zender and Van Stone 2011; Kettunen and Lacadena 2014, following Lacadena's 1995 study of the palaeography of signs in the Maya writing system; Kettunen and Helmke 2013). The selection of hands as graphic elements in ancient Maya glyphs – for which semantic contexts are largely known – provides excellent material to examine possible correspondences (Maitland Gardner 2017).

Gesture families

The third approach is the framework of gesture families. Kendon (2004) developed the idea of gesture families based on patterning that he observed in gestural actions of southern Italians. Gesture families are groups or sets of gestures that share formal properties and kinesic features. What is important is that 'each [family] is also distinct in its *semantic* themes' (Kendon 2004: 227, emphasis my own). For example, the R-family (bringing the tips of the thumb and finger together to form a ring-shape) is a ritualized form of precision grip action (ibid.: 283). The theme that unites the gestures is a notion of precision, joining or an object that is round in shape, whereby the manipulative hand action or the properties of the object that are being represented (such as a coin), serves as the base for the gestures' meanings (e.g. 'money'; see Morris, Collett, Marsh and O'Shaughnessy 1979; Kita 2009; de Jorio [1832] 2000: 83–6; Maitland Gardner 2017: 651–2, 697, 2019: 108–10; Gouy, this volume for discussion of a ring-shape gesture in Etruscan wall paintings; Kuehn, this volume for cross-cultural discussion). The gesture family that I examine in this chapter is the gesture family of palm open hand, which is

explained further below. Following these explorations on the topic of gesture, attention can now turn to Classic Maya figural art.

Arm and hands in Classic Maya art

Classic Maya figural representations show an astonishing variety of arm and hand actions and, particularly, finger positions, which are often depicted in detail. Handshapes – which are produced through the arrangement of the fingers – range from all fingers extended and adducted (flat hands), to fists, encompassing spread fingers, index finger extended, pincers, closed pinches and ring-shape hands (see Table 8.1). These groupings are based on shared formal properties (namely finger configuration) akin to the importance of such elements in recording sign languages. Within each group there are notable variations. For example, among pincer-shape hands, the space between the extended digit and thumb can be produced with the index finger and thumb, or middle finger and thumb; the index finger can be straight or bent at the knuckle; if the pincer shape is produced with the index finger, the middle and ring fingers can be straight or bent in to the palm. Furthermore, the same handshape can be produced with different wrist flexion, and with the arm either partially or maximally extended. Flat hands can be depicted laterally with palm up or palm down, or with hand vertical with palm facing away from the figure's body.

Handshape variation, in part, can be due to stylistic rendering (i.e. differences in painting/representation style in one area of the Maya region or another), but the same handshapes and hand/arm configurations crop up in images on pots from different places.

Table 8.1 Handshape classification based on finger configuration in Maya art

Finger configuration	Description
Flat hands	Fingers extended and adducted (thumb can be extended or adducted, fingers may be slightly curved)
Spread-fingers	Fingers spread (including spans, little finger and thumb extended)
Index finger extended	Index finger extended (other fingers are bent into the palm)
Pincers	Thumb and forefinger (or another digit) extended to create a space between the tips. Other fingers bent or extended
Closed pinches	Thumb and forefinger (or another digit) pressed together
Ring-shape	Tips of thumb and finger joined to form a ring or circle
Fists	Fingers curved into palm of hand (loose or tight action)

Source: Adapted from A. J. Maitland Gardner, 'Posture and Gesture in Ancient Maya Art and Culture', PhD diss., UCL (2017: 301, 307).

Tracing Gestures

An example would be an arm/hand action that features maximal extension of arm; the forearm is supine with hand vertical, fingers pointing down, little finger extended, palm facing out, thumb extended and middle fingers adducted. This form is shown on vessels from Chama (K7017), Hokeb-Ha (K2699) and an Ik' polity style vessel from Motul de San José (K1399), which suggests that there are certain conventions in the rendering of gestural actions across the Maya region. At the same time, handshape variation occurs within the context of the same image (such as the extension of the little finger or not), which suggests that even small differences in form have meaningful distinctions.

In addition to visual observations, tracing hands through drawing and recording helps to identify and clarify differences and similarities in handshape, which are not always immediately apparent through looking at the art alone. Many forms (such as the arm/hand action on the three vessels mentioned above) show fingers extended and adducted with the little finger raised or extended. This form – depicted in profile – may be akin to a hand span, in which the fingers are spread. Depicted frontally, the hand features the middle fingers adducted and little finger and thumb extended, which can be seen on a cylindrical vase from Tikal (K2697). An image on a vessel of unknown provenance (K1509), in which profile and frontal depictions of the spread-fingers hand occur, supports the hypothesis that hands depicted with little finger extended (both frontal and profile) are the same handshape, rendered from different viewpoints. In the image on the vessel (K1509), the figure on the right displays a frontal rendering of this handshape; the figure on the left displays a profile rendering (right hand), his left hand features the same handshape, which is upturned to hold a ceramic bowl. Formal variations – such as little finger extended or not – are important to record because hands with fingers extended and adducted (flat hands or open palms) may express different kinds of meanings to those expressed by spans.

In discussing the visuality of gesture, it is also important to mention that many figures in Classic Maya depictions are shown with one hand occluded, most often on ceramic vessels, and most often with figures depicted in profile. The occlusion of hands perhaps shows that the arm/hand does not enter into the bodily dialogue and/or that the significance of the arm/hand rests on its withdrawal from action. In some instances, the arm is occluded but the hand is shown, such as ring-shape hands (e.g. one of the women depicted on vessel K764 mentioned above). However, the majority of hands are depicted when the arm is also represented (Maitland Gardner 2017: 420). The decision on the part of Maya artists (to depict both) suggests that the arm and hand together comprise meaningful components of gesture. Extension of the arm – either partial or maximal – brings the hand forwards in face-to-face dialogues; extension also functions in terms of directionality in the expression of meaning, and in terms of expansive movement, such as with palm open hands as I explain further below. In addition to full occlusions, visible renderings of retraction, such as placing the arms across the chest (or placing a hand on a shoulder as Seler 1908 noted) make such withdrawals visible to the observer. In contexts that show the hand only, it may be the case that artists compressed the form of the gesture, or depicted two gestures at the same time, for example arms crossed over the chest and a flat hand, palm up.

Before moving on to explore the palm open hand family of gestures in Maya art, I discuss aspects of the graphics of Classic Maya hieroglyphs. The reason is that many handshapes that are represented in the art also feature in the writing system. The semantic contexts of glyphs are largely known, providing opportunity to explore the form–meaning relationship in detail and enabling consideration of how different channels of communication – gesture and writing – overlap. I select some examples here to illustrate the points being made.

Semantics of hands in Classic Maya glyphs

The ancient Maya script is described linguistically as a logo-syllabic writing system. Graphic elements include a variety of vegetation, animals and human body parts. Hands are employed frequently as graphic elements in both logograms (signs that represent whole words) and syllables/phonemes (signs that can either work as syllables or phonetic complements). Hands occur in counting/calendrics and as nouns, such as the word for hand itself, *k'ab'* (see Montgomery 2006: 142; Maitland Gardner 2017: 583–4). Significantly, the majority of hands employed in the writing system occur in verbs (Maitland Gardner 2017: 584). Perhaps this should not be surprising, owing to the fact that verbs are action words, and that many actions are accomplished by doing something using our hands, but these verbs also show a strong correlation between their graphic elements (i.e. handshapes) and actions expressed. Two clear examples are the verbs **CHOK**, 'to throw, to scatter' and **TZ'IB'**, 'to write, to paint'. **CHOK** is graphically represented as a hand with droplets falling from the palm (Figure 8.1a); **TZ'IB'** is rendered as a hand holding a painting/writing implement. Both these actions are also shown in the art (for examples of painting/writing, see Coe and Kerr 1997: 107, figs 76 and 77).

Hands with fingers extended and adducted and hands that feature a pincer shape are also employed in the writing system. These hands are used in particular semantic contexts; in each, the form of the hand relates to the meaning denoted. The glyphs **K'AL**, 'to present, to lift, to bind/fasten, to wrap, to hold' (Figure 8.1b) and **CH'AM**, 'to receive' (Figure 8.1c) each feature a hand with fingers extended and adducted.[6] They are distinguished in their graphic renderings by one key feature: for **K'AL** the thumb is adducted; for **CH'AM** the thumb is extended. This formal distinction – thumb adducted/ extended – may have served to minimize confusion when these words were written (see Figure 8.1b–c). The open hands in both, with fingers outstretched likely relate to the notion that they denote: receiving (with hand open) and presenting/holding (with hand serving to support an object). These handshapes are relevant to the performative and practical contexts in which they can be used and expressive of their semantic contexts in the writing system.

Several hands also feature as syllables in the writing system. Boot's (2003) study provides an excellent discussion of the derivatives of these signs, which aids investigation into the relationship between form and meaning in gesture.[7] For example, the syllable **yo**

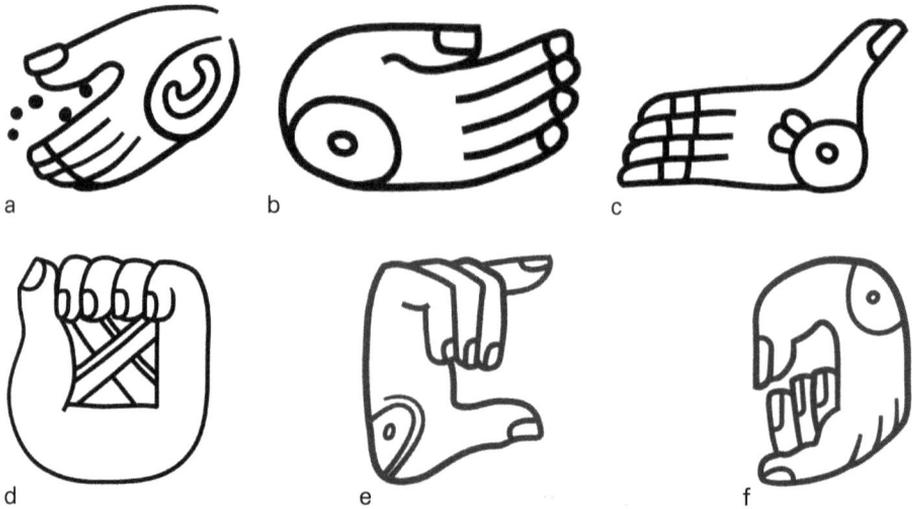

Figure 8.1 Hands in Maya writing: *(a)* logogram **CHOK**, 'to throw, to scatter'; *(b)* logogram **K'AL**, 'to present, to lift, to bind, to wrap, to hold'; *(c)* hand in logogram **CH'AM/K'AM**, 'to receive'; *(d)* syllable **yo**; *(e)* syllable **ke**; and *(f)* syllable **ye**. Illustrations by Amy J. Maitland Gardner based on glyph drawings by John Montgomery (a), Avis Tulloch (b, c and d), Harri Kettunen (e) and Mark Van Stone (f).

shows a clenched fist with markings in the palm (Figure 8.1d). Boot (2003: 17) proposes two possible derivatives for **yo**: (1) *yotz'*, which in Ch'ol means 'to press or to hold tight with the hand';[8] and (2) *yom*, which in Tzeltal is a numerical classifier that refers to 'handful (of) sized bunches, non-bound.'[9] The form of the hand in **yo** – a fist with markings in the palm – corresponds to action and meaning: holding or grasping something in the hand, or showing a handful of something. Given the use of hands for measuring quantities (handfuls/bunches) in markets, this sign (and its meaning) likely originates outside the elite sphere (Maitland Gardner 2017: 614). Trade in the marketplace may not necessarily be restricted to non-elite, but would certainly comprise a wider populace than the elite alone.

Two further syllables – **ke** and **ye** – feature hands with the same finger configurations with thumb and forefinger extended, other fingers curved into the palm. They differ on wrist flexion (upwards/downwards orientation) and semantic derivatives. The hand in **ke** is oriented upwards with the forefinger positioned on the top line and thumb positioned on the bottom line (Figure 8.1e). Boot (2003: 6) proposes that **ke** may derive from two terms in Tzeltal: *keh* – a numerical classifier for 'measure between knuckle of forefinger and thumb' – or *kehleh* – 'span between thumb and knuckle of forefinger (numeral one only)'. This span is nicely displayed in the graphic rendering of **ke**. In contrast to the upward orientation of **ke**, the hand in **ye** is oriented downwards with the thumb positioned on the top line and forefinger positioned on the bottom line (Figure 8.1f). Boot (ibid.: 16) notes that **ye** may derive from the verb, *ye'el*, which, in Ch'ol, means 'to grab, to take with

the hand'. In the graphic rendering of **ye**, the action of picking something up is shown with a space between the outstretched forefinger and thumb.

The meaning of each sign is related to the form of the sign – the pincer shape (the extension of the forefinger and thumb with a small space in between the tips of the digits): **ye** depicts a grasping action; **ke** shows a measurement. Wrist flexion (upwards/downwards positions) serves to contrast these signs in the writing system. There is a Preclassic rendering of **ye** (on Stela 10 from Kaminaljuyu in the Guatemalan Highlands; ibid.: 16) and an Early Classic rendering of **ke** (in a text on a plaque found in El Salvador; ibid.: 6). Based on these occurrences, we may argue that the distinction between hand shapes was maintained early on in the writing system. The finding of meaningful couplings suggests that gestures pre-date the script, with some couplings having deep history. Furthermore, the selection of hands to function as particular words and syllables in the writing system is not arbitrary; handshapes employed feature iconic and motivated properties.

Having explored some aspects of the writing system, we turn our attention to a group of gestures that feature hands with fingers extended and adducted and palm open in Classic Maya figural representations.

The palm open hand gesture family

The origins and source meaning of gestural actions that feature an open hand with palm upturned have been studied extensively in a variety of cultures and contexts (e.g. Morris 1977; McNeill 1992; Müller 2004; Kendon 2004; Streeck 2009; Chu, Meyer, Foulkes and Kita 2013; Cooperrider et al. 2018). Palm-up gestures are one of the most frequently used gestures in social interactions (Müller 2004: 234). They are documented widely around in the world (ibid.: 233) in both signed and spoken communities, including by home-signers (Cooperrider et al. 2018: 2). Despite their ubiquity, 'the same cluster of meanings pops up in culture after culture' (ibid. 2018: 2). This finding suggests that there is a significant relationship between form and meaning in these gestural acts and that this relationship may not only be found in gestures of cultures today, but perhaps also those of the past.

Although there are differences in how the family of palm-up gestures are classified – such as one large group with functional variations namely motion patterns (e.g. Müller 2004), or smaller families in which motivation pattern is a criterion for each group (e.g. Kendon 2004) – there is consensus that handshape, with fingers extended and adducted and orientation, palm up, are central formational characteristics of these gestures. There is also consensus that the source for meaning of palm-up open hand gestures is in object manipulation.

In her analysis of gestures used by Spanish-speakers, Müller (2004: 233) points out that the origins of the Palm Up Open Hand (PUOH) family of gestures are in 'instrumental actions of giving and receiving'. The PUOH family is defined by the adduction and extension of the fingers, with the palm oriented up. Metaphor is at play, by presenting an

abstract object as a physical, manipulable and visible one; placing the palm up invites participants to share perspectives on the object displayed (ibid.: 233). Müller (ibid.: 236) identifies two groups of actions that serve as the source domain for the PUOH. The first involves giving, showing or offering an object (by presenting it in the open palm); the second involves receiving an object with hand open (or displaying an empty hand, indicating a readiness to receive). Müller (ibid.: 236–7) argues that we perform these actions in many aspects of daily life, for example in the exchange of coins (in which the open hand functions as a kind of tray), showing an object to someone, such as a shell found on a beach, or offering a sweet. It is the fullness or emptiness of the hand that is important in these instrumental actions, which serve as the source domain for the PUOH gestures, produced with the same kinesic features – extended palm and upward orientation (ibid.: 241).

In his study of gestures used by Italian-speakers in Naples and English-speakers in Northumberland, Adam Kendon (2004) reaches a similar conclusion. For Kendon (2004: 264), these gestures are called the Open Hand Supine (OHS) or 'palm up' family of gestures: the open hand is maintained on a supine forearm so that the palm of the hand faces upwards. Two sub-sets of gestures within this family involve presenting or displaying. The first set is Palm Presentation (PP) gestures, which are produced when the speaker extends the OHS forwards: the wrist is extended, the hand lowered slightly, then a hold. PP gestures are used in conjunction with speech to mark something being presented and drawing attention to the utterance (ibid.: 265). The second set is Palm Addressed (PA) gestures, in which the OHS is directed towards something, whether another person or an object, as if the hand is being placed to offer something or to receive something (ibid.: 272). PA gestures are used in conjunction with the verb 'to give'. They are also used when one expects (or hopes) to receive something, such as a piece of information, an explanation, a justification or a physical object (ibid.: 272). Kendon notes that both PP and PA gestures can be interpreted as gestures of 'offering', 'presenting' or 'being ready to receive' as Müller (ibid.) and also Morris (1977) have suggested.

Returning to the ancient Maya context, the use of hands with fingers extended and adducted in glyphs that denote receiving (**CH'AM**) and presenting (**K'AL**) are supported by Müller's (2004) and Kendon's (2004) observations. Open hands are also used in the manipulation of objects and as components in gestural actions in Classic Maya figural representations. Flat hands can be depicted laterally with palm up or with hand vertical and palm facing out. I discuss both forms here. Palm open hands feature in scenes with one focal point of action, scenes in which figures face the same direction and with figures depicted on their own. Their occurrence in various compositions suggests flexibility in their use, functioning in a range of contexts and interactions, as I discuss in the following sections.

Open palm: The action of scattering

One of the clearest correspondences between handshape and hand/arm configuration with handling objects in the palm is the action of scattering. Scattering is shown with an

open hand with fingers adducted and with wrist flexed such that the hand is angled forty-five degrees below horizontal, vertically downwards or with the fingers angled back towards the body such that the heel of the hand is furthest from the body. Droplets are shown falling from the open hand. (This action is described in texts by the verb, *chok*, 'to throw, to scatter' that I mention above.) Scattering rituals are depicted on Stela 15 from Nimli Punit, Lintel 2 from La Pasadita and Stela 13 from Piedras Negras amongst others. These actions are interpreted as the ruler dispersing seeds or grain, copal incense (*pom*) or blood (see Rice 2007: 127 for discussion and references).

Open palm: Showing action

The notion of offering in scattering rituals – which have deep history – may provide the physical and semantic base for certain open palm gestural actions in the art. In these cases, the open hand can be used in showing or presenting action, perhaps comparable to Kendon's Palm Presentational gestures, which feature a slight lowering of the hand and a hold. For example, the image on ceramic vessel K767 (in Princeton University Art Museum; Miller and Martin 2004: 187, pl. 105) depicts a scene with a ruler seated on a bench with a large cushion backrest; figures are grouped standing, sitting and kneeling in a spatial setting that includes steps and a platform. The figure on the far top left of the rollout image is sat apart from the ongoings, yet his position and arm/hand action take a prominent role. He is located in the uppermost section of the scene, situated above a litter (which signals the arrival of people to the event and who are depicted interacting with the ruler on the bench) and he displays a similar handshape and arm/hand configuration to the form used in scattering rituals, with the arm extended forwards and palm out. Miller and Martin (ibid.: 187) observe that, 'he gestures and seems to be directing traffic'. In agreement, this figure's function seems to be to present the arrival of individuals and to indicate the interaction that is taking place. In terms of gesture, the palm of the hand is pushed away with maximal surface area to encompass the locus of action before him. The act of extending the arm is expressive of directionality ('this way') and palm open (display). One would imagine that this was a gesture that would be performed in person; his role and gesture are also made prominent in the image to guide the viewer (perhaps loosely glossed, 'look this way') as one would turn the vessel and encounter various aspects of the scene.

A similar form also features in the image on ceramic vessel K554 (in Kimbell Art Museum, Fort Worth; see Schele and Miller 1986: 164–5, pl. 48; see detail of the scene in Figure 8.2). This scene shows five figures and is thought to represent a marriage ceremony of two couples dancing, indicated by the women lifting one heel in movement (although the man in each couple might be the same person, Schele and Miller 1986: 152). The figure between the couples holds an object in his right hand; his left arm is extended forwards, hand vertical on a supine forearm, palm out, and fingers pointing down, similar to the depiction of the figure displaying this action on the vessel described above. Schele and Miller (ibid.) note that 'his position here, at the juncture between the two scenes [the couples], is ... to guide the viewer'. This is a likely function. The figure's open hand shows and draws attention to the couples' actions in the social context that it

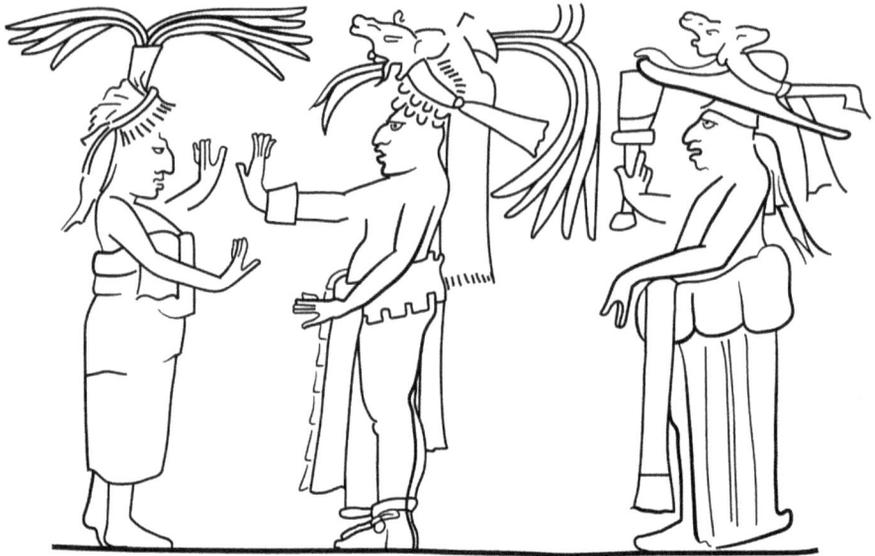

Figure 8.2 Sketch detail of scene on ceramic vessel K554. Illustration by Amy J. Maitland Gardner based on rollout photograph by Justin Kerr.

depicts as well as in the pictorial realm. It is interesting to note that this is the only rendering of the open palm in the scene; the hands of the other four figures show fingers adducted with little finger extended in a variety of supine and prone positions. In both scenes, the role of the open hand is to present action; the figures displaying these actions are not directly engaged in face-to-face conversation with another person.

Open hands: The offering and receiving of goods/items

Open hands may also serve to communicate offering or receiving of goods in a physical sense, indicated by both Müller's PUOH and Kendon's Palm Addressed gestures. In Maya art, open hands are employed in manipulation of objects (such as bowls among other items), as actions near objects, or displayed with no objects present (e.g. scene on vessel K6685). Outside of their gesture dichotomy of status-related gestures (in their terms 'absolute') and 'relational' gestures (such as greetings), Ancona-Ha and colleagues (2000) note that a gesture depicted on three ceramic vessels might signal 'presentation'. The form of this presentation gesture features both arms extended in front of the body with wrists pressed together and hands parted. Two vessels show depictions with objects in the hands; one vessel shows a depiction without.[10] The action taking place in one of the scenes – on vessel K2220 – has also been commented on by Coe, who notes that the image perhaps shows the offering of paper-polishers and stacked paper to the figure holding an open codex (Coe and Kerr 1997: 152–3, fig. 120).[11]

This relationship between palm open hands and objects in the Maya context suggests that manipulation serves as a source domain for these gestural actions. These actions can

be used in face-to-face engagements, which is illustrated in the scene on vessel K4688 (Figure 8.3a). In this image, a figure is sat cross-legged on a bench with his face turned to engage with the figure on his right-hand side. This figure is kneeling, with forearms extended in front of the body and holding a bundle of feathers. The other two figures in this scene are depicted kneeling: one on the central figure's left-hand side (with his arms crossed and hand gripping his upper arm), and one figure on his far right (with arms crossed and with his left hand as a fist positioned under his right arm). There is a stack of cloth by the bench directly below the central figure's extended right arm on the vertical axis. The hand of the central figure is shown with fingers adducted, palm out. The feathers held by the kneeling figure are rendered such that the tips of the feathers are closest to the central figure, with one tip rendered behind the central figure's wrist. Stacks of cloth with feathers atop are common item pairings in Maya iconography; their separation in this scene suggests an action in moving the feathers has occurred. Given the curvature of the feathers (with tips angled back towards the central figure) and the rendering of the central figure's right hand, we can hypothesize that the central figure has handed the bunch of feathers to the kneeling figure (the bunch is shown in the kneeling figure's hands). In this sense, this image depicts the final hold in a sequence of actions, whereby the feathers are picked up (from by the bench), handed to the kneeling figure (with arms extended forwards to receive them). The central figure displays directional flow through extension of the arm, palm out.

Another scene shows open hand actions with items, but it is more difficult to assess directionality. This is in part due to the fact that the open hands are depicted with three figures in this scene (rather than one) and that the open hands are displayed with figures that have their arms crossed over their chests. The image on vessel K5109 (of unknown provenance, but thought to be painted in the Ik' style in Petén in northern Guatemala, Kettunen 2006: 497) shows four figures (Figure 8.3b). One figure sits cross-legged on a bench with face turned to his right side. One figure kneels on the left; two figures stand on the right. The central figure has his left hand by the side of his body, and leans with right arm extended and hand grasping a bunch of flowers, which are angled towards his face. A container with more flowers is situated beside his right hand. To his left is a tied bundle. The figure in the left of the scene lowers his head, has arms placed across his chest with hand supine, palm up. The two standing figures on the right also have their arms placed across their chests. The standing figure closest to the action has his hand angled downwards with palm out; the figure further back has hand supine, palm up.

With these actions in place, we can consider how they relate to the narrative. Has the container of flowers been presented by the figure on the left, from which the central figure has plucked a bunch and brings them towards his face to inhale the scent? Have the figures on the right presented or offered the tied bundle, which now sits between them and the seated figure? Are both gestures at play, by which the standing figures on the right have presented a bundle and the central figure is giving a bunch of flowers from his container to the kneeling figure, whose supine open hand conveys a notion of 'being ready to receive'? It is difficult to know. Two other vessels feature images of persons holding flowers: one pot shows a ruler from the Ik' polity (K1453; see Tokovinine 2016:

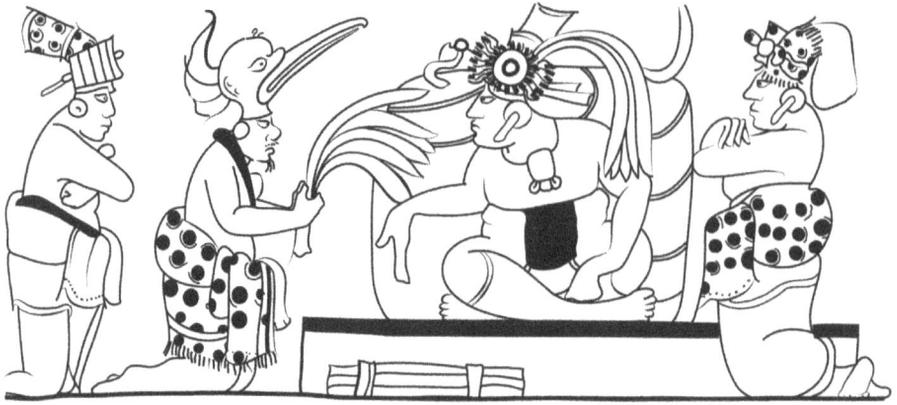

a

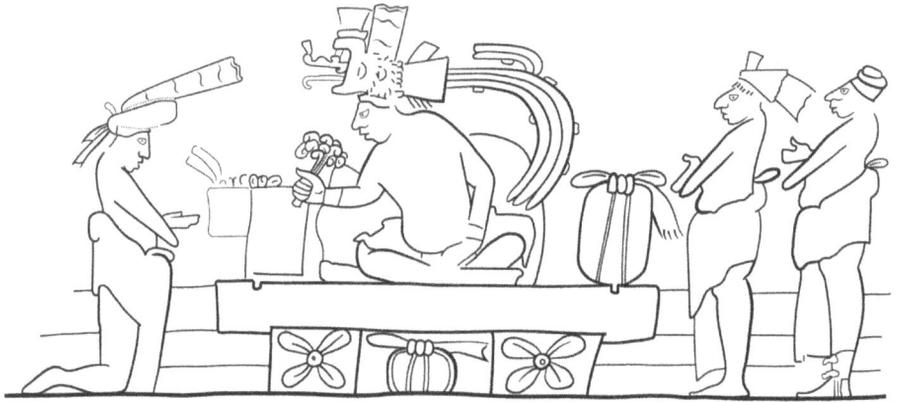

b

Figure 8.3 Palm open hands in face-to-face interactions with objects: *(a)* Scene on ceramic vessel K4688; *(b)* Scene on ceramic vessel K5109. Illustrations by Amy J. Maitland Gardner based on rollout photographs by Justin Kerr.

18, fig. 6b), the other shows a ruler from Dos Pilas (K1599; see ibid.: 19, fig. 7) both accompanied by persons sitting and standing in interior- or semi-interior locations. Both scenes show vessels and containers, and texts on both vessels express the consumption of *pulque* (fermented sap of the agave plant), although only one figure is shown consuming it (ibid.: 17). In contrast to the scene on vessel K1509 (Figure 8.3b), it is not the ruler seated on the bench who holds the flowers but rather the seated and standing participants. Tokovinine (ibid.: 17) points out that the nature of the events in these two scenes remains ambiguous, but that the presence of flowers hints at fragrance and the containers suggest a display of special food and drink. Although it is difficult to confirm directionality in the scene on vessel K1509, the use of open hands within this context of action suggests that an exchange is (or has) taken place, which in turn can only be understood through the relationship between the open hands displayed, and other elements – flowers and a bundle – that are also part of this scene.

Open hands: Shared participation

One interesting bowl (K9244, Kerr Archives) shows five figures facing the same direction in a band near the rim. All figures show arms extended at varying degrees with open palms in a variety of supine positions. We might hypothesize that these figures show a shared participation in the acts of giving and receiving. It is significant to highlight here that hands manipulated ceramic vessels on which many scenes described above are shown. As Boot (2014: 19–20) notes 'this manipulation meant not just a simple handing over of a ceramic container from one person to another; it also involved filling it with some kind of substance and either drinking or eating from it. The manipulation is thus not static, it is dynamic. This dynamic takes place not only on a vertical (up-down) or horizontal (left-right-forward-backward) plane, it also involves the rotation of the vessel around its vertical axis (which, for instance, is necessary to read the complete dedicatory text or view the full visual narrative).' Many vessels show ancient repairs, which suggests that they were handled often before their deposition in caches and burials (ibid.: 17–19).

The fact that vessels were passed around, and their contents offered, received and shared, suggests that these actions may symbolize shared participation. This is further emphasized by the composition – figures seated in a line – which suggests participation in action as a group, rather than illustrating a focused encounter between two individuals. The gestures employed (and depicted) are linked by the notions of giving and receiving, which are *co-productive* actions, centred on the important act of handling and moving the container. As Tokovinine and Beliaev (2013: 175) point out, drinking vessels changing hands in the sharing of beverages among participants at events may have been even more significant than gifting of vessels as socio-political statements. Notions of offering, receiving and sharing may have been heightened at politically and socially charged meetings and events at which these vessels were used. It is important to note, however, that such actions as sharing and gifting are not elite in and of themselves.

Open hand: Conversation

Another context for the open hand in Maya art is the scene on vessel K532, which shows six figures depicted with shields or banners and elaborate headdresses (Figure 8.4). The focus of action is with two figures that stand and face each other. The figure to the left holds his banner or shield frontally; his left hand (shaped as a fist) supports the position of the banner/shield by resting it on top of the shaft; his right hand holds the shaft with fingers curved and thumb on top. The figure on the right supports a similar banner/ shield with his left hand; he stretches his right hand forwards with palm open and wrist flexed forty-five degrees below the horizontal line.

The direct engagement between these figures (body positioning, gaze and gesture) suggests a different function of the extended hand/arm to the presentation (of action) function discussed further above. The open hand in this context seems to work in a metaphorical sense. By placing the hand forwards, the figure on the right invites the participant (on the left) to share perspectives on a topic. As both Kendon (2004: 274) and

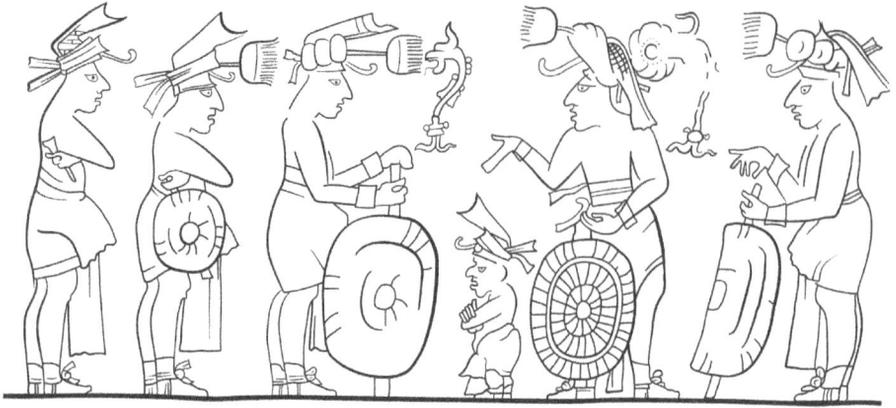

Figure 8.4 Scene on ceramic vessel K532. Illustration by Amy J. Maitland Gardner based on rollout photograph by Justin Kerr.

Müller (2004: 252) note, the object that is handled and which serves as the source domain for open hand gestures has *transitional* status: when the open hand is used in conversation, it is produced to invite perspective on a discursive comment, and does not show the shared result. Here, a perspective is offered by presenting the open hand. Given the presence of shields or banners among other elements, this interaction can perhaps be understood as a negotiation, centred on a topic of conversation at this meeting, or a recall of information following an event. All figures are depicted with open mouths, indicative of talk, which suggests that they all participate in the dialogue. It is interesting to note that the slight lowering of the head of the figure on the left and trajectory of his gaze focuses on the hand of the figure on the right. What the open hand is showing is the presentation of an idea or piece of information as a manipulable and visible one.

Open hands: Notions of plenty and expansive gestures

A final context for the open hand that I cover here is the depiction of open hands with the Maize God, such as the rendering on the ceramic plate K97 (Figure 8.5). What is immediately apparent is the maximal extension of both arms on the horizontal axis. Both hands are depicted with palms facing out; the god's right hand features fingers pointing up, his left hand shows fingers pointing down. In his study of the history of Mesoamerican sign languages, Fox Tree (2009: 354) notes an interesting correspondence between the Yucatec Maya sign, MILPA ('maize plant[s]', 'maize field[s]')[12] and gestures of the Maize God on two Classic Maya ceramics (K3933 and K5258, Kerr Archives). The images of the Maize God on these ceramics show the right arm extended upwards with an open palm; the form of the Yucatec Maya sign MILPA is executed by raising the arm and presenting the hand open with palm up, with the height of the hand and the angle of the wrist serve to indicate the healthy size of the maize plant.

Although Fox Tree's case for proto-signs based on formal similarities between signs in contemporary sign languages and in art in an earlier period in Maya history has been

Figure 8.5 Rendering of the Maize God on ceramic plate K97. Illustration by Amy J. Maitland Gardner based on photograph by Justin Kerr.

disputed by some scholars, Fox Tree does raise important considerations, namely that gestures selected in depictions of the Maize God potentially relate to maize cultivation. The gestures of offering used in scattering rituals for dispensing seeds or grain – likely indicative of sowing in terms of agriculture – and the open hands shown by the Maize God present an interesting point of comparison. Both these actions are shown within the Classic period and both could be related by the action of dispersal. As well as handshape (including hand orientation), we can consider the extension of the Maize God's arms and how these elements work together in the communication of meaning. Here it is useful to bring in a cross-cultural comparison, given that some aspects of gesture, such as amplitude, can be used in similar ways in different cultural contexts. In her study of French gestures, Calbris (1990: 61) relates arc-like movements with open palms to the expression of large quantities. Physical action – expansive movement – relates to the meaning communicated, 'large'. Similarly, the maximal extension of both arms shown by the Maize God on the ceramic plate may express notions of bounty or plenty related to the production of crops and harvest. Although these interpretations are tentative and conjectural, the intention is to demonstrate the breadth and diversity of gesture dialogues, all of which are important to consider in tracing meaning.

Instrumental actions and gesture: Further bases?

Following these explorations of open hands in Maya art, we may consider the role of objects in shaping gestural actions further. Müller (2004: 240) suggests that her method

for analysing open hands extends beyond the PUOH family: a recurrent kinesic feature can be taken as a starting point, its contexts of use examined, and consideration lent to see if there is a basic, instrumental action from which it originates. With regard to Maya art, particularly representations from the Usumacinta region, Benson advocates the importance of objects in communicative actions and argues that this topic requires in-depth study (1974: 109, 113–14, 116).

Object manipulation accounts for about fifty per cent of all hands shown in depictions in stone and on ceramics (Maitland Gardner 2017). Close inspection shows that objects are held with fingers configured in a variety of ways, and that many handshapes employed in manipulating objects parallel handshapes used in gestural actions. Objects can be held close to the body, extended from the body, in one hand or with both hands, with the arm maximally or partially extended; the forearm can also be used for bearing weight. Objects include painting/writing equipment, cloth, cylindrical vessels, bowls, shields, bars, torches, staffs, weapons, bundles, bags and musical instruments (Figure 8.6). Hands that feature a precision grip with forefinger and thumb are used to pick up or hold something small or thin, such as painting and writing equipment, or an object that requires a precision-grip action. Cloth is held with a light grasping action, with digits curved, or with cloth placed over the extended forearm. Many vessels, amongst other items (such as mirrors), are held with fingers adducted, palm up. Bundles of feathers and staffs are held with fists, with the fingers grasping the stem or handle/shaft in the hand. Scale, size and shape are important properties in determining how objects are manipulated in the hand. In the action of holding a vessel to pour hot chocolate, shown on a Codex Style vessel, K511 (see Miller and Martin 2004: 76, pl. 32; detail in Figure 8.6) the fingers are spread to be able to grip the pot and pour liquid without dropping the vessel or spilling the contents. Spread fingers are also used to manipulate bowls and cylindrical vessels in the action of drinking, such as in the scene on Ik' style vessel K1453 (in the National Gallery of Australia, Canberra; Miller and Martin 2004: 43, pl. 14) and in the murals from Calakmul (see Carrasco Vargas, Vázquez López and Martin 2009, figs 3 and 5).

The importance of object manipulation in the development of gestural actions is demonstrated in many fields, with strong evidence to suggest that many gestures draw upon motor skills used in dealing with objects (e.g. Chu and Kita 2008; Streeck 2009; Kendon 2004: 82 with references). In addition to hands with fingers extended and adducted discussed above, spread-fingers hands and pincer-shape hands, amongst other finger configurations that are used in dealing with objects, are shown as part of gestural actions in Maya art. The scene on vessel K2707 (Kerr Archives), which was excavated at Tayasal in Guatemala, shows a man and a woman reaching towards a basket of foodstuffs, with the fingers configured in the form of a precision grip in the action of picking up contents from a basket. Several scenes show objects manipulated with a pincer-shape hand, whereby the thumb and finger are extended with a gap in between. An image of a figure on a pot of unknown provenance (K8088, Kerr Archives) is particularly interesting because the figure displays the same handshape with both hands: in one hand, he manipulates a vessel; in the other hand, he does not. Such configurations (with the thumb and forefinger extended) often occur in place of arms extended with the

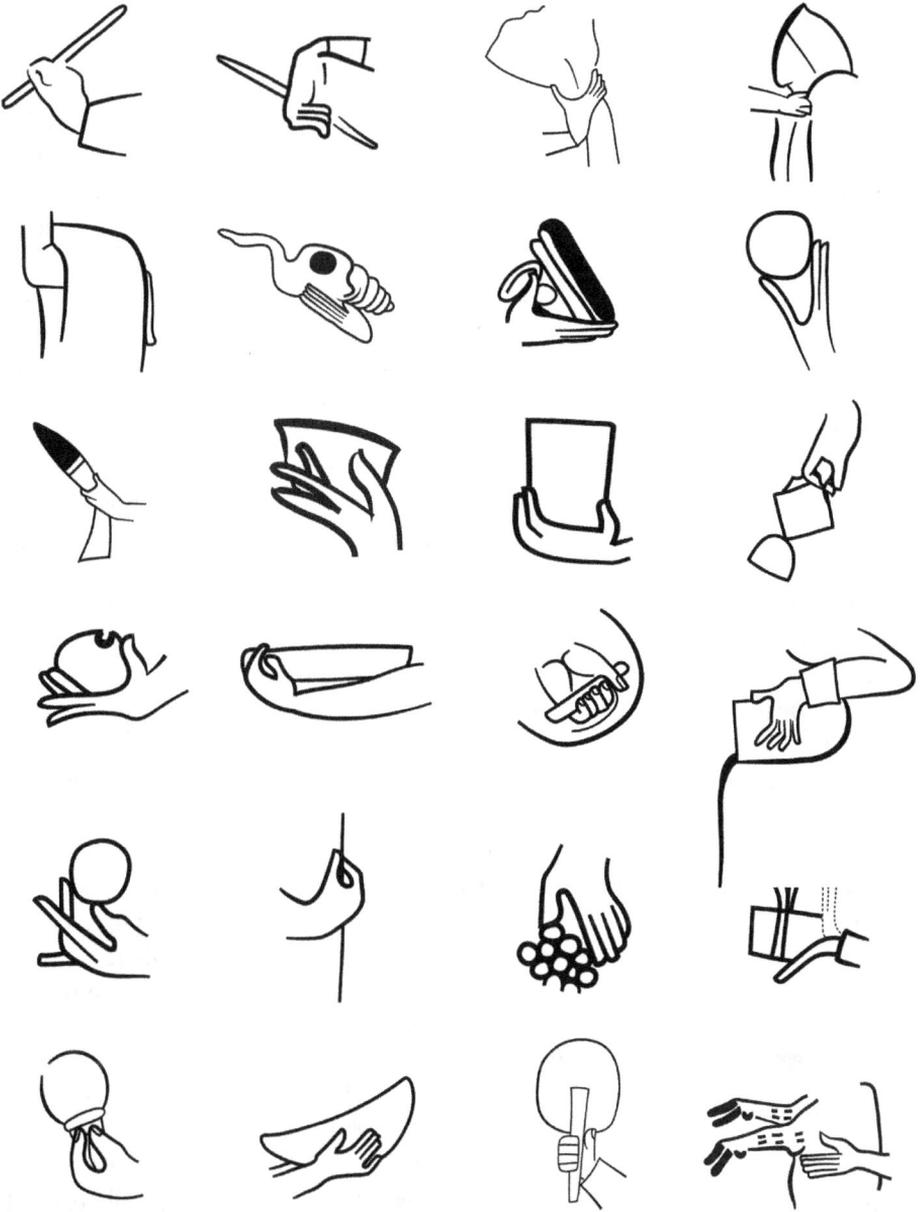

Figure 8.6 Examples of object manipulation in Maya art. Illustrations by Amy J. Maitland Gardner.

palm open, such as the depiction on a Chama-style vessel, K1785. The image on this vessel shows a figure leaning towards a basket of goods; his hand is enlarged, drawing attention to his action. From these occurrences, we may hypothesize that the origins of other Maya gestures (beyond open hands) may lie in or spring from tactile engagement with objects. However, a fuller examination of such correspondences must await future study.

Tracing the trace: Concluding remarks and future directions

Classic Maya depictions on ceramics and in stone provide a vast and detailed source through which to examine gestural repertoires. Given the nature of the surviving evidence, material culture is skewed towards the elite sector of society. Non-elite communication and representation in the Classic period has traditionally been viewed as something that is bound to be different and separate from elite representation (Grube 1992: 216). Yet, we need to be mindful that the source for gestural actions might not be bounded by their material representation in the elite sphere. People use gestures in everyday household communication and in bustling, public spaces such as markets, where hands are used in bartering and in the transaction of goods and items. In the Maya region today, sign languages are used as alternative to spoken languages in travel and markets (Fox Tree 2009) and 'linguistic data suggests that key market-related activities in the Maya lowlands emerged in the Preclassic period' (Tokovinine and Beliaev 2013: 172). Gestures could have been used in communication within and among communities in similar contexts in the past as well as such actions (communicating quantities, scale/size indication, handling and showing items, etc.) influencing gestural actions used in social, epigraphic and pictorial contexts earlier in Maya history.

A shift in frameworks – from a top-down model to a bottom-up approach – illuminates particular kinds of information and allows for everyday types of bodily action to be included and considered. This shift in perspective is necessary in efforts to understand meaning produced through a variety of actions in ancient Maya culture. In tracing meaning, we need to look beyond power and beyond viewing gestures through the lens of status (as status markers) to consider the ways in which a variety of material and social engagements shape arm and hand actions in communication. By considering how meaning relates to form – in terms of iconic/motivated/arbitrary properties of gesture and through the framework of gesture families – we can work towards an understanding of ancient Maya gestures that have, historically, been difficult to interpret. The case study of palm open hands demonstrates the helpfulness of contemporary studies of gesture in approaching ancient iconography and that, comparable to their meanings and functions in cultures today, there is a range of contexts for the open hand in Maya art, including showing action, offering/receiving items, shared participation, conversations, and denoting notions such as plenty.

Tracing the meaning of gestures through representations in ancient Maya culture is not a straightforward task but it is an important and potentially fruitful one. Isolating handshapes and actions in analysis is essential to be able to see the extent of the gestural repertoire and to explore the form–meaning relationship of gestural actions. It is also vital that we interpret gestures in relation to each other (within the system of communication) and in relation to the content and context of the representations. In thinking about ancient Maya gestures according to properties of iconicity and arbitrariness also brings in the stance of the analyst. The analyst's spectrum of what constitutes an arbitrary or motivated or iconic gesture may be different for the culture in which the art was produced, and thus

we must continually return to and re-assess our interpretations, paying attention to certain kinds of information that might have been overlooked. Gesture families provide a useful framework, and research on the role of objects and material engagement in the development of gestural actions provides food for thought. Dynamic engagement with the field of gesture studies within archaeology helps to raise fresh questions and open up new lines of investigation. By drawing upon methods that help in analysing the form, meaning and use-patterns of gesture, and by shifting frameworks from a top-down model to allow for a bottom-up approach, we gain deeper insights into the semantics of ancient Maya gesture. Rather than understand gestures as an add-on or peripheral in past social and cultural contexts, we must integrate gestures into wider discussion. The study of gesture in Maya art is – and must continue to be – an ongoing investigation.

Acknowledgements

I would like to thank Patrice Bonnafoux and Elizabeth Graham for their comments on this chapter, which were helpful in revisions. I also express my thanks to the reviewers for providing feedback on an earlier version of this manuscript.

Notes

1. For discussion of the role of audiences during public performances, see Inomata (2006).
2. Examples include a kneeling figure on a panel from Palenque, a seated figure on the façade of the Northern Building of the Nunnery Quadrangle at Uxmal and a standing figure incised on a bone found in Tomb 116 at Tikal (see Maitland Gardner 2017: 700).
3. Justin Kerr's rollout photographs of the ceramic vessels mentioned in this chapter, (K number), can be viewed online at Kerr (unknown date).
4. Note that 'sign' here is a concept in semiotics and not 'sign' as a (lexical) element in sign language.
5. See Kendon (1988a) for discussion of gesture categories; see McNeill (2000) for discussion of these gesture categories according to various properties, such as relationship to speech, linguistic properties, conventions and semiosis.
6. The hand in **CH'AM** has hieroglyphic signs affixed to it that distinguishes it from other glyphs, e.g. **YAL** (see Boot 2003: 3, 16, 28).
7. Formal variations of the same sign do occur. This variation may be due to temporal, regional and/or material factors in renderings and writing. Other formal variations share a semantic basis. For example, variation in handshape (e.g. index finger extended, ring-shape element) in renderings of the verb **TZUTZ** ('to complete [a period of time]') corresponds to the variety of hand gestures used in talking about time (see Maitland Gardner 2019: 102, 110–11). For a fuller discussion of hands in writing, see Maitland Gardner (2017: 573–629).
8. Ch'ol is a Mayan language that is spoken in the modern-day Mexican state of Chiapas.
9. Tzeltal is a Mayan language that is spoken in the modern-day Mexican state of Chiapas.

10. Comparatively, the formal characteristics of this 'presentation gesture' appear in Mixtec iconography. In the Codex Zouche-Nuttall, figures are shown paying homage with plants, flowers and gifts, with arms extended, palms apart and objects resting between the open palms.

11. There are also instances in Maya art where the wrists of figures are placed together (bound by cloth/rope) and hands parted holding an object, such as on a set of jade earspools (of unknown provenance, see Maitland Gardner 2017: 553–4). These occurrences highlight the use of metaphorical extension in gesture (through the presence/absence of objects with concepts of binding, obligation and offering).

12. Yucatec Maya Sign Language is used by both deaf and hearing persons in communities in the Yucatán Peninsula in Mexico. Please see the YMSL Project / Proyecto LSMY (2020) for further information.

References

Ancona-Ha, P., J. Perez de Lara and A. Van Stone (2000), 'Some Observations on Hand Gesture in Maya Art', in J. Kerr (ed.), *The Maya Vase Book*, Vol. 6, 1072–89, New York: Kerr Associates.

Argyle, M. (1988), *Bodily Communication*, London: Routledge.

Baudez, C. and P. Mathews (1978), 'Capture and Sacrifice at Palenque', in M. Greene Robertson and D. C. Jeffers (eds), *Tercera Mesa Redonda de Palenque*, Vol. 4, 31–40, California: Herald.

Benson, E. (1974), 'Gestures and Offerings', in M. Greene Robertson (ed.), *Primera Mesa Redonda de Palenque*, 109–20, Pebble Beach, CA: Pre-Columbian Art Research.

Boot, E. (2003), 'The Human Hand in Classic Maya Hieroglyphic Writing', *Mesoweb*. Available at: www.mesoweb.com/features/boot/Human_Hand.pdf (accessed 28 September 2021).

Boot, E. (2014), '"Out of Order!" Or are They? A Textual and Visual Analysis of Two Dedicatory Texts on Classic Maya Ceramics', *The PARI Journal*, 15 (2): 15–37.

Calbris, G. (1990), *The Semiotics of French Gestures*, Bloomington, IN: Indiana University Press.

Carrasco Vargas, R. C., V. A. Vázquez López and S. Martin (2009), 'Daily Life of the Ancient Maya Recorded on Murals at Calakmul, Mexico', *Proceedings of the National Academy of Sciences of the United States of America*, 106 (46): 1924–59.

Chu, M. and S. Kita (2008), 'Spontaneous Gestures during Mental Rotation Tasks: Insights into the Micro Development of the Motor Strategy', *Journal of Experimental Psychology*, 137 (4): 706–23.

Chu, M., A. Meyer, L. Foulkes and S. Kita (2013), 'Individual Differences in Frequency and Saliency of Speech-Accompanying Gestures: The Role of Cognitive Abilities and Empathy', *Journal of Experimental Psychology*, 143 (2): 694–709.

Coe, M. D. and J. Kerr (1997), *The Art of the Maya Scribe*, London: Thames and Hudson.

Cooperrider, K., N. Abner and S. Goldin-Meadow (2018), 'The Palm-Up Puzzle: Meanings and Origins of a Widespread Form in Gesture and Sign', *Frontiers in Communication*, 3 (23): 1–16.

de Jorio, A. ([1832] 2000), *Gesture in Naples and Gesture in Classical Antiquity*, trans. A. Kendon, Bloomington, IN: Indiana University Press.

Fox Tree, E. (2009), 'Meemul Tziij: An Indigenous Sign Language Complex of Mesoamerica', *Sign Language Studies*, 9 (3): 324–66.

Golden, C. (1999), 'La Pasadita Archaeological Project', *FAMSI*. Available at: www.famsi.org/reports/97042/97042Golden01.pdf (accessed 28 September 2021)

Grube, N. (1992), 'Classic Maya Dance', *Ancient Mesoamerica*, 3 (2): 201–18.

Hodge, R. and G. Kress (1988), *Social Semiotics*, Oxford: Polity Press.

Houston, S. (2001), Decorous Bodies and Disordered Passions', *World Archaeology*, 33 (2): 206–19.

Houston, S. and T. Inomata (2009), *The Classic Maya*, Cambridge: Cambridge University Press.

Houston, S., D. Stuart and K. Taube (2006), *The Memory of Bones: Body, Being and Experience among the Classic Maya*, Austin, TX: University of Texas Press.

Inomata, T. (2006), 'Plazas, Performers, and Spectators: Political Theaters of the Classic Maya', *Current Anthropology*, 47 (5): 805–42.

Jackson, S. (2009), 'Imagining Courtly Communities: An Exploration of Classic Maya Experiences of Status and Identity through Painted Ceramic Vessels', *Ancient Mesoamerica*, 20: 71–85.

Kendon, A. (1988a), 'How Gestures can Become Like Words', in F. Poyatos (ed.), *Cross-Cultural Perspectives in Nonverbal Communication*, 131–41, New York: C. J. Hogrefe.

Kendon, A. (1988b), *Sign Languages of Aboriginal Australia: Cultural, Semiotic and Communicative Perspectives*, Cambridge: Cambridge University Press.

Kendon, A. (2004), *Gesture: Visible Action as Utterance*, Cambridge: Cambridge University Press.

Kerr, J. (unknown date), Maya Vase Database. Available at: www.mayavase.com (accessed 19 January 2022).

Kettunen, H. (2006), *Nasal Motifs in Maya Iconography: A Methodological Approach to the Study of Ancient Maya Art*, Helsinki: Annales Academiæ Scientiarum Fennicæ.

Kettunen, H. and C. Helmke (2013), 'Water in Maya Imagery and Writing', *Contributions to New World Archaeology*, 5: 17–38.

Kettunen, H. and A. Lacadena (2014), *Methods in Maya Hieroglyphic Studies*, Workbook at the 19th European Maya Conference, Bratislava, Slovakia.

Kita, S. (2009), 'Cross-Cultural Variation of Speech-Accompanying Gesture: A Review', *Language and Cognitive Processes*, 24 (2): 145–67.

Lacadena, A. (1995), 'Evolución formal de las grafias escriturarias mayas: implicaciones históricas y culturales', PhD diss., Universidad Complutense de Madrid, Madrid.

Maitland Gardner, A. J. (2017), 'Posture and Gesture in Ancient Maya Art and Culture', PhD diss., University College London, London.

Maitland Gardner, A. J. (2019), 'Gestures of Time, Gestures in Space: Communicating Orientation in the Classic Maya World', in M. Kovác, H. Kettunen and G. Krempel (eds), *Maya Cosmology: Terrestrial and Celestial Landscapes*, Acta Mesoamericana, Vol. 29, 99–116, Munich: Verlag Anton Saurwein.

Martin, S. and N. Grube (2008), *Chronicle of the Maya Kings and Queens: Deciphering the Dynasties of the Ancient Maya*, London: Thames and Hudson.

McNeill, D. (1992), *Hand and Mind: What Gestures Reveal about Thought*, Chicago, IL: University of Chicago Press.

McNeill, D. (2000), 'Introduction', in D. McNeill (ed.), *Language and Gesture*, Cambridge: Cambridge University Press.

McNeill, D. and E. Levy (1982), 'Conceptual Representations in Language Activity and Gesture', in R. J. Jarvella and W. Klein (eds), *Speech, Place, and Action*, 271–96, Chichester: John Wiley and Sons.

Meadows, R. K. (2001), 'Crafting K'awil: A Comparative Analysis of Maya Symbolic Flaked Stone Assemblages from Three Sites in Northern Belize', PhD diss., University of Texas at Austin, Austin.

Miller, M. and S. Martin (2004), *Courtly Art of the Ancient Maya*, London: Thames and Hudson.

Miller, V. (1981), 'Pose and Gesture in Classic Maya Monumental Sculpture', PhD diss., University of Texas at Austin, Austin.

Miller, V. (1983), 'A Re-examination of Maya Gestures of Submission', *Journal of Latin American Lore*, 9 (1): 17–38.

Mittelberg, I. and V. Evola (2014), 'Iconic and Representational Gestures', in C. Müller, A. Cienki, E. Fricke, S. H. Ladewig, D. McNeill and J. Bressem (eds), *Body – Language – Communication: An International Handbook on Multimodality in Human Interaction* (Handbooks of Linguistics and Communication Science 38.2), 1732–46, Berlin: De Gruyter Mouton.

Montgomery, J. (2006), *Dictionary of Maya Hieroglyphs*, New York: Hippocrene Books.

Morris, D. (1977), *Manwatching: A Field Guide to Human Behaviour*, London: Jonathan Cape.

Morris, D., P. Collett, P. Marsh and M. O'Shaughnessy (1979), *Gestures: Their Origins and Distribution*, New York: Stein and Day.

Müller, C. (2004), 'Forms and Uses of the Palm Up Open Hand: A Case of a Gesture Family?', in C. Müller and R. Posner (eds), *The Semantics and Pragmatics of Everyday Gestures,* 233–56, Berlin: Weidler.

Peirce, C. S. (1940/1965), *Collected Papers*, Cambridge, MA: Belknap Press.

Perez de Lara, J. (n.d.), 'A Look at the Hand and Arm Gestures of the Characters on the Palenque Temple XIX Bench', *Mesoweb*. Available at: http://www.mesoweb.com/features/gestures/text.html (accessed 28 September 2021).

Perniss, P., R. L. Thompson and G. Vigliocco (2010), 'Iconicity as a General Property of Language: Evidence from Spoken and Signed Languages', *Frontiers in Psychology*, 1: 1–15.

Reents-Budet, D. (1994), 'Classic Maya Pottery Painting', in D. Reents-Budet (ed.), *Painting the Maya Universe: Royal Ceramics of the Classic Period*, 2–35, Durham, NC: Duke University Press.

Reents-Budet, D., R. L. Bishop and B. MacLeod (1994), 'Painting Styles, Workshop Locations and Pottery Production', in D. Reents-Budet (ed.), *Painting the Maya Universe: Royal Ceramics of the Classic Period*, 164–233, Durham, NC: Duke University Press.

Rice, P. M. (2007), *Maya Calendar Origins: Monuments, Mythistory and the Materialisation of Time*, Austin, TX: University of Texas Press.

Schele, L. and M. Miller (1986), *The Blood of Kings: Dynasty and Ritual in Maya Art*, London: Thames and Hudson.

Seler, E. (1908), 'The Vase of Chama', *Bureau of American Ethnology Bulletin*, 28: 651–4.

Stokoe, W. (1960), *Sign Language Structure: An Outline of the Visual Communication Systems of the American Deaf*, New York: University of Buffalo Press.

Streeck, J. (2009), *Gesturecraft: The Manu-facture of Meaning*, Amsterdam: John Benjamins.

Sutton-Spence, R. and B. Woll (1999), *The Linguistics of British Sign Language: An Introduction*, Cambridge: Cambridge University Press.

Tokovinine, A. (2003), 'A Classic Maya Term for Public Performance', *Mesoweb*. Available at: http://www.mesoweb.com/features/tokovinine/Performance.pdf (accessed 28 September 2021).

Tokovinine, A. (2016), '"It is His Image with Pulque": Drinks, Gifts, and Political Networking in Classic Maya Texts and Images', *Ancient Mesoamerica*, 27: 13–29.

Tokovinine, A. and D. Beliaev (2013), 'People of the Road: Traders and Travellers in Ancient Maya Words and Images', in K. G. Hirth and J. Pillsbury (eds), *Merchants, Markets and Exchange in the Pre-Columbian World*, 169–200, Washington DC: Dumbarton Oaks.

Tomaszewski, P. (2006), 'From Iconicity to Arbitrariness: How do Gestures Become Signs in Peer-Group Pidgin', *Psychology of Language and Communication*, 10 (2): 27–60.

YMSL Project / Proyecto LSMY (2020), Proyecto de documentación. Available at: www.ymslproject.org (accessed 20 January 2022)

Zender, M. and A. Van Stone (2011), *Reading Maya Art: A Hieroglyphic Guide to Ancient Maya Painting and Sculpture*, London: Thames and Hudson.

CHAPTER 9
GESTURE, POSTURE AND MEANING IN THE ULÚA CULTURAL SPHERE

Kathryn M. Hudson and John S. Henderson

The body, human or otherwise, is commonly conceptualized as a semantic locus that conveys information about the individual that it represents. Bodies and their referents are commonly viewed as primary in image-based analyses, though positional particularities in the form of gesture and posture have the potential to refine and supplement the more general connotations of a corporeal representation. In this chapter, we build on this theme and suggest that, in some contexts, gesture and posture can *indicate* rather than *generate* meaning. In these cases, rather than providing meaning directly, gesture and posture point to the semantic source and thus direct the interpretive process. These features can also serve as semantic loci apart from the body of which they are a part and, in these cases, the interpretive process must account for both potential functions.

The Ulúa context

The Ulúa cultural sphere encompasses territories in what is now Honduras and El Salvador (Figure 9.1). The likely core of this region is situated in the lower Ulúa Valley, which is located in north-western Honduras to the east of Copán. This territory formed a significant part of the south-eastern periphery of the Maya world, where many quintessentially Maya features – including monumental architecture, hieroglyphic texts and complex political structures centred on kings – are absent (Henderson and Hudson 2012, 2015). The region did, however, produce elaborately painted polychrome pottery that was widely distributed both within the south-eastern region and throughout the Maya world during the mid to late Classic period, from about 500 to 800 CE. Counter-intuitively – at least by comparison with the Maya world – these finely made vessels were not used exclusively, or even mainly, by an elite. Instead, they were produced for and used in households of every social and economic rank. The imagery that occurs on these vessels includes a variety of human and animal forms as well as abstract elements that occur in bands or as free-standing motifs. The compositional centre, however, is most often the human or animal figure, and it is arguable that these representations function as the semantic core.

Polychrome pottery in the Ulúa sphere

Orthodox approaches to the analysis of these materials (e.g. Robinson 1978) have often focused on represented bodies, human or otherwise, and assumed that their form and

Figure 9.1 Map of eastern Mesoamerica.

accoutrements serve as the semantic core of the composition and convey its central meaning. All other elements are typically viewed as secondary and most are most often interpreted as semantically supplemental; consequently, it is not uncommon for non-figural elements to be ignored or treated in less detail, both in analytical prose and in illustration. The persistent emphasis on banded structures, and the resulting conceptual separation of figure-containing fields from those housing frequent but non-figural elements, reinforces this tendency. Such strategies assume that motifs which are centrally positioned are more significant than those that occur in more outlying positions (e.g. in framing bands); this is reinforced by the concurrent – yet often unconscious – assumption that elements of the sort that commonly occur as foci in familiar Western artistic traditions, including figures of various sorts, are similarly privileged in non-Western and non-modern contexts.

It is certainly true that the primary meaning of Ulúa compositions is sometimes rooted in the figures themselves. In these cases, the posture of the figure is neutral and unmarked; the emphasis is thus placed on the identity that it conveys rather than on the particularities of *how* this representation is achieved. No explicit gesturing occurs, and the body itself is supplemented only by the occurrence of accessories such as clothing, headdresses and sceptres. The recognition of these identities (i.e. the successful

interpretation of their representations) is based on knowledge of the significances of these accessories and their combination in the context of a particular kind of figural form (e.g. human or animal), and – more significantly – on the recognition of the figure itself as indicative of a particular individual. Consequently, under conventional logic, the meaning of the figure is rooted primarily in the body and secondarily in its accompaniments; the figural identity is considered dominant over the refinements contributed by its associated elements.

In many cases, however, the bodies represented in Ulúa imagery appear to be secondary or supplemental. The meanings of these compositions are textually generated, in the sense that the bodies within them serve as constituent elements that help refine the meaning of the compositional whole rather than as a compositional core refined by other elements. This perspective entails a shift in analytical methodology, since more orthodox approaches (e.g. Robinson 1978; Nielsen and Brady 2006) – focused on figures and, secondarily, on their common appearance in bands identified as primary – concentrate mainly on a single element type. Such perspectives tend to homogenize figural representations by viewing them firstly as instantiations of the general category of figures; this classification, in combination with the assumptions concerning the semantic primacy of figures described above, reinforces the view of figures as singular semantic entities representative of individual identities. An alternative perspective is warranted, however, if figures are reconceptualized as constituent elements that – at least in some cases – function in a manner analogous to other semantically refining constituents. The syntactic textuality framework being developed by Hudson (2013, 2014; see also Hudson and Milisauskas 2015) is ideal for this purpose. This approach emphasizes the underlying structure of a composition and views the generation of meaning as a process in which structural patterns produce meaning at the level of the composition by guiding the interpretive combination of *all* constituent elements. When viewed in such a way, the postures and gestures of Ulúa figures can be seen as indicators of semantic loci rather than as secondary refiners of the meaning of the figure of which they are a part. The figure itself may be such a locus, but it need not be; body positioning can *indicate*, or locate meaning as readily as it can represent it.

'Spread-eagle' figures

The so-called 'spread-eagle' figures provide a good example of the indicative role of gesture and posture (Figure 9.2a). These figures are labelled for their posture, which is characterized by a front-facing torso with splayed limbs and a turned head. The torso is typically embellished in some way, and it is often disproportionately larger than the other body parts. These figures occur most frequently as full-body forms in which all four limbs are present, but they can also appear as half-body forms in which only the head, torso and upper limbs are depicted. Such half-body forms are noticeably less common but, when they do appear, they are frequently placed adjacent to key features of the vessel's form (e.g. just below the rim) and within or underneath painted bands; the overall effect is that they appear to be hanging rather than standing independently within

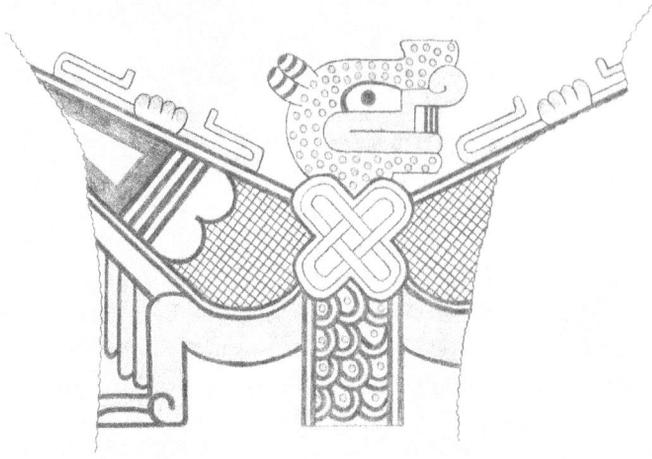

a

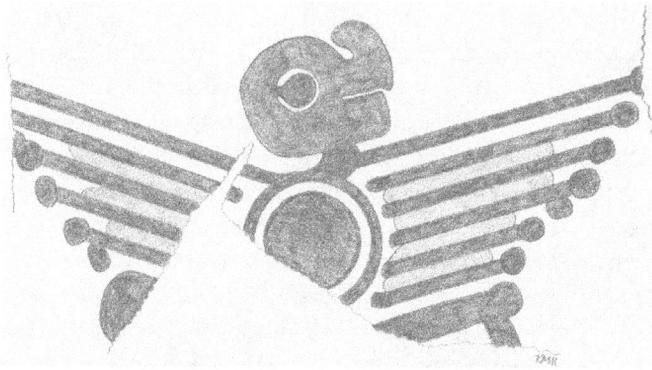

b

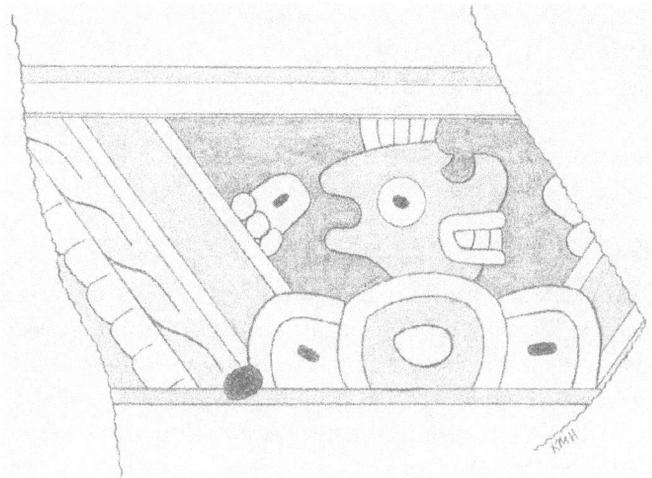

c

Figure 9.2 Spread-eagle figures: *(a)* Full figure, Lower Ulúa Valley. Peabody Museum, Harvard University, No. PM303; *(b)* Full figure, Santa Rita. Peabody Museum, Harvard University, No. PM813; *(c)* Half-body, Santa Rita. Peabody Museum, Harvard University, No. PM540. Illustrations by Kathryn M. Hudson.

the composition. This positioning most commonly occurs with animal figures, which often constitute the largest and most central element within an Ulúa composition; birds are particularly common, though reptiles and other unidentifiable creatures also occur.

The 'spread-eagle' posture locates the primary meaning of the composition not in the body itself but in the element that is infixed within its torso. Although the limb and head positions are features that characterize this posture and thus indicate the structure used for this pattern of meaning generation, the figure is not itself a primary semantic locus. Instead, the splaying of the limbs and de-emphasis on the frontal part of the face – where many individually identifying features often occur – direct attention to the torso, which is situated in the centre of the array and afforded a measure of prominence by its frontal orientation and relatively larger size. In the example shown in Figure 9.2a, a schematic mat or 'knot' motif occurs at the centre of the body and is singled out by the 'spread-eagle' posture of the figural body that encloses it. The role of this motif as the semantic core is reinforced by the presence of a mat band near the top of the vessel and by the very common association of mats with power and significance in Mesoamerican cultures (see e.g. Robicsek 1975; Robinson 2014; Hudson and Henderson 2015).

The majority of figures with this posture have embellished torsos, often in the form of elaborated elements that occur where the torso ought to be, as seen in Figure 9.2a, but sometimes they take the form of elements or sets of elements infixed in a frame or border that also demarcates the torso itself, articulating with the limb and head/neck (Figure 9.2b). In these cases, the 'spread-eagle' posture transforms the body into a frame and converts the figure in its entirety into a medallion motif. Medallions have been considered in some detail by Hudson (2012, 2013; see also Hudson and Milisauskas 2015); they can be succinctly defined as compositions containing a central element surrounded by a frame or set of frames that demarcate the interior space, thus directing attention to the infixed element and setting it apart from any surrounding imagery. They constitute a distinctive subset of Ulúa imagery and signal a particular interpretive process in which the framing elements and any imagery incorporated into them supplement and refine the significance of the infixed motif to generate the intended compositional meaning. The 'spread-eagle' posture transforms a figural body into a medallion frame in which the head and limbs, by virtue of their attachment to the torso, serve as components of the frame itself at the broadest level of interpretation. It uses the body to indicate the key semantic locus, which occurs in the torso in the form of the infixed element, and so directs the interpretive process.

These observations apply to half-body forms as well as full-body forms. The torsos of half-body forms can be embellished with elaborated elements placed in the position where the torso ought to be (Figure 9.2c); they can also be embellished with elements embedded within a frame that demarcates the figure's torso and articulates with the head and depicted limbs. In both cases, the posture of the figure indicates that the semantic centre is embodied by the element or elements that occur in the torso position. The head and limbs are secondary elements that function as indicators of this semantically crucial position; the frontal orientation of the torso, particularly when compared to the turned position of the head and the splayed arrangement of the limbs, contribute to this

indicative role. These representations are still recognizable as figures and, more specifically, as spread-eagle figures by the distinctive arrangement of the head and limbs and by the relationship of these features to the torso. The presence of only one set of limbs does not minimize this effect but instead allows it to occur in a broader array of positions; such positional flexibility, in turn, expands the functional scope of figures and permits figural representations to contribute to the meaning(s) of compositions in an increased number of ways.

Crossed figures

The crossed figures found on many Ulúa vessels (Figure 9.3a) provide another example of the indicative power of posture. Although they are usually labelled 'dancing figures', they are most often interpreted as engaged in sexual intercourse (Lehmann 1910: 740; Yde 1938: 80; Stone 1957: 27; Nielsen and Brady 2006: 208) or some kind of phallic ritual (Strong, Kidder and Paul 1938: 51) rather than in dance. This interpretation is entirely unconvincing, particularly in light of the absence of representation of a phallus or vulva or indeed any imagery that clearly references erotic subject matter. Although some (e.g. Nielsen and Brady 2006) base this conclusion on analogies with other Mesoamerican traditions and on the subsequent but seemingly arbitrary identification of the figures' location in a cave, such justifications overly simplify the region's complex cultural reality and make assumptions about the meaning of images that are based on little more than narrative convenience.

The crossed-figure composition consists of two anthropomorphic figures that face one another. Their upper bodies are typically upright or nearly upright, but their lower limbs are angled towards one another other so that their legs cross. This position is a crossing in the literal sense, since one pair of legs – usually, but not quite always, belonging to the figure on the left – crosses over the other; the individual limbs are not intertwined. One figure is painted red while the other is orange, and their accessories – including headdresses, waistbands and ear spools – tend to be matched. Their facial features also tend to occur in parallel, and any accompanying imagery that occurs with them is mirrored on each side. A black bar or sceptre commonly appears between the figures and extends from the space in between their faces to somewhere in the vicinity of their lower torsos.

The 'crossed' posture provides further evidence that meaning in Ulúa imagery is frequently rooted in extra-corporeal features distinct from the body itself. In these compositions, the interpretation of the figures is inextricably linked to their posture, since a consideration of the figures themselves can provide only part of the meaning. Most significantly, the posture suggests that these figures do not represent separate individuals but rather two sides of the same being. It allows both sides of an individual to be simultaneously depicted, perhaps as a means of emphasizing their significance by explicitly illustrating the entirety of the corporeal form. The parallel details found on each figure – in combination with the consistent pairing of red and orange pigments and the apparent reflection of the accompanying imagery – give the crossed figures a mirror-image quality

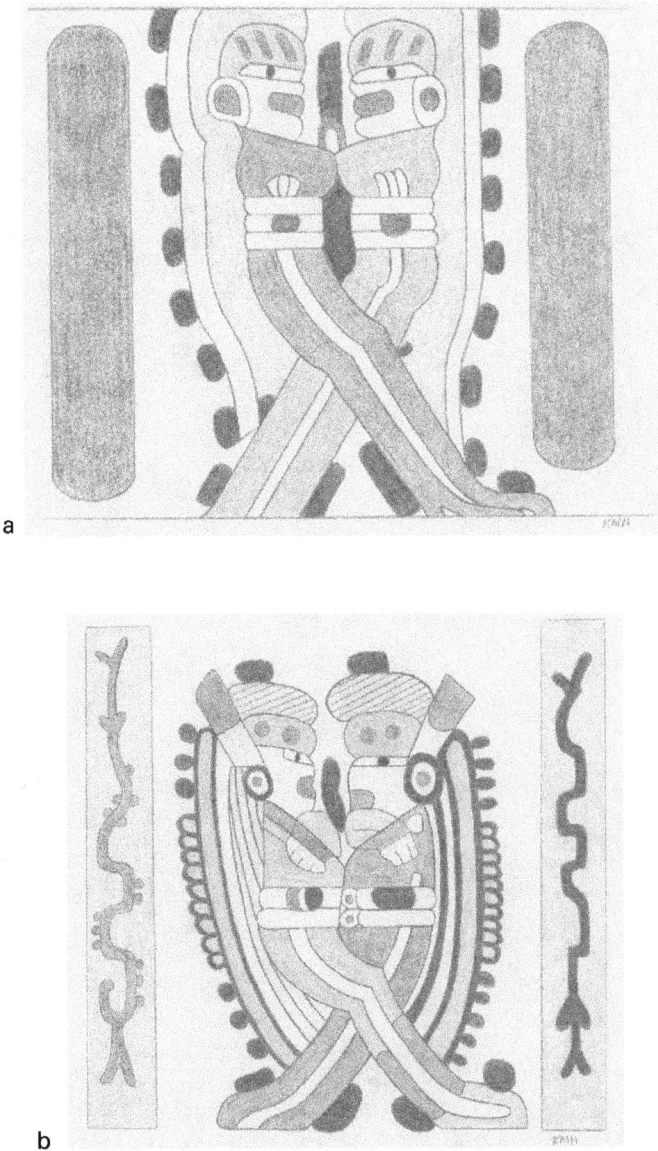

a

b

Figure 9.3 Crossed and auto-crossed figures: *(a)* Crossed figures, Santa Rita. Peabody Museum, Harvard University, No. PM018; *(b)* Crossed figures, detail, Los Naranjos. Peabody Museum, Harvard University, No. PM037. (*Figure 9.3 continues on next page*)

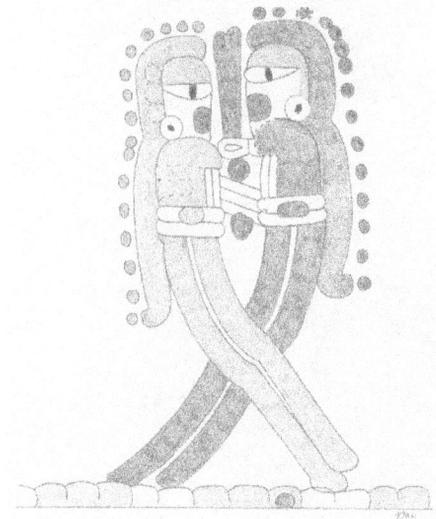

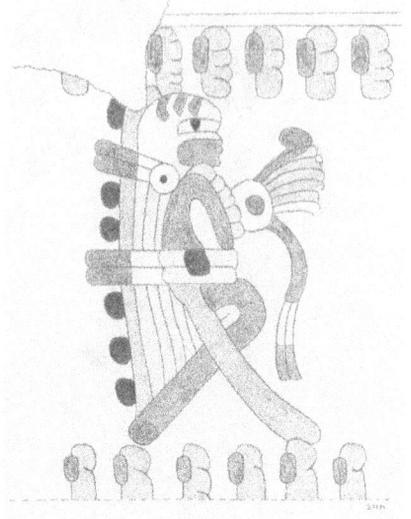

c d

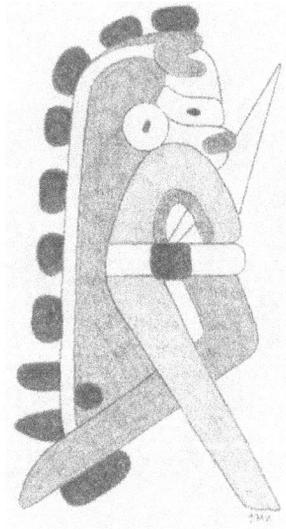

e

Figure 9.3 (*continued*) *(c)* Crossed figures, Lower Ulúa Valley. Museo de Antropología e Historia de San Pedro Sula; *(d)* Auto-crossed figure, Santa Rita. Peabody Museum, Harvard University, No. PM008; *(e)* Auto-crossed figure, Santa Rita. Peabody Museum, Harvard University, No. PM100. Illustrations by Kathryn M. Hudson.

that reinforces the suggestion that they are reflections of the same individual. More telling is the articulation of crossed figures in the region of the torso (see Figure 9.3b–c), which – as illustrated by the figures with the 'spread-eagle' posture – is a common locus of meaning in Ulúa compositions. This articulation can be direct, or it can be accomplished through joint attachment to the bar or sceptre positioned between the figures; the key in both cases is the physical connection made in a region that frequently carries meaning. The bar or sceptre itself may indicate a point of reflection that marks the place where the reflection or shift in perspective occurs.

Additional evidence comes from single figures depicted with one side of the body painted red while the other is orange (see Figure 9.3d–e). The parallel to figures in the 'crossed' posture is apparent by this colour scheme and further suggested by the accessories associated with such figures, which include similar styles of headgear and other accoutrements. Most strikingly, variations of the 'crossed' posture also occur with these figures. Their upper bodies are vertical or nearly vertical while their legs – one of which is red and the other of which is orange – are angled below the torso and crossed so that one passes over the other. The leg that occurs on top is straight, but the one that is positioned behind it appears to be bent, perhaps at the knee. This variation on the 'crossed' posture – which we describe as 'auto-crossed' – suggests that this category of figural arrangement does more than mark two figures as sides of the same individual. This 'auto-crossed' posture, in combination with the more common 'crossed' postures composed of two figures, suggests that leg crossing marks a figure as important and worthy of whole-body depiction.

Winged figures

Winged figures in the Ulúa ceramic corpus (Figure 9.4a) provide a third example of how posture cues the interpretive process. These figures are a distinctive Ulúa composition in which a relatively unadorned figure is bent at the waist. A large wing-like appendage attaches to the figure in the vicinity of the bent waist and takes up most of the image frame; this wing most typically extends outward behind the body from its point of articulation in a relatively independent fashion, though it is also possible for it to be partially mounted on the back of the figure. Supplemental imagery, when it occurs, is most often found in the spaces surrounding the figure and rarely attaches directly to the figural body itself. The conventional assumption is that the bent figure provides most of the semantic content of the composition and is, in essence, wearing the wing (e.g. Taube 2009: 45). This approach assumes that the wing and its associated meaning(s) are supplemental and serve as refinements of the meaning inherent in the figure to which it is attached. Close examination of the particulars of the composition suggests that the wing is, however, wearing the figure, and an alternative interpretive framework is thus required.

The prominence of the wing in these compositions, marked especially by its relative size, indicates that the semantic focus of the wing-bearing posture compositions is on the wing itself rather than on the figure attached to it. The bent position at the waist offers one of the few deviations from the generally neutral presentation of the body and

serves as an indicator of something semantically significant; in essence, it graphically marks the attached wing as providing the core of the meaning. This is reinforced by the often elaborate embellishment found on the wing vis-à-vis the relatively plain and unadorned character of the body, and by the relative size differences between the large wing and the noticeably smaller figure. The human figure that bears the wing is, in essence, an accompaniment akin to the headdresses and other accessories found in other compositions. It functions as a kind of graphic and semantic host that refines the meaning of the wing and contributes to the semantic whole, but it *locates* rather than generates the central meaning. Although this indicative function is reinforced by compositional features, such as the embellishment patterns described above and the spatial centring of the wing rather than the figure, the main semantic indicator is the figural posture.

This interpretation is reinforced by the compositional specifics of the wings themselves. An analysis of the underlying structure and constituent components of these elements reveals that they are stylized reptiles, which supports their role as the key semantic locus indicated by the 'wing-bearing' posture. The region that attaches to the bent figure is the head of the reptile (Figure 9.4b–c) and is – by analogy with other corporeally indicated meaning loci – the most likely source of the wing's significances. The wing itself constitutes an elaborated jaw, and the associated feathering correlates with the beards found under many reptile jaws. The overall effect is that the human figure supplements the meaning of the reptile that is portrayed in wing form. Given the

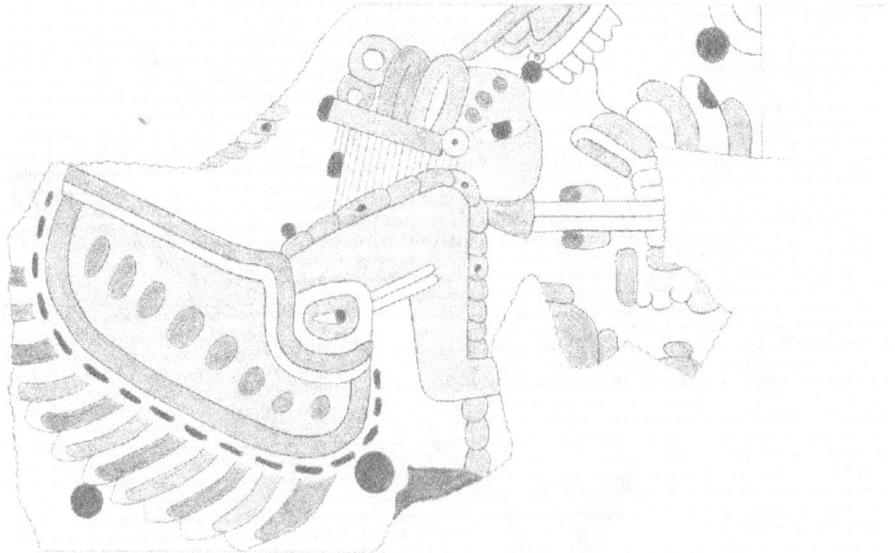

a

Figure 9.4 Winged figures: *(a)* Winged figure, Santa Rita. Peabody Museum, Harvard University, No. PM047. Illustration by Kathryn M. Hudson. (*Figure 9.4 continues on next pag*e);

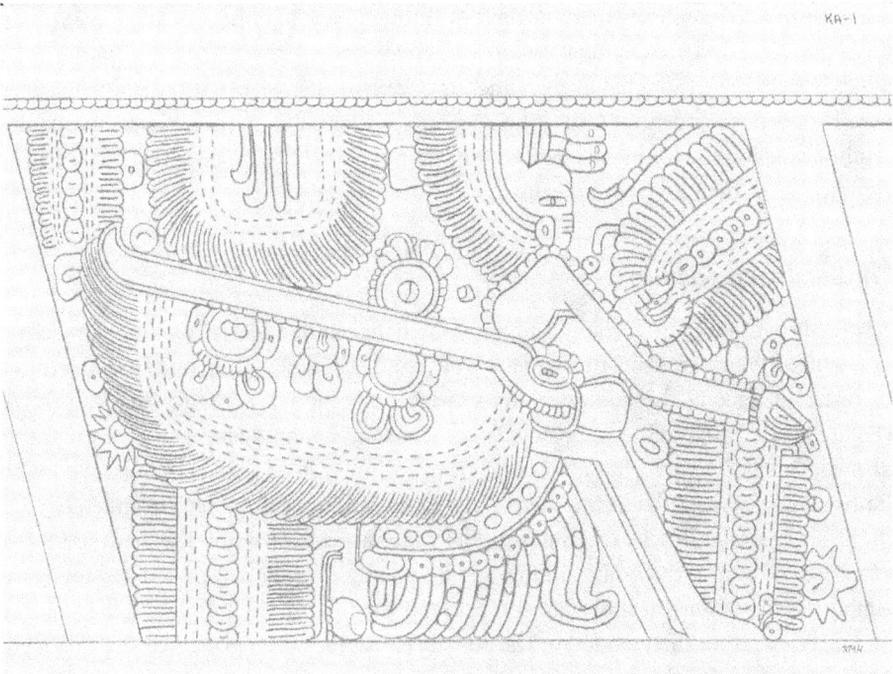

b

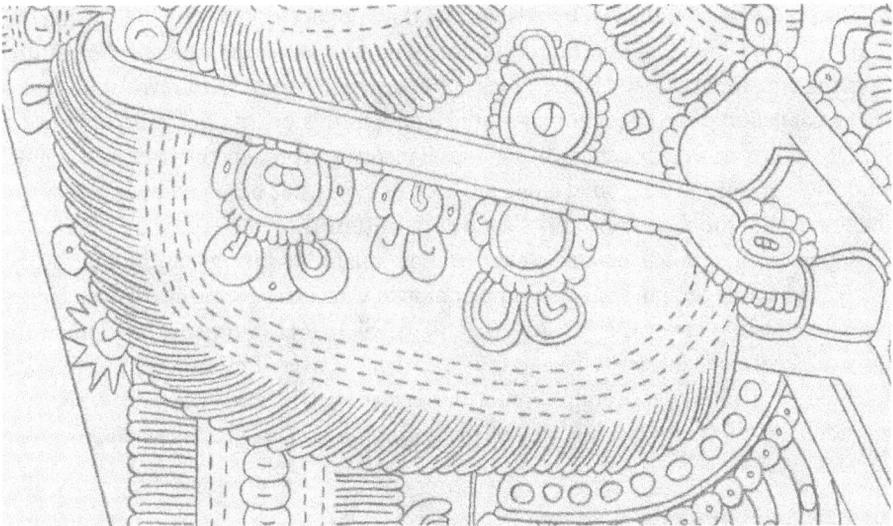

c

Figure 9.4 *(continued)* *(b)* Winged figure, unprovenanced vessel from private collection. Illustration by Kathryn M. Hudson after Kerr 8635; *(c)* Close-up of winged figure, unprovenanced vessel from private collection. Illustration by Kathryn M. Hudson after Kerr 8635.

ubiquity and frequent centrality of reptiles throughout Ulúa imagery (Viel 1978), it is unsurprising to find such elements marked as semantically primary. The anthropomorphic figure is secondary, though it likely refines or complements the reptile's meaning in some way. However, the postural indication of primacy, combined with the large size of the reptile wing and its dominance within the compositional field, makes clear the relative significance of these two components.

The symbiotic posture

A related posture occurs in compositions in which the reptile and non-reptile components of a winged figure are conflated to such a degree that disentangling one from the other in order to decode the composition's significance requires a change of perspective (Figure 9.5a). This 'symbiotic' posture occurs when a human figure is bent at the waist, as in the winged figures, but appears to be crouching rather than standing. The lower limbs may be stylized, as in the sherd shown here, and they are often shrunken so that they appear noticeably less significant than other aspects of body. The arms are often extended in front of the body and they are frequently elongated; the head and torso are simply portrayed and, in some cases, appear more similar in their details to the features of a monkey rather than a human. The body itself is most often presented in a relatively unadorned manner, though corporeal embellishments such as articulated fringes and supplemental details at the wrists and torso may occur.

The reptile figure indicated by this posture does not occur in an appended wing but rather is incorporated into the human figure itself in a manner indicated by the posture. Rotating a figure in the 'symbiotic' posture 180 degrees (Figure 9.5b) reveals the extent of the conflation of reptile and non-reptile figure. In this orientation, it becomes clear that the limbs of the crouching figure simultaneously represent the jaws of a reptile, while the embellishments found along the back of the figure's head and body demarcate the lower jaw. The figure's head is thus being consumed by the reptile or, perhaps, is emerging from it. Such creative interpretation might, at first glance, appear to be excessive, but this composition is not uncommon in Ulúa imagery and also has analogues elsewhere in Mesoamerican imagery (e.g. Bardawil 1976). Its orientation aligns with other figure-based compositions and indicates that the overall meaning is rooted in an interaction of reptile and anthropomorphic figure that is accessible only through a consideration of the spaces indicated by the posture.

Neutral and sprouting gestures

Gesture, and the particularities of gestural arrangement, can also indicate the key semantic locus of a composition, and this marking technique is particularly common when the core meaning-bearing element is relatively more disassociated from the body itself. In many cases, the details of hand shape and positioning are less important than the directionality marked by its placement and, in this way, gesture can be viewed as serving the same indicative function that we suggest for posture. The hand or hands

a b

Figure 9.5 Symbiotic postures: *(a)* Symbiotic posture, Santa Rita. Peabody Museum, Harvard University, No. PM057; *(b)* Symbiotic posture inverted, Santa Rita. Peabody Museum, Harvard University, No. PM057. Illustrations by Kathryn M. Hudson.

often seem to be secondary or supplemental, and the meaning of the whole is textually generated and rooted in the recognition of the hand(s) as constituent elements that refine the meaning of the composition rather than function as a semantic locus. In this way, the gestures of Ulúa figures indicate semantic loci rather than simply representing them; they are semantic markers that function as secondary refiners of the meaning of the figure of which they are a part.

In the example shown in Figure 9.6a, the figure itself is relatively unremarkable and is presented with a neutral posture. Although it is wearing a skirt or loincloth tied around the waist and has a small headdress, these accessories are relatively simply presented and little embellishment of the body itself occurs. The figure occupies a significant portion of the frame and is not dwarfed by any accompanying imagery; its meaning thus appears to be primary. However, a closer look at the placement of the hands suggests that a different interpretation is called for. Perhaps most obviously, the hand located *behind* the figure's body indicates a reptile motif that seems to emerge from between the fingers and thumb of this hand. This 'sprouting' gesture directs the viewer's attention to the primary semantic locus by directionally signalling its location as well as by marking the place at which the core element appears. In this example, the eye, upper jaw, and upper teeth emerge from the hand itself while the lower jaw and lower teeth are formed by the back-rack worn attached to the figure's skirt. The 'sprouting' gesture, and the upper components of the reptile head that are articulated with it, indicate that these features form a semantic locus and are more significant than other surrounding imagery.

The hand positioned in *front* of the body forms the 'neutral' gesture in which the hand is open but the fingers and thumb curve slightly towards each other. Although the gesture may, at first glance, appear strikingly similar to the 'sprouting' gesture described in the preceding paragraph, a close consideration of its details reveals that the fingers and thumb are more relaxed and oriented towards each other in a way that partially closes off the space adjacent to the palm rather than opening it up for an associated element. The function of this gestural configuration is underspecified: it occurs in many compositions and appears to serve a general indicative function designed to attract the viewer's eye to some significant element or set of elements. This indicative role may be rooted in the configurational contrast that exists when one hand of a figure occurs as a 'neutral' gesture while the other has a more elaborate arrangement. In these cases, the 'neutral' gesture could be used to mark which of the hands is more semantically significant by offering a clear point of visual contrast and differentiation. This gesture could also function as a secondary semantic indicator that reinforces the perception that a core meaning is connected to the associated figure and suggests to the reader that an additional indicative gesture also occurs.

In the figure presented in Figure 9.6a, a combination of these two possibilities seems to occur. The raised position of the hand in the 'neutral' gesture position draws attention to the figure itself in a manner that deviates from more standard figural representations and may have been used to indicate the presence of a semantic locus associated with the depicted individual. The 'neutral' gesture of this hand also reinforces the significance of the hand that occurs in the 'sprouting' gesture by virtue of its comparative simplicity. This 'neutral' gesture may indicate the presence of a semantic locus at the level of the figure while simultaneously indicating a more precise location by emphasizing the elaboration associated with the 'sprouting' gesture. Such a dualistic role is also implied by the fact that the hand in the 'neutral' gesture is a near mirror image of the one with the 'sprouting' gesture and thus may function as a reflection – or reflector – of the figure's significance. The raising of the 'neutral' gesture hand is also suggestive of an item being lifted, namely, the reptile that is hanging from the lower part of the associated arm. Although the gesturing hand does not directly articulate with this element, its raised position and general indicative function marks the associated reptile motif as important. This interpretation is reinforced by the reptile motif associated with the 'sprouting' gesture hand and may offer another instance of semantic reflection and reinforcement.

Wing-head-hand arrangement

The 'wing-head-hand' cluster of features (Figure 9.6b–d) represents a related but somewhat more abstract composition. This compound arrangement represents a posture-gesture hybrid and involves one hand in the 'neutral' gesture that is placed immediately in front of a disembodied head. This hand is most often presented in a stylized form that seems to be viewed from the side and, while individual fingers are not typically portrayed, it is possible for abbreviated representations of multiple digits to occur. As is typical for this gestural form, the hand is open but the fingers and thumb

curve slightly towards each other. The palm of the hand may face either towards or away from the head, which is portrayed in an elaborated form. Two crossed wings occur on top of the head as part of a headdress and – like the wings that occur behind figures in the 'wing-bearing' posture – they incorporate reptilian motifs. More specifically, they appear to represent two distinct reptiles, one for each wing, that overlap in the vicinity of their eyes. The combination of these reptiles appears to generate a composite representation of a more elaborate reptilian figure; as described below, it is possible that these representations mark two sides of the same reptile in a manner analogous to the crossed figures. A second hand in the 'neutral' gesture occurs between these wings, most commonly with the back of the hand placed against the upper edge of the left-hand wing, and may serve as an additional indication of the reptile's significance.

a

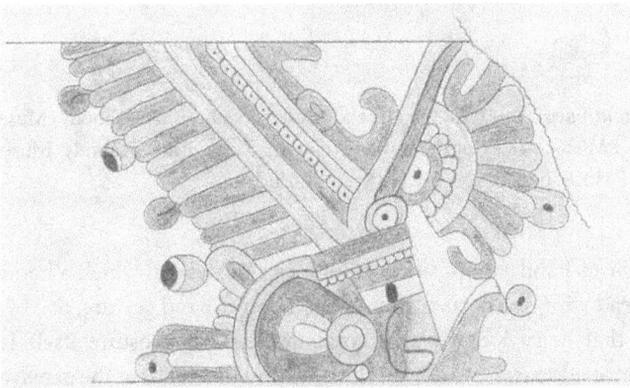

b

Figure 9.6 Indication and wing-head-hand clusters: *(a)* Figure indicating reptile head, unprovenanced vessel from private collection; *(b)* Wing-head-hand cluster, Santa Rita. Peabody Museum, Harvard University, No. PM025. (*Figure 9.6 continues on next page*)

c

d

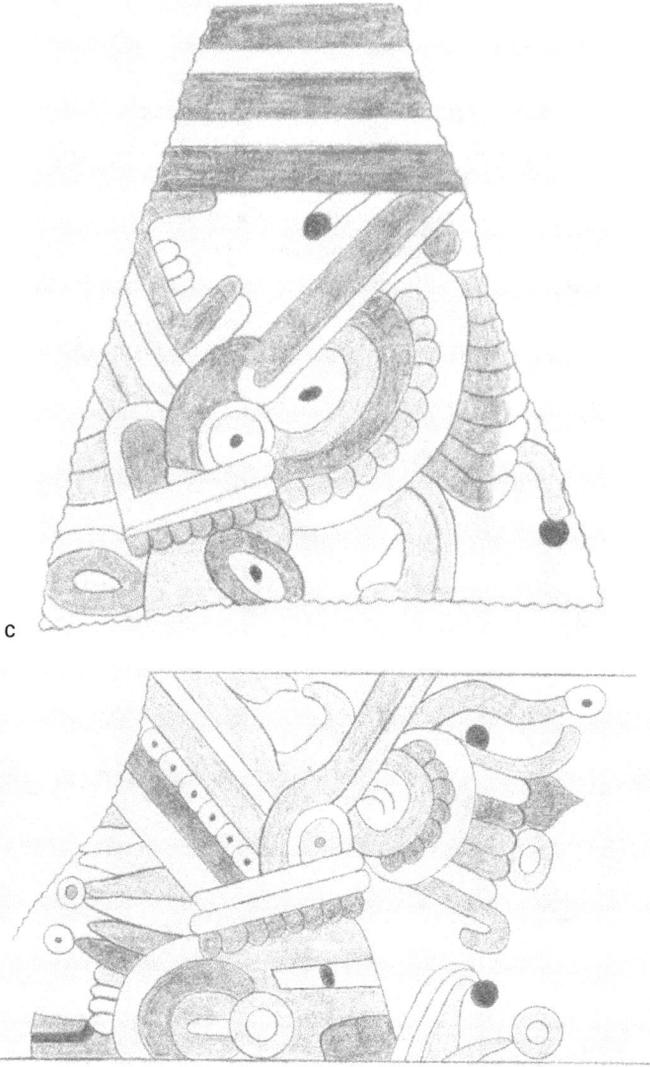

Figure 9.6 (*continued*) *(c)* Wing-head-hand cluster, Santa Rita. Peabody Museum, Harvard University, No. PM026; *(d)* Wing-head-hand cluster, Santa Rita. Peabody Museum, Harvard University, No. PM029. Illustrations by Kathryn M. Hudson.

The 'wing-head-hand' composition combines a posture in which a hand is placed in front of the head with two occurrences of the 'neutral' hand gesture, one of which is the frontal hand that helps identify this configuration. The posture itself is distinctive, particularly since it focuses entirely on the head and the hands at the expense of all other parts of the body. This draws attention to the elements associated with these features and, specifically, the two wings that occur above the head. Such selective representation allows for more extensive embellishment of these features and reinforces the composition's

indicative function by limiting the figural representation to components that are semantically crucial. The presence of a hand in the 'neutral' gesture in front of the head marks the overall composition as representative of something of note, while the placement of a second hand with the gesture alongside one of the wings reinforces their significance and refines the referent of the gesturing hand that occurs in front of the head. The simultaneous use of both hands, each with a 'neutral' gesture, thus provides a level of indicative redundancy that marks the meaning of the wings as primary; the head itself, though host to these elements, offers a foundation for the headdress composed of the wings and appears to play a semantically secondary role.

The structural relationship between the crossed wings found in 'wing-head-hand' compositions and the crossed legs that occur in the eponymous crossed figures and related representations is apparent. This similarity reinforces the interpretation that the gesture and posture found in the 'wing-head-hand' motifs is intended to emphasize the significance of the reptiles represented by the wings and mark them as the primary loci of meaning. Furthermore, it is possible that the dual wings and their crossing are intended to represent both sides of the depicted reptile in a manner analogous to the figural representation that is cued by the 'crossed' posture. By allowing both sides of the reptile to be simultaneously depicted, this arrangement would emphasize its significance by illustrating the entirety of its corporeal form. Although the two sides are rarely perfectly matched in all their details, the underlying structural similarities – combined with their articulation at the eye in a manner evocative of the torso-based joining of crossed figures – create a mirror-image quality that suggests they may represent different reflections of a single creature.

Concluding remarks

Gesture and posture have the potential to refine and supplement the more general connotations of corporeal representations and, in some contexts, these elements can illustrate the semantic source and direct the interpretive process rather than generate a composition's significance. In the imagery found on Ulúa polychrome ceramics, a variety of postures and gestures function in this way and graphically indicate the key loci of meaning within broader compositions. Consideration of their underlying structures and constituent elements supports this interpretation, and comparative analyses incorporating elements found elsewhere in the corpus of Ulúa imagery provide additional evidence such as the varied contexts of human heads framed by reptile jaws. Figures that are being consumed by, or emerging from the jaws of, various reptilian creatures are well attested throughout the Mesoamerican cultural sphere, and varied combinations of bird and reptile elements are even more common. The presence of comparable compositions in Ulúa imagery is a reminder of its place within the broader Mesoamerican tradition, but the structure and iconography of Ulúa imagery are as distinctive as its style. Ulúa compositions cannot be understood simply by reference to Kukulcan and 'serpent wings' in Maya art; they must be analysed in the first instance on their own terms.

References

Bardawil, L. (1976), 'The Principal Bird Deity in Maya Art: An Iconographic Study of Form and Meaning', in M. G. Robertson (ed.), *The Art, Iconography and Dynastic History of Palenque, Part III*, 195–209, Pebble Beach, CA: Robert Louis Stevenson School.

Henderson, J. S. and K. M. Hudson (2012), 'The Southeastern Fringe of Mesoamerica', in D. L. Nichols and C. A. Pool (eds), *The Oxford Handbook of Mesoamerican Archaeology*, 482–94, New York: Oxford University Press.

Henderson, J. S. and K. M. Hudson (2015), 'The Myth of Maya: Archaeology and the Construction of Mesoamerican Histories', in H. Kettunen and C. Helmke (eds), *On Methods: How We Know What We Think We Know about the Maya*, 7–24, Acta Mesoamericana, Vol. 28, Markt Schwaben: Verlag Anton Saurwein.

Hudson, K. M. (2012), 'A Preliminary Lexicon of Ulúa Medallion Motifs', MA diss., Cornell University, Ithaca, NY.

Hudson, K. M. (2013), 'Text and Textuality in Ulúa Iconography', *Anthropology: Bachelors to Doctorates*, 1 (1): 2–20.

Hudson, K. M. (2014), 'Sherd Stories: Ceramic Collections as Archives for Archaeological Analysis', *Archaeological Review from Cambridge: The Archive Issue*, 29 (2): 164–78.

Hudson, K. M. and J. S. Henderson (2015), 'Weaving Words and Interwoven Meanings: Textual Polyvocality and Visual Literacy in the Reading of Copán's Stela J', *Image: Zeitschrift für Interdisziplinäre Bildwissenschaft*, 22: 108–28.

Hudson, K. M. and S. Milisauskas (2015), 'Interacting Forms and Visualized Identities: The Implications of Graphic and Syntactic Variability in the Symbolic Repertoires of Tripilian Culture Groups', in A. Diachenko, F. Menotti, S. Ryzhov, E. Buniatian and S. Kadrow (eds), *The Cucuteni-Tripolye Cultural Complex and Its Neighbors: Essays in Memory of Volodynyr Kruts*, 57–94, Lviv: Publisher Astrolabe.

Lehmann, W. (1910), 'Ergebnisse einer Forschungsreise in Mittelamerika und Mexico 1907–09', *Zeitschrift für Ethnologie*, 42: 687–749.

Nielsen, J. and J. E. Brady (2006), 'The Couple in the Cave: Origin Iconography on a Ceramic Vessel from Los Naranjos, Honduras', *Ancient Mesoamerica*, 17 (2): 203–17.

Robicsek, F. (1975), *A Study in Maya Art and History: The Mat Symbol*, New York: Museum of the American Indian, Heye Foundation.

Robinson, E. J. (1978), 'Maya Design Features of Mayoid Vessels of the Ulua-Yojoa Polychromes', MA diss., Tulane University, New Orleans, LA.

Robinson, T. P. E. (2014), 'Cords of Time: An Iconographic Analysis of the Flat Two-Dimensional Knot in the Context of Classic Period Maya Representation', PhD diss., University College London, London.

Stone, D. Z. (1957), *The Archaeology of Central and Southern Honduras*, Peabody Museum Papers, Vol. 49, No. 3, Cambridge, MA: Harvard University.

Strong, W. D., A. V. Kidder and A. J. D. Paul (1938), *Preliminary Report on the Smithsonian Institution–Harvard University Archeological Expedition to Northwestern Honduras, 1936*, Miscellaneous Collections, Vol. 97, No. 1, Washington, DC: Smithsonian Institution.

Taube, K. A. (2009), 'The Maya Maize God and the Mythic Origins of Dance', in G. Le Fort, R. Gardiol, S. Matteo and C. Helmke (eds), *The Maya and Their Sacred Narratives: Text and Context in Maya Mythologies*, 41–52, Markt Schwaben: Verlag Anton Saurwein.

Viel, R. (1978), 'Étude de la ceramique Ulua-Yojoa polychrome (nord-ouest de Honduras): Essai d'analyse stylistique du Babilonia', PhD diss., Université René Descartes, Paris.

Yde, J. (1938), *An Archaeological Reconnaissance of Northern Honduras*, Copenhagen: Acta Archaeologica IX.

CHAPTER 10

IDEALIZED DIVINITY VERSUS IDENTIFICATION: ANCIENT 'LIFELIKE' GESTURES OF THE BUDDHIST SCULPTURES 五百羅漢 (*500 RAKAN*)

Christine Kuehn

菊の香や	Chrysanthemums' scent –
奈良には古き	In the old town of Nara,
仏たち	Many ancient Buddhas.

<div align="right">Basho 1694, in Ueda 1982: 66</div>

Next to the entrance of the Great Buddha Hall in the old town of Nara, we can find a wooden sculpture on a chair-like mounting, severely withered by time and wrapped in red cloth. Only the face and hands are to be seen clearly. The raised right hand tells us to have no fear and the left hand is holding a medicine jar (Figure 10.1). Millions of tourists have passed by to see the world's largest bronze statue of the Buddha *Vairocana* inside the hall. Many may have not noticed the old sculpture next to the entrance, some may have stopped to read the explanation sign, a few may have shyly touched a part of the sculpture and thereafter the corresponding part of their own body, since legend holds that by such a touch, an ailment of that body part will disappear. But how many of these people know the origin of this sculpture – a *Rakan* named *Binzuru*, one of the first disciples of Buddha.

In this chapter, I argue that the 'lifelike quality' commonly ascribed to the group of sculptures called *500 Rakan*, is primarily due to their gestures. Before going into detailed examinations of one specific Buddhist *Mudra*, I provide a few aspects concerning the contextual integration of the sculptured gestures, such as the naturalistic way of production, religious motivations and inherent folk beliefs – allowing for a wide variety of interpretations ranging from deeply human to strangely divine. In the search for appropriate ways to analyse the specificity of a gesture on one side, and the comparability of its use in different cultures on the other side, I suggest to look beyond codified semiotic descriptions and favour a more holistic and dynamic approach to gesture.

Buddha's disciples: Origin, types and tradition of *Rakan* sculptures

In Buddhism, *Rakan* 羅漢 are described as saints, who have completely freed themselves of all earthly desires and possessions. The Japanese term *Arakan* or *Rakan* (Chinese,

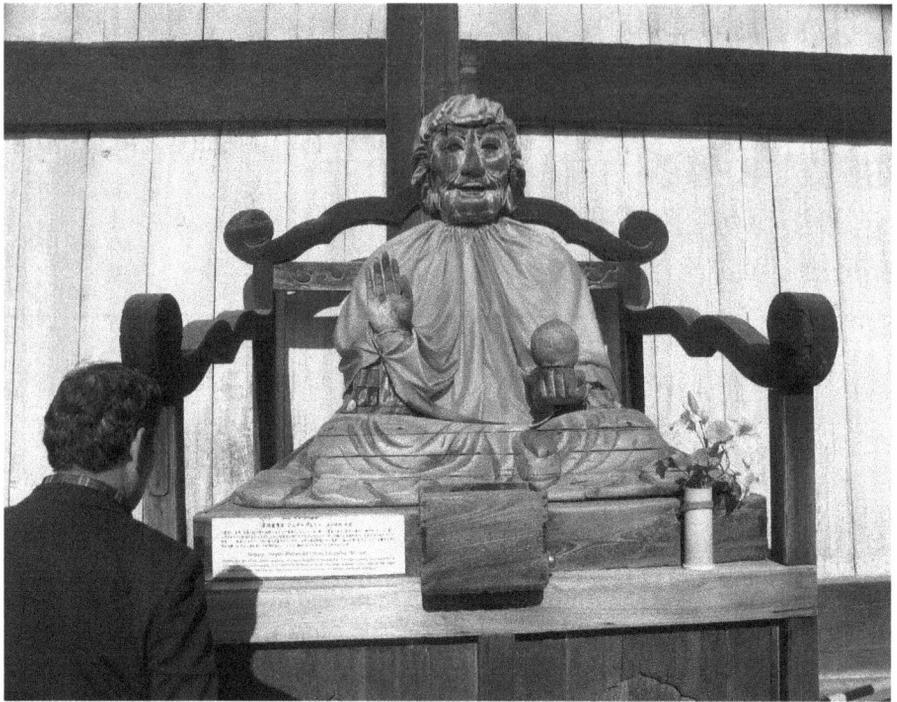

Figure 10.1 *Binzuru Rakan, Todai-ji*, Nara. Photograph by Christine Kuehn.

alohan, lohan; Korean, *anahan, nahan*) comes from the Sanskrit, *Arhat* (*arhati*, 'be worthy of'): 'one who is worthy of reference because he has attained the penultimate state of perfection' (Bowker 2000: 51; for discussion of competing Buddhist ideals in Theravada and Mahayana Buddhism, see Ven. Bhikku Bodhi 2013). In contrast to ordinary mortals, *Rakan* can hear and understand all sounds in the universe, know the thoughts of others and remember previous existences. Each *Rakan* has distinctive features, expression and physique. They are often displayed in groups of sixteen or eighteen to represent the first disciples of Buddha, or in groups of five hundred to represent the monks assembled during the first Buddhist council.

In Japan, we can find various *Rakan* places, not all of them well preserved and famous, like the *Rakan-ji* that is located in the registered UNESCO World Heritage Site of Iwami Ginzan Area. Today, many sets of *Rakan* sculptures are tended to by religious institutions of various denominations and often serve as tourist attractions. A few sculptures have found their way to international art museums and private collections; others seem forgotten, left in the woods or behind rice paddies. Aside from some rather glamorous traces in art history, like the famous *Ukiyoe*-prints and some sketches of the *Rakan-ji* in Edo by Hokusai, Hiroshige and Utamaro, there is very little known about the sculptures archaeologically, and, unfortunately, very few scholarly works (for an excellent study of the history of Ten'onzan Gohyaku *Rakan-ji*, see Screech 1993; for a detailed overview of temples and places with stone Buddhist sculptures of Rakan, see Moriyama 1984).

For a systematic approach to the *Rakan,* it is useful to differentiate between at least two types based on the material of their construction: stone or wood.[1] Consequently, *Rakan* belong either to the *Sekibutsu* (stone Buddhist sculptures) or to the *Mokuzoubutsu* (wooden Buddhist sculptures). The two general categories of *Mokuzoubutsu* are images that lack finish and those of wood finished with colour, gilding or lacquer. The term *Sekibutsu* is a collective noun for various Buddhist sculptures made out of stone, such as Buddha (Nyorai), Bosattsu (Bodhisattva) and others. Kubota (1996: 7) calls them not only 'material products of religious belief' but also 'concrete embodiments of the spiritual activity of the faithful'.

Usually, *Sekibutsu* are further subdivided into two groups: the freely standing sculptures like the *500 Rakan* of *Rakan-ji* in Kasai, and those that are carved into rocks (*Magaibutsu*), like the ones found on the cliffs of Tono. However, the religious background, the arrangement of the *Sekibutsu*, the origin of the art, the sculptors and influences from the continent have not been established and remain widely unknown. Ledderose (1996) focused on the aspect of folk belief and compared the *Sekibutsu* to Christian crucifixes or little chapels under open skies – all of which were thought to function as signs of an almighty power to protect the fields, woods and people. Ledderose established that *Sekibutsu* have a special status within Japanese religious art as indicated by their construction and placement. *Sekibutsu* differ from most other Japanese religious cult figures in that they are made of stone rather than wood, lacquer or clay. In addition, *Sekibutsu* are rarely found in proximity to temples or cloisters. Instead, they are typically placed in the woods, near a path, in the underbrush or in caves. In this way, *Sekibutsu* may have served to pass on local religious traditions from Shintoism, just as the above-mentioned Christian monuments do with paganism.

At first sight, there are quite a few differences between the *Sekibutsu* and the *Mokuzoubutsu*. While the stone *Rakan* are found under open skies, the wooden *Rakan* are usually found in temples, either in the main hall (e.g. *Gyokuhou-ji* in Odawara) or in a specially erected hall on the temple grounds (e.g. the *Rakan-do* of *Daikaku-ji* in Sapporo). Although the aspect of shared identity in a group seems to be of importance for both stone and wooden *Rakan*, the spatial arrangement can be very different. The wooden *Rakan* for example are usually presented to the left and to the right of the *Daibutsu* (big Buddha statue) on shelves or stage-like settings. Similar arrangements for stone *Rakan* can be found in a newly erected *Rakan* Hall of *Toukaku-ji* in Matsue or a theatre-like setting under open sky at *Toukou-ji* from 1859 in Usa. Otherwise, the distances between stone *Rakan* and their placement under the open sky are much more variable. For example, the stone *Rakan* of *Chouan-ji* in Hakone are situated on a hilly woodland of about 400 metres squared or the huge area of *Unpen-ji* on top of *Unpen-ji-*mountains on Shikoku-Island. Except for newly manufactured stone *Rakan*, their origin and temporal classification cannot be determined, and they are considered to be anonymous works, stemming from Japanese folk belief and manufactured by the faithful.

More specific information is available for most wooden *Rakan*, on the basis of their religious institutionalization, including the exact date of their manufacture (e.g. *Souen-ji* in Otaru), the names of the artists (e.g. Soeda Brothers, *Gyokuhou-ji* in Odawara), as well

as the naming and detailed description of individual *Rakan* sculptures that have been modelled after historical personalities (Marco Polo and Kublai Khan at *Hoon-ji* in Morioka).

Strangely divine and deeply human: Encarved faith, legends and a gesture game

While the different types of *Rakan* may provide the first hints of their temporal, local, artistic and religious classification, they do not explain their very special impact. Observers from different theoretical and practical backgrounds frequently ascribe a stunning expressiveness to the *Rakan* and feel surprised by how lifelike they are. For example, Kubota (1996: 111) writes that one is unable to resist the feeling that they are alive. But what is the difference between *Rakan* and other sculptures of saints? What makes them so special and lifelike?

All existing descriptions of *Rakan* discuss two aspects, a divine aspect as well as a human aspect:

> Beginning in the Tang period, these figures were portrayed as intense, often bizarre individuals, humbly dressed but always with an expressive, focused gaze, reflecting their profound spiritual attainments ... Their combination of picturesque features and concentrated expressions was immediately attractive to artists, and some of the greatest painters of East Asia devoted their talents to the subject of the arhat, an ascetic type of figure that remained an ideal and also acted as a model for some images of Shakyamuni.
>
> *Fisher 1993: 121–2*

> In contrast to the many exotic deities of the Mahayana pantheon, the *Rakan* are humans who have reached a state of enlightenment equal to that of Shaka. *Rakan* sculptures are often seen in Zen temples, which prefer these human examples to those of idealized divinity ... They are certainly down to earth; one can have no illusions about fellows, who pick at their gums and nostrils, scratch their scruffy heads, and wear such dumbly blissful grins.
>
> *Kinoshita and Palevsky 1998: 56*

The focus on the human aspect opens up the possibility of identification and the opportunity to consider a number of associated legends: in many *Rakan* sites, the belief is that one will find the person one seeks among the numerous faces of the *500 Rakan*. It is said about the *Rakan-ji* in Kasai that each visitor will find a face of one of the *Rakan* that resembles his or her own. In Kawagoe, a person seeking a loved one goes to the Kita-in Temple on a moonless night and touches the features of each *Rakan* in turn until he finds one that is warm to his touch. He identifies the warm *Rakan* by sticking a piece of

paper to it. The next day he will find his lost relation or sweetheart in the features of the warm *Rakan* (Bushell 1995: 26).

The rather emotional attachment to the *Rakan* might also be based in the circumstances of their manufacturing, especially after natural (or man-made) disasters. For example, in 1699, after a flood had taken the lives of 487 people including the head of the Isahaya Clan, the temple *Daiou-ji* was erected and 503 *Rakan* figures were carved into the rocks nearby what is today Isahaya town. Another set of 501 stone sculptures was crafted with the cooperation of the local people to appease the souls of the workers killed in the silver mine at Iwami Ginzan in Oomori around 1741. This reminds us of the idea mentioned above, of the embodiment of spiritual activity in the stone sculptures, and might well account for the wooden sculptures:

> As we think about Buddhist carvings in wood in the context of Japan, where there already existed indigenous beliefs in tree spirits and tree deities, the significance of the wood material and the idea of entrusting ones prayers to figures made from it gives us a strong sense of the unbroken continuity of Japanese belief systems as they have been passed down from ancient times to the present day.
>
> *Tokyo National Museum 2006: III*

However one approaches the *Rakan*, both aspects – the strangely divine and the deeply human – play an important role. Whether revering a divinity, entrusting prayers to the *Rakan*, or finding a lost one in the features of a sculpture – one factor connecting these different aspects seems to be the gestures of the *Rakan*. In fact, for some observers the gestures were so prominent that a Gesture Game named '*Rakansan*' evolved. It is listed in the archive of *Warabeuta* – Japanese children's folk songs.[2] The lyrics of the song and descriptions of the game can still be found at kinder-gardens, as well as on several homepages (e.g. Japanese Boy scouts). While there are often different names for the game that either refer to the *Rakan* (*Rakansan, Rakansan ga sorotara, Rakansan mawashi*) or the gestures (*Shigusa mawashi*), the lyrics are consistent:

らかんさんが そろたら	When all the *Rakan* have come together
そろそろ まわそじゃ ないか	Let us start passing around (the gesture/
ヨイヤサノ ヨイヤサ ...	the *Rakan*). Yoyasa no yoyasa

During the gesture game, the children sit in a circle and sing the first two lines of the song while rolling their arms in front of the body. With the beginning of the third line every child makes a gesture, e.g. crossing the arms in front of the breast, touching the earlobes, etc. and start the *Kakegoe* 'Yoyasa', which is like a chant or shout that keeps the rhythm and gives encouragement. From this point on, every child has to mimic the gesture of his left neighbour, so that the gesture is smoothly passed around. While everyone keeps chanting, the pace of the wandering gestures speeds up, and the game eventually ends with laughing faces and twisted limbs.

The question of lifelike qualities: From ancient to modern gestures

When visiting one of the many places containing *500 Rakan* sculptures, lined up on shelves to the left and the right, or in rows in front of the observer, the first impression might be that they all look alike. However, a second look reveals that each one of the *Rakan* is different. Some look the viewer straight in the eye. Others are turned away and seem to dream. Some stand upright, others sit dangling their legs. Some lecture with a raised index finger, others scratch their heads with an attitude of inquiry. Some of the gestures are small and subtle, while others are large and inclusive – a vast mixture of gestures from ancient daily life, art and ritual (see Figure 10.2).

It is assumed that one key to the solution of the question of lifelike qualities is the gestures of the *Rakan*. A closer look may reveal how the gestures of these sculptures convey such a complex and lifelike impression, serving both the divine and human aspect, as well as offering viewers opportunities for personal identification.

Attempting to classify the gestures of the *Rakan* according to the theoretical descriptions of traditional gesture research proves to be a rather puzzling experience. The gestures seem to escape any categorization. This might be due to the fact that traditional gesture research has been almost exclusively concerned with the production or expression of a gesture (for a historical overview on categorization and classification in traditional gesture research, see Kuehn 2002a).

Striving to establish a status for gesture comparable to language is scientifically acknowledged but has resulted in only focusing on the conventionalized gestures, on gestural features that can be exactly described, measured, counted and collected. This concentration on the *rational side* of gesture has left behind other, arguably just as important parts of gesture. As we know from the interpretation of works of art, such as painting, sculpture or dance, there is another side of gesture that is important – a side

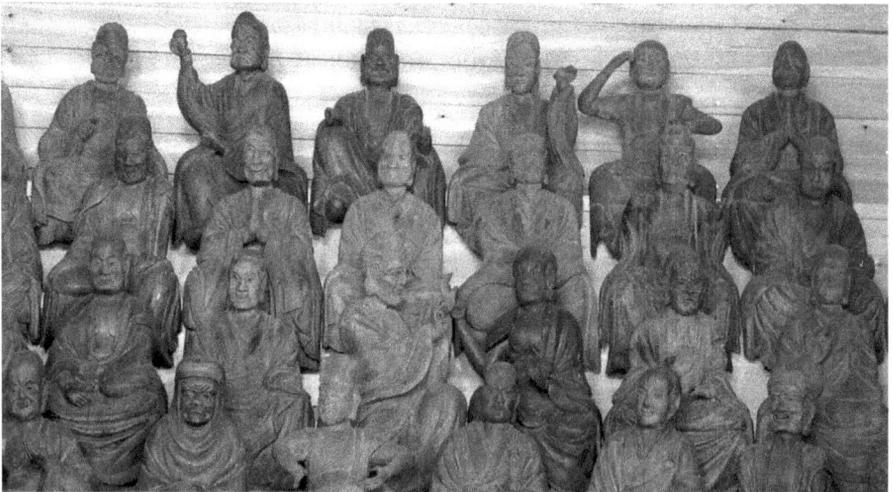

Figure 10.2 *500 Rakan, Souen-ji*, Otaru. Photograph by Christine Kuehn.

that includes emotional, ritualistic or even spiritual aspects. So far, we have yet to find connections between these two sides.

In the search for a less restricted and more comprehensive interpretation of gestures, we need to challenge traditionally established dichotomies such as production versus reception, universality versus cultural specificity and conventionalized versus non-conventionalized gestures. The following discussion will touch on some of these issues and will look at how the scientific understanding of gestures can be used in our interpretation of the *Rakan*. Specifically, I explore why gesture research should go beyond production processes to encompass reception processes, and why the separation between conventionalized and non-conventionalized gestures in traditional classification systems is artificial and not useful for discriminating the gestures of the *Rakan*. I finish with discussing some benefits and limitations of the traditional perspective of gestures as either universal or culture-specific signs. While stressing the need to overcome artificial dichotomies, I argue that this 'softer approach' facilitates our access to gestures in art and religion and helps us to better understand the lifelike quality and the magnetism that the *Rakan* embrace.

Speaking hands: *Mudra* in iconography, medicine and yoga

To illustrate the dilemma of traditional categorization, one gestural prototype will be shown, exemplifying strict codification on the one hand and interpretative variety on the other. As the *Rakan* have divine status, their poses can be investigated in the context of the strictly codified Buddhist gesture system of *Mudra*, making this the starting point for observation.

Recently, the term *Mudra* has become quite popular in Europe, as well as in North America. It has also been given a variety of definitions in a variety of contexts, such as self-help books, yoga and meditation classes, medical practices, or even advertisements. Aside from these popular definitions, with sometimes inconsistent meanings, very little is known about this term scientifically and there are very few scholarly works dealing with the subject in Western publications (for an alphabetically listed compilation of *Mudras* in Buddhist and Hindu Practices see Bunce 2005). Nevertheless, the body of research on Buddhist iconography[3] that exists offers several definitions of *Mudra*, ranging from '*geste mystique*' or 'finger signs' to 'manual signs indicative of various ideas', as well as 'an established and conventional sign language', or 'a system of magic gesticulation consisting in distorting the fingers so as to imitate ancient Sanskrit characters, of supposed magic effect' (Saunders 1985: 5).

As Saunders (1985: 8) noted, the word *Mudra* itself has 'probably been drained of meaning for most non-Indian readers, and the ideogram 'in' 印 came largely to express the totality of the idea.' In that, the idea of *seal* or *sign* binds three significations. In addition to the symbolic gestures of the hand used as *seals*, which guarantee the efficacy of the spoken word, the ideogram includes symbolic objects used as

marks of identity as well as the *dharani*, spoken formulas, which 'seal' the magic of the rites.

The *Mudra* may be divided into two general groups: *Mudra* in the sense of signs symbolic of the metaphysical aspect of esoteric ceremonies; and *Mudra* used to evoke a specific episode of the Buddhist legend or to identify divinities. This second group, the 'iconographic' group, has multiplied greatly in sculpture and painting and Saunders (1985) distinguishes eight principal symbolic gestures and six secondary hand gestures. These *Mudra* – including their many variants in form, enactment, handedness, etc. – are called the *Mudra* of the principal personages of the Buddhist pantheon and also the principal *Mudra* of the greater part of Far Eastern art.

In the following section, I introduce one of the most frequent *Mudra*, the *An-i-in*. After a basic explanation of the name and the enactment as well as the specific features of the codified gesture within the gesture system of *Mudra*, I give a brief discussion of the symbolism, the ritual origin and the iconographical use of this *Mudra* in a Buddhist context. Finally, I trace the *An-i-in* type and its components – hand shape or movement pattern – by its usage in historical and contemporary documents of daily life, as well as in the art, science and religion of various cultures.

The codified buddhist gesture system of *Mudra*: 安慰印 *An-i-in*

One of the eight principal symbolic gestures that I mention above is the 安慰印 *An-i-in* or *Seppo-in*. As *An-i-in*, the *Mudra* of appeasement, this gesture has a calming function. As *Seppo-in*, the *Mudra* of the exposition of the law, the gesture corresponds directly to Sanskrit *Vitarka* (Sino-Jap. *Bitaka*), the Indian gesture of argumentation or teaching.

The *An-i-in* is formed with at least one hand raised in front of the breast and the palm facing outward (see Figure 10.3). The thumb touches the end of an inflected finger, either the index or the middle finger, or, more rarely, the ring finger. The remaining fingers are straight or slightly bent. Since the *An-i-in* may be formed with one hand at a time or with both hands at the same time as well as the options of bringing together the thumb with one of three fingers, there are many variations. Each variation may alter the interpretation of the gesture, e.g. in our case the representation of a different divinity.

The symbolism of the *An-i-in* derives from the perfect form of the circle, having neither beginning nor end – resembling the law of the Buddha that is perfect and eternal. This *Mudra* form may be related to the Wheel of the Law, one of the attributes that traditionally symbolize the predication of the Law or the teaching of the Doctrine. In Tibet, this gesture is sometimes called 'the triangular pose, the mystical gesture of the Taras or the eight Bodhisattvas' (Saunders 1985: 72).

In Japan, this gesture is attributed to Shakyamuni and to Amida. The different enactments of the *An-i-in* (Figure 10.3) represent six of the nine different levels or grades of rebirth used by Amida when welcoming the dead into the Pure Land. When applied to Amida Nyorai, the term *Raigo-in* (welcoming *Mudra*) is used. The *Lower Class* is represented by

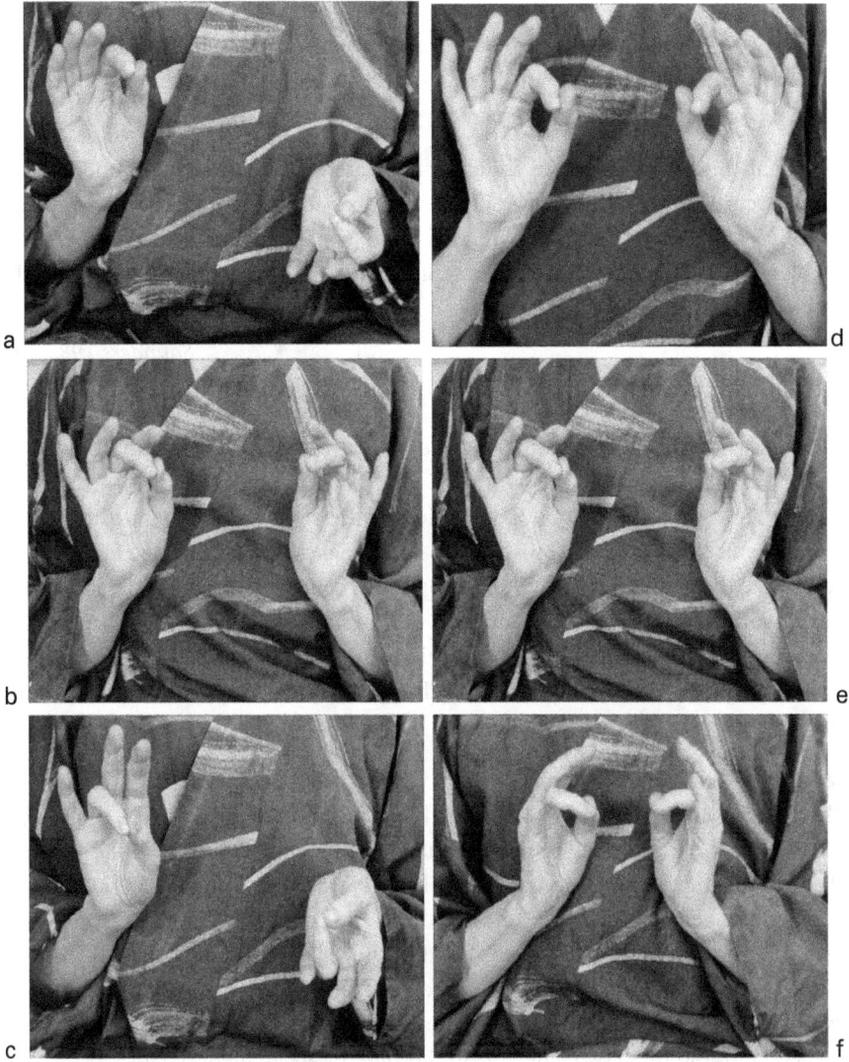

Figure 10.3 *Mudra* of the *Amidas* of the middle and lower classes. *(a)* Lower Class: Upper Life; *(b)* Lower Class: Middle life; *(c)* Lower Class: Lower Life. *(d)* Middle Class: Lower Life; *(e)* Middle Class: Middle Life; *(f)* Middle Class: Upper Life. Photographs by Christine Kuehn.

the right hand raised to shoulder level, the left hand reposing on the left knee, palm upward. Each hand makes the *An-i-in* with the thumb and one other finger: for the *Lower Life*, the ring fingers (Figure 10.3c), for the *Middle Life*, the middle fingers (Figure 10.3b), and for the *Upper Life*, the indexes (Figure 10.3a). The *Middle Class* is represented by the two hands held in front of the breast, each one forming the mystic circle with the thumb and one other finger. For the *Lower Life*, the indexes (Figure 10.3d), for the *Middle Life*, middle fingers (Figure 10.3e), and for the *Upper Life*, the ring fingers (Figure 10.3f).

As *Seppo-in*, it frequently appears on standing statues of Amida, such as in the sect Jodo, Tendai and Soto (see Figure 10.4a). As such, it may be used as the seal of the third of the nine Amidas of the nine classes:

> The right hand, which is raised, indicates the search for the Awakening, and its five fingers represent the worlds of Auditors, Buddhas-for-self, Bodhisattvas, Exoteric Buddhas and Esoteric Buddhas. The left hand, which is pendent, symbolizes the conversion of Beings, its five fingers representing the worlds of men, gods, dead, animals, and infernal (beings).
>
> *Saunders 1985: 73*

Codification versus interpretative variety: Appeasement, emphasis, insult

The same hand shape as well as the position of the right hand is found in Christian iconography as the sign of the cross, the so-called *Benedictio Latina* (see Figure 10.4b). In contrast to the interpretation within the Buddhist context, the fingers do not symbolize different worlds, but imitate the monogram of the name of Christ. This is also similar to one definition of *Mudra*, in which it was said to 'imitate ancient Sanskrit characters, of supposed magic effect' (Saunders 1985: 5). Thus, for Christian symbolism, the positions of the fingers represent letters as follows:

> When you desire to represent a hand in the act of blessing, you must not join the three fingers together, but let the thumb be crossed on the third finger, so that the first called the index, may remain open, and the second finger be slightly bent. Those two fingers form the name of Christ *Ιησους*, I.C. In fact, the first finger remaining open signifies an I (iôta), and the curvature of the second forms a C (sigma). The thumb is placed across the third finger, and the fourth, or little finger, is slightly bent, thus indicating the word *Χριστος*, X.C. The union of the thumb with the third finger makes an X (chi), and the curvature of the little finger forms a C (sigma), and these two letters form the 'sigle', or abridgment of Christos.
>
> *Byzantine 'Guide for Painting'; quoted after Bäuml and Bäuml 1997: 263*

In Buddhist, as well as in Christian tradition, a close relationship to speech is ascribed to this gesture. In Buddhism, it is considered to be the exposition of the law, while the Christian interpretation reads, 'the scroll in the left hand contains the written speech; the gesture of the right one expresses the realization of the written in the living word' (L'Orange 1982: 175). Although there are slightly different interpretations that could be assigned to this gesture, Saunders (1985) argues in favour of the teaching interpretation rather than the benedictory interpretation. He emphasizes the similarity of this interpretation across cultures, which could indicate the existence of a basic universal meaning of this gesture.

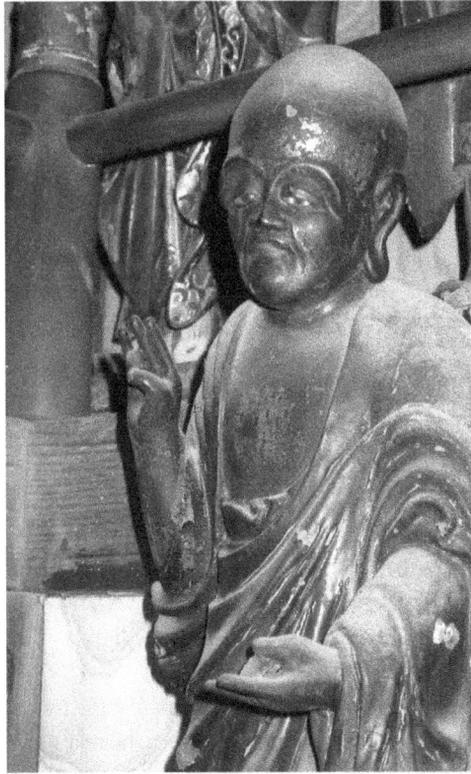

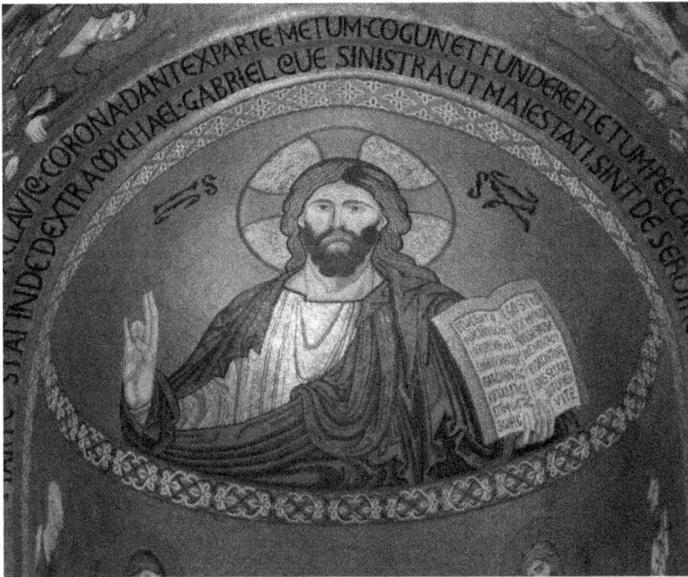

Figure 10.4 Gesture with ring-shape element in Buddhist and Christian iconography: *(a) Rakan, Tenkeizan Gyokuho-ji* in Odawara. Photograph by Christine Kuehn; *(b) Christus Pantokrator*, Palentine Chapel, Palermo, Italy © José Luiz Bernardes Ribeiro / CC BY-SA 4.0.

Other examples of the presence of the *An-i-in* type, particularly the one-handed gesture of the right hand joining the thumb and the index finger, can be found throughout recorded history. In comparison to the conventionalized forms of *Mudra*, the gesture is much less consciously performed, shows no degree of conventionalization, and is therefore called *gesticulation* by Kendon (2004) or *spontaneous or speech-associated gesture* by McNeill (1995). Another example of the one-handed gesture of the right hand joining the thumb and the index finger has been observed by Auboyer (1951: 156) as one that is used by Indians mechanically during their conversations. Auboyer calls it the 'gesture of argumentation'. In contrast to the iconographic codification representing a specific divinity in Buddhism, the same hand shape and position of the hand are believed to be dependent upon speech, merely stressing or emphasizing the rhythm.

A higher degree of conventionalization is ascribed to the gesture for its use in formal rhetoric. Quintilian, a first century Roman orator, and Bulwer, a seventeenth century physician and rhetorician, describe the gesture as one used to express agreement:

> If the first finger touches the middle of the right-hand edge of the thumbnail with its extremity, the other fingers being relaxed, we shall have a graceful gesture well suited to express approval.
>
> *Quintilian 1958–60: XI, III: 104*

> The top of the forefinger moved to join with the nail of the thumb that is next unto it, the other fingers in remitter, is opportune for those who relate, distinguish, or approve.
>
> *Bulwer 1974: 199*

According to classification systems in the tradition of Efron (1972) and Ekman and Friesen (1969) the *An-i-in* type could also be characterized as an *emblem* or *autonomous* or *quotable gesture*. In this capacity, it fulfils the criteria of translatability, familiarity, consciousness and intentionality (Ekman 1976). In Japan, this gesture may stand for 'money'. The Anglo-American meaning of this gesture, 'OK', is often used for the purposes of conveying a recommendation or indicating that someone or something is 'good'. In contrast, the technical language of car drivers in Germany assigns a completely different meaning to this gesture and authorities warn that making the so called 'Ring' of thumb and index finger means 'asshole', and may cost up to €750. In this way, this gesture is legally treated as an emblem and it is assumed that everybody knows what it means (see also de Jorio [1832] 2000).

Finally, this gesture type is given the highest degree of conventionalization and language likeness when it appears as part of a sign language. The *An-i-in* resembles the shape of the 'F-hand' of the finger alphabet in German Sign Language (DGS) and is often employed as a part of various other signs.

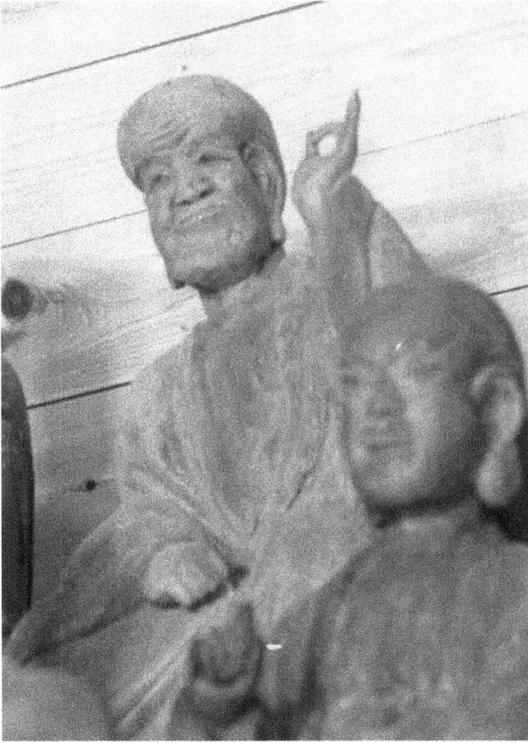

Figure 10.5 *Rakan, Souen-ji*, Otaru. Photograph by Christine Kuehn.

The eye of the observer: From idealized divinity to identification

Imagine for a moment that you have not read this chapter. How would you understand the gesture of the *Rakan* in this picture (Figure 10.5)? Would you consider this to be a Buddhist *Mudra* or would you think this is a request for you to pay for your admission? Or does the *Rakan* show you that it is acceptable ('OK') to be a tourist and stare at him? Or do you rather feel insulted? As a casual observer of the *Rakan* you can discover both the human and the divine. You may or may not feel awestruck, but you may be overwhelmed by the immense variety and lifelikeness of the *Rakan*.

The great diversity of the *Rakan* is found, not only in the form of various gestures, but also in the changing interpretations of a single gesture as it appears in different categories of meaning. In this way, every gesture encompasses different degrees of conventionalization and it is up to the observer to ascribe one or more interpretations to it, according to the communicative context and personal communicative history: whether as *Mudra* in Buddhist iconography, as a blessing gesture in Christianity, as a rhetorical gesture of approval or as an insult, as an emblem for 'money' or 'OK', as a mechanically and unconsciously made conversational gesture, or even as a part of a sign language.

Exploring the gradual change in the formal interpretation of gestures emphasizes the importance of breaking away from traditionally established dichotomies such as

production versus reception, universality versus cultural specificity and conventionalized versus non-conventionalized gestures. Future research needs to consider three lines of thought towards a more comprehensive interpretation of gesture. One step in this direction might be to focus on perception by questioning the necessity of postulates such as consciousness, intentionality and codification; and, further, view the observer as a direct participant in the process of constructing meaning. In other words, the lifelike quality of the sculptures is not only the result of a mixture of traditionally defined ritual and communicative gestures; but it also seems to be inherent in the visual medium inhabited by gesture, and thereby invites non-conventional methods of understanding.

Obviously, semiotic decoding processes are not easily transferrable to gestures. The visual form of the gesture cannot be 'split', but instead may facilitate the reception process by mediating between emotion and reason as well as concrete and abstract levels of reasoning (for detailed discussions of embodied understanding of gesture, see Kuehn 2002a, 2004, 2005). Just as the boundaries between the different gestural forms of traditional categorization merge and overlap, so too it is difficult to classify the gestures of the *Rakan* in a traditional way, differentiating elements of art from elements of daily life.

Another closely related impulse for considering a more comprehensive interpretation of gesture may be described as *contextualization*, i.e. to view gesture as an integral part of bodily communication, including facial and oculesic features (see López-Bertran, this volume), haptic qualities (see Morris and Goodison, this volume) as well as objects or artefacts (see Walsh, this volume). Further, it seems important to situate the gesture in time and space, not only with respect to body posture, spatial orientation and movement patterns but also to the different perspectives on one gesture and the changes caused by variations in proximity (for an application model on multi-sensory perception see Kuehn 2001, 2008). This leads directly to a third impulse – the consideration of the potential movement inherent in gesture. This may, at the same time, give us a glimpse of the roots or antecedents of these ancient gestures: 'that the form, the artistic rhythm, even the symbolism of Buddhist sculptures are a visual manifestation of the unquestionable bond which united iconography and the dance' (Saunders 1985: 12).

Admittedly, to look at the impact of gestures beyond codified semiotic descriptions, to fully explore the contextual integration and to detect frozen movements of dance may be an additional burden to the archaeologist in search for the truth about the time of origin. Having said this, such an understanding may facilitate the scientific as well as the emotional and spiritual access to a religious piece of art, in modern times and through the ages.

Acknowledgements

I am deeply indebted to the abbots, monks and lay persons who take care of all the *Rakan* sites throughout Japan. I thank them for their patience, their stories and their helpfulness, and for always providing a delicious bowl of tea. I am grateful to my colleagues and students at Hokkaido University for all the help they gave me in finding those special

hidden spots and the almost forgotten literature. Most of all, I want to acknowledge and thank Tsushima Sensei and my fellow students at the Buddhist sculpting course; it was through them that I learnt to use my eyes, hands and heart in new and different ways to approach these special wooden sculptures.

Notes

1. There are at least two large sets of paintings, one 100-painting series on hanging scrolls created between 1854 and 1863 by Kano Kazunobu (1816–63) for the Pure Land Buddhist temple *Zōjō-ji* in Edo/Tokyo and one 460-painting series created between 1921 and 1941 by Hayashi Takejirou (1871–1941), now displayed at the *Soutou* temple *Zengen-ji* in Furubira, Hokkaido. Under the title 'Masters of Mercy: Buddha's Amazing Disciples', selections from Kazunobu's series were displayed for the first time outside Japan at the Smithsonian's Arthur M. Sackler Gallery in 2012. A very recent fascinating addition in the field of Contemporary Art is the 100 metre-long painting, *The 500 Arhats* by Takashi Murakami (2012), created in the wake of the Great East Japan Earthquake of March 2011. For further details, see Murakami (2015).

2. See Yukari Yamada's Children's Rhymes and Happy Days (unknown date), including a video of the Gesture Game.

3. Future research needs to consider *Mudra* also in a Hindu context, which is beyond the scope of this chapter. For the following portion on Buddhist sculptures, I use Saunders' (1985) terminology and classification. His study of symbolic gestures in Japanese Buddhist sculpture is possibly the best reference book on the market.

References

Auboyer, J. (1951), 'Moudrâ et hasta ou le langage par signes', *Oriental Art*, 3: 153–61.

Bäuml, B. J. and F. H. Bäuml (1997), *Dictionary of Worldwide Gestures*, Lanham, MD, and London: Scarecrow Press.

Bhikkhu Bodhi (2013), *Arahants, Bodhisattvas, and Buddhas: Access to Insight (Legacy Edition)*, 30 November. Available at: http://www.accesstoinsight.org/lib/authors/bodhi/arahantsbodhisattvas.html (accessed 28 September 2021).

Bowker, J. (2000), *The Concise Oxford Dictionary of World Religions*, New York: Oxford University Press.

Bröker, G. (1968), *Ikonen*, Leipzig: Insel.

Bulwer, J. (1974), *Chirologia or the Natural Language of the Hand and Chironomia: Or the Art of Manual Rhetoric*, ed. by T. Cleary, reprint, Carbondale, IL: Southern Illinois University Press.

Bunce, F. W. (2005), *Mudras in Buddhist and Hindu Practices*, New Delhi: Printworld (P).

Bushell, R. (1995), *The Wonderful World of Netsuke*, Tokyo: Charles E. Tuttle Company.

de Jorio, A. ([1832] 2000), *Gesture in Naples and Gesture in Classical Antiquity*, trans. A. Kendon. Bloomington, IN: Indiana University Press.

Efron, D. (1972), *Gesture, Race and Culture* (Approaches to Semiotics 9), The Hague: Mouton.

Ekman, P. (1976), Movements with Precise Meanings, *Journal of Communication*, 26: 14–26.

Ekman, P. and W. V. Friesen (1969), 'The Repertoire of Nonverbal Behavior: Categories, Origins, Usage and Coding', *Semiotica*, 1: 49–98.

Fisher, R. E. (1993), *Buddhist Art and Architecture*, London: Thames and Hudson.

Kendon, A. (2004), *Gesture: Visible Action as Utterance*, Cambridge: Cambridge University Press.

Kinoshita, J. and N. Palevsky (1998), *Gateway to Japan*, Tokyo: Kodansha.

Kubota, T. (1996), *Buddha, Wegzeugen aus Stein*, Heidelberg: Braus.

Kuehn, C. (2001), 'Fushigi no karada: ibunka kan komyunikeeshon ni okeru higengo komyunikeeshon. (Yoshijima Sh.-yaku)', in K. Matsuno and S. Yoshijima (eds), *Gaikokugokyoiku: riron kara jissen mad*,. 55–75, Tokyo: Asahi Shuppansha.

Kuehn, C. (2002a), *Körper-Sprache: Elemente einer sprachwissenschaftlichen Explikation non-verbaler Kommunikation*, Frankfurt am Main: Lang.

Kuehn, C. (2002b), '500 Rakan – Archaische Gesten zwischen Konversation und Kodifizierung', in U. Kramer (ed.), *Archaismen-Archaisierungsprozesse- Sprachdynamik*, 121–36, Frankfurt am Main: Lang.

Kuehn, C. (2004), 'Body & Soul: Gestures as Mediators in Communication', in R. Posner and C. Müller (eds), *The Semantics and Pragmatics of Everyday Gestures: Proceedings of the Berlin Conference*, 225–31, Berlin: Weidler.

Kuehn, C. (2005), 'Von Gestik, Sprache und halben Wahrheiten. Zur Notwendigkeit einer integrativen Perspektive auf sprachliche und visuell-körperliche Kommunikation im Verstehensprozess', in K. Bührig and S. F. Sager (eds), *Nonverbale Kommunikation im Gespräch* (Osnabrücker Beiträge zur Sprachtheorie 70), 93–116, Duisburg: Gilles and Francke KG.

Kuehn, C. (2008), 'Kulturspezifika der nonverbalen Kommunikation: Ganzheitliches Lehren und Lernen im Deutschunterricht', in *Interkulturelle Kommunikation – Interkulturalität. Der Deutschunterricht* 5, 47–64, Velber: Friedrich.

L'Orange, H. P. (1982), *Studies on the Iconography of Cosmic Kingship in the Ancient World*, New Rochelle: Caratzas.

Ledderose, L. (1996), 'Vorwort', in T. Kubota (ed.), *Buddha. Wegzeugen aus Stein*, 5, Heidelberg: Braus.

McNeill, D. (1995), *Hand and Mind: What Gestures Reveal about Thought*, Chicago, IL: University of Chicago Press.

Moriyama, R. (1984), *Rakan no Sekai – Junrei to Kanshou*, Tokyo: Kashiwa Shobou.

Murakami, T. (2015), *The 500 Arhats*, Tokyo: Heibonsha.

Quintilian, M. F. (1958–60), *Institutio Oratoria*, ed. by M. Niedermann, Cambridge, MA: Harvard University Press.

Saunders, D. E. (1985), *Mudrà: A Study of Symbolic Gestures in Japanese Buddhist Sculptures*, Princeton, NJ: Princeton University Press.

Screech, T. (1993), 'The Strangest Place in Edo: The Temple of the Five Hundred Arhats', *Monumenta Nipponica*, 48 (4): 407–28.

Tokyo National Museum (2006), *Shaping Faith: Japanese Ichiboku Buddhist Statues*, Tokyo: Yomiuri Shinbun.

Ueda, M. (1982), *Matsuo Basho: The Master Haiku Poet*, Bunkyō, Tokyo: Kodansha International.

Yukari Yamada's Children's Rhymes and Happy Days (unknown date). Available at: http://warabeuta.org/?p=48 (accessed 19 January 2022).

PART III
INTERDISCIPLINARY PERSPECTIVES ON GESTURE

CHAPTER 11
FREUD'S APPROACH TO GESTURE AND ITS ARCHAEOLOGICAL INSPIRATION
Josef Fulka

The topic of this chapter may seem surprising: what does the work of Sigmund Freud, the founder of psychoanalysis, have to do with the question of gesture and archaeology? My objective is to prove that making such a link is far less arbitrary – and less forced – than may first appear and that observation and interpretation of the patient's gestures is of crucial importance to Freud's approach to the human psyche (especially in the first period of the development of the psychoanalytic technique) which, in its turn, is largely based on something we might call an 'archaeological paradigm'. I proceed in several steps. First, I show that Freud's conception of the human psyche is unthinkable without his constant recourse to 'archaeological' metaphors. Second, I indicate why this specific approach leads him to pay considerable attention to gestures of neurotic subjects (especially in his first major work, *Studies on Hysteria*, published in 1895 and co-authored with Breuer). Third, I try to outline – in a necessarily sketchy way – some possible general consequences that the Freudian view of gestures might have for: (1) the realm of archaeology itself, in so far as the Freudian approach toward the unconscious bears certain characteristics that may not be without resemblance to the way archaeology itself interprets and treats its artefacts; (2) for gesture studies in general, as Freud has proposed, without knowing it, some extremely valuable general insights into what gesture is – gesture in general, not only that of the neurotics – and the way it is formed.

As far as the first point is concerned, I offer a double case study that may usefully illuminate the analogy between psychoanalytic and archaeological approach with special regard to gestures. The first one is a brief excursion to de Jorio's work on gestures in nineteenth century Naples that provide, as I argue, surprising analogies to what would later become psychoanalytic approach to human unconscious. The second one concerns Freud's interpretation of Michelangelo's statue in his paper 'The Moses of Michelangelo', which is a straightforward attempt to apply psychoanalytic method to a historical artefact. The point is to show that not only is psychoanalytic method, as Freud conceived of it, inspired by archaeology on the level of metaphors he uses, but that this very method, according to Freud, may be 'practically' used to interpret archaeological material, and also that psychoanalysis has probably stemmed from the same conceptual background as a certain version of nineteenth century archaeology.

Psychoanalysis and archaeology

When it comes to characterizing Freudian psychoanalysis, especially in the French context, it has become commonplace to speak of the 'archaeology of subject' (Ricoeur 1965: 407, 1969: 161). In the work of Freud, a fervent student of archaeology and collector of archaeological artefacts, the 'archaeological' metaphors return too often to be taken lightly. These metaphors are obviously meant to indicate certain fundamental features of what the human psyche is and what the psychoanalytic method consists of. Let us quote some of those constantly recurring instances in which the work of the archaeologist is chosen as a paradigmatic explanatory model for the functioning of the human mind and for the psychoanalytic treatment. For example, in his essay 'On Psychotherapy', the work of the analyst is characterized, using the terms of Leonardo da Vinci, as '*via di levare*', i.e. a process which consists, quite literally, of excavating the causes of pathological phenomena out of the deep layers of the human unconscious where they lay buried: 'Analytic therapy . . . does not seek to add or to introduce anything new, but to take away something, to bring out something; and to this end concerns itself with the genesis of the morbid symptoms and the psychical context of the pathogenic idea which it seeks to remove' (Freud 1905: 1566). In the early *Studies on Hysteria* (a book to which we will return shortly), the psychoanalytic therapy, the method of 'clearing away the pathogenic psychical material layer by layer', is explicitly compared to 'the technique of excavating a buried city' (Breuer and Freud 1895: 125). In the 'Notes Upon a Case of Obsessional Neurosis' (also known as the case study of the famous Wolf Man), the same comparison takes on a more concrete form; Freud explains to his patient the basic principles of how the unconscious preserves, in an unchanged form and independently of the 'objective', conscious time flow, the pathogenic memories constituting the trauma which is at the origin of the Wolf Man's neurosis:

> I made some short observations upon the psychological differences between the conscious and the unconscious, and upon the fact that everything conscious was subject to a process of wearing-away, while what was unconscious was relatively unchangeable; and I illustrated my remarks by pointing to the antiques standing about in my room. They were in fact, I said, only objects found in a tomb, and their burial had been their preservation: the destruction of Pompeii was only beginning now that it had been dug up.
>
> *Freud 1909b: 2143*

The fact that this analogy appears persistently throughout Freud's writings from the earliest ones up to his last essays attests to the importance the Father of Psychoanalysis has ascribed to it. Perhaps the most salient expression of the analogy between the two ways of proceeding is to be found in a late text, entitled 'Constructions in Analysis':

> The psychoanalyst's work of construction or, if it is preferred, of reconstruction, resembles to a great extent an archaeologist's excavation of some dwelling place

that has been destroyed or buried or of some ancient edifice. The two processes are in fact identical, except that the analyst works under better conditions and has more material at his command to assist him ... But just as an archaeologist builds up the walls of the building from the foundations that have remained standing, determines the number and position of the columns from depressions in the floor ... so does the analyst proceed when he draws his inferences from the fragments of memories, from the associations, and from the behaviour of the subject of the analysis.

Freud 1937: 5051

This, of course, raises the question of how to interpret these constant metaphorical recourses to archaeological research. In his brilliant study on Freud and Antiquity, Armstrong (2005: 40) emphasizes the very ambiguous status of those recourses, namely, Freud's tendency to employ what he terms 'recursive analogies'. It is not clear whether the psychoanalytic method is itself explained by the analogy with archaeology, as Freud would seem to suggest in the passages quoted above, or whether it is this method itself that is able to cast some light on the historiographic material, as Freud would obviously attempt to do in several essays, such as the text on Leonardo da Vinci (Armstrong 2005: 63–83) or the paper on the Moses of Michelangelo, to which we will briefly turn in the conclusion. Are Freud's excursions in the domain of archaeology and historiography, with their rather loose approach to facts, a mere expression of 'empirical romance' (Armstrong 2005: 43), or is there a deeper lesson that archaeology can learn – on a conceptual rather than factographic level – from psychoanalysis itself? This is a question on which I would also like to comment with a special regard to the phenomenon of gesture.

Freud's approach to the unconscious phenomena in a historical context

I argue that Freud's archaeological comparisons should be taken seriously. In order to understand why, however, a few words must be said about Freud's originality concerning the view of the nature and treatment of mental disorders as compared to his predecessors, especially Charcot, under whom Freud had studied in Paris between 1885 and 1886 and who had inspired him, probably more than anyone else, to develop his own original approach towards neuroses in general and hysteria in particular. As has often been stated, the principal difference consisted in Freud's shifting the focus of interest from what is directly visible to what is hidden in the unconscious layers of the psyche, the visible symptoms being, in Freud's view, only transposed and transformed expressions of a pathogenic element of which the patient is not aware and which is connected with those visible expressions only indirectly, via a complicated chain of interposed relays. This very fact makes it difficult, as we shall see shortly, to speak about this pathogenic core in terms of a simple cause of the visible symptoms, as the chain in question does not necessarily have a strictly causal nature. Charcot's monumental work on hysteria, which

he pursued at Salpêtrière hospital in Paris, was based on the observation of the visible, even if not spectacular, aspects of the behaviour of hysterical subjects. Charcot's starting point – both in his research proper and in his public presentations of hysterical patients – was the famous '*grande attaque*', during which the subject usually produced a series of complicated body language elements (the gesture of crucifixion being the most widely noticed). The gestures of hysterics are, first of all, impregnated by affects: they represent a motor expression of affective movements and flows inhabiting the body of the hysterical subject. 'In hysteria, affects are gestures and gestures are visible appearances' (Didi-Huberman 1982: 151). This characterization of hysterical gesture is of considerable importance and will be taken over by Freud as a starting point of his own analysis. Various stages of the '*grande attaque*' are well documented, thanks to what might justly be called Charcot's iconographic obsession. Charcot, whom Freud himself later characterized as 'not a reflective man, not a thinker', but 'a *visuel*, a man who sees' (Freud 1893: 276), had many of his patients photographed and their pictures displayed on the walls of Salpêtrière (Didi-Huberman 1982: 47–50). This, and only this, was the material on which Charcot's account of hysteria was based. It was, so to speak, the surface of hysteria that was of interest; not its possible hidden causes. And it was the neutral observation of this surface that represented the only reliable source for diagnosis, and not the patient's speech, which, in this respect, came to be considered distracting and misleading (Charcot 1998: 119).

In Freud's early papers on hysteria, Freud certainly did not abandon the idea of a certain 'theatrical' flavour that seems to characterize hysteria in a Charcotian perspective. However, he adds a very important new dimension to it, a dimension that might be termed as 'archaeological'. Armstrong, who speaks, in this respect, about a 'conflation of the archaeological and theatrical paradigms', describes the new theoretical and therapeutic 'constellation' as follows: 'in a sense Freud could be seen to have transferred the performative element from the symptoms of hysteria (quite literally performed before the camera and on stage for an audience in Charcot's "theater of hysteria") to their removal in the "private theater" of the talking cure' (Armstrong 2005: 142). In brief, Freud's 'discovery' – to use his own word – consisted of considering the (visible) symptom as a sign of an unconscious trauma whose nature is often sexual and which, in a particular sense that I am going to specify, survives in an unconscious part or region of human subjectivity and whose transfer into the consciousness is often accompanied by resistance on the part of the analysed subject. This insight led Freud to propose a topographical or topological model of subjectivity, i.e. a model which is spatial rather than temporal in the sense that the subjectivity should be literally considered as a space comprising different regions or layers. Freud himself specified the nature of the survival of the unconscious contents: the affect that had been repressed does not undergo the process of wearing away because the unconscious is not governed by the rules of temporal succession (Freud 1915: 3010). The pathogenic memories are simply there, unchanged, but striving, at the same time, to re-emerge in the conscious region. What makes their re-emergence so troubling – and here we touch the very *raison d'être* of psychoanalysis and of psychoanalytic interpretation – is the fact that because of the defence mechanisms

employed by the subject precisely to hinder this 'return of the repressed', they do not emerge in the original form (whose troubling nature had been the very cause of their repression). There is not a direct causal link between the observable symptom and its unconscious origin. Later on, especially in *The Interpretation of Dreams*, Freud distinguishes several processes – condensation and displacement being the most famous (Freud 1900: 751–817) – which operate to disguise, so to speak, the repressed contents so that the return of the repressed takes place in a form which is unrecognizable for the neurotic subject herself and has to be interpreted on the basis of her free associations. We may therefore clearly see why Freud, in contrast to Charcot, has ascribed such a crucial importance to the patient's speech, which leads the analyst to discover and to interpret a set of links leading from the distorted manifest form of the symptom to the hidden, latent form of the trauma.

In 1896, in an important paper entitled 'The Aetiology of Hysteria', Freud presented a complicated account of hysterical symptoms based on the notion of overdetermination rather than simple causality. In interpreting the associations of the hysteric, what we come across are not simple, parallel and straightforward causal links between a symptom and a particular repressed experience or affect, but rather a complicated net of mutual determinations, characterized by what Freud calls 'nodal points', i.e. points in which various symptoms become interrelated and partially determine each other: 'The associative chains belonging to the different symptoms begin to enter into relationships with one another; the genealogical trees become intertwined. Thus a particular symptom in, for instance, the chain of memories relating to the symptom of vomiting, calls up not only the earlier links in its own chain but also a memory from another chain, relating to another symptom, such as a headache. The experience accordingly belongs to both series and in this way constitutes a nodal point, several of which are found in every analysis' (Freud 1896: 413). Freud concludes that one of the most fundamental rules of symptom formation consists in the fact that 'the idea which is selected for the production of a symptom is one which has been called up by a combination of several factors and which has been aroused from various directions simultaneously . . .: hysterical symptoms are overdetermined' (ibid.: 429).

Even such a simplified account enables us to see the sense and the function of archaeological metaphors employed by Freud. The psychoanalyst proceeds by removing, layer by layer, whatever blocks access to what is buried under different strata accumulated in the different stages of the patient's psychic life. Freud himself insisted on the necessary patience needed in order for that work (a word which returns consistently in his writings) to be completed successfully and for the resistances on the patient's part to be overcome, using the term 'working-through' (*Durcharbeitung*): 'One must allow the patient time to become more conversant with . . . the resistance with which he has now became acquainted, to work through it, to overcome it, by continuing, in defiance of it, the analytic work . . . This working-through of the resistance may, in practice, turn out to be an arduous task for the subject of the analysis and a trial of patience for the analyst' (Freud 1914a: 2506). It should be stressed that as original as Freud was when it came to investigating human subjectivity and its pathological phenomena, his approach was not

without analogies in the nineteenth century context. These analogies, however, concern different fields than that of psychology and medical science. Let us mention a few particularly salient examples.

Edward Tylor, whose work Freud was familiar with, coined the notion of survival in the realm of anthropology. In the study of culture, we often come across a certain 'survival of the old in the midst of the new' (Tylor 1958: 84). There are certain customs and phenomena which survive across the ages, even though the concrete form they may take makes them look unrecognizable at first. This form of survival is certainly not without resemblance to the survival of a repressed memory in its unchanged form. Perhaps more importantly, at the beginning of the nineteenth century, Andrea de Jorio undertook his famous study of Neapolitan gestures based on the same premise: de Jorio believed that his ethnographic approach towards gestures (Kendon 2000: xi) helped to explain the gestures depicted on the ancient wall paintings in Pompeii. This specific work will later be commented upon in some detail, for it appears that de Jorio and Freud treat their object of study in a remarkably similar way, and that the analogy Freud has drawn between the psychoanalytic study of human psyche and the work of an archaeologist is far from being a matter of mere metaphor. And we also know that those approaches converge in the monumental project of Freud's contemporary Aby Warburg, whose complex investigation into the history of Western art was based on the notion of *Nachleben*, i.e. the survival of artistic and anthropological forms independently of the 'objective' temporal succession. The similarities between Warburg's view of the history of art and Freud's metapsychology have been convincingly shown (Didi-Huberman 2002).

Many of Freud's followers have repeatedly stressed their master's originality, as far as his approach to psychopathological phenomena is concerned. But it should also be stressed that one of the possible ways of interpreting Freud's famous 'discovery' (that is, the discovery of an unconscious layer of the human subjectivity, a layer where certain repressed contents survive intact independently of temporal succession) might consist in pointing out that this originality consists in transposing the above mentioned ideas into the domain of the human psyche. In other words, it is not only that Freud chooses archaeology as one of the terms of comparison with his own method – in a sense, he probably considered himself *quite literally* to be a true archaeologist of human subjectivity.

Phenomenon of gesture in the papers on hysteria: Some case studies

These brief preliminary remarks lead us directly to the question of gestures. The shift affected by Freud, as has often been said and as I indicate above, consists in relying on the patient's speech, in abandoning Charcot's 'visual semiology' of hysteria, in penetrating beyond the surface of the visible and exploring the unconscious causes of neurotic disorders. But does this mean that an observation of the body language – and of gestures in particular – of the patients does not have any place in Freudian psychoanalysis? Not at all. Especially in his early works, Freud seems to pay great attention not only to the speech of the subject of analysis, but also to their observable behaviour (including

gestures), considered to be valid material for interpretation, situated on the same level of analysability as their speech itself. *Studies on Hysteria* is particularly instructive in this respect. I argue that this book stands at the crossroads between the old and the new. The stage was already set for great psychoanalytic discoveries to come (overdetermination, dream-work, the role of fantasy), but on the other hand, many links still remained to earlier conceptions of neurosis in general and hysteria in particular, especially to that of Charcot. As far as the study of gesture is concerned, the interest of Freud's early work resides in this clash of perspectives: the accent put on the observation of gestures is undoubtedly taken from older authors, but when it comes to interpreting those gestures, Freud uses a method which is already psychoanalytic and which may still, after more than a century, be of interest for gesture studies in general.

The attention paid to patients' gestures is largely due to the subject of Freud's study itself: hysteria. Freud's view of hysteria is itself a compromise between an older view and his own psychoanalytic approach. First of all, hysteria is classically very difficult to define, it is a neurosis with – to paraphrase an expression used by Kendon in a different context – rather 'fuzzy boundaries' (Kendon 2000: xix) and the huge variety of symptoms usually subsumed under that label has led some authors to believe that hysteria is, in fact, a kind of simulation (it was Charcot who was strongly opposed to this view and tried to prove the 'reality' of hysteria). Nevertheless, all the authors – including Freud – seem to agree that hysteria is the single most visible neurosis, 'the one neurosis within which the body would seem to occupy pride of place' (Silverman 1996: 9). Hysteria itself literally speaks through the subject's body: the body – and first and foremost its gestural 'language' – becomes, so to speak, a theatre or a stage on which the trauma, according to Freud's expressions, is repeated and acted out rather than remembered, understood or interpreted (Freud 1914a: 2501). As late as 1909, long after his psychoanalytic method was fully developed, in an essay entitled 'Some General Remarks on Hysterical Attacks', Freud still states that 'when one carries out the psychoanalysis of a hysterical woman patient [*sic*] whose complaint is manifested in attacks, one soon becomes convinced that these attacks are nothing else but phantasies translated into the motor sphere, projected on to motility and portrayed in pantomime' (Freud 1909a: 1981). This view is altogether already present in *Studies on Hysteria*. Unlike his precursors, however, Freud is interested precisely in the nature of the translation between the affective and the corporeal; the two dimensions are not deployed – as they were in Charcot's view – on the surface of the body, but connected by a more complicated link, pointing to the unconscious of the subject. What, then, is being translated through this 'theatre of hysteria'? Freud's answer is clear and it is expressed, in a condensed form, in what is probably the most famous sentence in *Studies on Hysteria*: 'Hysterics suffer mainly from reminiscences' (Breuer and Freud 1895: 10). The subject goes through an early experience which – for one reason or another – is repressed from her conscious life. Later, for reasons that cannot be fully determined in advance, through a set of coincidences that may sometimes be perfectly banal or trivial and that are connected with the original trauma through a series of associations, the 'traumatic force' of the experience is re-evoked through 'co-operation of memories' and becomes a symptom (Freud 1896: 408–15). During the

treatment, the symptom has to be traced back to its origin in order to eliminate the affect that has caused it. Freud frequently speaks about an 'abreaction' of the affect (Breuer and Freud 1895: 12, 13, 17). The important thing is that in hysteria, the pathogenic affect is often inscribed in the body – and in the gestures – of the patient who, through these corporeal means, repeats the original trauma or pathogenic situation without knowing it. One example of such a translation between the affective and the motor sphere, reported by Freud himself, should suffice to illustrate this point: 'A girl, watching beside a sick-bed in a torment of anxiety, fell into a twilight state and had a terrifying hallucination, while her right arm, which was hanging over the back of the chair, went to sleep; from this there developed a paresis of the same arm accompanied by contracture and anesthesia' (ibid.: 7). When it comes to explaining the nature of the 'translation' between the affective and the physical, Freud uses a key term of 'conversion': the effects are converted, sometimes in a very complex way, into physical symptoms. Freud admits that there is a variety of ways in which this transformation may take place. Sometimes, it may take on a form of a rather straightforward causal link (as in the case reported above), but in other instances, the conversion may be symbolic and the link between the original affect and the visible form of the symptom is complicated and difficult to discover. In a passage which clearly anticipates his ideas about psychic symbolism and dream-work, elaborated several years later, Freud states that in those more complicated cases, 'the connection consists only in what might be called a "symbolic" relation between the precipitating cause and the pathological phenomenon – a relation such as healthy people form in dreams' (Breuer and Freud 1895: 8).

Freud's interest in his patients' gestures is explained especially by this interaction between the psychic and the somatic. Gestures are read and interpreted as bodily translations – effected in various degrees of complexity – of the affect connected with pathogenic trauma. The case studies accompanying the *Studies on Hysteria* provide us with several remarkable examples in this respect. Let us mention two of those. The first one is an example of a relatively 'simple' translation that we encounter in the first of those case studies, that of Emmy von N., a 40-year-old hysterical woman. After having described her as a very intelligent and well-educated person (as far as the contents of her speech is concerned), Freud goes on to pinpoint her unusual body language which seems to be in a strange contrast with the coherence of her speech: her expression was painful, there was a 'heavy frown' on her forehead, frequent convulsive tic-like movements of her face and her fingers were agitated and tightly clasped together. But above all, she produced, from time to time, a curious gesture whose significance, as Freud believed, was somehow closely connected with some kind of repressed memory:

What she told me was perfectly coherent and revealed an unusual degree of education and intelligence. This made it all the more strange when every two or three minutes she suddenly broke off, contorted her face into an expression of horror and disgust, stretched out her hand towards me, spreading and crooking her fingers, and exclaimed in a changed voice, charged with anxiety: 'Keep still –

Don't say anything! – Don't touch me!' She was probably under influence of some recurrent hallucination of a horrifying kind and was keeping the intruding material at bay with this formula. These interpolations came to an end with equal suddenness and the patient took up what she had been saying, without pursuing her momentary excitement any further, and without explaining or apologising for her behaviour – probably, therefore, without herself having noticed the interpolation.

Breuer and Freud 1895: 47

The gesture, as we see, is conceived literally as a transposition of a repressed trauma. It stands out from the flow of speech and the patient herself is not conscious of making it. Thus, it clearly represents a form of survival (in the sense outlined above), situated at the crossroads between the somatic and the psychic: it is a motor form of defence against unbearable or intolerable overflow of affectivity – it is a defence made visible. Furthermore, it presents all the characteristics Freud has mentioned in connection with the hysterical symptom: it is repeated and its meaning – indeed, its very reality – is not legible for the subject herself. In this sense, if we were to classify the gesture according to categories proposed by modern theories, such as the so-called Kendon's continuum (McNeill 1992: 37), we would have encountered some difficulties: the gesture in question is not a co-speech gesture (even though it is accompanied by a ritual formula), it is not exactly an emblem (even though it is repeated in the same form, its meaning is not conventional) nor pantomime (it certainly does convey a message, but its character is not narrative). Given the above characteristics, Freud has reasons to believe that it is connected with the unconscious thought of the subject. It is, therefore, a symptom which has to be interpreted – not only observed – in order to deliver its true, hidden meaning. The gesture is, or may be, a solidified form of the survival of the repressed.

Freud's interpretation of the case – as usual – is extremely complex and cannot be summarized here. From the patient's associations and reminiscences, Freud goes on to 'excavate' the causes of her unusual symptoms. Her inability to drink water, for instance, is determined by an early experience of the members of her family being sick because of infected water; her fear of eating too much is caused by her mother's insistence that she always finish her meal even though it is cold and rather unappetizing, etc. The particular gesture used repeatedly by the patient allows, according to Freud, for a simple causal explanation. It is not a translation of a specific unconscious motive, but indeed a means of mastering the overflowing emotions generated by a set of repressed memories. In the general discussion of Emmy von N.'s case, Freud comments on the gesture while making an interesting reference to Darwin's *The Expression of the Emotions in Man and Animals* (1872):

Some of the more striking motor phenomena exhibited by Frau von N. were simply an expression of the emotions and could easily be recognised in that light. Thus, the way in which she stretched her hands in front of her with her fingers

spread out ... was a more lively and uninhibited way of expressing her emotions than was usual with women of her education and race ... This reason reminds one forcibly of one of the principles laid down by Darwin to explain the expression of the emotions – the principle of the overflow of excitation, which, for instance, accounts for dogs wagging their tails.

Breuer and Freud 1895: 83

The conversion, in this case, is not complicated, but still allows us to emphasize some of the specific features of the Freudian approach to gesture. The gesture and the affective burden it carries are produced in a borderline area or intermediary zone in which the physical and the psychical, the corporeal and the mental become indistinguishable and inseparable from one another. If it is to be taken into account during the analysis, it is because the gesture, from this point of view, does represent a meaningful unit, even though its signification is not legible to the subject who produces it. The meaning of the gesture – a defence against the assault of intolerable emotions – is encoded in the gesture itself. It is, so to speak, a meaning incarnate. It would perhaps not be without interest to sketch a brief comparison between Freud's treatment of gesture and the remarkable reflection of gesture and language, presented later by Merleau-Ponty in *Phenomenology of Perception* (Merleau-Ponty 1981: 174–202).

When Merleau-Ponty, whose chapter on language came to represent one of the seminal texts for gesture studies, attempts to 'deconstruct' the notion of language as a phenomenon based on duality (language being a mere instrumental expression of the subject's mental content), makes an explicit comparison of language and gesture which may be quite illuminating in our context: 'Speech is a genuine gesture, and it contains its meaning in the same way as the gesture contains its' (ibid.: 183). Merleau-Ponty goes on to clarify this idea: gesture – a threatening gesture, for example – conveys a meaning that the addressee of the gesture does not *deduce* from the gesture's visible form by making an analogy with his own affective state, either past or present. I do not have to recall my own feelings of wrath and transfer them to the other subject who is making the gesture in order to understand what is expressed by it. The message conveyed by the gesture does not consist in an affective state hidden 'behind' the gesture, in the mind of the gesturer: 'The gesture *does not make me think* of anger, it is anger itself' (ibid.: 184). It is obvious that while both Freud and Merleau-Ponty emphasize the meaningful, language-like nature of gesture, the principal difference consists in the fact that Merleau-Ponty's analogy is based on the idea of an *immediate legibility* of the emotion in the gesture itself (which does not have to be interpreted), while Freud, on the contrary, stresses a certain illegibility of the true meaning of the gesture, that has to be 'excavated' through interpretation due to the gesture's unconscious nature.

This illegibility becomes even more obvious in more complicated cases. Rosalia H., a 23-year-old woman described in another case study, starts suffering, during the analysis, from a symptom which also takes on the form of a gesture. This gesture is obviously a result of a conversion, the nature of which is considerably more complex than the one mentioned previously:

One day the patient came for her session with a new symptom, scarcely twenty-four hours old. She complained about a disagreeable pricking sensation in the tips of her fingers, which, she said, had been coming on every few hours since the day before and compelled her to make a peculiar kind of twitching movement with her fingers.

Breuer and Freud 1895: 156

When asked under hypnosis to produce associations, the patient provided a whole set of different memories and reminiscences, starting from early childhood and implying a kind of injury against which she could not defend herself: a memory of a school teacher, for instance, who would force her to hold out her hand and strike it with a ruler. One of those memories seemed to be endowed with a particular pathogenic power: her uncle, who suffered from rheumatism, once asked her to give him a massage and during the act he tried to rape her. Hence the affect was translated onto the fingers which performed the massage. There might be, as Freud suggests, a suppressed impulse to punish him. But this memory is not sufficient to explain why the gestural symptom appeared only recently. This recent reappearance is accounted for by another scene that happened the day before: the uncle, with whom she was now living under one roof, asked her to play something on the piano. Suddenly, Rosalia's aunt – who, as she believed, was away at the given moment – appeared at the door. Rosalia sprung up, slammed the lid of the piano and threw the score away. It was at that moment the symptom appeared. Freud's commentary on the gesture in question is quite illuminating: 'The movement of her fingers which I saw her make while she was reproducing this scene was one of twitching something away, in the way in which one literally and figuratively brushes something aside – tosses away a piece of paper or rejects a suggestion' (Breuer and Freud 1895: 156).

Let us try to disentangle the complex knot of significations, which are – to use an expression Freud will coin a few years later to explain the intricate nature of both dreams and neurotic symptoms – condensed in this apparently simple gesture. The gesture is clearly overdetermined: there is no one single simple cause; the gesture stems from several superposed sources, none of which can be called a cause in the proper sense of the word. Stretching out the hand at school and being hit with a ruler suggests the idea of a punishment. Her uncle's behaviour during the ancient scene suggests a punishable action: the fingers, which had been hit with the ruler and which performed the massage, become an overdetermined corporeal site on which the two superposed significations are inscribed in a form of a 'mnemic symbol', as Freud calls it. Furthermore, the recent scene with the piano – which, again, involves the motive of guilt and fear of punishment – functions as a trigger which retroactively animates the ancient complex of associations and transforms them into an obsessively executed gesture (later, Freud will frequently use the word *Naträglichkeit*, retroaction, to explain this seemingly paradoxical temporal process). It is only during the recent scene with the piano that the ancient repressed affects and memories are reactivated. We should also note Freud's fascinating comment on both the literal and figurative aspects of the gesture and its concurrent significations: tossing something away (the score) and rejecting an unpleasant suggestion and idea (the

rape attempt). Here, the role of gesture no longer consists in mastering the emotions but represents a condensed set of partial causes whose concurrence or confluence has to be analysed in order to deliver its meaning, which is both visible and hidden. It is visible because the traumatic memories take on the form of a bodily action, and it is hidden because those memories are symbolically transformed and not immediately readable from the gesture itself. Therefore gesture is obviously not a negligible element of the 'archaeology of the subject' as proposed by psychoanalysis. Its observation and interpretation – along with the patients' speech – greatly contribute to understanding the principles according to which the neurotic symptoms are formed. In Freud's view, the gesture does have a language-like quality in a very particular sense: there is, indeed, something that we might call 'affective grammar' of the neurotic subject's body, a grammar through which the repressed unconscious contents finds a way of expressing itself by means of certain symbolic transformations (condensation, overdetermination, retroactivity) which must be deciphered during analysis.

Freudian approach to gesture in the context of archaeology and gesture studies

In connection with this necessarily brief and partial account of Freudian approach to gesture, one question imposes itself: does this approach have the potential to teach us something about gestures in general? It is true that what Freud says about gestures might seem outdated, if not only for the fact that he speaks about the gestures of hysterical subjects, and not about those produced in 'normal' individuals. On the other hand, there is, perhaps, a lesson which might be retained for both gesture studies and archaeology in general. Freud did have an ambition – which grew more obvious as time progressed – to develop not only a theory of neurosis and its treatment, but also a 'metapsychology', a theory of the subjects' psychical life unrestricted to its pathological forms (his teaching on dreams, slips of the tongue, jokes and other phenomena provides convincing proof). Why should this not be true of gestures?

I propose two very brief case studies, each of them illuminating the possible interaction between psychoanalysis, archaeology and gesture studies from a different perspective. The first one aims to show that even before Freud, some authors adopted an approach towards archaeological study of gesture that is very strongly reminiscent of what would later find its rigorous conceptual expression in Freud's work. As early as 1832, de Jorio published a ground-breaking study of gestures in contemporary Naples, entitled *La mimica degli antichi investigata nel gestire napoletano*. Nowadays, the work is valued in particular for the acuity of its 'ethnographic' descriptions. De Jorio describes and analyses in great detail the gestures referred to – in modern parlance – as 'emblems' or 'quotable gestures' (Kendon 2004: 105) used in early nineteenth century Naples. He studies gestures, so to speak, in their natural environment, and his treatise has been described as 'the first ever to present a study of gesture from what today would be called an ethnographic point of view' (Kendon 2000: xx). It is, however, well known that de

Jorio's primary motivation for his study – as the very title suggests – is deeply rooted in his archaeological interests. The principle aim was to decipher the meaning of gestures de Jorio had observed on ancient frescoes in Pompeii and Herculaneum. In other words, de Jorio's study of Neapolitan gesturing was based on the idea that these ancient gestural forms have *survived*, in an unchanged form, in the manual 'language' of the common people in Naples. When it comes to explaining his fundamental methodological choice, that is, to start with the examination of the present in order to cast the light onto the past, de Jorio uses expressions almost identical to those employed later by Freud: modern gesturing 'is the first step on the staircase that ascends to the *piano nobile* of the great edifice of gesture' (de Jorio [1832] 2000: 7). Why should we proceed in this manner? Because the directly observable modern gestures may, retrospectively, help us to decipher ancient gestures that we cannot observe in their 'natural' context and in their dynamic existence: 'An understanding of modern gesture is not only a great help for understanding the gestures of the ancients, it is in fact the only standard of comparison that we have. We pass from the known to the unknown' (ibid.: 32). The similarity to Freud's specific method of interpretation is indeed striking. The modern gestures are considered as so many observable phenomena that may help us to understand the hidden signification of the archaic gestures to the meaning of which we have no direct access. But analogies between Freud's and de Jorio's approach may be drawn even further. Not only do we pass from the known to the unknown – in Freudian terms, we also pass from the manifest to the latent, as the following example shows.

De Jorio is well aware that there are many difficulties involved in such an undertaking. The principal one consists in the overdetermination of the meaning of gestures (even though de Jorio, of course, does not use this term): 'A gesture may have one meaning, or it may have more than one meaning, as is also found for words in any language, or even for the letters of the alphabet' (ibid.: 32). It is especially with regard to this particular difficulty that de Jorio considers his approach to be of great use, for modern gestures allow for their observation in their dynamic context, enabling the observer to reduce their potential polysemy, which, in the case of ancient gestures, remains insurmountable.

In brief, de Jorio's treatise on gestures is based on the idea that there is a 'gestural unconscious', where gestural forms become fossilized and remain unchanged across centuries. When it comes to archaeological interpretation of gestures, the archaeologist has to start from what he observes in the present, and it is this material that gives him access to what is archaic. Again, the analogy with the work of a psychoanalyst cannot be overlooked, for this is exactly how a psychoanalyst proceeds during the psychoanalytic cure. He starts by interpreting what is directly observable (manifest symptoms, overdetermined as to their meaning) and only through the lengthy process of *via di levare* (or working-through) does he gain access to the archaic depths of his patient's unconscious.

Whether Freud read de Jorio's work remains uncertain, but given his interest in archaeology, it is certainly not impossible. It is not even excluded that the analogy between de Jorio's approach to the study of gesture and Freud's treatment of

psychopathological phenomena is more than a matter of mere coincidence and that the former might have served, at least to a certain extent, as an inspiration for the latter.

The purpose of the second case study is to look at the relationship between psychoanalysis and archaeology from an inverse perspective. I have already stated that independent of Freud's concrete ventures into the field of historiography and archaeology, psychoanalysis might have something important to say about the very nature of the approach that the interpreter has to adopt when facing the historical material. The gestures are complex units; to adopt Freudian parlance, they are – or may be – overdetermined in their very essence. It is interesting, in this context, to look at one of the texts in which Freud attempts to interpret an ancient work of art: the 1914 paper entitled 'The Moses of Michelangelo'. It is a perfect example of 'recursive analogy': psychoanalytic perspective is employed to explain a particular artefact, or more precisely, the uncanny effect the marble statue of Moses by Michelangelo produces on the spectator. Freud proposes to proceed in a psychoanalytic way in a very special sense of the word: his interpretation consists in taking, as a starting point, two details of the sculpture that, as he believes, may lead us to an overall understanding (just like an overdetermined detail in a patient's dream may provide, during a psychoanalytic session, a key to the understanding of the dream as a whole). Significantly, one of those details is a very unusual *gesture*: the attitude of Moses's right hand, the index of which touches his beard from the left side: 'It cannot be denied that to press one's beard with one finger is an extraordinary gesture and one not easy to understand' (Freud 1914b: 2855). Freud's very minute interpretation of the gesture (as well as his analysis of the position of the Tablets in Moses's left hand), which displays all the virtues of the psychoanalyst's attention to details and which we cannot summarize here in all its complexity, leads him to conclude that Moses's unusual posture signifies 'not the inception of a violent action but the remains of a movement that has already taken place' (ibid.: 2861) and enables him to ascribe an unexpected meaning to the whole sculpture as such: 'In his first transport of fury, Moses desired to act, to spring up and take vengeance and forget the Tablets; but he has overcome the temptation, and he will now remain seated and still, in his frozen wrath and in his pain mingled with contempt' (ibid.: 2861). Let us note in passing that Warburg did not proceed otherwise when he proposed his revolutionary interpretations of Botticelli's *Primavera* and *The Birth of Venus*, considering every detail to be worthy of attention in order to illuminate the meaning of the whole.

It is not the question here whether Freud was, technically speaking, right or not. The point is that Freud's approach condenses, so to speak, a very complex hermeneutics: 'by examining certain insignificant details, (our conception) has arrived at an unexpected interpretation of the meaning and aim of the figure as such' (Freud 1914b: 2866). Independent of its concrete content, this interpretation, based on a presupposition of overdetermined nature of gesture, provides perhaps an important guideline to any archaeological interpretation of gesture. Despite the undoubtedly 'recursive' nature of Freudian archaeological analogies, the enrichment that psychoanalysis could possibly offer to archaeology is, as we have argued, a *conceptual* one. The notion of

overdetermination, among others, presents itself as a useful conceptual tool for deciphering complex messages conveyed by gestures in the realm of historiography.

In what follows, let us now move to the domain of gesture studies. As far as this specific field is concerned – even though we can only touch on this point very briefly – I am convinced that there are at least two ways in which Freudian theory might present two interesting guidelines for the study of gestures in general. The first one consists of Freud's emphasis on the connection of gesture and affectivity. A lot has been said about cognitive aspects of gesturing. It has been argued that gesture 'saves the speaker cognitive effort', that 'gesturing may not only reflect a speaker's cognitive state but may, by reducing cognitive load, also play a role in shaping that state' (Goldin-Meadow 2003: 150, 157). But the same is perhaps true of the affective state of the subject: the gestures' 'global-synthetic' nature (McNeill 1992: 19) and its way of 'conveying information through imagery' (Goldin-Meadow 2003: 24) are particularly apt to fulfil the task of incarnating the subject's affectivity. The first case study I mention above – that of a subject mastering the overflow of emotions through an obsessively repeated gesture – is particularly telling in this respect: the gesture in question does not function as a substitute for a verbal expression, nor does it exactly help the speaker to 'find the right word' (ibid.: 161). It is used to express precisely what cannot be put into words, the affective state – or states – the subject is unable to master verbally and which is obviously linked with repressed content, 'illegible' or undecipherable for the subject herself. Despite this opacity, the gesture is, according to Freud, a message and it does convey a meaning. In this respect, Freud is utterly convinced that 'gesture and language reflect the same basic principles of symbolic representation and sense-making: both provide us with schematic imagery with which to make sense' (Streeck 2009: 162). The gesture literally translates the subject's inability to circumscribe, so to speak, her affects by words, and makes visible what cannot be communicated verbally.

The second example – the complicated gesture of brushing something aside – provides us with an insight into how this sense-making is affected. In this respect, the Freudian concepts of overdetermination and condensation might perhaps also be of some use in the realm of gesture studies. The relationship between the gesture and the repressed scene of a rape attempt is neither a direct causal relation nor an arbitrary one. In other words, if the gesture, considered as a symptom in its own right, is a sign of repressed trauma in a certain sense, it does not function as a signifier in the Saussurian sense. Its link to the 'signified' is not arbitrary but motivated. This particular point might lead us away from the famous Lacanian interpretation of Freud, building precisely on an analogy between Saussurian linguistics and Freud's theory of psychic symbolism. Nor does it serve as an index in the Peirce sense because the link is not one of a simple cause and effect since several other partial factors intervene and concur in the formation of the gesture. In his later works, especially in *The Interpretation of Dreams* (Freud 1900) and *The Psychopathology of Everyday Life* (Freud 1901), Freud analysed the mechanism of overdetermination and condensation both in the case of verbal (slips of the tongue, jokes) and non-verbal (dreams) material. Whether these mechanisms intervene in the formation and production of gestures – any gestures – remains, I believe, a relevant

question. Gestures, after all, do convey information in a holistic, synthetic way which might not be without resemblance with the processes employed, say, in dream-work (condensing several overdetermined cognitive and/or affective processes into a single holistic unit).

In these respects, a Freudian approach to gesture – in a broader context of his approach to a subject's psychical life – can offer certain paths of research, independent of the particular examples that I have treated in this chapter. In a moment when gesture studies draw consistent inspiration from other domains – philosophy and phenomenology in particular (Streeck 2009: 55–7; McNeill 2005: 63–4), anthropology or sociology (Streeck 2009: 28–31) among others – psychoanalysis might offer useful conceptual tools for the study of the complex and fascinating object that the gesture is. The same is true of archaeology, for Freud invites archaeologists to avoid straightforward causal interpretations and to follow the prescription – forged by St Augustine and adopted by Warburg – according to which 'God in in the details'. The possible practical consequences of such an interdisciplinary interaction, however, must become the subject of another study.

References

Armstrong, R. H. (2005), *A Compulsion for Antiquity: Freud and the Ancient World*, Ithaca, NY, and London: Cornell University Press.

Breuer, J. and S. Freud (1895), 'The Studies on Hysteria', in *Freud – Complete Works*, 1–269. Available at: http://www.valas.fr/IMG/pdf/Freud_Complete_Works.pdf (accessed 28 September 2021).

Charcot, J.-M. (1998), *L'Hystérie*, Paris: Harmattan.

Darwin, C. (1872), *The Expression of the Emotions in Man and Animals*, London: John Murray.

de Jorio, A. ([1832] 2000), *Gesture in Naples and Gesture in Classical Antiquity*, trans. A. Kendon. Bloomington, IN: Indiana University Press.

Didi-Huberman, G. (1982), *Invention de l'hystérie. Charcot et l'iconographie photographique de la Salpêtrière*, Paris: Macula.

Didi-Huberman, G. (2002), *L'Image survivante. Histoire de l'art et temps des fantômes selon Aby Warburg*, Paris: Édition de Minuit.

Freud, S. (1893), 'Charcot', in *Freud – Complete Works*, 273–84. Available at http://www.valas.fr/IMG/pdf/Freud_Complete_Works.pdf (accessed 28 September 2021).

Freud, S. (1896), 'The Aetiology of Hysteria', in *Freud – Complete Works*, 405–33. Available at: http://www.valas.fr/IMG/pdf/Freud_Complete_Works.pdf (accessed 28 September 2021).

Freud, S. (1900), 'The Interpretation of Dreams', in *Freud – Complete Works*, 507–1048. Available at: http://www.valas.fr/IMG/pdf/Freud_Complete_Works.pdf (accessed 28 September 2021).

Freud, S. (1901), 'The Psychopathology of Everyday Life', in *Freud – Complete Works*, 1099–347. Available at http://www.valas.fr/IMG/pdf/Freud_Complete_Works.pdf (accessed 28 September 2021).

Freud, S. (1905), 'On Psychotherapy', in *Freud – Complete Works*, 1561–72. Available at: http://www.valas.fr/IMG/pdf/Freud_Complete_Works.pdf (accessed 28 September 2021).

Freud, S. (1909a), 'Some General Remarks on Hysterical Attacks', in *Freud – Complete Works*, 1979–84. Available at: http://www.valas.fr/IMG/pdf/Freud_Complete_Works.pdf (accessed 28 September 2021).

Freud, S. (1909b), 'Notes upon a Case of Obsessional Neurosis', in *Freud – Complete Works*, 2125–94. Available at: http://www.valas.fr/IMG/pdf/Freud_Complete_Works.pdf (accessed 28 September 2021).

Freud, S. (1910), 'Leonardo da Vinci and a Memory of His Childhood', in *Freud –Complete Works*, 2240–304. Available at: http://www.valas.fr/IMG/pdf/Freud_Complete_Works.pdf (accessed 28 September 2021).

Freud, S. (1914a), 'Remembering, Repeating and Working-Through', in *Freud – Complete Works*, 2496–506. Available at: http://www.valas.fr/IMG/pdf/Freud_Complete_Works.pdf (accessed 28 September 2021).

Freud, S. (1914b), 'The Moses of Michelangelo', in *Freud – Complete Works*, 2843–68. Available at http://www.valas.fr/IMG/pdf/Freud_Complete_Works.pdf (accessed 28 September 2021).

Freud, S. (1915), 'The Unconscious', in *Freud – Complete Works*, 2989–3024. Available at: http://www.valas.fr/IMG/pdf/Freud_Complete_Works.pdf (accessed 28 September 2021).

Freud, S. (1937), 'Constructions in Analysis', in *Freud – Complete Works*, 5047–59. Available at http://www.valas.fr/IMG/pdf/Freud_Complete_Works.pdf (accessed 28 September 2021).

Goldin-Meadow, S. (2003), *Hearing Gestures: How Our Hands Help Us Think*, Cambridge, MA: Harvard University Press.

Kendon, A. (2000), 'Andrea de Jorio and His Work on Gesture', in *Gesture in Naples and Gesture in Antiquity*, trans. A. Kendon, xix–cvii, Bloomington, IN: Indiana University Press.

Kendon, A. (2004), *Gesture: Visible Action as Utterance*, Cambridge: Cambridge University Press.

McNeill, D (1992), *Hand and Mind: What Gestures Reveal about Thought*, Chicago, IL: University of Chicago Press.

McNeill, D. (2005), *Gesture and Thought*, Chicago, IL: University of Chicago Press.

Merleau-Ponty, M. (1981), *Phenomenology of Perception*, trans. C. Smith, New York and London: Routledge.

Ricoeur, P. (1965), *De l'interprétation: Essai sur Freud*, Paris: Seuil.

Ricoeur, P. (1969), *Le Conflit des interprétations: Essais d'hermenéutique*, Paris: Seuil.

Silverman, K. (1996), *The Threshold of the Visible World*, New York and London: Routledge.

Streeck, J. (2009), *Gesturecraft: The Manu-Facture of Meaning*, Amsterdam: John Benjamins.

Tylor. E. (1958), *The Origins of Culture*, New York: Harper and Brothers.

CHAPTER 12

GESTURES OF MAKING: AN EXPLORATION OF MATERIAL / BODY DIALOGUE THROUGH ART PROCESS

Alice Clough and Fo Hamblin

This chapter has been developed as part of a collaborative relationship between a maker – Fo Hamblin, and an anthropologist – Alice Clough. Initially we connected over a shared interest in materials, the body and making. The focus of this chapter is the making of a 'test' piece, conceived by Fo Hamblin in preparation for *Crafting Anatomies* exhibition held at Bonington Gallery, Nottingham Trent University in January 2015. The artwork and practices of making described here, are intended as a kind of three-dimensional sketch or draft, a kind of 'performative' installation piece, primarily composed of pins, thread, elastic, plaster, charcoal and graphite powder. Possibilities for the exhibition piece are explored (Figure 12.1), whilst investigating and drawing out material/body dialogues involving tension, resistance, permeability and traces of material and body to reveal patterns of making and material resonances. The piece was made over a period of three days, with Alice Clough, and the making process was filmed through collaboration with filmmakers R&A Collaborations. The resulting film was projected onto the final work – entitled 'Choreography of Making' – at *Crafting Anatomies*.

The work was constructed in the corner of the gallery, extending outwards into the space. Fo's arm span was mapped out in circular form, in pencil, across both walls extending from the corner (Figure 12.2a–b). Pins were hammered into the wall along these lines, roughly a finger space apart. These provided the anchor from which threads were pulled and extended out into the space, connecting to an elastic line, which stretched between the two walls some distance away. Effectively this meant the threads began in the corner, drawing lines into the space, opening out from a circle to a horizontal line (Figure 12.2c). Once all the threads had been attached (Figure 12.3a–d), other effects were explored through laying fine threads across the others. The elastic was then detached from the walls to enable play with possibilities of form, manipulating and raising the structure (Figure 12.4a–c). This culminated in the ends of the elastic being connected together to form an oval shape hanging in space, forming a draped thread structure, a kind of 'container' of activated space. The final stage of the experiment entailed coating the lower parts of the draped thread with plaster, crushed charcoal and graphite powder (Figure 12.5a), transforming both the process and the outcome.

In studies of material culture, focus has tended towards ready-made objects, end products and the life histories of these products and their users. Our interests lie with a more dynamic, developmental view somewhat aligned with the anthropology of

techniques explored by Leroi-Gourhan (1993) and Lemonnier (1992, 2012), amongst others, which include gesture alongside materials, placing importance on the performativity of materials and the body. Here, activity and processes of action in relation to matter bring into play 'making and doing' (see Naji and Douny 2009: 415). It is our aim to go beyond a conception of techniques as deterministic, rigid and mechanistic, and posit making as gestural, collaborative activity, potentially allowing the results or fragments of creative endeavour (however new or old) to retain vitality, and to go beyond representation.

Ingold builds on relational, process-driven conceptions of making and creative practices, and laments that:

> What is lost in both material and visual culture studies, is the creativity of the productive processes that bring the artefacts themselves into being: on the one hand in the generative currents of the materials of which they are made; on the other in the sensory awareness of practitioners. Thus processes of making appear swallowed up in objects made; processes of seeing in images seen.
>
> *2013: 7*

It is these 'lost' or invisible processes we were interested in exploring through our collaboration, where dialogue across disciplines aims to draw out and construct meaning through shared practices and ideas. We were curious about the ways an anthropological line of questioning and observation might enhance or be integrated into the artistic process, and the ways creative practice, incorporating cycles of action and reflection, might echo or crossover with anthropology. We are interested in the ways different perspectives or sets of knowledge both through etic and emic approaches, can complement or challenge one another, as well as the nature of the researcher as *bricoleur*, drawing from a range of disciplines to explore multiple pathways to knowing (Barry 1996). We consider our practices akin to those of archaeologists in that we have the potential to unravel and explore meaning through material encounters. The central argument of this chapter then, is the focus on *process* and *material / body dialogue* that exposes gesture as *active*, as a way of thinking, and as embedded, or present in, resultant material forms.

For the most part, this chapter comprises a text that we have written together. In places however, it has felt more appropriate to present our individual voices, to give a sense of the on-going conversations that have played an important role in its development, and to emphasize the significance of dialogue in making and material endeavours.

Gesture as thinking action

So, what is gesture? Gesture is concerned with expressive 'bodily movements, attitudes, expression of countenance, etc.' (*Oxford English Dictionary* 2015), sometimes accompanying speech, and is not usually associated with making or doing things. Earlier Latin etymology states *gestura* as 'bearing, behaviour and mode of action' (*Online*

Etymology Dictionary 2018), which broadens the possibility for *modes of action* to align with the entwining of bodily with material actions and techniques. According to Kendon, 'there is always the implication that the actor is deemed to exercise at least some degree of voluntary control over any movement regarded as "gesture" and what it expresses' (2004: 8). Conventional thinking understands gesture as supplementary, as something that *supports* or *expresses* thought or speech – the idea comes first, and the gesture second. But, what if gesture is seen as emergent, able to 'awaken our sensibility' (Bergson 1999: 130). Bergson defines gesture as 'the attitudes, movements and even the language by which a mental state expresses itself outwardly without any aim or profit, from no other cause than a kind of inner itching' (ibid.: 130). In fact, he places action in opposition to gesture, deeming action as intentional whereas gesture, he states, is not. Intentionality however, with regards to making, can itself be seen as emergent, and we will return to this later. We would argue that gesture is crucial to the *formation* of thought or meaning, or further to this, that gesture *is* thought and meaning, or '*thinking action*'. Clark argues:

> The act of gesturing . . . is not simply a motor act expressive of some fully neutrally realized process of thought. Instead, the physical act of gesturing is part and parcel of a coupled neural-bodily unfolding that is itself usefully seen as an organismically extended process of thought.
>
> *2013: 257*

While traditional understandings of gesture may posit a 'giver and receiver' relationship (Kendon, 2004: 7) we argue that gesture can be considered as the formation of reciprocal and dynamic relationships between body, material and space, where materials play a key role in creating and exploring meaning. So, when we talk of thinking action, we take an integrative approach to gesture, or gestural action, where materials are not simply seen as a means of expression, but as active participants in making meaning (see Bennett 2010).

Making, itself a performance, reveals rather than plays out meanings, and yet techniques utilized or developed can also be seen as a result of the socialization of the body (Mauss [1935] 1973). In taking this approach, we hope to draw focus away from 'the sphere of closed categories of persons and things' and toward 'the sphere of the fluid and relational transactions between them' (Malafouris 2013: 9).

So, what of gestures entwined with making, where materials as well as bodies themselves 'tell' something, though not in a concrete way? The integration of gesture in relation to creative material practices is important and drawn out of repetition and learnt sequences of action that become embodied (Leroi-Gourhan 1993) and are inherently cultural (Mauss [1935] 1973). What if we move from symbolic representation to considering interactions and vocabularies of material/bodily action, where forces and resonances oscillate between points of 'doing' and 'receiving', both in terms of maker/ material and viewer/material relationships? What if the made object can itself be seen as gestural, and in this sense provide direct rather than mediated experiences? Lemonnier's *Mundane Objects* points to the non-verbal dimension of meanings as manifested through artefacts and techniques, things 'wordlessly evoke . . . rules, tensions, or unspeakable

aspects of social relations . . . their strategies, material practices, anxieties, and hopes. At the core of this communication stand their material dimensions' (2012: 13). So it is that making sets out to explore complex relationships and desires.

In this particular art work, the 'made thing' itself is an exploration of process, revealing gestures of making through film and sound as well as physical traces of action in material residues (Figure 12.5b–c). In this chapter, we explore gestures of making as thinking action, by dissecting gestural activity not simply through frameworks of spatial / temporal patterns, but through process, playing with ideas of intentionality, dialogue and exchange whilst exploring materialities and 'generative currents' of bodily communication (Ingold 2013).

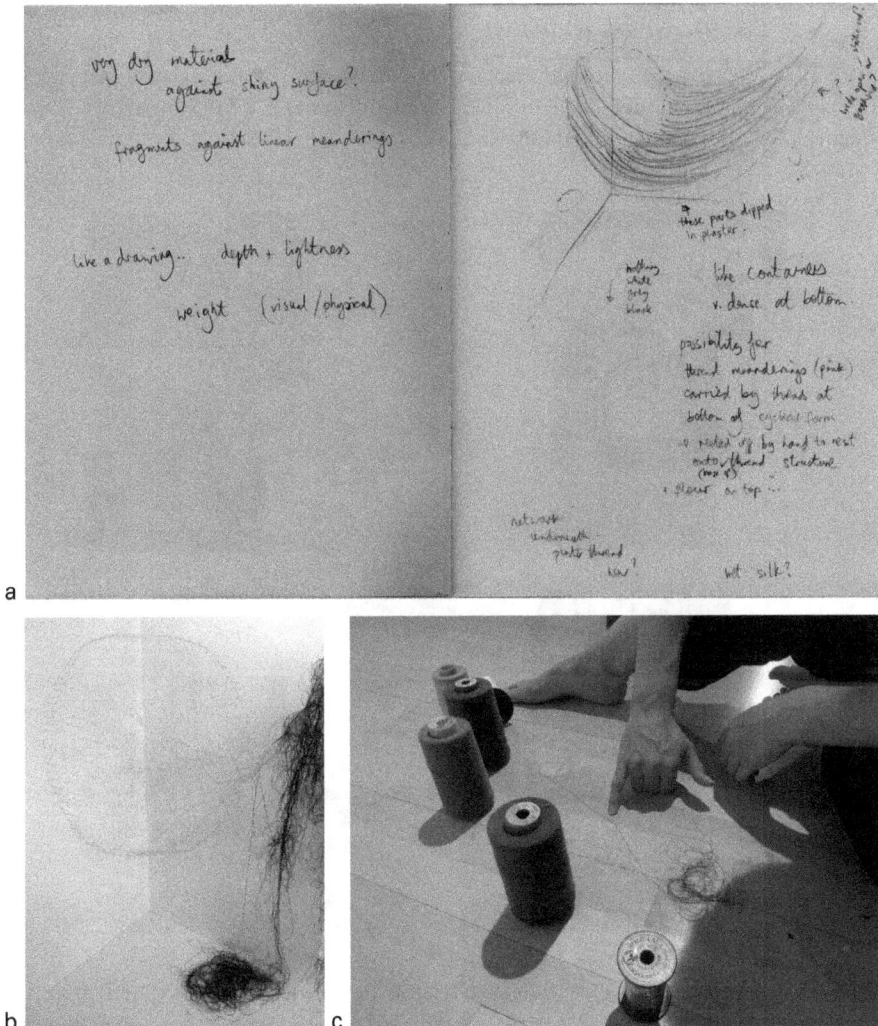

a

b

c

Figure 12.1 Exploring ideas: *(a)* sketchbook; *(b)* small mock-up/prototype; and *(c)* choosing threads, discussing possibilities. Photographs by Alice Clough and Fo Hamblin.

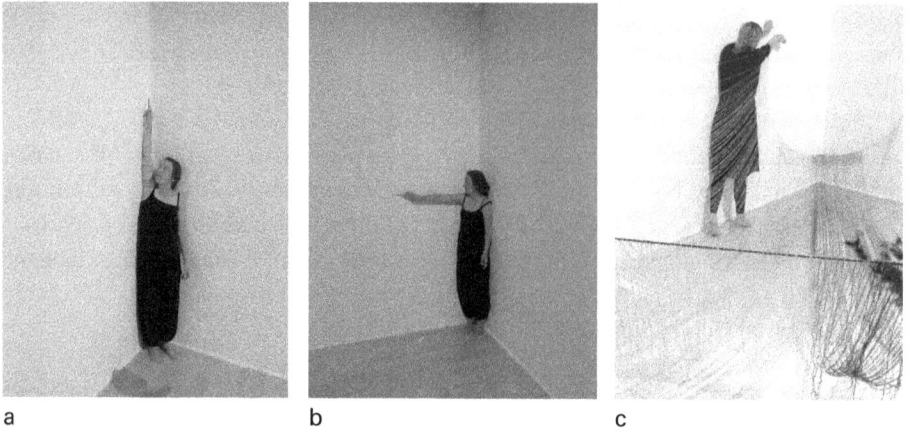

Figure 12.2 Mapping the space: *(a)* Mapping the corner with Fo's armspan; *(b)* Mapping the corner with Fo's armspan; *(c)* Circle to Line: reaching to connect threads in restricted space. Photographs by Alice Clough and Fo Hamblin.

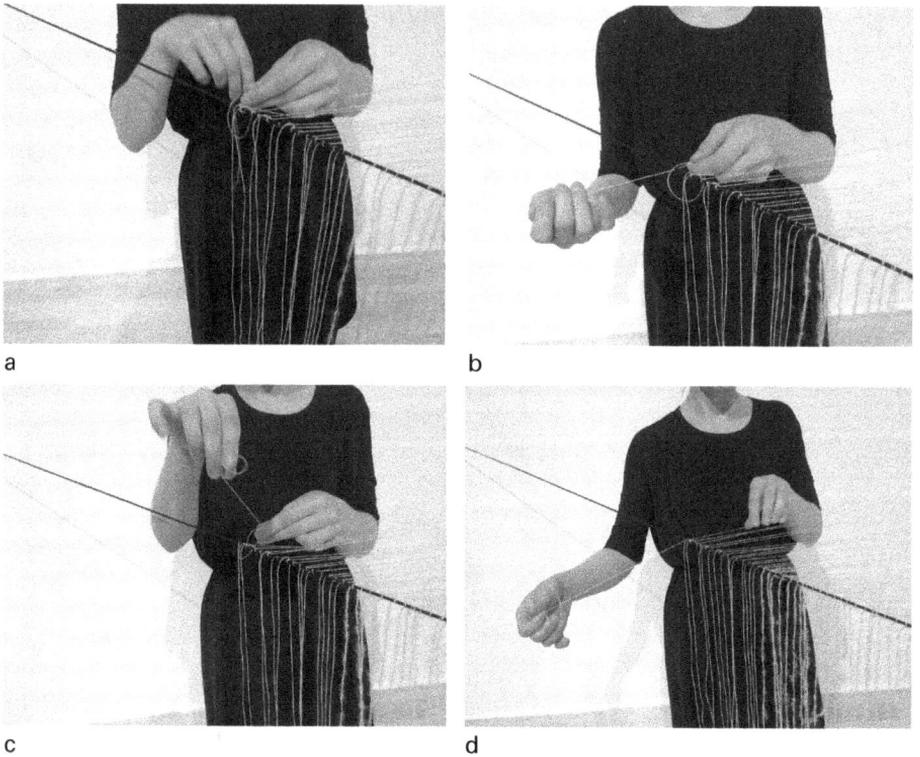

Figure 12.3 Alice navigating the technique of knot-tying shown in still photographs a, b, c and d. Photographs by Fo Hamblin.

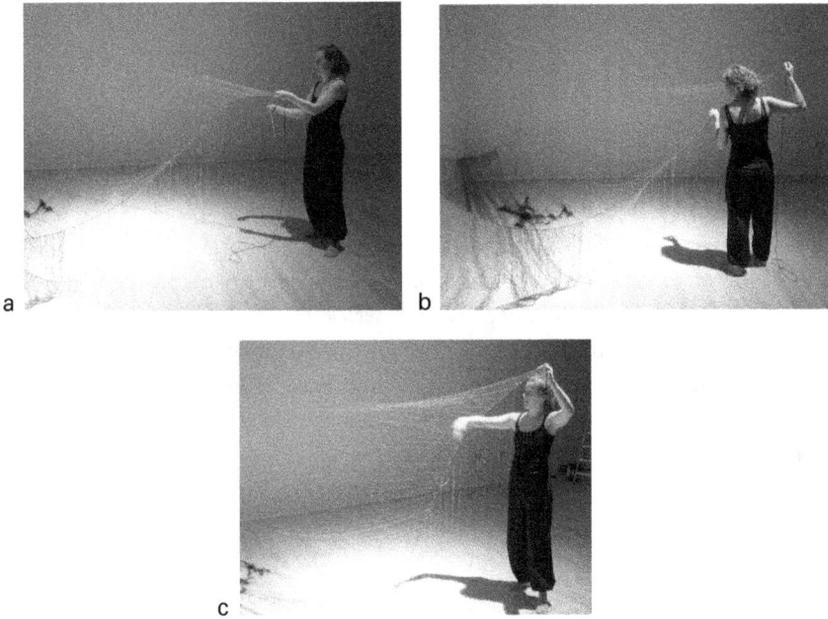

Figure 12.4 Playing with form: material/body/space in dialogue while elevating and moving the installation shown in still photographs a, b and c. Photographs by Alice Clough.

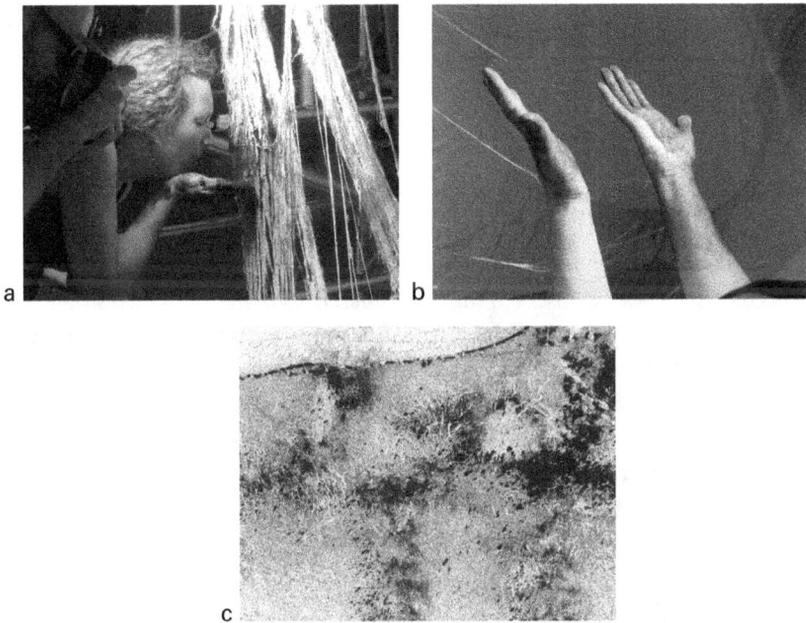

Figure 12.5 Residues, traces and permeability of materials: *(a)* Blowing charcoal onto plastered threads; *(b)* Traces of charcoal on the skin; *(c)* Results of blowing and pressing charcoal in installation. Photographs by Alice Clough and Fo Hamblin.

Making

The artwork

We have developed a breakdown of key phases of making the artwork with some specific actions/gestures stated, in order to show how a sequence of phases or activity evolved (see Tables 12.1–12.4). Some are given in more detail whilst others are grouped together, so phases are given more or less emphasis for our purposes here. We are drawing on the concept of the *chaîne opératoire* (operational sequence), as explored by Leroi-Gourhan (1993) and adapted by Lemonnier, as 'the series of operations involved in any transformation of matter (including our own body) by human beings.' (Lemonnier 1992: 26). We could create multiple iterations here, continuing towards the 'undoing' of the work, but for simplicity, we have focussed on the more obvious sequences concerning 'production'. The aim is to portray a kind of processual flow where actions might be picked out as significant. Yet each area of activity is a framework for complex networks of gestures that produce varying degrees of transformation. The tables are structured around four key phases of making: mapping and marking space (Table 12.1); unravelling, dissecting, connecting (Table 12.2); shifting weight, transformations (Table 12.3); and dynamic interactions – fragmentation and coagulation (Table 12.4). Each table shows strands of activity followed by each one of us, showing where those strands come together and separate off into different realms of activity. The tables themselves form different kinds of patterns, where Alice's role shifted between maker and observer, and between more obviously sequenced or integrated activities. Italics are used to create emphasis on particularly dynamic or significant elements within the process, pointing to more obviously gestural *thinking actions*.

Phase 1: Mapping and marking space (Table 12.1)

This phase was characterized by mapping out the work, both prior to the main three days of activity (Figure 12.1a–c shows different phases of preparation), and within the space (Figure 12.2a–b shows Fo using her body to map the piece onto the wall in the space). Tensions of material were observed through differences in hardness or resistance of the wall when hammering pins, and how levels of ease were achieved through grip and handling of the hammer and rhythmic changes. Balance and bodily positioning altered through extent of reach, use and positioning of a ladder, when used, and changes in angle and position were needed when pins reached the corner, in order for them to transition from one wall to another.

Table 12.1 Phase 1: Individual and joint processes of mapping and marking space. '*Thinking actions*' are written in italics

	Fo	Alice
	Sketchbooks – drawing ideas in pencil, key words, questions, notes – over a period of weeks (Figure 12.1a)	
	Selecting and gathering materials	
	Testing – small-scale mock-up (Figure 12.1b)	
	Selecting and gathering materials (Figure 12.1c)	Preparing equipment
	Entering the space	
	Visually / physically mapping (walking around the space to view from a range of distances)	Checking equipment
	Standing against the corner, mapping out the circle on the wall using a pencil (Figures 12.2a–b)	Standing at a distance observing
	Reaching	*Observing Fo's process*
	Stretching	*Observing the space*
	Spreading arms outwards from the corner	*Noting moments of interest*
	Stepping out from the corner	*Listening*
	Looking from different angles	*Photographing*
	Stepping back into the corner and Continuing	
	Looking at the circle from different angles	
	Adjustments, Drawing new lines	Discuss, Listen, Affirm
	Reflect, Discuss, Point, Gesticulate, Instruct	
	Selecting hammers	
	Gripping hammer, Pinching / Holding / Aligning pins:	
	Hammering pins along lines of circle – each roughly a finger-width apart	
	Shifting position	
	Climbing up and down ladder	
	Stretching	
	Reaching	
	Swapping hammers	
	Repetition until circle is complete – (half a day)	
	Sound play – *pinging pins*	

(Left margin label: End of process ← Time → Start of process)

Phase 2: Unravelling, dissecting, connecting (Table 12.2)

Repetitive knot tying accounted for a significant portion of the making (for example Figure 12.3a–d), and alignment of each unravelled thread to the next invited us to make judgements based on bodily positioning and line of sight. We dissected the space, which began to close in, making it difficult to access certain parts, so we had to crouch, kneel, bend, stretch and reach in different ways (Figure 12.2c shows Alice reaching to connect a thread to one of the pins within a restricted space).

Table 12.2 Phase 2: Individual and joint processes of unravelling, dissecting, connecting. '*Thinking actions*' are written in italics

	Fo	Alice
	Selecting elastic, Unravelling (elastic) cord	
	Guiding and stretching elastic across space to create a boundary (some distance from corner)	
	Checking eye level	Watching
	Hammering elastic to wall	Holding elastic tension, Securing
	Reflect, Discuss, Point, Gesticulate, Instruct	Discuss, Listen, Question, Affirm
Start of process → Time ← End of process	Knot tying: Tying thread to single pin on wall (Figure 12.2c) *Unravelling* thread across space: *Draping* *Guiding* *Touching* Checking levels *Ducking* (under elastic boundary) Knot tying: Tying thread to elastic (Figures 12.3a–d) *Pinching* *Looping* *Wrapping* *Pulling* *Guiding* *Teasing*	
	Repeat until all pins from circle connect with elastic line – 2 days	
	Constant minute adjustments – checking levels	
	In – out – in – out	

Phase 3: shifting weight, transformations (Table 12.3)

There was scope to experiment with the types of yarn used, to add depth and play with weight, density and 'visual' order or emphasis. This involved unravelling and tangling threads in space. Movement of the arms created a kind of fluid, figure of eight gesture, whilst weight shifted back and forth from one side of the body to the other, akin to 'silk reeling' patterns in *tai chi*. Once the threading was complete, the elastic was detached from the wall and elevated, transforming the piece, inviting a kind of dance, which played with positioning, drape and form of the thread structure (as illustrated in Figure 12.4a–c).

Table 12.3 Phase 3: Individual and joint processes of shifting weight, transformations. '*Thinking actions*' are written in italics

	Fo	Alice
	Exploring fine yarns – selecting material	Discussing, Questioning, Affirming
	Adding fine, tangled yarns into the main structure:	
	Swapping thread back and forth between hands	*Observing* *Photographing*
	Gaining momentum, so thread can hang in air	
	Shifting weight	
	Adding tangles of fine yarn into structure	
	Viewing / judging effects, Shifting viewpoints	
	Detach elastic from wall	
	Elevate (use of scaffold tower to reach height)	
	Playing with variations and possibilities of positioning (Figures 12.4a–c):	
	Dancing	*Observing*
	Stroking	*Photographing*
	Draping	*Discussing*
	Stretching	*Making Notes*
	Attach / Hang / Secure from above	

(Left axis: End of process ← Time → Start of process)

Phase 4: Dynamic interactions – Fragmentation and coagulation (Table 12.4)

This phase was characterized by more dynamic movements, in relation to the speed at which the plaster set. Charcoal was powdered through quick, repetitive movements, creating friction and fragmentation, and applied to the plastered threads by blowing and pressing, permeating the skin and air (Figure 12.5a–b).

Stop-motion filming (Figure 12.5a) was central to the making process throughout, as a technique that enabled us to identify and engage with movement, form and sound, in ways neither of us had done before, providing a reflective and pointed 'zooming in' that dissected periods of activity.

Table 12.4 Phase 4: Individual and joint dynamic interactions – fragmentation and coagulation. '*Thinking actions*' are written in italics

	Fo	Alice
	Collecting materials for plaster and charcoal	
	Preparing space: Laying down paper and plastic	
	Breaking up charcoal using scalpel: *Scratching* *Scraping*	*Pausing* *Observing* *Listening*
	Breaking up charcoal using hammer: *Tapping* *Pressing*	*Photographing* *Viewing Fo's process from different angles* *Moving through the space*
	Placing tub of water on floor (bending knees, carrying weight)	
	Adding plaster powder: Digging fingers in plaster sack *Pulling out, spreading fingers, sprinkling powder*	
	Bubbling, Watching, Waiting, Listening	
	Stirring, Rubbing, Mixing, Sloshing Repeat until desired consistency achieved	*Pausing* *Observing* *Listening*

(left margin, vertically: End of process ← Time → Start of process)

	Fo	Alice
	Drawing plaster down thread structure *Grasping* *Pulling* *Drawing Down* *Dripping*	*Photographing* *Viewing Fo's process from different angles* *Moving through the space*
	Applying charcoal to plaster (Figure 12.5a): *Cupping* *Blowing* *Pressing* *Rubbing*	

Making practices

The above descriptions should give the reader a sense of some of the bodily interactions with materials and space involved in constructing novel forms and cohesions, but how can we further expose making as a process of discovery, where dialogue and exchange are central in constructing meaning? In our concept of *thinking action*, 'thinking is not something that happens "inside" brains, bodies, or things; rather, it emerges from contextualized processes that take place "between" brains, bodies, and things' (Malafouris 2013: 77–8). Indeed, our gestural activities transformed matter through performative, attentive, unfolding patterns and frameworks for action.

Several aspects of the making process emerged as important, not least, that making might occur through the 'before', 'after' and 'in between' phases of construction, and as a reciprocal process between bodily/material/spatial patterns and exchanges. There was a natural tendency of the film making process to focus on *doing* in a *deliberate* way; but as the work developed, we started to recognize some of the more intangible gestures, and the significance of moments missed. This created an interesting play with recreating gestures or a 'holding back' when recognizing moments of insight in advance. We became aware of unique, personal gestures – playing with hair, chewing a pencil, rubbing temples, rubbing the neck, which formed part of our individual, stylistic processes of thought or reflection.

We both felt that the making process was structured by phases, though our interpretations of these phases differed in terms of our relationship with the piece. In the tables shown, there are definite 'phases within phases', depending on the focus and technicalities of each of our strands of activity. Stopping to film interrupted the natural flow of making and provided a kind of punctuation, creating further opportunities for reflection and dialogue. It added another layer to the idea of making, since we were also 'making' film, which had its own particular pace, rhythm and set of associated gestures.

This in effect created another stream of activity in the operational chain, creating a tension between sequence and flow – sometimes the filming disrupted or provided new flows of activity.

Notes from initial reflective dialogue, shortly after the work was made:

Alice *The phases of making, for me, related to the extent to which I was able to participate in the process. There were phases defined by particular learnable skills like hammering pins or tying knots, and there was also a phase where Fo took ownership of the process, responding to the materials with spontaneity or even urgency. As a helper and an observer, I was unable to share that dialogue, where Fo was in conversation with the materials. After that, there was an interesting moment when we started to play with projecting the film onto the piece, at this stage the piece opened up, and we were all able to participate.*

Fo *There was a definite sense of building, anticipation and 'letting go'. At times there was a meditative and fluid feel, through the repetitive threading process, shifting to unease or impatience, when evidence of action was slow to reveal itself visually. Speed and fluidity changed according to the materials, but also in relation to the energy and focus of the maker.*

Alice *My understanding of the pauses is that they were outwardly 'inactive' moments, where we would rest, stand back or sit down. I would often use the pauses to return to my notebook and write down ideas or refuel with a drink or snack. These moments became a vital part of the making process for me, for both conscious and unconscious reflection.*

Fo *The pauses, for me did not involve resting, even when breaking from the space; I was focussed on anticipating the possibilities of the work. Anxiety was a driving force, consistently re-evaluating time and aesthetic.*

Alice *These phases and pauses created a rhythm that for me defines the piece. There was a rhythm in the way the piece took shape, in our movements into and out of the space, in our moods and energy levels. We also each had our own rhythm relating to our own embodied skills – so at the beginning Fo was able to use threads and tie knots much faster than me, but by the end I'd developed my own way of interacting with the yarns so I didn't snag or get tangled up in them.*

Making, and indeed technical processes, can be understood as a combination of multiple forces and intentions, from specific or practical to open and ambiguous. If we broaden the 'doing' notion of making, to conceive it as a way of exploring and defining ideas, we can see it as a way of thinking *through* the body, where suggesting, mapping and exploring are features of a process of discovery with materials. Leroi-Gourhan

focuses on techniques 'from the perspective of . . . manipulation. His originality was to link the properties of materials (chemistry, flexibility, fluidity) with the properties of performing bodies (muscular energy, forces)' (Naji and Douny 2009: 412), and this promotes an active view at once discursive (Figure 12.4a–c shows how material and body perform in a discursive relationship with one another). Through our experiments and reflections, we can start to appreciate the multiple practices 'entangled' in the discourse, and begin to navigate multiple routes and possibilities in making and gestural activities. By playing with ways to describe these intersections, we can develop evocative semantics that both expand and drill down into dialogues of making/doing (the broader view) and gestures/actions (more distinctive techniques) through materials/bodies/spaces. Making actions frame the gestural actions, and together they form an understanding of transformative *thinking actions*. In the following list, we have teased out some of these making actions and the gestural actions from our making process:

Making (doing)

Sketchbook: draw, dissect, build, write, map, describe . . .

Pins: position, measure, hammer . . .

Threads + Elastic: unravel, guide, transport, drape, direct, follow, align, juxtapose, insert, separate, connect, secure, repeat, add, construct, restrict, contain, expand, dance . . .

Viewing / Mapping: extend, oscillate, observe, consider, translate, play . . .

Detachment and positioning of structure: undo, remove, interact, perform . . .

Powder / liquid / solid (plaster): carry, mix, coat, conceal, manipulate, disrupt, congeal, distort, transform . . .

Solid / powder (charcoal): deconstruct, fragment, extract, gather, merge, reveal, blur, disperse . . .

Gestures (actions) (of material *and* body)

Pencils: grasp, stroke (page) . . .

Pins: pinch, purse (lips), tap, pierce, push, ping, flick, stroke . . .

Elastic: grasp, pull, stretch, bend, twist . . .

Threads (Table 12.2): pinch, grasp, pull, tease, entangle, unravel, caress, wrap . . .

Threads (Table 12.3): stretch, reach, flow . . .

Plaster: open (hands), rub, squash, pour, drip, slap, drop . . .

Charcoal: carve, scratch, rub, blow, breathe . . .

Gestures of making might be distinct or seep into one another, and can be characterized by pressure, energy, weight, velocity, direction, tension, resistance of body or material, dependant as much on material forces as intention, skill or knowledge of materials. But

gestures are also built into the body's memory, learnt and embedded, a toolbox of possible actions and reactions.

Gestures might be stylistic and individual, dynamic, intricate, evocative, whilst intentionality drifts between considered, responsive, impulsive and refined:

> intentionality should be understood as a distributed, emergent, and interactive phenomenon ... The artefact should not be construed as the passive content or object of human intentionality, but as the concrete substantiating instance that brings forth the intentional state.
>
> *Malafouris 2013: 144*

The making process, therefore, allowed us to consider what we are thinking of as the '*embeddedness of gesture*', the idea that some gestures are so intrinsic to experience we have difficulty isolating or anticipating them, *and* the idea that multiple gestures are captured within material forms.

Materials

We see materials as having their own resonances and energies within the making process: they are not seen as inert but instead have their own *life* (Figure 12.5c illustrates the active and dynamic nature of materials, traces of human and material forces interacting, rather than static or inert residue of human activity). Making is about engaging with and exploring material qualities and forces, or, according to Deleuze 'it is not a matter of reproducing or inventing forms, but of capturing forces' (2003: 56).

Materials can be seen as an invitation, summoning a particular set of gestures, where material qualities and tensions play a central role in tactile manipulation. Bergson explores this notion, noting that 'the objects which surround my body reflect its possible action on them.' (2016: 6). Working with materials in different states, for example plaster, through powder – liquid – solid, coagulating, transforming, created a need for speed and dictated a spontaneity and energy; a letting go of preciousness. Threads on the other hand, invited dexterity and guidance; travelling in space, dissecting and informing currents of air, unravelling, stretching, relaxing, and with their own sense of gravity. Each thread has its own relationship with the one next to it – tangling, clinging or keeping separate/distancing: forces of attraction and repulsion at play. Threads transformed in space from reels to singular lines into structure, plane and form, uniting to become a 'thing'.

Fo *We had no clear idea of how the piece would behave once we had removed the elastic from the wall, and at this point the whole piece transformed and had a life of its own ... it kind of dictated my movements, and it became like a dance, playing with variations of*

form, light, space . . . there was a kind of 'handing over', where materials were given space to reveal their own energies and intentions.

Each material has its own life, and one cannot without punishment destroy a living material to make a dumb senseless thing. That is, we must not make materials speak our own language, we must go with them to the point where others will understand their language.

<div align="right">

Pallasmaa 2009: 55

</div>

In this way, materials play a central role in articulating gestures of making. Materials are not only in dialogue with the maker, but have the potential to communicate with the viewer/observer, through elements such as density, rigidity, weight, resilience, tension, fluidity and permeability. In turn, this creates opportunities to explore and articulate meaning, though perhaps not in a concrete way. Seamon reviews Merleau-Ponty's claim that 'qualities of the world directly resonate with the lived body and thereby convey immediate meanings and ambiences, though typically at a tacit, unself-conscious level of awareness' (2010 in forthcoming: 3).

Materiality of sound

Sound became part of the making process as a tangible (albeit ephemeral) material. It became an active component – as resonance and vibration, as forces and flows of reverberant potential with which we could interact and play – malleable, as well as affecting (LaBelle 2010). By identifying, isolating and recording different sounds for the film, we developed our own way of listening with the recording equipment (Rice 2010). Sometimes sounds resulted from intentional actions and interactions, and sometimes they took us by surprise. Once identified, sounds were isolated and experienced close up in headphones. This personal, private interaction with sound created a space to experiment and play with subtle sonic utterances, shifts in pitch and tone, and variations in materials. The play with sound teased out the nuances of pressure, positioning, tension, resistance and resilience. The piece became a musical instrument: listening was not passive, but a way of making and participating.

We know (but perhaps do not know why) that paper sounds dry, pins sound sharp, charcoal sounds scratchy and elastic 'twangs', though these are concepts bound up in culturally specific associations. Through our specific material interactions, we formed our own auditory understanding of the piece through embodied associations, a kind of mapping of tensions and motion. It could be said that when listening, people often know (or perhaps imagine) the bodily movement either causing or associated with a particular sound or sounds. The immediacy of this 'action–sound coupling' means we create mental and physical understandings of human movement through the act of listening

(Van Nort 2009: 178). We may sense or understand the *feeling* of an action, without necessarily moving ourselves – an 'understanding *from* the body' which Marchand (in discussion of visual comprehension of action) terms 'motor simulation' (2010a: 15), and which Godøy (in discussion of music perception) terms 'motor-mimesis' (2006). We would argue that in the same way, *sounds* – emerging from sound-making actions with physical objects – 'evoke a sense of embodiment' (Van Nort 2009: 177). Our engagement with sound therefore also extended beyond the vibratory, beyond listening, to incorporate active reception, resonance and bodily empathy.

Sounds are gestural – not simply indexes of action, but sculpted energy transfers or trajectories of energy between materials, bodies and spaces (Van Nort 2009). We understand sound as movement and interaction, with materials, their tensions and resistances. During the making process sounds did not simply result from gesture: they also *generated* gestures and *were themselves* a form of gesture, simultaneously connecting and triggering forms of discourse and knowledge (LaBelle 2010: xix). Making sound became an extension of the making process, a way of making in its own right, as we explored the sonic potential embedded within materials and processes.

Gestures of . . .

Throughout the making process, a number of central concepts emerged. We recognized a number of specific and distinct gestures, from the delicate to the sweeping (such as *pinching* and *stretching*), with varying levels of impact (such as *flicking* and *blowing*), to the more obviously material gestures (such as *dripping* and *dispersing*). Each had its own trajectory through bodily, material and spatial relationships. However, we were also keen to explore a more nuanced interpretation of gesture as a complex, networked set of processes. We consider each of the following concepts as a lens through which to examine and reflect on patterns of action, gestural qualities and intentions.

. . . mapping

A significant theme that permeates the work is that of mapping. Bodily actions, or *thinking action* creates ways of navigating material and spatial landscapes, exploring possibilities and relationships, constantly shifting, oscillating between different forces and forms of intention. Making is a state of flux, where pauses, breaks and mistakes jut and flow between and within phases of action. Every mark or movement shifts perceptions and experience, and mapping becomes a way of attempting to anchor the space between reflection and projection, in a continually changing present. Mapping can be seen as a kind of choreography, but one that is emergent, as Sheets-Johnstone describes:

> The movement which I actually create at any moment is not a *thing* which I do, an action which I take, but a passing moment within a dynamic process, a process

which I cannot divide into beginnings and endings ... [a] perpetually moving present.

<div align="right">

Sheets-Johnstone 1981: 405

</div>

Making begins with curiosity, the seed of an idea, with sketches, conversations, prototypes and play (Figure 12.1a–c shows the early stages of Fo's making process). Tiny drawings mapped the work in relation to the artist's body, extending threads through space, with Fo's inherent sense of scale, space, weight, form and movement being explored through pencil markings in numerous ways (Figure 12.1a). The hand and the pencil stroke, dot, stab, sweep, meander across the page, both image-making and imag(e)-ining possibilities, as Pallasmaa explores:

As a consequence of the mental transfer from the actuality of the drawing or the model to the material reality of the project, the images with which the designer advances are not mere visual renderings; they constitute a fully haptic and multi-sensory reality of imagination

<div align="right">

Pallasmaa 2009: 59

</div>

Writing and drawing are themselves gestural, mapping potential; 'the drawing is not the visible shadow of a mental event; *it is a process of thinking, not the projection of a thought*' (Ingold 2013: 128). The hands link directly to imagination, perception and memory (Sennett 2008).

Another mapping phase of the making process started when entering the gallery space, defining the area within which to work. Gestures of looking, through the moving body and flickering eye, themselves body techniques, could be said to map the space, sweeping in–out–through, responding to and situating the body in space (as described in Table 12.1). We learn to look, our probing eyes searching within our own (cultural) frameworks of understanding (Mauss [1935] 1973).

Fo *As a maker, I see the space as a landscape – a space to be explored, a space to find pathways, within which to carve into the air and reveal invisible spatial forces, flows of proximity and distance.*

Physically, the process of mapping out the piece was dictated by Fo's arm span and physical reach, so the scale and proportion of the piece was developed in direct relation to her body (Figure 12.2a–b shows Fo marking the piece onto the wall, using her body's reach for scale). The resulting circle, positioned in the corner of the room, created the nucleus of the piece, from which materials and the body could extend, connect and transform.

Movement was intrinsic to the visual experience of the piece. A circle situated in a corner creates a series of optical illusions, looking egg-shaped, pear-shaped or mismatched from different angles and approaches. A length of elastic stretched horizontally across the space at roughly eye level created a line, which had the effect of simultaneously defining and breaking up the space. Our resulting movements seemed to be 'into' or 'out of' the space, whilst the line necessitated particular bodily movements – bending or crouching to duck beneath it, or using the arms to raise it above the head. The body naturally moved to accommodate the line – bringing it to eye level, running hands along it or purposefully moving beyond it into the active space. Visually it created a sense of distance, perspective or scale, which enabled the eye to assess and interact with the space in a different way. The line became an anchor for the eye, creating a resonance with the basic elements of line, shape, form and symmetry.

Alice *I found myself closing one eye at a time to refine my sense of shape, proximity and perspective when looking at the elastic 'line' in relation to the corner of the space.*

Fo *I was aware of not looking 'too hard', rather my vision was oscillating between far and near, present and future, visualizing the space as potential for more intersections, judging the possible impact of new connecting lines.*

. . . difference

The process of making alongside one another highlighted different viewpoints and questions, backgrounds and ways of understanding. As two makers, we have extremely different skill sets based on previous experience and embodied knowledge, as well as cultural imprints stemming from disciplinary norms. Our bodies tell stories based on personal histories and unique rhythms – rhythms which both emerge from the body and which are incorporated into and informed by practice. Marchand notes that motor-based understanding 'constitutes a knowing *how from* the body, as differentiated from merely knowing *that about* the body' (2010b: 99). More experience of an activity leads to greater attention to detail – 'practical skill therefore develops *in* bodily practice' (ibid.: 99).

Alice *On the first day my body felt large and clumsy, as I wasn't used to working with fine threads, tension or small pins. I wasn't able to move fluidly through the space to avoid threads sticking to me, and I couldn't tie knots quickly or smoothly. But with repetition over the three days, my physical gestures slowly began to resemble Fo's – my knots became less hesitant and more confident. I gradually learned how to move in this new environment.*

As our physical skill-sets developed and expanded during the work, individual and stylistic differences became noticeable. Each thread was tied in a slightly different way (Figure 12.3a–d shows Alice tying a knot, navigating material behaviours), dependent on positioning, tension, focus, etc. Each pin was hammered a slightly different amount and from a different angle. Tiny adjustments were made in each iteration and we developed 'motor algorithms' – described by Warnier as 'the kind of motor habits we use in given materialities when there is some amount of uncertainty or unpredictability in the situation' (2001: 9).

Personal difference also manifested in our individual and subconscious gestures of concentration or reflection: Fo plays with her hair when she thinks; Alice rubs her temples. People bite their lips, curl their toes, play with props or clothes when they think. Repetitive actions are therefore also personal actions; and whereas 'repetition' may imply the mechanical or automatic, 'patterns of action' may provide a more nuanced term to describe these seemingly simple, iterative processes.

. . . exchange

Exchange was present throughout the making process in the form of discourse, sharing knowledge, ideas and opinions, and collaboration. Alongside this, specific moments of exchange were also noticeable. Some of these were physical, for example, we often found ourselves swapping places to work with different thread qualities, or swapping tools to test different weights and handling, while some were more cooperative, for example passing reels of yarn between us to speed up the process. Other exchanges were verbal or experiential. There were moments where language was inadequate to describe, so showing and performing were used.

Sharing and exchange are transformative acts, creating the potential for new forms of knowledge to develop and for multiple pathways of knowledge to emerge. We found that our anthropological and artistic ways of knowing complemented each other, opening up new lines of questioning or echoing each other in our approaches.

Traces of gesture / permeability

The body is residual in material forms, through memory and traces of bodily action. The skin of the body – as with the skin of a thread or a plastered wall – is porous and permeable, a carrier of information (Bergson 2016). Figure 12.5b–c shows this porous relationship between skin and material. In art and design the term 'quality of line' is used to describe how marks hold the energy of the maker, tension between the maker and material, pressure, direction, positioning and speed. The maker therefore permeates the work in subtle yet intrinsic ways.

Physical traces of us as makers are present – for example, in threads, which accumulated deposits of skin cells as we drew our fingers along their lengths; or walls, which retain holes marking where a pin was once hammered in. Similarly, our bodies

carried *material* deposits and traces – charcoal powder became engrained in crevices of fingers and fingernails; pins left momentary indentations on fingertips. Material traces also permeated the space via unintentional charcoal-covered footprints, the work itself seeping out of its boundaries.

Makers are therefore inscribed into the things they make, just as making processes are inscribed into muscle memory and onto skin. 'If we accept that mind and matter achieve a co-dependency through the medium of bodily action, then it follows that ideas and attitudes, rather than occupying a separate domain from the material, actually find themselves inscribed "in" the object' (Knappett 2005: 169). Made objects therefore communicate with us. As viewers, touchers, listeners and users of these objects, we engage with these traces – and therefore with the maker – in sensory and embodied ways.

Conclusion and reflection

We entered into this work with a mutual interest in opening up or broadening definitions of gesture, attempting to question the idea that it is simply secondary or indexical of thought. Approaching the work with this mind-set created conceptual space for us to explore the different potential manifestations of gesture. We have developed a flexible understanding of gesture as pre-semiological, as 'inherently multi-modal', as *thinking action* – playing a central role in being and knowing (Van Nort 2011: 1181). Thought is not separate from its expressive form; it need not be '*transcribed* into movement'. 'Mind-doing' is not separate from 'body-doing'. Instead, perceiving and moving, experiencing and acting are simultaneous and mutually informing – my perceptions are 'plaited into my here-now flow of movement' (Sheets-Johnstone 1981: 401–3). We are able to 'think' through non-verbal processes of inferences, adjusting material and bodily gestures in relation to one another.

The making process was inherently **discursive**, and it is worth noting in particular the discursive nature of our interactions with materials. We learnt primarily through our *material* encounters, 'technical' processes of temporal relations with materials. Combinations of gestures were simultaneous or sequential, iterative, collaborative. Dialogue also manifested in the form of verbal exchanges, and through bodily demonstration and imitation. Gesture both creates and unfolds in discourse, but we are keen to avoid a universalizing 'giver and receiver' interpretation. An understanding of gesture as reciprocal incorporates not just bodies, but space and materials too. Gesturing bodies are situated in place and time, and gestures may reside outside of or beyond the body (for example in the case of sound, or material traces).

Gesture is **transformative**: the *body* is shaped by gesture, as are materials (as in a *chaîne opératoire*). Bodily gestures may evolve and become quicker, more fluid or more complex as skill and embodied knowledge develop. The maker works *with* materials in an explorative way, responding to challenges and needs with sensitivity whilst attempting to 'listen' to the material and avoid the imposition of form. In this work, we saw fragments (ideas, techniques, threads, pins, etc.) combined and transformed to make wholes.

Thread became line, became boundary, or form; powder became liquid then solid; breath became tool; ephemeral sonic moment became digital file; fingers became adept.

This understanding of gesture incorporates *both* distinct, specific sets of actions *and* indistinct or fluid relational forces between bodies, materials and space. Precisely where the boundary lies between 'gesture' and 'action' is unclear – our conversations throughout the making process have centred around dialogue and reciprocal flows of energy (not simply from A to B, but relational and complex). The film making process both jutted *into* and reflected *out* from the operational chains, providing alternative viewpoints and modalities for phases of activity.

We feel that a flexible approach to gesture can help develop a more holistic (and therefore realistic) understanding of movement and interaction. Notably, the gestures we have explored here are those that may have eluded more simplistic frameworks. Mapping, the revealing of difference, and exchange emerged as important, alongside potentially less tangible themes of sonic gesture, traces and permeability.

This instance of making has demonstrated to us that gesture – especially through material interactions – is fundamental in constructing meaning and value. Gesture informs our understandings of the world around us, and is part of a reciprocal process of co-construction. Rhythm emerging from the body, movements in and out, and oscillation have felt significant; this rhythmic nature of making may not always be tangible or explicit, but is necessarily both aesthetic and visceral (Leroi-Gourhan 1993: 281). Cycles and phases of action became apparent in relation to material forms and states, and material gestures and qualities informed the direction and meaning of the work, subsequently enhancing our corporeal understanding of the world. We would therefore argue for a more nuanced and flexible understanding of gesture as integrative and consolidating, as *thinking action*. Both gesture and making are transformative processes emerging from dialogue – with each other, with materials, with the environment.

Appendix

Exhibition video

We would encourage the reader to watch the accompanying film to give context to this text: Choreography of Making film: https://vimeo.com/114395167 See further R&A Collaborations on vimeo: https://vimeo.com/racollaborations

The film resulting from this work, titled *Choreography of Making*, was shown within a second iteration of the material form, as part of *Crafting Anatomies* in Bonington Gallery, Nottingham Trent University, in January 2015. It was made in collaboration with R&A Collaborations.

Publications related to the exhibition

Journeaux, J. (2015), 'Exhibition Review: Crafting Anatomies', *Journal of Textile Design Research and Practice*, 3 (1–2): 117–24. See discussion of this work, *Choreography of Making*, on p. 122.

Townsend, K., Soloman, R. and Briggs-Goode, A. (eds) (2020), *Crafting Anatomies: The Body as Site in Fashion and Textile Research Practice*, London: Bloomsbury Academic.

References

Barry, D. (1996), 'Artful Inquiry: A Symbolic Constructivist Approach to Social Science Research', *Qualitative Inquiry*, 2 (4): 411–38.

Bennett, J. (2010), *Vibrant Matter: A Political Ecology of Things*, London: Duke University Press.

Bergson, H. (1999), *Laughter: An Essay on the Meaning of the Comic*, trans. C. Brereton and F. Rothwell, Copenhagen: Green Integer Books.

Bergson, H. (2016), *Matter and Memory*, Colorado: Random Shack.

Clark, A. (2013), 'Gesture as Thought?', in Z. Radman (ed.), *The Hand, and Organ of the Mind: What the Manual Tells the Mental*, 255–68, London: MIT Press.

Deleuze, G. (2003), *Francis Bacon: The Logic of Sensation*, London: Continuum.

Godøy, R. I. (2006), 'Gestural-Sonorous Objects: Embodied Extensions of Schaeffer's Conceptual Apparatus', *Organised Sound*, 11 (2): 149–57.

Ingold, T. (2013), *Making: Anthropology, Archaeology, Art and Architecture*, London: Routledge.

Kendon, A. (2004), *Gesture: Visible Action as Utterance*, Cambridge: Cambridge University Press.

Knappett, C. (2005), *Thinking through Material Culture*, Philadelphia, PA: University of Pennsylvania Press.

LaBelle, B. (2010), *Acoustic Territories: Sound Culture and Everyday Life*, London: Bloomsbury Academic.

Lemonnier, P. (1992), *Elements for an Anthropology of Technology*, Ann Arbor, MI: University of Michigan.

Lemonnier, P. (2012), *Mundane Objects: Materiality and Non-Verbal Communication*, Walnut Creek: Left Coast Press.

Leroi-Gourhan, A. (1993), *Gesture and Speech*, trans. A. Bostock Berger, Cambridge, MA, and London: MIT Press.

Malafouris, L. (2013), *How Things Shape the Mind: A Theory of Material Engagement*, London: MIT Press.

Marchand, T. (2010a), 'Introduction', in T. Marchand (ed.), *Making Knowledge: Explorations of the Indissoluble Relation between Mind, Body, and Environment*, Special Issue of the Journal of the Royal Anthropological Institute, 1–20, Oxford: Wiley-Blackwell.

Marchand, T. (2010b), 'Embodied Cognition and Communication: Studies with British Fine Woodworkers', in T. Marchand (ed.), *Making Knowledge: Explorations of the Indissoluble Relation between Mind, Body, and Environment*, Special Issue of the Journal of the Royal Anthropological Institute, 95–115, Oxford: Wiley-Blackwell.

Mauss, M. ([1935] 1973), 'Techniques of the Body', *Economy and Society*, 2 (1): 70–88.

Naji, M. and L. Douny (2009), 'Editorial: The "Making" and "Doing" of the Material World: French Anthropology of Techniques Revisited', *Journal of Material Culture*, 14 (4): 411–31.

Online Etymology Dictionary (2018), 'Gesture'. Available at: https://www.etymonline.com/word/gesture (accessed 28 September 2021).

Oxford English Dictionary (OED) (2015), 'Gesture'. Available at: http://www.oed.com/view/Entry/77985?rskey=RxzhiY&result=1&isAdvanced=false#eid (accessed 28 September 2021).

Pallasmaa, J. (2009), *The Thinking Hand: Existential and Embodied Wisdom in Architecture*, Chichester: John Wiley and Sons.

Rice, T. (2010), 'Learning to Listen: Auscultation and the Transmission of Auditory Knowledge', in T. Marchand (ed.), *Making Knowledge: Explorations of the Indissoluble Relation between*

Mind, Body, and Environment, Special Issue of the Journal of the Royal Anthropological Institute, 39–59, Oxford: Wiley-Blackwell.

Seamon, D. (2010), 'Merleau-Ponty, Perception, and Environmental Embodiment: Implications for Architectural and Environmental Studies', 1–16. Available at: https://academia.edu/resource/work/948750 (accessed 19 January 2022).

Sennett, R. (2008), *The Craftsman*, New Haven, CT: Yale University Press.

Sheets-Johnstone, M. (1981), 'Thinking in Movement', *Journal of Aesthetics and Art Criticism*, 39 (4): 399–407.

Van Nort, D. (2009), 'Instrumental Listening: Sonic Gesture as Design Principle', *Organised Sound*, 14 (2): 177–87.

Van Nort, D. (2011), 'Human: Machine: Human: Gesture, Sound and Embodiment', *Kybernetes*, 40 (7–8): 1179–88.

Warnier, J.-P. (2001), 'A Praxeological Approach to Subjectivation in a Material World', *Journal of Material Culture*, 6 (1): 5–24.

EPILOGUE
TOUCHING ON THE FUTURE OF GESTURE

Amy J. Maitland Gardner and Carl Walsh

This volume has delved into how traces of gesture in past societies can be approached using a diverse range of theories, methodologies and perspectives. Contributors have provided reflection on how archaeologists might further expand their understanding of gesture through a continued interdisciplinary engagement among specialists within and outside of the discipline. Contributors have also highlighted work still to be done in their respective fields, to build from the studies presented in this volume as well as increase collaboration. In these closing comments, the editors highlight a few topics of interest that run through the chapters, from the multiplicity of gesture to issues of interpreting gesture, and the diverse roles of gesture within past societies. The editors conclude with some considerations of the visuality and materiality of bodily communication in the on-going development of gesture research in archaeology, as communication develops, ever increasingly, in the digital world.

The multiplicity of gesture

The range of gesture examined in this volume has illuminated the inherent multiplicity of bodily communication in the ancient world. Contexts of gesture included performance and touch in Minoan Crete (Morris and Goodison, this volume), courtly etiquette in Bronze Age Syria (Walsh, this volume), pre-Roman wine consumption, union and rituality (Gouy, this volume), interactions and community in the Maltese Neolithic (Vella Gregory, this volume), masks and facial expressions in the Phoenician-Punic world (López-Bertran, this volume), communication and narratives in ancient Greece (McNiven, this volume), rituals and performative contexts in the Near East (Calabro, this volume), social exchanges among the ancient Maya (Maitland Gardner, this volume), bodily depictions and their functions in the Ulúa culture sphere (Hudson and Henderson, this volume), interactions with *Rakan* statues in Japan (Kuehn, this volume), relations between the mind and the body in the work of Freud (Fulka, this volume), and body/material relationships in contemporary art (Clough and Hamblin, this volume). Gestural acts examined in this volume were similarly diverse, including hand movements, ways of walking, sitting techniques, object handling, full body movements and facial expressions. These gestural actions were also examined through multiple lines of evidence – architecture, figural art, objects, materials, burials and texts. The variety of gesture forms highlights that any type of bodily action can have great significance, and that diversity in

archaeological data, materials and contexts are useful in exploring the multiplicity of bodily communication in the past.

Multiplicity was also explored through the different ways in which gesture in past societies can be studied. Using approaches from praxeology to body techniques, the inherent materiality of gesture has become apparent through the intimate ways that material culture is designed to interact with gestures of the body. Tracing the visuality of gesture in ancient figural art provided ways to record gestural repertories, such as lexigraphy, and various frameworks that could guide interpretation, such as thick description. Through these approaches, it became apparent how iconographic gestures are intimately embedded in cultural understandings of the body, with their meanings shaped by context and function. Approaches to gesture through the lens of Freud's work (e.g. overdetermination) and through the construction of an art installation (e.g. multimodality) demonstrated that gestural production is multilayered. The diversity of approaches used throughout this volume illustrates the importance of interdisciplinarity, both for inspiration in exploring different stances and in a collaborative effort to further the study of gesture across disciplinary boundaries.

Issues of interpretation

A recurring issue throughout several chapters was how ancient gestures are interpreted. A number of contributors addressed the fact that gestures are often labelled unilaterally: once a description is produced further investigation halts (Maitland Gardner, this volume) or becomes 'flattened' (Morris and Goodison, this volume). Employing alternative frameworks allowed for labels to be challenged and for gestures to be reinterpreted with different meanings and functions. For example, Morris and Goodison's sensory approach to Minoan imagery worked to reframe the 'ecstatic' labelling of baetyl stone touching and 'potter at work' composition. By focusing on the process of experiencing bodily action in these scenes, gestures of touch became deliberate, controlled actions rather than secondary products of larger narratives of 'worship' or 'work'. This allowed their roles to be reinterpreted, from a sprawl of abandonment to a highly choreographed movement and from pot making to ritualized funerary acts. Similarly, López-Bertran reviewed the 'grimacing' label of Phoenician masks, highlighting that the experiential aspects of smiling, resulting from emotion and sensory alteration (including the ingestion of certain substances), allowed them to be reinterpreted as having transformative and protective roles. Even if a label for a gesture is fitting, such as 'handshaking' in ancient Greece, such acts can function in multiple ways, and their full dynamics and dimensions must be explored (McNiven, this volume).

Calabro, Maitland Gardner, and Hudson and Henderson also highlighted this issue in their respective fields. In discussion of ritual gestures in the Near East, Calabro showed that descriptions of the lowered form of raising one hand as a gesture of 'greeting', 'blessing' or 'adoration' did not fit all contexts of this gesture's depiction. Rather, action must first and foremost be considered performative, with meaning generated through

contextual practice. This point was further emphasized by Maitland Gardner, who illustrated that the overarching label of ancient Maya gestures as 'courtly' minimized discussion of other types of information that could be communicated beyond status and power relations. Unpacking the culturally shaped origins of gesture production and relating gestures of elite art to everyday social contexts (e.g. actions of offering, giving, sharing and showing) worked to renegotiate the dimensions of gesture usages and their meanings. Hudson and Henderson's encounter of descriptive labels of postures in Ulúa art also showed that the labelling of figures, such as 'dancing', with interpretation focused on 'sexual intercourse', hindered explanation of these scenes. By shifting focus from identifying relatable experiences (as modern observers), to how the body functions in the iconographic realm, Hudson and Henderson showed that gesture can function as indicators that can locate meaning as readily as they can generate meaning as an individual element.

These examples illustrate clear issues in the subjective labelling of gestures without full consideration of their functions and meanings. Such descriptive labels can be difficult to escape from in archaeological approaches and writing, especially considering the need for terms in which gestures can be described. However, in labelling gestures, scholars often risk interpreting them at the same time (McNiven, Maitland Gardner, Morris and Goodison, this volume). It is this point between description and interpretation that has required reflexivity in discussing gestures according to physical properties, their performative aspects and contextual functions. Moving forward in approaching gesture, the subjective bias in interpretation needs to be continually addressed; bringing scholars back to question previous identifications while also providing alternative readings.

Repetition, interaction and identity

The repetition of bodily movements in social exchanges and engagements with things (e.g. materials, objects, images and architecture) establishes ways of communicating in societies around the world. Ultimately, it is the repetitive nature of gesture that allows for the study of bodily action in the archaeological record. Doing things in certain ways over and over again materializes patterns of bodily actions, leaving lasting visual and tactile traces. For example, bodily acts in lived practice – such as movements of the arms and hands – become conventionalized through their repeated use, such as raising the arms and hands (Calabro, this volume) or extending them forwards (Hudson and Henderson, Maitland Gardner, this volume). These types of actions are selected and adapted in representations of the body, with repetition serving to minimize ambiguity and allowing for the same actions to be visually recognized (McNiven, this volume). Repeated and materialized acts can also be seen in the design of vessels, which enables particular ways of participating at drinking events (Gouy, this volume), or walking on a staircase (Walsh, this volume), where bodily actions are actively planned into the design of objects and architecture. This point is particularly essential in considering the agency of material culture design, in how meaning is generated through the interaction between the body

and things (Vella Gregory, this volume). This interaction is not passive or mechanical, but deliberate and purposeful, often considered before making (Clough and Hamblin, this volume).

The repetitive nature of gesture also acts as a process through which meaning is constructed. For example, a number of chapters pointed to how gesture can function as mnemonic devices, with repetitive bodily actions facilitating the retention of information over time. This mnemonic quality of gesture can be found at the individual level in the muscle memory of rhythmic, repeated actions of the body interacting with things (Morris and Goodison, Gouy, Clough and Hamblin, this volume). Memories are also personal, that influence gestural expression in a particular place, at a particular time (Clough and Hamblin, this volume), and which can manifest through the recalling of past emotional states and experiences (Fulka, this volume). At the same time, these bodily memories can be learned, social behaviours (Walsh, Morris and Goodison, this volume) used in the construction of collective memory in the form of place making, *habitus* and shared interpersonal acts (Walsh, Vella Gregory, López-Bertran, Gouy, Maitland Gardner, Calabro, this volume). Vella Gregory's examination of place making in Maltese Neolithic monumental spaces was particularly illustrative of this, in how the construction of social memory cannot be achieved only through verbal narratives, but through collective bodily performances involving physical spaces and material things, that can continue even beyond death. Indeed, many things that cannot be expressed verbally (such as memories) manifest in bodily acts (Fulka, this volume), with performance often employed in situations in which verbal exchanges are inadequate (Clough and Hamblin, this volume).

The interactive, performative nature of gesture formed a common theme across the chapters. Communication requires interaction among participants, which were variously referred to within this volume as 'actors', 'performers' and 'initiators' (participants producing actions) and 'audiences', 'viewers' and 'receptors' (participants witnessing and/or engaging in action). Rather than constructed in dualistic terms of active/passive directionality in the communication of meaning, audiences, viewers and receptors are key actors themselves, whose reception of gesture works to measure and define it (Kuehn, this volume). Gouy highlighted this through her study of the coordinated techniques of using *doppieri* vessels. In this case, the interaction between actors and vessel created performative, choreographed movements involving other participants at the banquet that worked to express unity between initiators and receptors during drinking. The role of audiences, in how they participate in the reception of gesture, was discussed by both Walsh and Vella Gregory. They considered how the physicality of space – architecture and furniture – served to construct social theatres for the performance and reception of gesture during events such as processions and burials.

Significantly, materials themselves (e.g. threads, charcoal, pins) also have an active role in mediating relationships. Physical properties of materials (such as weight and tension) create 'oscillations' between artists/makers and viewers/observers (Clough and Hamblin, this volume). The same person – at various points in an activity – can perform each role (Clough and Hamblin, this volume), reminding us that the role of participants

is not always static, but fluid. These communicative aspects of gesture among participants are essential in the successful generation of meaning, which of course can also be unsuccessful. Success and failure in the performance or production of gesture is determined by the manner in which audiences/viewers/receptors respond to the communication of meaning, who are, in turn, inherently involved in constructing these dialogues.

These interactions among participants facilitate the construction and expression of identity, a subject touched upon in almost every chapter. Discussion of identity often made distinctions of scale, from personal to collective. The role of gesture in personal identity was nicely invoked in an observation by Clough and Hamblin: 'We became aware of unique, personal gestures – playing with hair, chewing a pencil, rubbing temples, rubbing the neck, which formed part of our individual, stylistic processes of thought or reflection.' Fulka also demonstrated that gestures can be personally and historically shaped by individual life histories (such as a woman who experienced a pricking sensation and twitch in her fingers, which was a visible bodily action related to her playing the piano for her uncle, who had before tried to rape her during a massage). These observations in modern contexts show how gestures express personal bodily narratives and identities. These relationships between personal identity and gesture can be difficult to trace in the archaeological record, as they largely depend on how personal identity is emphasized or expressed through visual, written and material culture. However, they can be uncovered in some cases where ancient cultures place particular emphasis on expressing this form of identity in material mediums (e.g. vase painting in ancient Greece, McNiven, this volume).

Larger collective and cultural identities utilize gesture in a variety of ways, to include/exclude individuals, to express collective values and beliefs, and to negotiate the roles of individuals in relation to larger groups. The examination of courtly identities in the chapters by Walsh and Maitland Gardner was particularly illustrative of how gesture can be used to construct collective identities through inclusion and exclusion. Walsh showed that courtly gestures at Bronze Age Ebla in Syria were produced through learned bodily experiences shaped by material culture through the *habitus* of the court. These gesture vocabularies were distinctly elite and became an outward expression of status identities, which served to distinguish between courtly participants and audiences at the palace. While acknowledging that status and power had a role in ancient Maya art and social relationships, Maitland Gardner showed that many gestures likely originated outside of the elite sphere, finding relevant depiction in the art of the elite for particular intents. Hands employed in the formation of the ancient Maya script suggested that many gestures in writing and the art were drawn from wider (and earlier) practices rather than through the development of a distinctly courtly etiquette later in Maya history. In this way, gesture did not serve exclusively to separate courtly bodies from others in ancient Maya society, but found points of inclusion through their overlap in both non-elite and elite contexts.

A number of contributors also illustrated how gesture could be emphasized or de-emphasized to express collective identities. This can be seen in Vella Gregory's

observations of bodily features and gesture in Maltese Neolithic figurines. These figurines often had different insertable heads, which minimized individuality, while emphasizing their gestures relating to the human lifecycle (e.g. sleep and birth). The emphasis on the figurines' lifecycle gestures, along with their long-term use by the community over generations, worked to construct and reinforce collective memory and community identity. López-Bertran came to a similar conclusion, in noting how gestures and decorations of Phoenician masks and their display at entranceways to burial chambers, houses and shrines, expressed community and family group identity. The transformative nature of the masks materialized individuals into nebulous ancestral identities that served to offer protection at the community level and across the western Mediterranean. This distinction between individuality and collectivity can often be blurred, as seen in Kuehn's chapter on groups of *Rakan* statues in Japan. She noted that these statues could emphasize collective identity through their spatial groupings. At the same time, the statues offer opportunities for individual identification, such as finding one's own or loved one's features, enabled by their lifelike qualities. This blurring of distinction between individual and collective identities highlights that shifting resolution between micro and macro experiences is necessary in the study of gesture across the ancient world.

Future directions: Gesture in the digital world

Looking beyond the typical gaze of the archaeologist, we can see that the uses of gesture continue to develop today. The rapid development of technology – through a spectrum of objects and media – has facilitated whole new channels of communication, allowing the body to expanded beyond the confines of its organic physicality into cyber and digital worlds. Here, the editors provide some thoughts on the relationship between technology and gesture, and how these can be useful in looking back at the past.

In recent years, there has been an overwhelming proliferation of pictures, video and reproductions of the body and its actions through the internet, video games, television, film, books and magazines. This global distribution has made it possible for gestures to be constructed, reproduced, transmitted and analysed on staggering levels. In particular, moving images allow whole series of gestural performances and vocabularies to be observed by global audiences (Piccini 2015). They also allow gesture to continue to generate meaning, even after the act itself has ended, providing temporal longevity. Both of these factors facilitate opportunities for gestures to be imbued with new meaning, produced and observed in different contexts. Clough and Hamblin's video documentation of their making process (this volume) is particularly illustrative of this. The edited video transformed their gestures from a perceived mechanical process into a performative piece of art. The transition from embodied making to moving image was a transformative one, providing new sensory experiences and meaning through the manipulation of sound, colour and cutaway images. The projection of this video onto their installation as

part of the exhibition provided new ways for visitors to experience the making process. The subsequent publication of the video online[1] provides the opportunity for their performance to be viewed by other audiences, who can interpret their own meaning and personal responses to it.

The immersive nature of modern media has provided new modalities for gesture. For example, mobile phones enable communication through several types of media – videos, photographs, talking, and texts and emails. Instantaneous written communication through these hand-held devices has required the development of emoticons[2] and emoji.[3] These images include an enormous array of gesture, including facial expressions and handshapes. They are used either in place of a word or phrase or as additional determinative markers to make sure that what is written is interpreted in the way that the writer intended, such as denoting emotional states, attitudes and intentions (Rezabek and Cochenour 1998; Walther and D'Addario 2001). Fundamentally, emoticons and emoji are used to communicate non-linguistic information that would be transmitted and understood in face-to-face engagements that are lacking in digitally and computer-mediated interactions (Dresner and Herring 2010). This demonstrates the prevalence of bodily communication in sociality. Although technology has enabled new ways to communicate, gesture is still required for successful, holistic communication. Research on emoticons and emoji in computer sciences, psychology and marketing (e.g. Kaye, Malone and Wall 2017; Bai, Dan, Mu and Yang 2019) provides a contemporary point of comparison, in reflecting on how gesture arises in visual channels of communication, such as in art, as well as how pictorial elements centred on the body can be developed to communicate particular messages and emotions.

Advances in modern technology also begin to expand our concepts of how gesture moves beyond the organic body. The concept of cyborg bodies, the incorporation of non-human materials into the body, is now a common reality for humans, and has been discussed in the detail in the wider social sciences since the 1980s (Lupton 2015). Humans have of course been adding non-human materials into the body for thousands of years, but this is increasingly pushed in new ways, from wearable computing, the insertion of implants into the body, the advancement of prosthetics, and even robotics, all of which utilize and mimic the human body and senses (Cai et al. 2017; Nguyen-Dinh, Calatroni and Troster 2018; Robb and Harris 2013; Schneider, MacLean, Swindells and Booth 2017). These cyborg bodies with their body/material interactions highlight that perhaps archaeology, interested in how material culture can be used in examining human societies, might benefit from collaboration with the various fields involved with information technology, artificial intelligence and robotics.

The ability of technology to interact with gesture is becoming hugely influential in technological design, with distinct cultural and social impacts in modern societies. The success of user interface technology, such as touch screens, has provided new ways that digital, material and bodily worlds interact. Whole new gestural vocabularies, transmitted on global scales, have emerged that are intimately tied to specific material culture and digital programmes, such as the linear finger scrolling of digital media, the swipe right or left of dating apps, the command control gestures for tablets and the use of tablet pens.

Considering these types of body/material interactions present new ways of approaching the role of gesture, as Morris and Goodison (this volume) point out; 'the possibility that the process of touch itself – touching and being touched – could be central to a ritual has been neglected and undervalued. Perhaps like the touch of fingers on a smart phone or iPad (and it has to be bare fingers), this touch itself is the crucial pathway that opens a door to another world of communication.' This burgeoning of gestural technologies allows us the opportunity to pause and consider not only how the interplay between body, image and objects shape the future human societies, but also those of the past.

The concept of digital bodies, which can range from medical records, social media profiles and interactive human bodies constructed through immersive media such as video games, particularly blur the boundaries between the visual, the material and the body (Broadhurst and Price 2017). These digital bodies provide whole new avenues to construct forms of bodily communication. The commercial success of video game technology, such as Nintendo's Wii console or Microsoft's Kinect, clearly illustrate the blurring of these boundaries. These consoles use motion sensor technology and hand-held remotes to allow designers to produce interactive games that incorporated the performance of gesture to achieve in-game goals. This often results in the synchronized performance of gesture between a physical and digital body, mediated through the interaction between body, remote, sensor and video programming, which recognizes the gesture for what it is. The immense complexity of these interactions is taken even further in totally immersive virtual reality, which allow human bodies to insert themselves into interactive digital worlds.

These musings on the visual and material evolutions of gesture in the modern world provide food for thought in considering just some of the ways which archaeologists can find inspiration. Although digital technologies are absent in the ancient world, human communities live in enmeshed worlds with their material surroundings and find channels of expression through the physicality and visuality of bodily acts. Gesture studies are continually evolving and ever increasing. Archaeology – with its deep history and breadth of cultures – has a significant role in the continuing development of this field. The editors intend this volume to help spearhead further enquiry into gesture, in considering its deep roots, its current experiences and its future modalities.

Notes

1. To watch this video, go to https://vimeo.com/114395167

2. Emoticons ('emotion icons') are formed by characters on a keyboard (Godin 1993). Their origins are commonly attributed to a smiley face :-) and a frown face :-(proposed by Scott Fahlman in the early 1980s as a character sequence for joke/no joke markers (to be read sideways). Their development arose out of a difficulty recognizing sarcasm on an electronic bulletin board among colleagues at Carnegie Mellon University in Pittsburgh.

3. Emoji are small images, a transliteration from the Japanese *e-mo-ji* 'picture-write-character'. Shigetaka Kurita created the original set in the early 1990s.

References

Bai, Q., Q. Dan, Z. Mu and M. Yang (2019), 'A Systematic Review of Emoji: Current Research and Future Perspectives', *Frontiers in Psychology*, 10. DOI: 10.3389/fpsyg.2019.02221.

Broadhurst, S. and S. Price (eds) (2017), *Digital Bodies: Creativity and Technology in the Arts and Humanities*, Basingstoke: Palgrave Macmillian.

Cai, L., S. Cui, M. Xiang, J. Yu and J. Zhang (2017), 'Dynamic Hand Gesture Recognition Using RGB-D Data for Natural Human–Computer Interaction', *Journal of Intelligent & Fuzzy Systems*, 32 (5): 3495–507.

Clough, A. (date unknown), *Collaboration*. Available at: http://www.aliceclough.com/choreographyofmaking (accessed 19 January 2022).

Dresner, E. and S. C. Herring (2010), 'Functions of the Nonverbal in CMC: Emoticons and Illocutionary Force', *Communication Theory*, 20 (3): 249–68.

Godin, S. (1993), *Smiley Dictionary: Cool Things to Do with Your Keyboard*, Berkeley, CA: Peachpit Press.

Kaye, L. K., S. A. Malone and H. J. Wall (2017), 'Emojis: Insights, Affordances, and Possibilities for Psychological Science', *Trends in Cognitive Psychology*, 21 (2): 66–8.

Lupton, D. (2015), 'Digital Bodies', in D. Andrews, M. Silk and H. Thorpe (eds), *Routledge Handbook of Physical Cultural Studies*, 200–8, London: Routledge.

Nguyen-Dinh, L., A. Calatroni and G. Troster (2018), 'Supporting One-Time Point Annotations for Gesture Recognition', *IEEE Transactions on Pattern Analysis & Machine Intelligence*, 39 (11): 2270–83.

Piccini, A. (2015), '"To See What's Down There": Embodiment, Gestural Archaeologies and Materializing Futures', *Paragraph* (Modern Critical Theory Group), 38 (1): 55–68.

Rezabek, L. and L. Cochenour (1998), 'Visual Cues in Computer Mediated Communication: Supplementing Text with Emoticons', *Journal of Visual Literacy*, 18: 201–15.

Robb, J. and O. Harris (2013), 'Body Worlds and Their History: Some Working Concepts', in J. Robb and O. Harris (eds), *The Body in History: Europe from Palaeolithic to the Future*, 7–13, Cambridge: Cambridge University Press.

Schneider, O., K. MacLean, C. Swindells and K. Booth (2017), 'Haptic Experience Design: What Hapticians Do and Where They Need Help', *International Journal of Human–Computer Studies*, 107: 5–21.

Walther, J. and K. D'Addario (2001), 'The Impacts of Emoticons on Message Interpretation in Computer Mediated Communication', *Social Science Computer Review*, 19 (3): 324–47.

INDEX

The letter *f* following an entry indicates a page with a figure.
The letter *t* following an entry indicates a page with a table.

Index

Index

Index

www.ingramcontent.com/pod-product-compliance
Lightning Source LLC
Chambersburg PA
CBHW050412280326
41932CB00013BA/1833